ourney 1921

A Private View of

L. S. LOWRY

A PRIVATE VIEW OF
L. S. LOWRY

Shelley Rohde

Foreword by John Rothenstein

COLLINS
St James's Place, London
1979

William Collins Sons & Co Ltd
London · Glasgow · Sydney · Auckland
Toronto · Johannesburg

First published 1979
© Shelley Rohde 1979

ISBN 0 00 216478 7

Set in Baskerville
Made and Printed in Great Britain by
Butler & Tanner Ltd, Frome and London

CONTENTS

LIST OF ILLUSTRATIONS

For Gavin, Christian, Daniel and Michele,
for tolerance, patience and understanding
above and beyond the call of filial duty.

ACKNOWLEDGEMENTS

I first met L. S. Lowry one bleak day in January, 1972, and almost immediately fell under the spell of his personality. I had been sent to interview him on the occasion of his so-called retirement from painting, by the *Daily Mail*. It was an intrusion, without appointment or warning, that he accepted with patience and courtesy. I met him only three times after that but became, and have remained, an intemperate admirer of both the man and the artist. When he died the *Daily Mail* again asked me to write of him: an obituary. It was at this point, while sifting the piles of newspaper cuttings, that I first became aware how little was known of him; much had been written, little said.

From the time of my first approach to his heir, the former Carol Ann Lowry, now Mrs John Spiers, with the suggestion that I should write a biography of her benefactor, she has treated my efforts with echoing patience and courtesy; and the valued addition of her friendship. Here I express my heartfelt gratitude to her, to her husband, John, who has accepted my intrusion into their lives with good-natured tolerance, and to their tiny daughter, Leonie Lowry Spiers, who has enlivened the long hours immersed in dusty papers with her antics. I am grateful not only for their hospitality during the many months of work among the documents in Mrs Spiers' possession, but also for her permission to read, copy and reproduce the information gained from the massive collection of letters, diaries, account books, photograph albums, rent books, etc. I regard myself as fortunate not only in having obtained her consent to make use of what he left, but also that he left so much. I must add that, in return, Mrs Spiers demanded no sight of my script and that the views and opinions expressed therein are not necessarily hers, except where directly attributed to her.

Lowry's closest living relative, Mrs May Eddowes, the daughter of his mother's sister, who had grown up with him, died while this book was still in preparation. I must, however, acknowledge my

debt to her for the long hours of reminiscences, even during her last illness, which were invaluable to me in my early research. I want also to place on record my gratitude to one who wishes to remain anonymous: a man of charm and courtesy who, having once decided to tell me what he knew of the artist—to whom he is closely related and whom he strongly resembles—was wholehearted in his co-operation.

So many others among Lowry's associates have been unstinting in their offers of help that it is impossible to assess the value of one above the other. Those with tape-recorded conversations with the artist have been of particular worth in enabling me not only to hear his exact words but also the manner and mood in which his statements were made. Of these I acknowledge my debt to: The sons of Lowry's cousin and old friend, the late William J. Shephard: the artist's godson, Professor Ronald Shephard and his wife Betty, who gave much of their time and thought to the project; and Professor Geoffrey Shephard and his wife Helen, who spent many hours sorting through the diaries and photograph albums of the late William Henry Shephard and his wife Annie (née Hall) on my behalf.

Mrs J. M. Dickie who handed over to me all the notes, transcripts and manuscripts of her father, the late Professor Hugh B. Maitland; Professor Maitland had spent several years working on his biography of the artist which he had promised not to publish until after Lowry's death; the author, however, died before the artist. The many hours of tapes were almost as revealing as the private observations of a man who had known and observed Lowry for nearly thirty years.

Mr Monty Bloom who has given me many hours of his time, has allowed me to listen to and transcribe his own tapes of the artist, and to use much of their personal correspondence; also to reproduce pictures from his collection.

Mr Frank Mullineux who, with his friend and the artist's, the late Gerald Cotton, also made many tapes which he allowed me to hear and to use.

Mrs Joan Ellis who allowed me to see and to use the notes of her late husband, Tony Ellis, who until his death had been preparing a biography of the artist.

The Executors of the estate of the late Margo Ingham, who allowed me to have the notes she had prepared for her biography of the artist.

My particular thanks are also due and gratefully offered to many from whose conversations and letters I greatly benefited: Miss Elizabeth Appleton; Mr Fred Ball; Archdeacon Selwyn Bean; the

Rev. Geoffrey Bennett; Svetlana Beriosova; Mrs Helen Bernard, who went to considerable trouble to obtain for me the notes and records of her late friend Margo Ingham; Frank and Constance Bradley, who also undertook research on my behalf; Wendy Bridgman of the Adam Collection; Miss Gladys Brooke; Mrs Barbara Carr, who also gave me permission to quote from the letters of her late husband, David Carr, to the artist; Miss Mary Connolly; Margery Clarke; Pat Cooke, whose continuing interest and encouragement has been invaluable to me; Robert Crowther; the late Albert Denis; Louis Duffy; Sheila Duncan; Mr Denys Dyer Ball; Mr Jock Elliott; Miss Sheila Fell, R.A.; Mr James Fitton, R.A.; Mr Philip Fletcher, who also provided photographs taken by his late father, Frank Joplin Fletcher; Councillor and Mrs Jack Gallagher; Josephine Gilchik; Geoffrey and Jan Green of the Tib Lane Gallery, Manchester; W. H. Haslam; Mrs Lucy Holmes; the late Margo Ingham; Miss Doris Jewell; Mr Bert Jones; Mr Andras Kalman of the Crane Kalman Gallery, London, and for his efforts to trace certain Lowry pictures for me; the Kunzels of Clithero; Dr Gordon Laing; Mr and Mrs Enoch Leatherbarrow; Edith Le Breton; Mr Alick Leggat; Mrs Mattie Lowry; A. S. McDonald; Professor Clive Mellor; John Morris; John Muxworthy; Mr N. O. Nicholl; Mr Clifford Openshaw for the many hours he gave me; Miss Muriel Orton; Dr Harold Palmer; Mrs Margaret Priestner; Sam Rabin; John Read; Harold Riley; Mr and Mrs Philip Robertson; Mr and Mrs James Robinson; Mr Charles Roscoe; Ellis Shaw; Mrs Doreen Sieja; Mr Michael Spring, who also gave me permission to quote from the letters of his late father, Howard Spring; the late Mrs Bessie Swindles; Ethelwyn Taylor; Mrs Edith Timperley, who also gave me permission to quote from the letters of her late husband, Harold Timperley, to the artist, and from her novel *The Mink Coat*; Dame Ninette de Valois; Frank Whalley, also for permission to use one of the portrait heads in his collection; the Rev. Albert Willcock; Mr Leslie Woodhead; the Rev. David Wyatt.

I also acknowledge, with gratitude, the assistance, co-operation and time given by: Messrs James Bourlet and Sons of London, who have allowed me to quote from their letters to the artist; the Executors of Lowry's estate, Mr E. D. Green of the National Westminster Bank, and Mr A. Hulme; Mr Rowley Fletcher, Chairman of the Trustees of Bennett Street Sunday School and of St Paul's Literary Society; Mr Stanley Shaw, Judith Sandling, and the staff at Salford City Art Gallery; Mr A. N. Cross, Salford City Archivist; Mr C. Carson, local history librarian at Swinton Central Library; Malcolm Taylor, Deputy Headmaster of Oldham Blue Coat

School; Mr Ronald Alley, Keeper of the Modern Collection at the Tate Gallery; Janet Green of Sotheby and Co., London; the Courtauld Institute of Art; Mr N. M. Baines of General Accident Fire and Life Assurance Corporation Ltd; Miss Georgina Miller, Secretary for Ceremonials at Manchester University; Professor Gillian White and Dame Mabel Tylecote; Ann Sidgwick of Ganymed; Mr N. Goodfellow of the Pall Mall Property Co. Ltd; the Rosella Hightower School of Ballet, Cannes; Dr Wendy Barron of the Property Services Agency; the staff of the Victoria and Albert Museum Library; Mr R. Bennett of Queens Park Union Chapel, Harpurhey; Miss Elizabeth Leech of the Music Department of Manchester City Library, and the staff of both the Library Archives Department and the Local History Department; Miss Sandra Martin of Manchester City Art Gallery; Mr Francis Hawcroft of the Whitworth Art Gallery, Manchester; Mr Hal Yates of the Manchester Academy of Fine Art; Mrs Roach, historian of St Bride's Church, Old Trafford; the Rev. Alan Pugmire; and Mr Derek Seddon who photographed much of the work in the Lowry estate and in Salford City Art Gallery for me.

For copyright permission I am indebted to:

The British Broadcasting Corporation for permission to quote from their films *L. S. Lowry* and *I'm Just A Simple Man*, both produced by John Read; Granada Television for permission to quote from their film *Mr Lowry*, produced by Leslie Woodhead; Tyne Tees Television for permission to quote from their film *Mr Lowry*, produced by Robert Tyrrell.

To Alex Reid and Lefevre of London for permission to quote from *The Discovery of L. S. Lowry* by Maurice Collis and from the letters from their company to the artist; Robert Wraight for permission to quote from his books *The Art Game*, *The Art Game Again* and *Hip, Hip, R.A.*; *The Observer* newspaper for permission to quote from an article by John Heilpern.

To Popperfoto of Fleet Street, London, for permission to use the *John Bull* photographs.

And I do most particularly wish to thank Sir John Rothenstein, both for permission to quote from his books and for writing the Foreword to this one.

Also my thanks to all those who have allowed me to reproduce Lowry works in their collections; and to all those, with my apologies, whom I might inadvertently have neglected to mention by name.

S.R.

FOREWORD
by John Rothenstein

Miss Rohde's book offers a comprehensive account not only of Lowry's character, life and art, but also of his family, friends and the many others with whom he had significant relations, real or on occasion, perhaps, imaginary, as well as of the Manchester and Salford of his most creative years. It constitutes the most detailed description of Lowry so far produced, or likely to be.

Most people, I imagine, have experienced acceding to requests for confidential advice from people whom they regarded as lacking in interest and leading uneventful lives, and being astonished at the unexpected drama or strangeness of what they hear. Nobody who knew Lowry would be likely to regard him as dull, but few people, even his intimates, were aware of important aspects of his life. For instance, the introduction to the catalogue of a highly representative exhibition of his work, consisting of 171 paintings and drawings, organized by the Arts Council in 1966, and shown, besides three other places, in his native Manchester, does not contain even the most oblique reference to the duality of his life which had so radical an effect on both his character and his art. Indeed the author, Edwin Mullins, was ignorant of it, as is apparent from the inclusion of a characteristic following statement by Lowry in an article he contributed to the *Sunday Telegraph* of November 20th 1966: 'Of course I often used to wonder if I'd ever make any money,' it runs. 'I was living at home so it wasn't urgent, but every now and then I felt thoroughly fed up and I'd say: "This is ridiculous: I'll take a job." But I didn't like the thought of going to the office with a bag in my hand at half past nine every morning. And then some little sale would come along—there were always a few private buyers in Manchester and Salford—and that was enough to keep me going for another year.'

I do not quote this wholly misleading statement as in any way a reflection on Mr Mullins, for I suppose I 'knew' Lowry better than

he, yet I was not aware even of his alleged dependence on 'some little sale' or that he was ever other than a full-time professional painter and draughtsman. There are many writers on the arts who believe that the life of an artist has little effect on his art, or even none at all. A fairly extensive relationship with artists convinces me, on the contrary, that circumstances of an artist's life, often those seemingly trivial, may have a crucial effect upon his art, with the probable exception of the practitioner of the abstract.

One of Lowry's most marked characteristics was the inconsistency of his accounts—which with the years grew steadily more adroit and subtle in their expression—of himself, his circumstances and his relations with his fellow men or rather his fellow women, primarily those far his juniors.

There is one certainty that I wish to emphasize—and there is nothing in the exhaustively researched work which follows to weaken it; namely that none of Lowry's evasive, contradictory and on occasions—such as that already quoted—untrue statements was inspired by malice, or the intention of causing harm to anyone. Of this, although never an intimate friend, I knew him well enough to be convinced. The inconsistencies of his conduct were due mainly to four circumstances: the condescension, contempt, even hostility to which, as an artist, he was subjected in his early years by people prominent in the art establishment of Manchester, resulting in a defensive self-mistrust; his profound and enduring embarrassment at the menial work as a clerk and rent collector which he was compelled to undertake for more than forty years; the cynicism with which he regarded the flattery and cadging resulting from his eventual success, and from his singular relationships with a succession of young girls. Occasionally, however, he misinformed people for no discernible reason, for instance when he deliberately and repeatedly gave a wrong date for the death of an aunt; he also denied receiving certain presents from his parents, but family relationships are sometimes so complex that to this undue significance should not, I think, be attached.

Nor, indeed, to his passion for young girls, a not uncommon phenomenon; except that in Lowry's case there is no suggestion that it found the slightest physical expression. Miss Rohde puts the situation so precisely that it should not be paraphrased: 'The truth was that there was not one girl, but many, each of whom featured briefly in his own private and personal image: an image of Ann ... Each in her own time was undoubtedly important to him.... It seemed as if he were perpetually seeking an ideal; yearning to recapture, or perhaps to discover for the first time, the personifica-

tion of a girl who would remain forever young, forever innocent, forever vulnerable. As each one failed him, through the inevitable progression of time and experience, there was always another to take her place. "Subtly he always let you know that," says one of them. "I always knew there was another Ann around the corner."'

I will leave to the author of this book the identification of the mysterious original, Ann, and ideas about the question of her existence.

In spite of the variety of the accounts Lowry gave of how he became an artist it is clear that while still a young boy—there survives a sketch made when he was six—he had an impulse to draw. Particularly on holidays he would make his own sketchbooks out of scraps of paper, and he expressed the hope that he might eventually attend an art school.

But support from his mother, whom he idolized until the end of her life, was not forthcoming; she wished him to adopt a career which promised respectable material success, and being an extreme puritan she was shocked by the prospect of his drawing from the nude. In spite of his habitual obedience to her wishes he nevertheless applied for admission, only to be rejected. It was necessary for him to have an occupation for which he was paid, but his distress at being unable to become an artist, although he disclaimed it—'I was never anxious to paint,' he used to say—was apparent to an uncle and aunt who persuaded his parents to allow him to attend a small class held on two evenings a week.

These classes provided a useful technical basis for his art. His claim, made in later years, that he was virtually coerced into studying art because he was incapable of undertaking any other occupation is, of course, absurd: he was in fact an efficient clerk and rent collector but his preoccupation with art was clearly apparent to the few who knew him well. He went on, in 1905, to attend, also in the evenings, art classes at All Saints School, and later the same year transferring to Manchester Municipal College of Art where, also in the evenings, he studied painting as well as drawing. The understanding of his unconventionality and the encouragement shown him by the French painter Adolphe Valette have been several times described, but Valette declined Lowry's request to give him private lessons, introducing him to William Fitz with whom he worked, on and off, for nearly ten years, in fact until Fitz's death in 1915.

In the spring of 1909 occurred an event that promised melancholy consequences. Lowry's father, Robert, who described himself as an estate agent, though collector of small rents would accord more closely with the facts, and who after his marriage lived at several

addresses in the neighbourhood of Old Trafford, finally settled at an ample house in Victoria Park in the highly respectable neighbourhood of Rusholme. He was, however, a failure, and in 1909 the family— Laurence Stephen was the only child—had to move to the shabby industrial suburb of Pendlebury, Salford, settling at 117 Station Road. This they all found acutely depressing, especially the young art student.

The following year Lowry was made redundant by the firm for which he had worked since 1907 and was appointed rent collector with the Pall Mall Property Company, a position he held until he reached retirement some forty-two years later, aged sixty-five.

Miss Rohde appropriately heads her chapter describing his appointment to this position 'A Job for Life', which indeed it proved to be in a crucial sense. After the constant confinement of his previous post, he found himself before long enjoying tramping the Salford and Manchester suburbs, visiting the houses, coming to know their inhabitants. For someone brought up in respectable districts his enjoyment was surprising, for many of the streets he tramped—some have since been largely rebuilt—were among the most sordid products of the Industrial Revolution, in what was one of the ugliest regions that have ever disfigured the surface of the earth. A number of the buildings looked sordid on account of their condition rather than their architecture—for instance, the building in Lowry's *An Island** of 1942 in the City Art Gallery, Manchester, though it was very far from an architectural masterpiece, is a Georgian house which, when originally erected, surrounded by a garden, would have been a highly civilized place. Although in and off the Oldham Road there remain a number of such houses, now squalid from many years of neglect, this one stirred Lowry's imagination. 'I have learned much from that house,' he once said. But this observation was made long after he had decided, or rather, had been moved by an inward compulsion, to devote himself to the depiction of the industrial suburbs of Manchester and Salford.

As the dark satanic mills sprang up around the 1840s in dense clusters along the valleys of south Lancashire and west and south Yorkshire, so a vast proportion of the population of these areas was drawn into the industrial vortex—and as a result immense numbers of small houses had to be built, rapidly, back to back, to accommodate this continuous influx. According to a contemporary official report these houses were flimsy, with walls only half a brick thick, and in general made of shoddy materials and without foundations, drainage or ventilation. (A century later when Lowry saw them they

* All Lowry's works referred to, unless otherwise noted, are oils.

were, it is true, no longer rat-infested and rotten.) The rows were divided by what another contemporary called 'that mass of filth that constitutes a street'. But appallingly squalid though they were, over-crowded prisons for their inhabitants, they were—and the numerous survivors still are—in one respect visually superior to what constitute the suburbs of most of our modern cities: pretentious on the cheap, and of a trivial vulgarity difficult to surpass. The Salford and neigh-bouring buildings, whatever their shortcomings, were and are simple and wholly unpretentious, often classical in their symmetry, while the imposing character of many of the mills is surely beyond dispute.

It was in fact the sight of a mill that provided Lowry's moment of illumination—a moment several times described. So impressed was I that I at once recorded what he told me when I visited him on July 3rd, 1951, at his house in Mottram-in-Longdendale. 'One day I missed a train from Pendlebury—which I had ignored for seven years—and as I left the station I saw the Acme Spinning Com-pany's mill. The huge black framework of rows of yellow-lit windows stood up against the sad, damp-charged afternoon sky. The mill was turning out—hundreds of little pinched, black figures, heads bent down, as though to offer the smallest surface to the whirling particles of sodden grit, were hurrying across the asphalt, along the mean streets with the inexplicable derelict gaps in the rows of houses, past the telegraph poles, homewards to high tea or pubwards, away from the mill and without a backward glance. I watched this scene—which I'd looked at many times without seeing—with rapture.' Re-calling this experience some thirty years later he exclaimed with wonder: 'And to think it had never occurred to me to do Manchester subjects!'

This ideal he stated succinctly in the course of an interview which is recorded at some length in this book: 'I wanted to put the industrial scene on the map ... My ambition was to put the industrial scene on the map because nobody had done it ... nobody had done it seriously.' He was right: of course innumerable pictures of every kind of industrial scene had been produced but, as he said, none 'seriously'. No one of his stature and his long and intimate know-ledge had portrayed it with remotely comparable insight.

We drove to Oldham Road, he expressing delight in the appro-priateness of the blowing drizzle and the all-enveloping gloom. Then on to Salford, stopping in Wharf Street so that he could show me just where he had made studies for his *Dwellings, Ordsall Lane* which we bought for the Tate (for £150) in 1939, and one of the preliminary drawings of which he presented to the Gallery in 1951.

We drove also along the streets in an area immediately adjacent

to the Oldham Road, namely Rockford Road, Apollo Street, Liversey Street, Mozart Square, Butler Street, Elizabeth Street, Woodward Street, Kemp Street (formerly Prussia Street) and Radhill Street (formerly Union Street), comprising the area which inspired his most intense and penetrating powers of observation. 'I used to walk the streets,' he said, 'making pencil notes on the backs of envelopes, occasionally a careful drawing. I don't know a soul in this district, but I love it more than any place I can imagine, especially this street ...' (it was along Union Street that we were walking, and Woodward Street and the footbridge over the canal) '... it's not too much to say that in bad·times it's this district that keeps me going. After a little time in the country or by the sea I have to come back.'

When Lowry expressed his purpose as 'putting the industrial scene on the map', he did not express himself precisely. In Manchester there were modern factories with their adjacent suburbs, but none of these, so far as I am aware, ever stirred his interest; he was, over the most creative period of his life, namely until the middle '60s, concerned almost exclusively with one particular aspect of the scene: the bleak, grim, twilight areas of disorderly dereliction, the last decaying vestiges of the Industrial Revolution. The concentration of his vision on certain areas of Manchester and Salford is evident by comparing even his least impressive representations of them with one of another city, *Piccadilly Circus* of 1960. (He made two, but one I haven't seen.) It is not an industrial slum, and its shoddy buildings and hurrying crowds are depicted with a striking absence of insight. Even an industrial landscape, *The Rhondda Valley* of 1962, fine though it is, lacks something of the originality with which his Lancashire subjects are imbued. *Peel Park, Salford*, in the Salford Art Gallery, is not a characteristic subject—it is too dignified and orderly—but it features his own district and, though far from being among his best works, is notable in comparison. I do not suggest that he was unable to represent other than Lancashire townscapes: *A Fylde Farm* of 1943, belonging to H.M. The Queen Mother, *Lake Landscape*, an imaginary subject, and *Heathcliff's House*, both of 1950, are all impressive, as are his seascapes, such as that made from his room at the Seaburn Hotel, Sunderland, in 1966. Referring to the first two, however, he spoke of his diminishing feeling for rural landscapes, and more than once for 'beauty' in any accepted sense.

Owing to the primitive character of his crowds of black-clothed men, women and children, usually hurrying and strangely detached from one another—which he regarded as the principal feature of his works—Lowry's mastery of composition is apt to be overlooked.

In *The Pond*, an oil of 1950 acquired by the Tate the following year, innumerable figures, buildings, chimneys, besides a number of boats, covering a huge area, are perfectly harmonized. This is one of the most complex and surely among the most impressive of all his works. A masterpiece. Lowry himself thought well of it, and included it— under the title *The Lake*—in a list he sent us at the Tate Gallery of five paintings which he regarded as his chief works. (The others were *Good Friday, Daisy Nook*; *Industrial Landscape* at the Leicester City Art Gallery; *Black Tower* and *The Steps*.) With reference to *The Pond*, he also described, in a letter of January 21st, 1956, his procedure: 'This is a composite picture built up from a blank canvas. I hadn't the slightest idea of what I was going to put in the picture but it eventually came out as you see it.' He later believed that it was made not in Salford but Maryport. 'This is the way I like working best.' Of *Industrial Landscape* of 1955, which we acquired the following year, he wrote showing that he had followed the same procedure. 'The picture is of no particular place. When I started it on the plain canvas I hadn't the slightest idea as to what sort of industrial scene would result. But by making a start, by putting in say a church or chimney near the middle, this picture seemed to come bit by bit.' And of *Coming out of School* of 1927, he wrote: 'This is not a depiction of a particular place but is based on recollections of a schoolroom in Lancashire.' Yet of the Tate's eight works, three nevertheless were made from specific subjects. These are *Dwellings, Ordsall Lane, Salford; The Old House, Grove Street, Salford*, of 1948, which he described in a letter of January 21st, 1950, as 'based on a careful pencil drawing made in 1927, the picture is as like the drawing as I could make it in 1948'; and *Hillside in Wales* of 1962, which, according to a letter of June 15th, 1965, he described as 'painted from notes and sketches made on the spot near Abertillery'. None of his paintings, at least those of his maturity, was made direct from life, but from imagination or memory; and sometimes from drawings, sometimes without.

The author quotes Lowry as saying how thankful he was when people called while he was working. For artists with such rare power of concentration, friendly interruptions are apt to be welcome; it is those who find sustained concentration difficult who discourage interruptions. Lowry's welcome of them is shared by at least two other artists known to me: Stanley Spencer enjoyed them at any time; as does Henry Moore enjoy them, provided a little notice is given. Lowry, unlike these two, was a lonely man, but this was not, I believe, the principal cause of his pleasure: he enjoyed the company of his friends, and his artistic purpose, whether imaginative or

based on drawing, was too definite to be disturbed by visits. If further evidence of that were necessary, a glance at the dozens of paintings in his studio, all on the way to completion, none tentative, sufficed.

But what strange phenomena Lowry's Salford paintings are, and how strange their impact! Representations of sombre urban scenes, often densely populated with hurrying, impersonal, black-clothed—and often crippled—figures. (He used to justify his inclusion of numerous cripples by showing friends how many in fact there were on the streets in real life.) Representations without pity, satire or social purpose or an iota of idealization.

I have never been able fully to understand his attitude towards his urban subjects—one which I do not believe he himself ever approached putting into words. As several artists have said, 'If I could say it I wouldn't paint it'. Nevertheless the significance of much, if not all, of the work of most artists is clear (again excluding abstraction), or at least decipherable. That Lowry was fascinated by his Salford subjects is of course indisputable, but he resented being regarded as a satirist or a social reformer moved by pity. Discussing an article which attributed to him such motives he turned to me in emphatic protest: 'I don't feel anything at all. I simply paint. Of course,' he conceded, 'I must have some unconscious feeling.' But what feeling, beyond a spontaneous and passionate response to an immensely varied, melancholy, disintegrating scene, populated by robot-like, primitively depicted figures? And these are works by a man who had spent many years at art schools, largely devoted to making drawings of models, which he learned to do exceptionally well.

But Lowry's mastery of his subject is complete. It may be on the grand scale with the complexities of, for instance, the *Industrial Scene* of 1936, and *Black Tower* of 1938, or in such paintings as *River Scene* of 1942, belonging to the Corporation of Glasgow, *An Island* in the City Art Gallery, Manchester, or *The Pond*. It may be of subjects so simple that most people would not spare them a glance, such as *The Footbridge* of 1946 or *Old House in Stow* of 1947 (this last not, like the other, a Lancashire subject). The first depicts the access to an ordinary little bridge; the second the almost featureless façade of a house; yet in both the artist compels not only instant attention but enduring interest. But the ability he showed of endowing the most commonplace, even the dullest, subjects with interest does not exclude the occasional response to the dramatic, as exemplified by the grim *St Simon's Church* of 1928, in the Salford Art Gallery, or the dark, almost menacing, *Northleach Church* of 1947—the building

contrasting with the numerous light gravestones between it and the spectator.

Lowry's depiction of the industrial scene was not to continue for the rest of his life. By 1961 he had ceased to paint industrial subjects. In consequence he was widely accused of perversity. The author of this book writes that 'it would have been more accurate to have called it integrity'. There can, I believe, be little doubt that her opinion is justified. Although he made notable paintings in several parts of the country, an area of Salford remained the focus of Lowry's most intense interest and most penetrating understanding. 'It's not too much to say,' he told me, 'that ... it's only around the Oldham Road that I'm entirely alive.' But this area was not a large one, and during the thirty years he had devoted to its representation he had explored minutely almost every feature of it, architectural and human. Miss Rohde writes that 'the vision had faded and died'. I would say rather that Lowry had accomplished what he had set out to do—so what remained? 'I always said I would stop when I had put the industrial scene on the map.' And this he had achieved. As he had so impressively succeeded, it was surely his purpose rather than his vision that 'faded and died'. 'I could do it now,' he confided to a friend, 'but I have no desire to do it now ... and that would show.' Of course his desire did not evaporate abruptly, but, from the early '50s, gradually.

Fascination with industrial subjects was replaced by another: the portrait. Lowry's industrial scenes were populated, often densely. In *Fun Fair, Good Friday, Daisy Nook* of 1974, and *Agricultural Fair, Mottram-in-Longdendale* of 1949, for instance, there are hundreds, perhaps, even thousands, of figures. Of course these figures are readily distinguishable: many are fit, many are inclined to be boneless, to droop, some are mentally defective as well as crippled, many are children. But they form an integral part of the scene. One painting at least, *The Cripples* of 1948, represents a number of them, including two legless, in a crowd of which—some children apart—they even appear to constitute a majority. They frequently appear in other works, for instance *Figures in a Park* of 1964. However animated and varied, however expressive their gestures, there is about all these figures an element of the anonymous—not unusual in the depiction of crowds. But as Lowry's obsession with the urban scene was satisfied, so interest in individuals increased. The author thus precisely describes the change: '... his people, his single figures, his grotesques. The struggling, surging homunculi, who had lived for so long in the shadow of the mills had emerged finally ... to stand alone.'

Like almost all changes in the work of artists this was not sudden. *Head of a Man* of 1931 and that of 1938 (I do not include the portraits of his father and his mother, both of 1910, for many artists paint their parents and other relations) are characteristic examples. Comparison between them shows the marked degree to which Lowry's personal style had moved. Although he painted portraits fairly regularly it was not until the change had come about that he stated: 'I feel more strongly about these people than I ever did about the industrial scene.' This was not indeed the first occasion on which he had expressed a comparable opinion, but the significance of that quoted is clearly reflected in his work. During the '50s and '60s he painted an occasional industrial scene such as *The Rhondda Valley* of 1962, already mentioned, and *Bargoed, South Wales* of three years later; but from the early '50s his prime interest was his fellow men and women, almost invariably those who peopled the industrial scene or others akin to them. A 'portrait painter' in the generally recognized sense of one who accepts commissions or invites people who interest him to sit, he never became—except in one regard. Reference has already been made to his increasing obsession with attractive young girls; of several of them he did make portraits, perhaps the best known being the mysterious *Ann* of 1959. But this obsession did not deter him from depicting the grotesque, for instance *Woman with a Beard* of 1957, and a long beard at that. (He said that he had also depicted another.)

One of Lowry's remarkable characteristics was his achievement of success, both prestigious and financial, when every feature of his work was in contradiction to prevailing opinion. When first recognized in London certain people admired his work as 'primitive', a successor to that of the Douanier Rousseau or Alfred Wallis; but when, before long, it became known that Lowry had attended art schools for many years and was a capable, realistic draughtsman, the justification for its markedly, often predominantly 'primitive' character dwindled. What would have offered grave affront to such opinion had it been known was the illustrative character of Lowry's work. Of much of his later work it could truthfully have been said, as was contemptuously repeated of popular Victorian painting, 'every picture tells a story'. 'Lowry had,' as the author observes of his later works, and as his friends and acquaintances knew, 'a story to tell about each one of them'.

Lowry was so original and gifted an artist that his qualities are reflected in almost all his work, but—to me, at least—his portraits are not in the same class as his industrial scenes, his few sea pieces and the best of his landscapes. The reason is relatively simple: his

portrayal of industrial subjects was based on the most extensive and minutely detailed observation of his subjects, accumulated in the course of endless walks along all the streets in the limited area of his choice for more than a third of a century. It would be difficult to name a painter of comparable subjects whose works rival his. But with regard to portraits the situation was radically different. He had some devoted friends and his was a most likeable personality, but he was surely among the most temperamentally lonely of men—a loneliness exacerbated by his determination to conceal from those who knew him as an artist, and from the public at large, the dual circumstances of his life as rent collector and the like as well as artist—involving him in a variety of elaborate forms of deceit, the severing of relations with those who knew the truth. This, combined with his natural shyness, indeed timidity, resulted in an inconsistency of outlook that affected not only his self-knowledge but also his ability to portray his fellow men and women. 'If he saw them as odd,' the author writes, 'it was because he felt himself to be odd.' Oddity he admirably portrayed, but oddity is not the dominant human characteristic (though more common than the casual observer is apt to notice). Nor can his concentration on it be justified by any special characteristic of the people among whom he lived. 'Manchester people,' he used to say, 'are no different from people anywhere else.'

Thus, by nature and by design, Lowry was isolated from his fellow men and women to a degree that deprived him of the insight into character that is crucial to a portrait painter. He tended therefore to depict 'types' rather than individuals, which prevented him from becoming a serious portrait painter. The profound admiration so justly evoked by his industrial subjects and a number of landscapes and seascapes, caused his portraits to be regarded with an admiration which I do not believe they deserve. While it is difficult to think of his equal as a painter and draughtsman of a long succession of industrial subjects, where—compared with any dozen or so portrait painters and draughtsmen of merit whose names come to mind—does Lowry stand?

But an artist must be judged by his best work, and Lowry has painted and drawn his urban area, even though he regarded it with fascination rather than affection, with a passion and understanding, as well as skill in a quasi-primitive guise, that gives it a unique place in British art. For many years he had much to endure. Manchester and Salford people felt that he was giving a sordid impression of their cities, which they bitterly resented; Manchester artists ridiculed his work as amateurish, and its Art Gallery Director was discourteously condescending. For all this there was an element of

justification; not, indeed, because of any defect in Lowry's work, but because Manchester had long been a major cultural centre, its Art Gallery among the best in Britain—(Madox Brown's murals of the '80s and '90s in the Town Hall are among the most impressive of their time in Britain, and the exhibition 'Art Treasures of the United Kingdom' of 1857 even drew Whistler from Paris)—so that the disposition to despise the early neglected Lowry, whose menial forms of employment were widely known, and to resent the later highly successful Lowry, however mistaken, is at least comprehensible. Salford had no such impressive cultural record and was without the resulting prejudice, and to its credit assembled the largest collection of Lowrys in any public gallery.

Although Lowry was 'provincial' in his choice of subjects and there was a 'primitive' element in most of his figures, there was nothing of either in his wide-ranging knowledge of the work of other artists. His passion for Rossetti is well known—I have never heard anyone speak of him with more ardent admiration, or of Madox Brown, whose work was also well represented in the big Pre-Raphaelite exhibition held in Manchester in 1911. He was an enthusiastic collector, and his little house in Mottram contained more pictures than could possibly be hung there. Out of kindness he bought works by unsuccessful artists, as well as by his idol Rossetti, other Pre-Raphaelites, and Burne-Jones. To see examples of their work he travelled widely, though never abroad. He also admired Sickert, Sargent, Stanley Spencer, Magritte and Delvaux, and many others. Of Rossetti and Brown 'not, if you were to ask me, could I tell you,' he said to me, 'why these two artists are constantly in my mind'.

Various attempts have been made to relate Lowry's work to that of other painters, but it is as remote from any of them—particularly those whom he most revered—as it is from being 'primitive'. At our first meeting, Lowry seemed to me a rather simple, straightforward man, and his art primarily an expression of these characteristics. Further knowledge of both showed how erroneous was this impression. For example, one of his unusual characteristics was the nature of his ambition. Most artists, indeed most people, identify their work with themselves, accepting or seeking personal recognition of their achievements. Lowry, on the contrary, delighted, until it became excessive, in the ever-growing recognition of his work in its representation in public collections, in his membership of the Royal Academy and the like, subscribing to two press-cutting agencies; but, a few university degrees apart, he declined all personal honours and continued to live in the most modest circumstances.

Many of Lowry's paintings have a barrier in the foreground: the edge of a pavement or a path, a fence, iron railings or else simply a margin of darkness. These surely represent, consciously or unconsciously, his sense of isolation, even from the part of the world he knew most intimately. Miss Rohde's scrupulously researched book—which includes a detailed account of his family background, of his friendships and of the areas where he worked—will enable many of her readers to pass these barriers, though much of what they find, both about the man and about his art, will still remain mysterious.

PART ONE

The Manchester Man

'He has had the courage and the imagination which have made it possible to penetrate "realism" and arrive at reality.'

T. S. Eliot of Pirandello

1 '_Is it a girl?_'

LAURENCE STEPHEN LOWRY was a disappointment to his parents
from the moment of his birth. His mother, Elizabeth, had wanted a
daughter, frail and sensitive, moulded in her own imagined image.
His father, Robert, had wanted whatever his wife wanted; anything,
in fact, that would bring her—and consequently him—happiness or,
at the very least, contentment. What they got was a son, the young
Laurie, a big child, and clumsy. He conformed to no standards his
mother could recognize, displayed no talents she could admire; and
when, finally, he came to paint his vision, she saw in it only ugliness,
and dismissed his art as a minor aberration which, if she protested
enough, he might for her sake abandon. Inevitably, as he grew to
manhood Lowry came to see himself through her eyes: a misfit, a
grotesque substitute for the daughter of whom she had dreamed.
While able to perceive the truth about him and to communicate
that truth—though not to her—he was utterly unable to see the
reality of himself.

For half a century he lived in the shadow of rejection and, though
he endured to eighty-eight, he never escaped its shroud. Fame, when
it came, had little meaning for him. His paintings were bought, in
the last twenty years of his life, by royalty, great galleries, important
collectors, and for prices that matched any achieved by other British
artists of the day. He was offered an Order of the British Empire,
a Knighthood, an Order of the Companions of Honour. He was
made a Royal Academician and invited to dine at Downing Street.
The Hallé Orchestra celebrated his birthday with music and, after
his death, a pop-song about him went to number one in the charts.
He was honoured with Doctorates from three universities, and with

4 A Private View of L. S. Lowry

the Freedom of Salford, the city he was once said to have insulted by his paintings.

Some honours he accepted, most he rejected. Others might call him a Master, a genius, a great man, but while he knew himself to be a failure to her, his mother, such accolades had no value. When he had needed recognition and acclaim, to justify himself to her, to bring her to understanding, none had been offered; now, it was too late.

Thus was shaped the paradox that became the man: a genius and, in his own eyes, a failure; an honest man, a man of integrity and courage, who hid behind a false façade lest others might see him as he believed himself to be. He was a man of great humour who found much joy in a life that, had he allowed, could have been a tragedy worthy of the Greeks. He was a loving man who denied his emotions, a man of dedication who pretended disinterest, an artist of perception who perceived all truth except the truth about himself.

The making of the enigma of Laurence Stephen Lowry lay not simply in his own background, in his unwanted conception or his ultimate inability to fulfil his parents' ambitions for them. It had all begun long before, in the aftermath of the Industrial Revolution, with Elizabeth, the delicate daughter, who learned her values from Manchester Men, and Robert, the humble clerk, who wanted only happiness and was to be ever disappointed.

Lowry's mother, Elizabeth, was born in March, 1858, in the parish of Manchester, to Ruthetta and William Hobson. Ruth, née Hall, had been born and raised in the Isle of Man; she was a woman of a particularly gentle disposition, whose patience and understanding were renowned among family and friends.[1] William, although still in his early twenties when he married in 1853, was already established as a modestly prosperous hatter—a business which his forbears had pursued for as long as records[2] and memory could relate. The Hobsons lived, throughout their marriage, in a succession of rented homes in one or other of the red-brick terraces that fringed the Oldham Road, where William, like his brothers and cousins, also followed his trade. They were a close-knit community, united under soot-laden skies in the pursuit of prosperity.

Manchester, in the decades that followed the Industrial Revolution, was indeed a town devoted to the pursuit of prosperity, through business and through trade. As De Quincey complained when he fled his Manchester school by night: 'In this place trade is the elysium and money is the god ... I cannot sit out of doors but I am nosed

by a factory, a cotton-boy, a cotton-dealer, or something else allied to that most detestable commerce.'[3] The Ship Canal had yet to be opened, and the Oldham Road, and its parallel neighbour, the Rochdale Road, had much of the feel of frontier thoroughfares, linking as they did the thriving mills of Yorkshire with the city of Manchester. Every morning the Hobsons would hear the dawn sound of the knockers' poles, punctuated by the noisy trundling over cobbled stones of the horse drays slowly carting great bales of cotton to the rich warehouses of Lancashire. But if the symptoms of success were all about them, so too were the symptoms of failure: the bare-foot children and the women, old before their time, huddled into the shawls of their depression; the grey faces, the poverty ingrained like dirt, the brawling of drunken men who had eased their frustrations in cheap ale; the pawnbrokers, thriving on others' needs.

It was a hard, challenging place in which to live: the criterion of the Manchester Man was success, success in business, and by one's own efforts. And so if William Hobson was a proud man, he had just cause to be; independent, hard-working and ambitious, he was a successful tradesman in a city that honoured private industry above titles, cultivated accents and even art.

Godliness was another criterion of the Manchester Man; and as befitted a man in his position in the community, William Hobson took his family to attend, with unfailing regularity, the parish church of St Paul's at New Cross. It was here, in turn, that the Hobson children were baptized: Edward, destined to follow in his father's footsteps; George, a wanderer with a lust for adventure; Ruth, who died in infancy; Elizabeth, who was to be the apple of her father's eye; then Mary, gentle like her mother; and finally Willie, who brought shame upon them all.

Elizabeth, born shortly after the death of the Hobsons' first daughter,[4] received from the first her parents' especial care. She, too, was delicate and at first they despaired of her survival. But although she was never to be a strong child, prone to bronchitis and lassitude, she flourished, displaying what her father considered an almost masculine intelligence and aptitude for learning.[5] And so she was taught not merely to embroider and play the pianoforte, as was proper for young ladies, but also Greek and Latin and elementary sciences. She was an apt and eager pupil; her school reports praised her academic work quite as highly as her more conventional studies. Her 'conduct and order' were exemplary, and any absences were predictably due to 'indisposition'. At Sunday School, too, Elizabeth was an exemplary student. The Bennett Street Sunday School[6]—an

establishment remarkable for the piety of its founders and the constancy of its followers, and which was later to play an important part in the life of the Hobson daughters—awarded her her first prize, a 'reward of merit', at the age of eight: a religious tract entitled 'Nellie Newton or Patience and Perseverance'.

And so already, perhaps, Elizabeth had decided on her values— the values she had learned from her father: success as the just reward of virtue and endeavour, failure as the natural corollary of indolence. As she grew older, she would become intolerant of weakness in any form, even in herself. For her, who had adopted the Manchester Man's philosophy literally and without concession, it was what you did that counted; and what you were seen to have done.

However, when Elizabeth was eleven, in 1869, the father whom she admired so much and who, until then, had done everything that could be expected of him, died. And within another two years his uncle, James Jackson, a draper from nearby Bradford Street who, as trustee, had taken on responsibility for the family, was also dead. Fortunately the second trustee, George Anderson, a boot and shoe manufacturer who also lived and worked in the Oldham Road, was to prove a long-lived and thoughtful administrator. During the next ten years he found young George a job as warehouse-boy, and watched Edward emerge as the master hatter of the family. When in 1879 Ruth Hobson died of the same wasting disease (consumption) that had taken her husband, he was again nominated trustee. William Hobson's will had left the bulk of his £1,500 estate in trust for his children until the boys should reach the age of twenty-one and the girls should marry; Ruth's provided for the continuation of the hatter's shop at 250 Oldham Road—the little business, sandwiched between a provision merchant and a beer retailer, that she had so carefully continued to manage—and for its profits to be divided between Mary, Elizabeth and Willie 'for their sole and absolute use'—an instruction that Elizabeth carried out to the letter, for even after her marriage these profits never passed into Robert Lowry's hands.[7]

During this difficult time Elizabeth seems to have taken solace mainly in her studies; she attended Ladies' Classes at the Manchester Mechanics' Institution (fees: five shillings a quarter),[8] one of the first such schools founded in the country for the children of the artisan classes rather than the gentry. It was not here, however, that she was to find the inspiration for her consuming ambition. It was in her music. Her study-free hours were spent at the upright piano in the family's Sunday parlour. Chopin was her particular forte and,

according even to the more critical members of her circle, in these pieces she excelled. Soon she was giving piano lessons and earning enough to be able to afford to offer her services free as a teacher of music at Bennett Street Sunday School. Throughout the 1870s she absorbed herself in her subject, attending lectures, variously entitled 'Characteristic Sketches of Great Musicians' or 'The History of Pianoforte Playing', going to organ recitals and receiving lessons from a Mr R. Leicester. She began to withdraw rather from her family; young Mary Hobson found herself closer to the two Anderson girls—also, confusingly, called Elizabeth and Mary—than to her own sister. She rarely helped in the house, leaving most of the chores to the servant girl, Alice Bell. Even during her mother's last illness she was hardly ever called upon: Elizabeth had a 'gift' and was not to be diverted from the development of her talents[9]—a precedent of indulgence set by William Hobson and one which his wife, even now, would not gainsay.

When Ruth Hobson died, Elizabeth was twenty-one and Mary nineteen. Neither was particularly blessed with good looks, having inherited the protuberant Hobson nose and rather insipid colouring, enlivened only by clear blue eyes; but they both carried themselves with straight backs that owed as much to firm corseting as practised deportment, and Elizabeth, particularly, was proud of her tiny waist which she accentuated with the lightly padded skirts and exaggerated leg-of-mutton sleeves so favoured of the time. She wore her fine brown-to-auburn hair in a single plait which she wrapped around her head or curled into a knot at the nape of her neck, the severity of the style softened by wispy curls fringing her face. Both girls were still unmarried, and both were still attending Bennett Street Sunday School and its offshoot the St Paul's Literary and Educational Society, established in 1843 with the elegant sub-title 'a mutual improvement class'. Elizabeth was a pupil in one of the Adult Ladies' Classes, and, with her cousin Annie Hall, a teacher at the Sunday School. Here, typically, she collected a selection of edifying rewards, each presented by the Visitors 'as a token of their approbation of services rendered as a gratuitous teacher'.

Bennett Street Sunday School, with its attendant classes and lectures, was typical of hundreds of such institutions of its time which offered young people an opportunity to broaden their cultural and intellectual horizons, and to meet each other—all within a carefully maintained moral and religious framework. It was the sort of place that became almost a way of life. As one former member observes: 'Once one had become caught up in it, one went two or three times a week. . . . There was always something going on: chess, the drama

society, music, rambles, lectures. Most of one's friends were BSSS people.'[10] Often one's wife or husband turned out to be a BSSS person too; for though segregation was strictly the rule at the Sunday School proper, in the literary and other groups things were considerably more relaxed. Yet the religious emphasis remained strong. A stalwart of the Society was a certain George Milner who, though worldly enough to enjoy smoking large cigars and wearing checkered cloaks, frowned upon roistering behaviour, and preferred that his associates should spend their time enquiring 'into the social and spiritual life of the people among whom we were sojourning'.[11] He was also 'prone to earnest appeals to the young boys and youths, particularly the latter, to choose their companions from amongst those they met at Sunday School, and stick to them'.[12]

Another and very important member of Bennett Street was Charles Rowley, the son of a local picture-frame maker—a Peterloo Man—who in 1875 had been elected to the City Council as a representative of the Hobsons' own district, the New Cross Ward (60,000 citizens, 40 churches, 40 chapels and 140 beerhouses).[13] Rowley, founder of the Ancoats Brotherhood, was a friend of the Pre-Raphaelites, in particular William Morris; of George Bernard Shaw; and of Kropotkin, the Russian who fled his homeland to teach botany and biology in Manchester. Distressed as much by the lack of culture as by the lack of money in the lives of the poor of Manchester in general, and Ancoats in particular, he dedicated himself to bringing them 'sweetness and light'.[14] He was later credited with 'having a great deal to do with securing the services of Mr Ford Madox Brown to paint the fine series of mural paintings in the large room of the Manchester Town Hall illustrative of the history of the town',[15] an event which seems to have been to Manchester what Michelangelo was to Rome and the Sistine Chapel.

(Many years later Lowry often related how 'a boy I knew', accompanying his father to the Town Hall on business, came by chance on the great man engaged in his work and was 'addressed most courteously' by the artist. Sometimes the tale was told about the young Laurence himself, although Ford Madox Brown was 'driven finally back to London by the failing health of his wife' in 1886,[16] a year before Lowry was born. And in fact only two of the Town Hall frescoes were actually done *in situ*, the rest were painted on canvas and then stuck on to the wall.[17])

Rowley's influence with the great names of the century was certainly awesome. Apart from organizing healthy rambles into the country, where his followers could 'play and pray'[18] together, he

brought Shaw to Manchester to speak, together with university professors and leading politicians. 'I always go for the best,'[19] he remarked, displaying an enviable ability to persuade some of the world's finest musicians to give gratuitous performances at his own New Islington Hall. He staged concerts by the renowned Brodsky Quartet, and arranged recitals by Busoni. And in 1881 he invited Elizabeth Hobson to play for him.

Miss Hobson, overwhelmed by this singular honour, accepted the engagement with alacrity. She talked and thought of little else. In the tiny parlour of the house in Oldham Road, three doors down from where brother Willie, now seventeen, was struggling to maintain the standards of business set by his father, she practised incessantly. From that time on Elizabeth gave the impression that for her, now, only one future would suffice: that of a concert pianist.

In another time or another place she might perhaps have fulfilled her dream. She was unfortunate in that the standards of musical excellence in the era of her opportunity were so incredibly high. As Sir Edward Elgar was to remark, Manchester was the centre of musical England.[20] Charles Hallé had arrived, out of work, from Paris and had formed the orchestra which was to become internationally renowned; Chopin had performed in the Gentleman's Concert Hall, where the Midland Hotel now stands; Hans Richter, friend of Wagner, was to succeed Hallé; Adolph Brodsky, the great Russian violinist, was a humble professor at the Manchester College of Music, where Carl Fuchs taught the cello; Richard Strauss visited Manchester, and Rachmaninov, and Grieg.... Mancunian music-lovers still speak with awe of the night Fritz Kreisler *stood in* for Bronislaw Hubermann, who was indisposed.

Whether or not Elizabeth's career was blighted by too much competition, it failed to blossom. She soon became accepted as a technically excellent, if not over-patient, teacher, and a skilled accompanist to the great voices of the day; but no more. For her, of course, mere mediocrity was not enough. The less charitable members of her family noted that her bronchial attacks became curiously more frequent, her lassitude more pronounced.

It would be wrong to blame Elizabeth too strenuously for her preoccupation with health and with ambition. Her standards of success and her intolerance of failure she had learned from her father. Perhaps, from his indulgence, she had also discovered very early that an attack of the vapours—or 'canary fits'[21]—was a sure way of winning sympathy. Certainly it was a technique she perfected, and used throughout her later life to gain the attention of her husband and, indeed, of her son. Now, with the frustration of her ambition,

her poor health became an excuse and a justification for the failure that she was unable otherwise to accept.

Mary, meanwhile, within a few weeks of joining the 'mutual improvement class' also began to dream of a particular future. She had met a young cashier named Thomas Frederick Shephard, a slight man with soulful brown eyes and a sensitive face. His elder brother, William Henry Shephard, a warehouseman living in Harpurhey, was a Superintendent at the Sunday School and a protégé of both Milner and Rowley, and, as such, a figure of some respect in the district. Mary looked no further. Early in 1882 she and Tom were married and moved to a small house in Clifford Street, Chorlton-upon-Medlock, on the Cheshire side of the town where the air was reputed to be marginally purer—for Mary too was 'chesty' although, according to her youngest daughter, May, she 'did not complain like Aunt Elizabeth'.

Elizabeth remained at home in the Oldham Road, near Willie and the shop that brought her income, and the Anderson girls with whom she felt she had little in common. Her particular friend, Ann Jackson, daughter of James Jackson, William Hobson's deceased uncle, had married and moved to London, where she already had a 'delicate daughter' [22] of her own. But she wrote frequently enquiring after brother George—who had gone to sea more than five years before, and was later reported drowned in Australia[23]—or Mary, recovering from the birth of her first daughter, and wanting details of her friend's progress on the concert platform. By the end of 1883 Elizabeth had little to report, simply a sufficiency of pupils. Her peak, it seemed, had come and gone. The solo appearances had almost ceased. There was still the occasional call to be an accompanist at the Brand Lane concerts, a sort of Mancunian equivalent of the London Proms;[24] but even that was now rare. Her most pressing invitations to play were at family musical evenings, notably those at Clifford Street, where Mary was establishing a local reputation as an excellent hostess. Predictably, apart from family, most of the intimates of such pleasant soirées were from Bennett Street. Annie Hall was there, as stand-by pianist in case Elizabeth was indisposed; and Lizzie and Mary Anderson; and Will Shephard with his voluptuous wife Emma, and her spade-bearded brother, Thomas Moore, Will's teaching partner in the Adult Men's room at Bennett Street. Edward Hobson, married by this time and with his own hatter's business in Pendleton, would arrive in a carriage with his wife Selina but not the children,[25] and, on special occasions, young Willie Hobson, despite his sad disregard for the special mores of the group and his obvious preference for other less desirable company.

Also, with increasing regularity, came a particular friend of Tom's, an earnest young man who had conceived a distant admiration for the elder Miss Hobson, but who wooed her with a diffidence that made both Tom and Mary despair. His name was Robert Lowry.

If Robert Lowry seemed to his new friends to be a particularly humble young man, it was more by his demeanour than by anything he said. He seemed to lack the typical Manchester Man's wayward independence, yet shared his secretiveness, his love of drama, and managed to create a curious aura of mystery about himself and his activities.[26] He spoke seldom of his family, saying simply, when anyone enquired too closely, that he came from good stock, and implying respectability at least. Yet to anyone of any standing who happened to show him attention he could be almost embarrassingly deferential. It became generally accepted that he had known considerable hardship in childhood, and this was undoubtedly close to the truth.

Robert Lowry was born on June 4th, 1857, at 30 Crompton Street, in the Manchester parish of St George. The house, which the Lowrys rented for barely a year at the modest sum of five shillings and six pence per week,[27] was just like the succession of other homes that they rented on the peripheries of the Cheetham Hill Road: little more than a shelter, clinging with a kind of desperate tenacity to the hems of the city streets, much as its occupants clung to life. Such houses boasted neither fence nor garden, but spilled directly on to dirty cobbled roads that teemed with horse-drawn traffic and ragged peddlars. If they lacked the twentieth-century niceties of life, such as bathrooms or inside water closets, few felt deprived; they accepted their station and feared only the loss of it or, almost worse, the temptation to get ideas above it.

Frederick Lowry, Robert's father, may well have aspired to better things: the description of 'estate agent' on Robert's birth certificate implied a greater degree of substance than was in fact the case. For a few years at least he carried on an accountancy and estate business in partnership with John Chambers in King Street, one of the smarter areas of Manchester; but Frederick dealt with the estate side of things which, in those days, involved not so much the selling of large properties as the collection of small rents. And his fortunes seem to have deteriorated rapidly until, in 1862, when his son was only five, he died intestate, as did his wife, Eliza—the daughter of a Manchester spinner named Robert Berry—some three years later.

So few facts are known about either Frederick or Eliza Lowry

that they remain, as both Robert and his son would have wished, figures of some mystery, despite the odd clue that Lowry loved to drop into a conversation. On several occasions he told how his great-grandfather, Jacob, a bootmaker, had moved with the infant Frederick from Belfast to Port Patrick[28] in 1829 and, unable to find work, had eventually 'died of the drink'. At other times the tale was told about Frederick, spiced with the information that poor Robert was left totally destitute while practically a babe in arms.[29] It is interesting, in view of these stories, and of the metaphorical nudging and winking that accompanied references to Lowry's Irish heritage, to remember that Lowry was never known to drink. Not that he disapproved of drinking by others, rather delighting, as an addicted observer of human nature, in watching the effect it had upon them. One of his favourite anecdotes, told to intimates, concerned an eminent critic, a man known to enjoy a drink or three: 'And he said to me, "Don't ever forget, Mr Lowry, you are a very important man, a great man . . ." and he swayed a bit from the effect of all the hot milk he had been drinking.'[30] When asked, as he frequently was, why he never took anything stronger than orange juice (apart from an occasional indulgence in pudding laced with brandy sauce—'I'll have a bit more of that excellent gravy, Sir'[31]) he would say that, living alone, he feared the temptation to excess should he once begin: 'Oh, I dare not, I dare not. I've seen what it can do.'[32] An adult rationalization, perhaps; he did not live alone until he was over fifty. Once, when pressed by new friends who felt handicapped by being unable to tempt him to champagne, he became suitably dramatic: 'Had an uncle—took to drink—it was terrible, terrible.' On occasion he confided that his mother had made him promise never to touch drink; some versions go so far as to say that she literally made him 'sign the pledge'.[33] A few of the artist's acquaintances have assumed that it was Robert who had the drink problem; but maidservants, who as a breed rarely miss much, cannot remember ever having seen alcohol in the Lowry house or on the table. At one point in his life, applying for a life insurance with a Temperance Union, Robert in fact declared himself to be a 'life-long abstainer'—under the circumstances, perhaps, a predictable assertion. But even Lowry, who was not given to denying his father's faults, once said of Robert: 'A very sober, punctual man, my father.'[34]

Whatever the true cause of Frederick's downfall, if downfall it was, the cause of his death, at the age of forty-one, was recorded as tympanitis, an infection of the outer ear. His widow, Eliza, died in 1865, of a strangulated hernia. Again, because of the scarcity of

authenticated records, it is not clear how many children they left.[35] Family papers record only two baptisms: Robert Stephen McAll in July, 1857, and Mary Fletcher in October, 1855, both at the Union Chapel, Queen's Park, Harpurhey, one of the many smaller villages that formed a suburban belt round Manchester. The chapel was not especially close to the Lowrys' home, but the three non-conformist chapels serving the local community were fraught with rivalry (one newspaper dubbed Queen's Park the 'Disunion Chapel') and each pastor guarded his flock with such ferocity that the Lowrys obviously remained loyal to the rather distant Rev. Mr Weekes. The next recorded event in Robert's life is his admission, as a 'Manchester orphan'[36] in March, 1867, when he was not yet eleven, to Oldham Blue Coat School, a charitable institution founded on the bequest of a wealthy hat manufacturer, Thos. Henshaw, who had started as a humble apprentice and ended by drowning himself in a reservoir while in a state of 'mental derangement'.[37]

Although no account of Robert's particular circumstances is preserved, the school records state that '... boys elected to the school were rescued from poverty and the squalor that often accompanies it ...' Many of them were orphans; all were poor. Unlike other children in the town,[38] they were schooled until their fourteenth birthday, undergoing 'mental, physical, moral and spiritual training which was designed to prepare them for useful and satisfying adult life'. The days were long and rigorous, lessons lasting more or less from morning prayers at six to evening prayers at eight. Boys slept two in a bed and bathed communally in pump water once a week. Rules were strict and rigidly enforced: '... for the atrocious sins of lying, stealing and swearing, or of any flagrant breach of good manners, for fighting, beating or abusing each other, the most exemplary and as far as may be proportionate punishment shall always be inflicted.' The boys were required to learn the Epistle by heart each Sunday and the Catechism, 'not only to repeat the words from mere force of memory ... but to understand the sentiment and to make it their own'. They were taught obedience, humility and good writing so that, after leaving, many of them might 'become clerks in offices'. Robert left in 1871 with the parting gift of a suit, a prayer book and a Bible.

Although Lowry later told friends that Robert then went to live 'with relatives' in Liverpool, the records of the school Benevolent Society—which Robert subscribed to for many years—list him at various addresses in and around Manchester: at Blackley with his friends the Tophams, and later in Chorlton-on-Medlock. It is possible, of course, that he was in Liverpool before he went to Oldham

School, in the two years between his parents' death and his admittance to the institution. Typically neither Robert nor his son spoke of such 'relatives' by name, but Lowry must have believed they existed: his personal papers show that he did some research in the town to try to discover if he was related to Malcolm Lowry, the author, who died an alcoholic in 1957. Indeed he once told some adopted relations that he had established the connection. It is hard to understand why Lowry in his later life should so often have tried to prove blood-ties with so many who were, in all probability, not related, while at the same time denying the very existence of those who were. Possibly he simply preferred the security of new-found relatives, uninfluenced by Elizabeth's assessments of his worth, to actual ties with elderly cousins who knew the truth he tried to hide.

Whether or not Robert Lowry went to Liverpool at this juncture, it is certain that before long he had become just what Oldham Blue Coat School had intended, a clerk in an office. The offices were those of Lancashire and Earnshaw, Estate Agents of Manchester, who had dealt with, among others, the property of the late William Hobson, and who employed Robert Lowry for more than half a century. And in 1879, when he was twenty-one, he was taken for the first time to Bennett Street—the Literary Society, not the Sunday School—by a particular friend, John H. Topham.

Quite early in his association with Bennett Street, Robert Lowry was drawn to young Tom Shephard, who was shortly to marry Mary Hobson. He also admired the other brother, William Henry, for his dedication to learning and his facility with words; and he envied Will's intense delight in life, being apparently unable to enjoy such freedom of spirit himself. He found Will's unworldliness and total unconcern with financial success somewhat mystifying. As with Elizabeth, such sentiments had not come within the scope of his experience. And so, within the Bennett Street circle, he found much to interest and attract him—and one woman in particular.

He met Elizabeth frequently on social occasions, at Tom Shephard's and at St Paul's Church at New Cross, which they both attended each Sunday. When asked, he was able to offer her advice on matters of 'estate' and proved himself more than willing to turn the pages of her music when she played for them at soirées. Endowed with a pleasing tenor voice, he spent many hours meticulously transcribing pieces most suited to their joint talents. But, given Robert's diffidence, the courtship was slow and at times it seemed to their friends as if it might never come to anything. Mary, ever since Tom had told her of Robert's admiration for Elizabeth, had seen

marriage as the perfect solution to the problems of her petulant sister. But it took her constant encouragement and not a little manœuvring to 'foster an attraction between them'.[39] They had known each other, casually if not intimately, for all of six years before the engagement was announced to the accompaniment of sighs of relief all round.

The wedding on July 22nd, 1885, was far from typical of their subsequent married life in that the church, the witnesses and the rector were all of Robert's choosing. In a rare moment of sentiment he had asked his bride if she would agree to be married not at St Paul's but at St Andrew's in Blackley, so that John Topham's father, Robert, whom he regarded much as a father himself, and who was in failing health after a long struggle against 'mental depression',[40] could attend. Elizabeth was delighted to agree; the Tophams, with their fine home and their position in local society, were very much the kind of people with whom she liked to be associated.

After a short honeymoon in Lytham the newly-weds set up home at 8 Barrett Street in Old Trafford, one of the pleasanter suburbs of Manchester where, huddled at the end of squalid Deansgate, 'poverty tapered off and respectability began'.[41] It was a small house, squashed into a terrace of identical burnt-umber brick houses and dominated by the grey slate steeple of the church at the far end. On one side lived William McClean, a traveller, on the other was Edward Schofield, a commission agent, and at the corner of the row stood a provision shop with sanded stone floors and a pervading smell of paraffin oil. It was a far cry from hobnobbing with the Tophams.

Robert had moved there from Chorlton-on-Medlock in the autumn of the previous year, and although it was hardly the ideal setting for the kind of life Elizabeth envisaged, she accepted it as a beginning and struggled valiantly to create, within the home, the illusion of that cultured gentility she so much revered. At this time she was as happy as anyone had ever known her; there was an extra confidence in her manner, a fresh brilliance in her piano-playing. To her friends and relatives it seemed that she had embraced marriage as others embrace a cause, placing in it all her hopes of success and endowing Robert with the attributes she had most admired in her father. Realistic enough to see that, as yet, he was only a clerk, she plainly believed that, with her driving ambition and his obvious expectations of life, together they could make a prosperous future. It was as if all the hopes of happiness so cruelly frustrated were born again and concentrated in the marriage.

Robert revealed less of his feelings to the family. He seemed happy to acquiesce in his wife's wishes and to play the part she demanded to the best of his ability. But it is interesting to consider here a letter written by Will Shephard to Annie Hall at the time when he was courting her in 1888; it is the Shephard family background that this letter describes, and yet the patterns of feeling and behaviour it outlines must have been typical of many similar families, and may well have been shared by Robert Lowry. He identified very closely with the Shephard brothers; indeed he was frequently heard to remark that he felt Tom to be more of a brother than a brother-in-law.[42]

'Very early I had begun to dream and isolate myself from those about me. The hard struggle to live had not fostered the growth of sympathy in our home. My father never drew us out, never seemed to concern himself about us. He never courted the sympathy of his children and he never got it. My mother was too busily occupied with the cares and difficulties which fell to her in bringing us up to call for our confidences, even had she the power to do so.... With the exception of the little sister that I had to nurse ... little Amy, now an angel of God—I had no companions, and though we would have done all in our power to help each other, we did not permit our emotions to become visible and did not even express our feelings for each other. He [Tom] only knew my care for him when a bigger boy attacked him, and I only knew his for me when he would come to me to help him out of some difficulty. ... I never remember kissing any member of my family but Amy. We can see ourselves reflected in others much more clearly than we can see our own true self, cannot we, dear? Well, I have seen in our Tom what I fear must be also in myself! He cannot detach his feeling from his own personality. He looks at things too exclusively from his own standpoint. I have seen him throw Mary back upon herself from sheer blindness to see her feelings. His love was not deep enough to enable him to interpret her tenderest instincts. Not that he was conscious of checking her or that he did not love her with all his heart. No, I believe his love is intense enough, but it is wanting in tenderness and breadth. He loves Mary too exclusively to be a real interpreter of her nature.'[43]

Robert too, perhaps, loved Elizabeth, the elder sister, too exclusively to be a real interpreter of her nature. He admired her, he indulged her whims, he concerned himself with her health and

endured her dominance with a patience that was, perhaps, neither wise nor perceptive.

Ironically, in the same way that Tom and Mary Shephard had encouraged Robert and his bride in their courtship, now Elizabeth was to do the same for Will, but with considerably more force and less finesse than her sister had employed. Will's first wife, Emma, had died tragically young in 1884. Now, when not to be seen wandering down the Oldham Road 'deep in earnest conversation, probably relating to the lesson of the previous Sunday, or the one about to be delivered',[44] he could be found in Anson Terrace, where Tom and Mary now lived or, of an evening, in the front room at Barrett Street. There on Sundays, after a day of spiritual rewards, quiet confidences were exchanged; when the card games were over, and the ghost stories all told, the men—Will puffing his cigar—would sit chatting of their aspirations and ambitions while Elizabeth or Annie played the piano and Mary or the Anderson girls busied themselves with the final cups of tea.

The atmosphere was warm with comradeship in the glow of the gas lamps and the flickering coal fire; and slowly a deep love grew between Will and the homely Annie Hall, a gentle girl with a round sunny face, who had long treasured an admiration for the elder Shephard. But, out of respect for Emma so recently deceased, the couple were constrained to conceal their affections even from each other initially, and later from their friends: 'holding hands under the table when we thought no one was looking'.[45] It took Elizabeth's directness to bring the matter into the open. As Will wrote to Annie:

'Neither Tom nor Mary could speak of you to me without embarrassment. If Mary mentioned your name she would let her eyes drop in doing so.... But your cousin Lizzie has made the most direct attempts to get at my feelings. She has not had the same need for diffidence that Mary had. The many talks she and Robert and I have had after the music was over had disposed us to mutual confidences, and gave her the courage to put questions to me that no one else ventured. She would like to know if I were looking with such regret on the past as to be blind to the present or indifferent to the future, if I would always stop with our people or should I ever be, well, like her and Robert, Tom and Mary; I ought to have a home of my own; it seemed not right that I should only be on sufferance within so charming a circle, etc., etc., and, of course, I could see that she had someone in her mind that would just supply all the harmonies in the discord—"but men are so stupid". I was not

sorry that she should try and get at my feelings in a general way and I knew she would gain sufficient to warrant her in forming conclusions agreeable to her own wishes....

'Do you remember that Tuesday night, Annie? I may be wronging them, but I believe they meant our meeting not to be merely accidental. Robert's invitation to me was much more direct than customary; he laid special stress on my coming that night. And when Lizzie saw how wet the night was she could not conceal her disappointment ... How delighted I was when I heard your knock at the door ... the uncertainty of your coming had made my feelings correspond with the weather, I felt its gloom and wretchedness as a part of my own nature, but you came, Annie, and all was changed! I was far from pleased to let Robert see you to the tram, though I knew my doing so would be to confirm their suspicions....'[46]

That letter reveals as much of Elizabeth, and possibly Robert, as it does of Will. Elizabeth did, indeed, feel their circle to be charmed and anyone outside it to be 'on sufferance'—even a man as high-minded as William Henry Shephard, protégé of Milner and Rowley. Furthermore, although Will's letter does not make it clear whether Elizabeth actually uttered the words 'men are so stupid', it is plain that such sentiments would be recognized as typical of her. Robert is cast in the subservient role, as the bearer of invitations; Elizabeth it was who planned the strategy, ferreted out the facts and organized the campaign—in just the same way, perhaps, as she organized married life. The friendship between the three men, for example—Robert, Will and Tom—she allowed to continue only as long as it suited her. In 1895, the trio 'fell victim to the cycling epidemic'.[47] Like Will, Robert 'could not rest until he had mastered the art of balancing, pedaling, mounting, and had got a machine', and soon a spanking new penny-farthing appeared in the narrow hallway of their home—an invasion which was to cause many complaints when it interfered with the passage of the perambulator. With not too good a grace Elizabeth permitted 'a few Saturday afternoon runs to such places as Alderley Hedge, Prestbury, Gawsworth and Rosthern Mere' which 'opened out the rare delights of the wheel'; but when it came to the autumn holidays and a cycling trip planned by Tom and Will to Cambridge and beyond, she refused to respond to Robert's tentative suggestions that he might join them: she was 'far too delicate' to be left for so long. In the same way, after 1887 Robert's name disappeared from the Literary Society registers. He was to find an alternative outlet for his apparent need to repay, by

good works, the debt he felt he owed to society: he became a lay preacher and Sunday School superintendent at St Clement's Church in Longsight, where he was regarded with a respect he seemed unable to inspire at home.

Another relationship of which Elizabeth disapproved was with her cousin Robert Hall, Annie's brother. He might be 'a jolly man who did conjuring tricks for the children' but he was also 'a bit of a rolling stone' and, worse, 'a red hot socialist'. In later years he had a small van and would tour the district—as Karl Marx had done—addressing political meetings; but Elizabeth had severed connections with her socialist cousin long before then. Will had been hard enough for her to accept, with his Darwinian theories and his habit of dismissing in tones of contempt anyone who did not agree with such progressive thinking: 'The man's a muff,' he would say, lighting another cigar and sitting back in his chair as if that settled the matter. As one of Will's sons observed: 'Robert was not a Darwinian: Elizabeth would not let him be.'

And so, well in control of home and husband, Elizabeth was content to bask in the glow of their charming circle of suitable friends. She was happy. The splendour of Jubilee Year, 1887, swept her up, as it did the whole city, in a fever of excitement; and the great Royal Jubilee Exhibition, when it was opened—fairy fountain and illuminated lake, cosmopolitan attractions, bandstands—was only half a mile away up the Chester Road at Old Trafford. On a quiet evening in Barrett Street there wafted on the still night air the 'rich aroma of Mexican cigars'[48] and the distant sound of sweet music. But Elizabeth's happiness was short-lived. Even before the great exhibition had been declared open by the Prince of Wales that May, she knew the worst. Life was to be very different and not at all what she had planned. She arrived unexpectedly one afternoon, in a state of some distress, to break the news to her sister; she was too distraught to write of it, she had to come herself: Elizabeth was pregnant, and she was convinced that she was to die of it.

Mary was astonished by the news; well aware of the prudish streak in Elizabeth's fastidious nature, she had assumed the marriage to be platonic.[49] Now, faced with proof to the contrary, she marvelled at the naïvety of her sister's outrage. Repeatedly over the next few months Elizabeth declared herself to be unequal not only to the physical strain of childbirth and its attendant indignities, but to the unpalatable demands of motherhood. Nothing that either Robert or Mary could say would comfort her; she lost weight and became yet paler than before; she could not rise from her bed until noon, when she would take a carriage to her sister's house and recline

there, prostrate with worry, while Mary hushed the children until Robert arrived from work to take her home. Tom was bewildered by the commotion that threatened to disrupt his household. He and Mary already had two children—Ruth Mary, now four, and Grace Margaret, nearly two; their third, Georgina May, was to be born a year later. Mary had displayed no such fears before the birth and only joy afterwards. He had no experience of a reaction such as Elizabeth's and he was at a loss to know how best to advise his brother-in-law. The fuss continued throughout the summer, until he despaired of ever seeing his friend hold up his head again. These days Robert walked like a man cowed, while Elizabeth endured her pregnancy with what could only be described as peevish martyrdom.

Finally, with the coming of autumn and the inevitability of her confinement, Elizabeth became resigned to her fate. And, observing how delightful were Mary's daughters, how pretty and how bright, how they clung to their dear mama and how they loved her, she calmed herself with a new conviction: she would not die, she would have a daughter. For her this was no mere whim, it was a fact. She *knew* it to be so. And when, in the *esprit d'escalier* of that Jubilee Year her time came, her first words to her sister and to the midwife who stood at her bedside in the poky bedroom at Barrett Street were not so much a question as a statement:

'Is it a girl?' she asked, and wept beyond reason when they told her 'No'.[50]

2 'A horrible child'

ACCORDING TO the record, Laurence Stephen Lowry was born on November 1st, 1887. In fact, he insisted, his birth had been in the early hours of the following day, but 'like everything else in my life, they got it wrong'.

He was, he would say, a sickly child; they thought he would never reach adulthood. Predictably he had inherited a 'weak chest' and was prone to coughs and colds and spells of unaccountable crying.[1] Even then he had the protuberant Hobson nose, his hands and feet were disproportionately large on his tiny body, and he had difficulty in co-ordinating his limbs. As one friend commented rather unkindly: 'If the term autistic had been in use then, it would have been applied to Lowry.'

His mother, when she could bring herself to look at him, thought him ugly; his father adored him on sight.[2] They took him no further than the end of the street, to the nine-year-old sandstone church of St Bride's, for the baptism on December 18th,[3] some six weeks after his birth. It was a cold, damp day and Elizabeth worried that she might take a chill. The baby, of course, cried.

Mary Shephard, despite her knowledge of her sister's nature and the experience of the previous months, was shocked by Elizabeth's insistence that Robert hire a wet-nurse for the baby. The new mother's weakness was declared to be the reason, but Mary thought differently and feared for the child's emotional development should Elizabeth's detachment continue. Faced with her sister's repeated complaints at the injustice of a fate that gave her, Mary, 'three splendid daughters'[4] while she, Elizabeth, had only a 'clumsy boy',[5] Mary became increasingly protective towards the young Lowry and, throughout his childhood, was to make strenuous efforts to

concern herself in his upbringing, as far as Elizabeth would allow. She made a point of involving him in parties, holidays and outings— much to the irritation of her daughters who found him 'difficult' and 'aggressive'.[6]

Elizabeth was somewhat consoled by Mary's suggestion that in maturity Laurie might prove to be more of a support than a daughter. Perhaps she had already begun to suspect that Robert would be as much of a disappointment to her as he was to himself. The combination of a series of minor frustrations, coupled with a pair of extraordinarily expectant personalities, was to turn what should have been a simple discovery of the harsh realities of life into something approaching bitterness. Yet by all accounts Robert never wavered in his devotion to his demanding wife. Whatever her faults, Elizabeth managed, throughout her life, to inspire the constant devotion of both her spouse and her son. She must have had virtues that others failed to see: nearly all those who knew the family wrote or spoke of Robert as 'good' or 'kind' or 'true', but no such terms were used in relation to Elizabeth; they wrote only of her 'suffering' and of the 'excessive demands' she made upon the two men. A nephew once summed her up as 'a brilliant pianist who became a hypochondriac'.

Elizabeth was, reputedly, ordered by her doctor not to have another child. By her own account, her health never totally recovered from the accouchement. And as soon as he was old enough to interpret his mother's insidious complaints, the child whose birth had, he presumed, been responsible for her suffering began to feel guilt for her frailty and for the supposed loss of a brilliant career as a pianist. Nevertheless, his own subsequent years of careful nursing and constant attention to his mother were certainly inspired by filial devotion rather than by a cold sense of duty. Long before her death he rationalized his adolescent guilt feelings (which, at times, he seems almost to have pushed on to the father who caused the unwanted pregnancy) with comments such as 'had she so wished', or 'had she really wanted it', when talking of her unfulfilled talent. It is possible that his mother's disappointment over her career subconsciously led the adult Lowry to seek absolution in his frequent encouragement of young girl artists—an interest which, with one notable exception, ceased or at least waned when the protégées in question married.

In 1889, when Laurie was eighteen months old, the family moved from Barrett Street to 4 Ellesmere Street, Longsight, a slightly larger house which would accommodate the maid that Elizabeth insisted she needed. The new home was barely a mile from Rusholme Road

where Mary Fletcher Lowry, whom her brother called Pollie, was Assistant Matron and later Matron[7] of a charitable home for the children of widows. Robert was a frequent visitor to the Home, he made himself useful by helping to prepare the annual accounts, teaching shorthand to the boys, and trying to raise money for the care of the orphans. 'He was very good at getting other people to do things, but he could never do anything for himself,'[8] Lowry once said.

Mary Lowry, feeling as concerned as Mary Shephard—from whom she was distinguished by the name 'Aunt Lowry'—encouraged Robert to bring Laurie with him on these visits, although Elizabeth was not sure that the company of such unfortunate children was quite what she wanted for her son—forgetting, perhaps, that her husband was once such a child himself. But Mary persisted, and when Robert became Superintendent of the Sunday School at St Clement's Church in Longsight, where he was already an enthusiastic lay preacher, she backed him in his determination to take Laurie with him on his Sunday afternoon tours of the parish. The boy was to take his first communion there,[9] although by the time of his confirmation (at St Matthew's, Ardwick, on February 26th, 1903)[10] the family had moved from the district.

Mary Lowry even went and 'sat' with Elizabeth each week, both to free Robert and to give the maid an afternoon off. She was still doing this at the turn of the century when Lucy, the fifteen-year-old maidservant of the time, remembers her as being 'rather jolly and with a particular way with young people'.[11] On each visit she would find a kind word for young Lucy, complimenting her either on her cooking or on her skills as a laundress. To Lucy, just parted from her widowed mother, this kindness must have contrasted surprisingly with Elizabeth's superior manner:

'I was always watching myself in her presence; she had a very refined air about her and never spoke without drawling her words. Her sentences would sort of fade away with a little flick of her cambric handkerchief....'

Not surprisingly, she found communication with her mistress difficult, and recalls with embarrassment the time she had a 'silly accident': while bending down to make a living-room fire she pierced a breast with one of the whalebone stays that had worked loose from her corset. She suffered silently for three days until driven by discomfort to show the wound to Elizabeth. Her mistress, reclining on her chaise-longue, looked at it with ill-concealed distaste and dismissed the girl with the words: 'Go home to your mother to get it attended to.' Lucy, used to Victorian sensibilities, found nothing surprising in being dispatched a distance of some three miles to have the cut

bathed and dressed—treatment that Elizabeth could have administered herself in a matter of minutes.

In the ten years in which the Lowrys lived in Longsight, Elizabeth's health had not deteriorated enough to keep her exclusively at home. There were still the pleasant soirées at Mary and Tom's in Anson Terrace, and the occasional visits to Annie Hall in Ancoats, which were, of course, returned. As Annie noted in her diary: 'Will came up early and we had a nice walk to my cousin Lizzie's. Mary was there before us and Tom came in afterwards from school. After tea we had some glorious music....'[12] Annie and Will were not yet married (the wedding took place in September 1890, when he was forty-one and she ten years younger). Will still lived in Pickup Street, Harpurhey, and Annie was working at Samuel Ralph's flint glass works in Prussia Street, off the Oldham Road, an experience which was to stand her in good stead when she later tired of Will's unworldliness and opened their own glass and china shop in the Wilmslow Road. Robert Lowry often passed by on his rent-collecting rounds, and would call in. Annie records: 'I went to town at noon and bought Laurie a needlework pinafore. Robert came to the works in the afternoon for some peat I had promised him and he took the pinafore back with him. How pleased he is in anything done for his child. I *am* fond of Robert Lowry. I do think he is good and kind and true....'[13]

The friendships within the 'charming circle' were still strong: 'I met Will coming out of school and we went to my cousin Lizzie's. Laurie was quite friendly, especially with Will. He is growing a nice little fellow. After he had gone to bed we had some music; *she* played splendidly, some of her best. How enjoyable it was. We had supper and then sat round the fire talking of our future, Will's and mine. How bright it looks. They would like us to live near them, Robert is very fond of Will.'[14] And again: 'Elizabeth and Robert brought little Laurie in the afternoon and we had a nice day. He has got such a merry little fellow, bless him.'[15]

The infant Laurie, then just two years old, may have seemed a 'merry little fellow' to the intimates of the group, but he was very different with those outside it. Surrounded by the warmth of the 'charming circle' the child could have been expected to blossom as he grew. That he became desperately shy with strangers, awkward in company and difficult with his peers, can only be ascribed to Elizabeth's possessiveness, her autocratic bearing in society, her increasing isolation and her dependence on his adoration. When she died, it was the loss of her need for him—whilst his for her endured—that nearly destroyed him.

Laurie was seven years old when he first 'went down'[16] to Bennett Street Sunday School. Elizabeth was then the organist in the No. 4 Adult Ladies' Room, and although by rights the boy should have gone into a class with the other boys, the rule that segregated the sexes was ignored, and because he was 'so painfully shy' he was allowed to stay with his mother. 'He would stand by the organ, silently watching the ladies singing hymns' and 'if anyone spoke to him he would hide behind her skirts'.[17] When the scholars were required to walk round the parish, Laurie could be seen dutifully trotting a pace or two behind his mother, clutching in both hands a small wooden stool 'in case she should need to sit down'.[18] This continued until he was past eleven and they both ceased to go to Bennett Street, except for special anniversaries at which Elizabeth would arrive in a 'bathchair' pushed by her son.[19] Laurie never attended classes on his own, even when his cousins Billie and Bertie, the sons of Will and Annie Shephard, were enrolled there.

It was not only in his mother's presence that Laurie acted so bashfully; it was the same when he accompanied his father on jaunts round the parish. The wife of one of the churchwardens remembers: 'He was different from most boys, really rather shy and a little odd. He preferred the company of the few people whom he knew well, rather than continually making new introductions.'[20]

If Robert was concerned by his son's excessive timidity, his wife found it quite appealing and commented to her sister on his 'delightfully sensitive nature'.[21] She appeared rather to approve of it, glorying in their growing dependence on each other. There was no longer anything in her attitude that hinted of rejection; rather the contrary. She came to accept the incidental disappointment in his abilities: he showed no aptitude for the piano, despite his large hands and long fingers which could span more than an octave. It was the Shephard girls (Ruth and Grace, but not May) who most enjoyed their piano lessons with their aunt, and the elder of Annie's two sons, Billie. The younger, Bertie, soon gave up his attempts to master the keyboard; when his brother was engaged in his lessons at the Lowry home, he would escape upstairs with Laurie, five years his senior, to read adventure books by Dumas and Henty, most of which were Robert's selection for prizes to be presented to the St Clement's scholars. Lowry was to remain an avid reader and enjoyed quoting from what he had read, graduating from Boys' Own adventure tales to Dickens and Thackeray, the plays of Vanbrugh and Congreve, and the poems of Tennyson, Milton and Rossetti.[22]

As early as 1889 Elizabeth was beginning to detach herself from the worries of the Hobson family, just as she had done when her

mother died. Again it was Mary who took the responsibility, this time for the problems of their young brother, Willie. He had got himself badly into debt and the family business was to be taken over by his old friend Robert Hall. 'Poor foolish lad,' Annie wrote in her diary on May 2nd. 'What a lot he has got to learn even to begin again at the very bottom ... he was such a nice lad and gave such fair promise ... and now he has thrown away all he began with, and for what? A few worthless companions.' Two weeks later she continued: 'Poor Mary, she is in sad trouble about Willie. She has come to the wisest conclusion she could, that he must go away....' By the end of the year Willie Hobson had been dispatched far from the scene of his disgrace; he died in America some years later.[23]

This event seems to have served only in estranging briefly the more concerned members of the family: they could not understand Elizabeth's detachment from the crisis. Mary visited Ellesmere Street less frequently, although she maintained a watchful interest in her young nephew. 'She felt sorry for him,' recalled May. 'She was always telling us to be kind to him and insisting on inviting him to all our parties and on every outing. "Oh, no," we would say, but she would have it. "He's so lonely," she would tell us, pointing out that we girls were fortunate to have each other while Laurie had no brothers or sisters, nor could he invite companions to the house on account of his mother's sickness. We did find him difficult, though. As if he almost resented our invitations. Once he came on Hallowe'en, which we made a fuss of because it was his birthday the next day, but as soon as he came in he kicked our turnip lanterns to pieces. My mother wanted him to say sorry, but he wouldn't. Grace was a bit aggressive, too, and the pair of them seemed to find it funny and sniggered in the corner for ages. Ruth went into the front parlour—we were in the cellar—and told Aunt Lizzie, but she just put her hand to her head and said nothing. She was a very different sort to my mother, although they were close in affection; my mother was a gentle sort and wanted to give Laurie the childhood pleasures she felt he should have had.'

It was not often that Mary was able to persuade Elizabeth to allow Laurie to visit on his own; but in 1898, while her sister was in the throes of an 'attack', she took the ten-year-old boy with her own family on holiday to Scotland. There they hiked across rough moorland, visited local tourist spots, and explored the countryside on bicycles which they hired by the day in the nearby village of Scaur O'Doon. One such excursion was described by Ruth, then aged fifteen, in an essay: 'A Scotch tea, with its miscellaneous assortment of scones, jellies and other home-made delicacies, added not a little

to the enjoyment of the day . . . As two of our party were very young, and one of the machines turned out to be not all that could be desired, we decided to at once make for the coast by a side road, instead of going straight on to Girvan. Turning to the right we came to a steep hill and as we walked our machines slowly down it, we obtained a grand view of the coast and the surrounding country. . . .'[24]

Holidays, however, were something that Elizabeth greatly enjoyed and she rarely allowed herself to be left at home. It was Robert, according to his son, who 'wasn't interested in holidays at all',[25] an attitude perhaps dictated more by motives of economy than by anything else. But Laurie and his mother often took themselves away from the grime of Manchester at Easter, and sometimes Whitsun too. In the late summer of 1900 they went to St Anne's, on the Fylde coast, where Annie, with her sons Billie and Bertie, and Cousin May, joined them later, staying at a guest house which they all knew well. Annie wrote: 'Our laddies have been out nearly all the time although it has been showery and we got a nice hour on the pier this afternoon and I ate a good tea after it. . . .'[26] Young cousin Billie, who was then nine years old, remembered such outings long into his old age, telling his sons how he and Laurie tried to get on to the pier with only one ticket between them; as soon as one had been admitted, he would drop the ticket over the side to the other who waited below. '. . . Sometimes it would blow away and Laurie would have to chase it way across the sands before he could join me. . . .'[27] The brash humour of the seaside comics particularly appealed to the two schoolboys, who would re-tell the same jokes to each other all the way home, and fall about laughing extravagantly as if it was the first time they had heard them. (Some thirty years later when a young friend at Lytham rebuked Lowry: 'How can you laugh so at those old jokes?' he replied: 'Well, child, I've been laughing at them for thirty years and I can't see why I shouldn't continue to laugh at them.'[28])

But there was not much laughter in Lowry's childhood. 'I didn't like being a child; I was not interested; my schooldays too. It was not a nice time at all. I have no use for the story that it is the best time of your life—that's all bunkum to me.'[29]

But he did remember the wild thrill of the sea, which fascinated him all his life. He recalled the intoxication of days with the herring fleet, seventy-five miles out into the North Sea off Peterhead or Frazerburgh,[30] while his parents waited sedately on shore for his return. He saw in the inexorable ebb and flow of the tides the same vain struggle for survival that possessed the people among whom he was to live and work. 'It's the Battle of Life—the turbulence of the sea

—and life's pretty turbulent, isn't it? I am very fond of the sea, of course, I have been fond of the sea all my life: how wonderful it is, yet how terrible it is. But I often think ... what if it suddenly changed its mind and didn't turn the tide? And came straight on? If it didn't stop and came on and on and on and on and on. . . . That would be the end of it all.'[31]

It was not until 1898 that Elizabeth persuaded Robert to make their bid for ultimate respectability: they moved to Victoria Park, a remarkable private estate where 'Gothic palaces jostle each other and gardeners dust the soot from the leaves of the trees'.[32] There, within toll gates manned by uniformed keepers, neither horse-drawn trams nor the common electric ones that replaced them in 1902 were permitted to pass; the private motor-car was eventually admitted on sufferance and in the naïve belief that 'only two or three of the inhabitants of the district would ever use them'.[33] (Lowry was twenty-one years old before he left Victoria Park, so this perhaps accounts for the remark with which he astonished a friend in Huddersfield in the late 'fifties: 'Don't those cars over there look funny—all going along without horses.'[34])

Victoria Park held Manchester's intelligentsia and some of its richest citizens. The city still boasted the dubious title of 'Cottonopolis', and many of its great cotton merchants—including a number of German Jewish emigrés—settled in Victoria Park, where they kept carriages with liveried coachmen. Others lived outside Manchester in an 'attempt to escape the dense pall of smoke from factory chimneys which covered the town and all its buildings in filth through which the sun shone, as de Tocqueville said, like a disc without rays'.[35] But Ford Madox Brown, whose work Lowry so admired, once lived at No. 3 Addison Terrace,[36] and the Pankhurst family lived for years in Buckingham Crescent—the Shephard boys astride their tandem recall seeing the Pankhurst girls out on their own bicycles, 'and handsome young women they were too'.

But the Lowrys had moved only 'just inside the railings'; Elizabeth still had to put up with the sort of neighbours who 'sat in chairs on their front door steps'.[37] Behind the door of their home at 14 Pine Grove, where the rent was £26 a year instead of the £16 it had been at Ellesmere Street,[38] life was as frugal as ever. The grocer who called at the house each week knew exactly what to bring: the poorer cut of meat which Lucy, under the watchful eye of her mistress, would divide in two: 'the curly bit for potato pie for Saturday, and the rest for Sunday. She showed me how to separate just enough pastry from the pie to make exactly four Eccles cakes for Sunday tea—and

when Miss Lowry didn't come I was allowed to have one. If there was one thing she taught me it was to be an economical housekeeper, which was good for me: at home we were always poor because my mother spent too much on food for us.'

To Lucy the Lowrys were middle class, but 'very, very careful. The mistress instructed me in the art of building a fire so that it would burn for five or six hours, making it up systematically with little knuckles of coal at the front and slack at the back. The coal was delivered down a shoot into the cellar where Mr Lowry would spend hours in the evenings sorting it out into graduated piles of big and little bits; they never had a fire in the front room except on Sundays.... During the week they lived in the dining-room.'

Laurie had already been initiated into the pretentious realities of life in Victoria Park when, against all family advice, Elizabeth had insisted on sending him to Grafton House School, an exclusive and expensive establishment that catered for the children of the rich. He hated it. For the rest of his life he complained about the 'teasing and the ragging' he endured there.[39] The teachers, too, made him the butt of their sarcasm. One of his masters commented: 'Lowry, you are a living example of Darwin's theory.'[40] Lowry, not understanding, had taken this as a compliment. His father explained the inference, apparently irritated less by the remark itself than by the fact that a man with influence over young minds could even speak of such unacceptable writings.

Lowry's school life can hardly have been made any easier by the quaintly effeminate style in which Elizabeth insisted on dressing him, and which can only have accentuated his awkwardness. She always took particular care with her son's appearance:[41] as a baby she had dressed him in long frilly frocks and as a boy she put him in pretty sailor-suits with smart leather gloves and highly polished shoes. When he was in his teens he invariably left home immaculate, a clean handkerchief in his pocket and his tie perfectly straight, even if he did not always return in the same state. Later, things were different. In his twenties and thirties Lowry may have been 'rather vain'[42] and given to wearing soft felt hats and neat suits, but once past fifty his predilection for grubby raincoats was to prove something of an embarrassment to his friends. In 1971, when someone asked what he did with his old clothes, he replied: 'I wear them.'[43]

For his mother's sake Lowry did apply himself at school, and in 1897, when he was ten, he was awarded a Certificate for Special Diligence in dictation, geography and writing.[44] Apparently this was the only recognition of academic endeavour that he was to receive; it became a matter of some pride to him that he never passed an

examination in his life. Boasting of this to a group of students in 1965,[45] he added: 'I've no brains, that's the trouble.' They were astonished. 'No brains? You've a very poor opinion of yourself, haven't you?' Lowry shrugged. 'No, I have no opinion at all. I'm only stating fact.' But this rationalization of his inability to make his mother proud of his scholastic work was to come much later; at the time his failures hurt him deeply, because they hurt her. 'He lived for her, for her smile and for a word of praise. He was absorbed in her and she took up all his time.'[46]

Homework was a constant struggle to him. 'He could never settle to it,' Lucy recalls. 'He was always slipping into the kitchen to talk to me: he never seemed to have any friends, which is probably why he spent time with me. I'd ask him about school—I was two years older and that seemed a lot to me—but he'd always shrug and grin as if I knew he was no good at it. I often wondered when he'd settle down. He was so full of life, full of beans; he seemed like a lad who needed to let off steam but didn't because his mother wouldn't have liked it. He was very well behaved—as if he were continually holding himself in check. He'd come in from school and throw his cap at the hat-stand—he always missed—and his hair would be sticking up on end at funny angles. His mother was always on at him to brush it down. He'd pop his head round the kitchen door, teasing a little, and saying, "Are we having roast pork today?" and I'd say, "No, silly," because he knew full well we never did. He was very thin— and the image of his father—but he loved his food, particularly my meat and potato pie.'

While Lucy remembers him as a cheerful boy, Lowry's own recollections of his youth were imbued with gloom. 'It was not a nice time at all ... I have no really happy memories of my childhood ... I've a one-track mind, sir. Poverty and gloom. Never a joyous picture of mine you'll see. Always gloom. I never do a jolly picture. You'll never see the sun in one of my pictures. No. Never see the sun, do you?'[47] He could ignore the implicit humour in so many of his paintings, just as he could ignore, or obliterate from his memory, the incidental sunshine in the dark days of his youth. He told friends that he never received presents for his birthday or at Christmas,[48] yet among his possessions were many books inscribed with good wishes, and greetings cards signed 'With Mother and Father's love, for Laurie.' He said there were no celebrations in his home at Christmas, omitting to mention that the whole family invariably decamped to the Shephards' where, as Mary's birthday fell on December 25th, the festivities were the highlight of their year.

Already he was displaying a paradoxical delight in the company

of those he knew well and with whom he felt secure, while at the same time relishing the isolation of his position within the family unit. He enjoyed the companionship of his boisterous cousins, Billie and Bertie, yet never sought it. He reacted with evident pleasure to invitations from the Shephard girls yet, once there, seemed to resent their attentions, as if they tolerated his presence out of pity for circumstances which, in fact, well suited his solitary spirit. He seemed disturbed only when faced with parental criticism, or the distress his failures caused his mother. It was many years before he could speak lightly of such feelings; writing to enquire about the son of a friend, he said: 'How is ... that poor unfortunate fellow who was unlucky enough to be born on November 1st? I hope he is being a very good little boy and keeping fit and well, not like another little boy some 64 years ago who, I have an idea, was a great trial to his parents. ...'[49]

He never admitted to an affection for his childhood save once, when, after his mother's death, he painted a romantic view of a country lane near Macclesfield, up which Elizabeth had 'tried to push me in a perambulator'[50] in 1888. 'I must have been very sentimental,'[51] he remarked, and happily posed for a snapshot of himself on the very spot.

'I was a horrible child,' he once said. 'Always howling. My father wanted to throw me out of the window when I was about five months old.'[52]

This was a tale he repeated many times, as one he had heard often from his mother. But, knowing Robert's reputed forbearance and patience, it does seem to be an incident which may well have become exaggerated with time and telling. It is intriguing to speculate on the reasons for Lowry's continued denigration of his father; his recollections of Robert invariably show the poor man in a far from flattering light. Memories of Elizabeth are quite the reverse. Observations on her character were imbued with compassion and understanding as if, aware of her shortcomings, he loved her because of them rather than despite them. Robert's eventual withdrawal from the unequal battle for the attention and affection of his only son seems to have convinced the artist that his father was devoid of feeling: 'He was a cold fish.'[53]

This may well have been true by the time the child's awareness of the balance of power in the parental relationship had developed; it would have been remarkable if Robert had not sublimated his emotions in the long years of marriage that were to follow. With hindsight it is obvious that he did feel, did care; he cared for Elizabeth enough to conceal, at some pain to himself, the true state of

their finances; he felt pride in the artistic achievements of his son
and told of them in letters to distant friends who, responding with
equal warmth, wrote: 'What a brick Laurie is' ... 'How we do
admire him' ... 'Not many young men decide what they want to
do as he has done and stick at it and make such success of it' ...
'How proud both you and Elizabeth must feel of Laurie....'[54]

None of these sentiments was acknowledged publicly by Lowry,
nor even hinted at in his own recollections of his father. Perhaps the
old man was unable to demonstrate them to his son or, if he did,
Lowry was unable to accept them. He failed to recognize any affec-
tion from his father, even after Robert's death, and continued to
dismiss him—when he spoke of him at all—as uninterested and
detached.

He seems to have despised his father for allowing himself to be
so dominated by his mother, and yet that is exactly what Lowry did
himself for more than half a century. Possibly it was a case of a man
detesting in another those traits that he most disliked in himself. A
curious example of this is demonstrated in a tape-recorded conversa-
tion which took place in November, 1970, between the artist and
Professor Hugh Maitland, an eminent bacteriologist and amateur
artist, who was preparing a biography of his old friend. Maitland
was trying to discover the extent of the parents' encouragement of
their son in his art:

> 'But your mother was sympathetic to you in your work?'
> 'Sympathetic, but not interested.'
> 'Your father more or less just sat on the sidelines, didn't he?'
> 'Yes. He was a queer bird, my father. I shouldn't say that,
> should I? ... I never saw him very pleased with anything and
> I never saw him very annoyed with anything. I remember him
> telling my mother that Mary, his sister, was dead. "I suppose
> I'd better go to the funeral," he said. She died in London. "I
> ought to go. I don't know. It happens to all of us, you know.
> I don't see why I should go to the funeral." He didn't.'

That story is curious for two reasons. Firstly, it is not true. Robert
Lowry's sister died on December 28th, 1934, two years *after* her
brother; and yet Lowry distinctly states, and repeats later, that Mary
died first, while knowing this to be false. There were letters of condo-
lence on Robert's death from Mary among Lowry's personal papers
and a photograph of Mary's grave with the date, 1934, clearly
marked. And secondly, many of Lowry's friends admitted, after his
death, that their friendship had been marred, if not ended, by the
artist's lack of emotion or interest when someone dear to them, and

presumably to him, had died. On at least two occasions he neither sent condolences nor attended the funeral of men who had been particularly close to him.

Yet despite the lack of warmth in their relationship, Lowry was able to learn well from his father, and progressed quickly in the shorthand lessons Robert gave him each week. But, having reached a peak of 60 to 80 words per minute at the age of fifteen, his speed remained static; he had fulfilled the minimum requirements and saw no value in exerting himself further.

During the years at Pine Grove, Elizabeth's health was noticeably deteriorating. Her breakfast, toast with marmalade and tea 'in her own special pot',[55] was taken to her in bed. Robert and Laurie had porridge and tea downstairs and left the house—Robert travelling to work in Manchester on his bicycle, which he kept in the cellar with the coal. At eleven, when the dining-room fire was burning brightly, Elizabeth would come down for a bowl of bread and milk, which Lucy would serve to her where she lay on the couch.

According to Lucy: 'She never did anything but lie on the sofa, propped up by a few cushions, except when she got the urge to play the piano. But there was no heat in the front room and she never played for long; it seemed to exhaust her. I don't know what was the matter with her but I got the impression it was something internal, probably from Laurie's birth.

'They were so different, Mr and Mrs Lowry; he was very cheerful, always whistling; and he had an uproarious laugh that you could hear all over the house, even up in the attic where I used to sleep. He was very kind to me and often did the shopping to help out. When I look back on it I wonder how he stayed so cheerful with an invalid wife; I've wondered since, although I didn't think it at the time, if she were unhappy because she realized what a drag she was on them. It was obvious they had to be careful with their money and couldn't really afford having someone in to look after her. They were the only family in the cul-de-sac with a maid. They had a miserable life, never going out and never entertaining. There was only Miss Lowry who came and sometimes Miss Lizzie Anderson and once in a while one of the Shephard girls for a piano lesson.

'Despite it all they seemed happy enough. I never, never, never heard any words between them; they seemed in perfect harmony— he was such a gentle man, not rough in any way. They both adored her and she adored her son. She was always saying "Master Laurie would like that ..." or "Master Laurie will be pleased...."

'Sometimes Laurie would go to visit the Shephard cousins and I'd go too, to see my friend Pollie who worked there. Mrs Shephard

was a very kind lady, always worrying about whether Laurie was getting out enough and whether he had friends and a life of his own. But he didn't, of course.'

Cheerful was exactly the word Lowry once used to describe his parents. 'They were cheerful,' he said, adding thoughtfully, 'not happy, but cheerful.'

Robert had tried hard to enlist his son's support for the junior football team he coached for St Clement's. They were a lively bunch of lads from mixed backgrounds, but there seemed none among them with whom Laurie could make friends. They all went to different schools and regarded Laurie as 'rather odd' and 'a bit of a snob'. Although in interviews Lowry insisted that he had no sporting ability, it is more probable that he feared to upset Elizabeth by indulging in such dirty pastimes. He never denied his interest—entertaining his friends with recitations of great teams long past, much as a child performs a party piece; he professed simply to be more of a spectator than a player.

Billie and Bertie, however, remembered otherwise. 'One day when we were a man short we pressed Laurie, who was passing on his way home from school, into joining us. He really was jolly good. We had put him in goal and he threw himself all over the place, getting plastered in mud and thoroughly enjoying himself. Much to our surprise, we won. The other team didn't score once. He was very much the hero of the match, but, my goodness, he did look a sight. There was mud all over him, but he went off home with a beatific grin on his face. I don't think he realized what a mess he was in until he saw his mother's face. I gather she practically had the vapours. He got in a frightful row; she was horrified to think that any son of hers could have walked through the streets in such a state. He never played with us again. We asked, lots of times, but he never would.'

3 'Fit for nothing else'

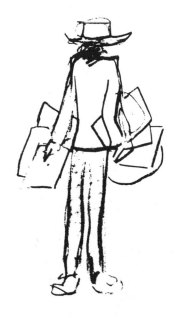

THE FAMILY debates on Laurie's future began in the spring of 1903, when he was fifteen. They were long and heated and they were, for him, painful: he discovered for the first time the full extent of his mother's disappointment in him. He learned that what he most wanted to do brought her neither pride nor pleasure.

For some years he had delighted in drawing, a preoccupation well suited to his solitary hours when homework seemed too tedious and company there was none. At home such a frivolous pursuit had gone mainly unnoticed; the doodling of a child was hardly noteworthy in a household hypnotized by virtuoso renderings of Mozart and Chopin.

Neither Elizabeth nor Robert was particularly attuned to art, either as a culture or as an aesthetic enjoyment. Robert did occasionally take his son on an educational, rather than appreciative, tour of the City Art Gallery,[1] but the only picture that hung in their home was an oleograph 'Portrait of Beethoven' which dominated the hall.[2] On holiday, with more perceptive members of the family, Laurie's facility with a pencil, his habit of making sketchbooks out of odd scraps of paper and filling them with drawings, had been observed and remembered.[3]

Laurie wanted to continue to draw and expected, without too deep an examination of either method or means, that he would be

allowed to further his desires with a formal education in art. In his naïvety he had assumed that his mother would indulge his wish; he had failed to take into account her excessive expectations of his success—on her terms. Dabbling with paints was not considered a proper foundation for any future worth having, far less an acceptable route to respectability.

At that time scandal was practically synonymous with art, a situation created as much by Whistler and Wilde as by the distant echoes of events in Paris which were avidly reported by the press of the day. Wilde's imprisonment had effectively moderated the public activities of the aesthetes; as Yeats put it: 'Everybody got down off his stilts . . . nobody drank absinthe with his black coffee; nobody went mad; nobody committed suicide; nobody joined the Catholic Church. . . .'⁴ England outside the Café Royal had atrophied in the Victorian age. Moral judgements and artistic attitudes which so typified the Queen's reign were to endure long after her death, and nowhere more than in Manchester. The reaction of Elizabeth, that epitome of Victorian womanhood, when she was eventually faced with her son's simultaneous exposure to the raw material of the life class and the influence of a master tainted by self-confessed association with the Impressionists, is not recorded: it cannot have been a happy one.

Despite his life-long habit of submission to parental discipline, Laurie tried to find for himself a full-time place at art school. This must have been one of his first totally self-motivated actions, and his failure to be accepted cannot in any way have enhanced his self-esteem. That such efforts were totally unsuccessful only seems to have increased the boy's belief in his mother's judgement of his worth. She was not, apparently, upset by such a rejection of her son; she would certainly have been far more disturbed had he been accepted, and entered into the wild Bohemian life of her imagination. She blamed his private school, the best that money could provide, for failing to endow him with either the ability or the ambition to progress in a traditional academic way. The Shephard cousins had been sent to quite 'ordinary' schools and yet were not only showing more promise than Laurie, but were well above average. Elizabeth had always imagined that her son would go on from Grafton House to university—as Ruth and Billie and Bertie were to do. That he acquired neither the scholastic skills nor the wish to do so, confounded her.

The causes of such failure were minutely examined, not only within the four walls of 14 Pine Grove, but also round the corner at 9 Birch Grove, the Shephard home. Both Tom and Mary were

greatly concerned for Laurie; they worried that his true potential was unrecognized by his parents, that he would be forever repressed by their efforts to mould him to conventions of success for which he had no aptitude. They saw him as 'different' and felt that those very differences which most disturbed Elizabeth should be encouraged rather than denied.

'Laurie worried them,' May recalls. 'Mother and Father knew he wanted to draw, wanted to be an artist. He was always sketching and doing little books of drawings and had his pockets crammed with bits of paper with scrawly things on them. But Aunt Lizzie thought there was no future in it. She wanted him to do something proud. Even Uncle Robert didn't seem to think much of Laurie's ideas; they would have been all right for a hobby, but not for a career. There was no money in it and they needed the money—not that Aunt Elizabeth would ever have admitted that....'

Whether or not Elizabeth realized the need for extra income in the family, Tom, and consequently Mary, were only too well aware of it; Tom and his brother, Will, were, up to a point, confidants of Robert, and were conscious of his concern. William Henry, who privately thought Elizabeth to be selfish and spoilt, remarked openly that Robert's earnings would have been better saved than invested in trying to 'make a silk purse out of a sow's ear'. Robert, one imagines, might well have said much the same had he dared.

Strangely, Elizabeth did not take exception to hearing her son thus described; her anger was reserved for the 'injustice' that allowed one child to fail while others, with fewer advantages, progressed so enviably. Will's sons recall the acrimony of her complaints. 'She was always going on about how unfair it all was. The way she saw it, she had given Laurie the best and he had achieved nothing. From the beginning she would not have considered sending Laurie to the elementary school in Ducie Street where we went. It was a very good, but ordinary, school and Aunt Lizzie was a fearful snob. Sometimes it was almost embarrassing, the way she would go on about it in front of him, as if he were stupid or something. In fact he had been so repressed that it was a wonder he had any character at all. We all knew what he wanted to do, but she wouldn't hear of it. Father thought she was selfish, but Uncle Robert and Laurie adored her. We children couldn't understand it—she was so fretful and demanding.'

In the months that followed it became apparent, even to Elizabeth, that there was no point in Laurie staying on at school any longer. Robert had never doubted that this would be the case; he had always assumed that his son would follow his own example and

go into business, starting as a humble clerk and, with luck, working his way up in the properly prescribed manner. He had few illusions about the boy, only about himself. Elizabeth, of course, had neither the tact nor the perception to restrain herself from remarking that a 'job as a clerk' was not exactly what she had in mind for Laurie. She said it, repeatedly, in Robert's hearing. He didn't like it, but he accepted it as he accepted everything else.

Now the problem was to find Laurie a job. Robert could do nothing for him at Earnshaw's; his influence there, as rent collector and clerk, was less than he pretended; but he was only forty-seven and Jacob Earnshaw was growing old. The son, John, was not expected to carry on alone after his father's death and Robert confidently believed that, when the time came, he would be taken into partnership. 'My father wouldn't have me. He wouldn't have anything to do with me, you know. You see, he knew me,'[5] was the way Lowry related the situation.

Finally, in the summer of 1903, Laurie was accepted for a post which had been advertised, in the usual way, in the *Manchester Guardian*: he became a clerk with Messrs Thomas Aldred and Son, Chartered Accountants, at 88 Mosley Street, Manchester.[6] He stayed there four years.

He was, apparently, a conscientious worker, with a reasonable knowledge of shorthand acquired from his father, a good head for figures and a neat hand. 'On my leaving them they were pleased to speak very highly of me,'[7] he later wrote in a further job application. It was obvious he was by no means the dunce he later pretended to have been; but that particular charade was only Lowry acting out the role he had chosen to perform in life.

The very essence of the paradox of Lowry the man and, indeed, Lowry the artist, was distilled from those early days of family debate and maternal disenchantment. Young as he was, he had learned that without expectation there can be no disappointment, without pretension there can be no shame in defeat, and without ambition there can be no failure. The image he was to project was that of a boy steered into art without either desire or interest on his part; in that way the responsibility for any lack of achievement could have no sting— there is no market in decrying a man who decries himself. But the fact remains that Laurie had the desire, the ambition, the need—a fact that, no matter how many times he forswore it later, remained indelibly imprinted upon the memories of those who knew him then.

Moved by the boy's evident frustration, Uncle Tom, encouraged by Mary, sought advice for his nephew from his friends at Bennett

Street. Among those he approached was Reginald Barber, an artist who, after a promising start as a student at the Royal Academy and a Silver Medallist at the Paris Salon,[8] had drifted into a kind of provincial obscurity. Barber, a Lancastrian from Ulverston[9] at that time living in Fallowfield not far from Victoria Park, did not share the popular disdain for the amateur. He held regular private classes at his studio in Brown Street where, on a Thursday evening and on Saturdays, eight or nine students from a variety of occupations would gather to draw heads and paint portraits.[10] 'Send the lad to see me,' Barber told Tom. 'If he has got anything, doing an office job won't stop him; and he can still go to classes—part-time.'[11]

Mary relayed this information to her nephew and, almost immediately, Laurie began visiting the artist after work in Mosley Street. 'I liked the sociability there,' he told Hugh Maitland, 'and I liked the class. They were all people who could draw quite decently. We just did heads. I kept on going until Barber died.'

Whether Barber, as Vice-President of the Manchester Academy of Fine Art, had any particular pull at the school that had earlier rejected Laurie as a full-time student on a grant is not recorded; but finally, in 1905, he was accepted as an evening pupil in preparatory antique and freehand drawing.

Lowry was not, of course, called upon to relate the circumstances of his beginnings until he had become known, by which time his projected image was more a part of him than the reality. By then he knew the role to perfection and most of the lines by heart. 'Whatever shall we do with Laurie?' was the first quote in a drama that depicted an anguished family deliberating the future of a brainless child; as with most of his tales, it contained the germ of truth.

Although the earliest exhibited Lowry work—a pencil and gouache yacht scene—is dated 1902, when he would have been fourteen, there is in existence a remarkable work, entitled *Chums* after Sir Edwin Landseer's renowned *Dignity and Impudence*, which is dated 1893.[12] Lowry would then have been under six years old. From this it would seem that he was displaying a precocious artistic ability at a very early age—a fact which he himself would have strenuously denied.

Hugh Maitland often asked Lowry about his beginnings; the script was invariably the same:

'How did you start to paint?' asked Maitland.
'Because an aunt suggested I went to art school. I used to draw little ships when I was eight....'

'Didn't you want to go to the art school?'
'I wasn't particularly anxious to paint, ever....'
'... You didn't pester your parents to go to the art school?'
'I didn't. No. I just went to the art school at my aunt's suggestion.'[13]

Only rarely did Lowry slip to reveal some point he later concealed, and that was usually in the early days when the act was still in rehearsal. Like one of the pier-end comics he so enjoyed, he refined and re-timed each anecdote, playing every line for maximum impact and each incident for calculated effect. In 1965, asked if he were influenced by the work of other artists as a boy, he replied: 'No, I did little books on the theme when I was eight. *And after that I tried to get into different places and couldn't.** And then an aunt of mine said, "I don't know what you are going to do with him *if he's that fond of drawing,** you had better send him to Art School"—I'll try anything once, you see. I got interested. That's how it happened. Because I wasn't fit to do anything else.'[14]

He told the same story to Harold Evans, in an interview on Granada Television in 1956. '... Started when I was fifteen. Don't know why. Aunt said I was no good for anything else, so they might as well send me to Art School. I didn't mind.' And to writers Frank and Vincent Tilsley he said: '... Not brainy enough to do anything else. You don't need brains to be a painter, just feelings.'[15]

By the time he was relating events to Hugh Maitland in 1970 he had been practically 'coerced' into art, and even that not until he was seventeen or eighteen. His old friend was not deceived: Maitland was not only a perceptive and questioning man but he had quietly researched his subject—and he had the benefit of thirty years' friendship with the artist. He wrote: 'The version of these events that he adopted later to the effect that he did not have a special desire to attend art school, that he did not want to do anything, that his parents sent him to art school as a last resort as he was unfit for anything else, needs to be discounted. It is clear that in these classes he was fulfilling an essential need and that his artistic development began at this time.'[16]

Finally, and perhaps inevitably, this persistent self-denigration, founded as it was on a shifting fear of inadequacy rather than on conviction, came to hurt him as deeply as rejection had done in early years; with time, the fantasy had become accepted as fact. Eventually he could contain his annoyance no longer. 'I am tired of people saying I am self-taught; I am sick of it.' He was almost shouting

* Author's italics.

as he spoke, the rumblings of his anger like the sound of distant thunder. 'I went one day to Art School and I said "Please, I want to join," and so I went into the Freehand Drawing Class and then I took Preparatory Antique, light and shade, and then, after a time, the Antique Class, and when they thought that I was sufficiently advanced in Antique I went into the Life Class; I did the life drawing for twelve solid years *as well as I could*, and that, I think, is the foundation of painting. I don't think you can teach painting because everybody's colour sense is different. But drawing ... the model is there and you either get it right or wrong, you see. And the strange thing is that you can *tell* whether people have drawn from life from their pictures.'[17] He was apparently irritated less by the *volte face* of the myth than by the inability of some critics to explode the fallacy for themselves, simply by looking at his work. In this, the last decade of his life, he had come to resent the 'primitive' label which in mellower days he had accepted with the words: 'Well, they've got to write something.'[18]

At first Lowry attended the school in All Saints only tentatively, struggling one night of the week with set objects—cubes and squares 'so arranged as to give the maximum number of headaches',[19] and another evening with the elusive qualities of the Venus de Milo. He once mystified a friend by claiming that he found drawing from the antique more difficult than from life. 'Why's that?' 'Well,' said Lowry with a grin, 'the antique doesn't move.' The friend was still bewildered. 'If you draw from life,' Lowry explained, 'whatever you do, you can say it was like that when I drew it, but it moved. You can't say that about the antique.'[20]

He never studied design, and indeed felt strongly in later life that it should not be taught as it 'anchored the student to tradition and made it more difficult to break away'.[21] He once said: 'I benefited extremely much from never having had a design lesson in my life. That's very important—it saved me.'[22] And again: 'I think I had a narrow escape there. Design is a natural thing and can't be taught. A gentleman of the press once said of me: "His design at times is so intricate that it does not look at first like good design." '[23]

It would be dramatically neat to be able to relate that, once Lowry had embarked on his studies, he found the self-esteem he so desperately needed. Unhappily, he did not. There was no sudden recognition of innate genius, no talk of brilliance, no admiration of his work; nor, indeed, were there any deep personal relationships to sustain him. Here, too, they thought him rather odd. But his strangeness came from his manner even more than from his appearance. He was a tall youth, well over six foot, and still remarkably

thin, the gaunt line of his face and figure as yet not softened by maturity. He had a large oval head and a thatch of sandy hair which, no matter how often he tried to smooth it, invariably stuck straight up from his head like a well-cropped field of hay, and which prompted one contemporary to describe him as looking like 'a boiled egg with pepper on top'.[24] He didn't seem to walk as others did, rather projecting himself across a room or down a street as if he were a puppet manipulated by a hand too small for the glove, his head tilted in a way characteristic of those given to listening to the voices inside rather than to those around them. 'Many years later,' observed James Fitton, R.A., 'when I had become familiar with the odd idiosyncratic figures that populated his canvases, I realized how very like they are to himself.'[25]

Already he had developed an air of personal isolation, but paradoxically he was gregarious as well as silent, friendly yet withdrawn—with others, but not of them. He was an enigma in a circle that accepted eccentricity on a grand scale but found minor peculiarities hard to understand. James Fitton remembers the attitude of the other students towards the man of whom he made a companion in his art school days, and admits to sharing it. 'Lowry was dogsbody. He was regarded as an oddity and a failure because he was unteachable. Unteachable by anybody. He used to sit in front of the nude model and by the time he had finished—he made a swipe from the neck to the ankle more or less—it looked as if it had been carved with a meat axe.' His work, say others, was 'a joke'.[26] Sam Rabin, a teenage sculptor, singer and amateur wrestler who passed briefly through the school on his way to the Slade, the concert platform and the Olympics, relates rather more kindly: 'Lowry wasn't a great figure draughtsman, but he would always try. Whatever else he lacked it wasn't enthusiasm.'

In the same year in which Lowry started at the Manchester School of Art, a Frenchman named Adolphe Valette began work designing calendars and piece-tickets for a printing firm in Princess Street, Manchester, where 'his main job was to paint portraits of various young ladies which were reproduced on stock tickets'. In the evenings, Valette, described as a 'brilliant pupil'[27] at his local art school in St Etienne, attended classes at the Municipal School. He brought with him the stimulus of new experience, the exhilaration of a personal knowledge of the French Impressionists and, curiously, an enthusiasm for the drab smoky hues of the industrial north. As a critic remarked in 1928, he saw Manchester as 'a town of strange subdued colourings, of blues, of mauves and of Turneresque greens, all lurking in its shadows'.[28] Within a year he had been offered, and

had accepted, the post of master in charge of the life class. He accepted, on the condition that he be allowed to teach by demonstration rather than by the accustomed lengthy lecture. His students delighted in his methods. 'One Valette drawing was worth three hours of talking,' said Sam Rabin.

Valette took up his duties just as Lowry, now eighteen, his tastes suitably purified by regulation exposure to the plaster-cast statues of the antique classes, joined them. The two had not previously met. 'Mr Monsieur', as they immediately dubbed him, was as puzzled as anyone by his strange pupil. In their early days together the master would stop by Lowry's work and, as he did with the others, draw on the corner of the pupil's paper a small sketch intended to demonstrate the balance of the figure or the drawing of a hand; he soon gave up. Later he would still stop, still look, but then, with a few almost unintelligible words of English and a gentle pat on Lowry's shoulder, would pass on, his brow lightly furrowed.[29] Although one student—Cyril Greenberg—remembers Valette complaining to Lowry about his 'caraceetoors',[30] there appears to have been no rejection in his criticism; Valette was a kindly man and seemed, more than anyone at that time, to understand the artist's need to explore his own abilities.

Lowry cannot, in fact, have been quite the 'joke' they now recall; only the best students were allowed to join the life class. New arrivals were 'compelled to join the elementary classes, which entailed careful exercises in light and shade, copying of ornament and drawing from antique casts'. Rather plaintively, Doris Taylor describes her apprenticeship: 'I had to draw David's (Michelangelo's) eye, nose, ear, hand, foot and then the head.'[31]

As Lowry himself said, somewhat defensively: 'You've no idea how long I spent on freehand, antique anatomy and full-length studies. At Art School they wanted accuracy more than anything else. They didn't start you doing a sketch out of your head, sort of slap-dash, and then say, "Oh, that's very good." If you were in the Art School, you drew like you would in Art School. And we didn't all come out like Titian, sir.'[32]

By the time he graduated to the life class he was looking for a greater commitment than he was prepared to admit. He conceded only that he relished the company. 'It was good to meet people there. My temperament made me very unsociable although that was not my wish.'[33] The models, and indeed the students, were not the sort he would have been likely to encounter within his family circle: the Pachito sisters from the chorus line at the Hippodrome, the novelist Pearl Binder, and the Italian Valenti,[34] who had once posed for the

great Lord Leighton;[35] the magnificent Hetty, of whom Lowry, Reginald Barber and Mrs Barber all exhibited drawings; and Valette's own discovery, a Titian-haired beauty of sixteen, from a chemist's shop in Altrincham, who sat for the master for four shillings an hour and tea and biscuits, and whom he used as a model for six angels later incorporated in a stained-glass window design for Lincoln Cathedral.[36]

It was now obvious that Lowry's needs were dictated more by his art than his desire for company. He would arrive at the school most nights of the week and spend half of Saturday with Reginald Barber. Early in 1907 he went to Valette to ask for private lessons. Valette refused, but recommended him to William Fitz of Alexandra Road. 'So I went,' said Lowry, 'and it did me a lot of good. Fitz was a very good painter, but I think he came down in the world.'[37] Two portraits by Fitz have been brought up from the bowels of Salford City Art Gallery, where they had been since Fitz's exhibition there in 1928, and are currently on show in the Lowry Room, beside Lowry's self-portrait, painted in 1925, ten years after Fitz's death. Lowry would have enjoyed the irony of his master's revival; one of his declared reasons for not leaving his pictures to a public gallery in his will was 'because they show them for a while and then stick them in the cellars where no one ever sees them again.'[38]

William Fitz—or Billy Fitz as his students called him—was an American who had given up a professorship at the Cooper Institute in New York to broaden his knowledge in Europe. In Munich he was instructed in 'the new methods in oil colour portraiture then in vogue'[39] and in Holland he studied the 'old Dutch Masters'.[40] Arriving in Manchester after the turn of the century, he found his work much admired and, deciding at last to put down roots, took out English naturalization papers. When Lowry went to him he was supplementing his income by giving lessons. His approach was very different to that of the gentle Valette. Lowry found him 'a rough, brusque man',[41] but admitted he learned from him 'the German solidity, mass and weight'.[42] On another occasion he said: 'He was very good at making you seek out the form of things.'[43]

Although Lowry continued to go to Fitz spasmodically for nearly ten years—until shortly before Fitz died in May 1915—and always spoke kindly of him, there is no indication that he ever achieved with this master the rapport he enjoyed with Valette. Mr Monsieur, who looked 'like all the Impressionists rolled into one, with a little black beard, black hair and a black cloak',[44] evoked in his young students both gratitude and affection—as much for his appreciation of their efforts as for his quaint manner of speech. 'He would walk around

and look at our paintings saying, sometimes, "Ah, you will repent that", meaning, we hoped, repaint it.'[45] They endowed him with an ambience of romance and, with much giggling and whispering, spun apocryphal tales about his Paris life. They promulgated the story of his mad passion for a mill girl whom he had supposedly met when she was on a coach tour of the artistic haunts of the Left Bank, and whom he had followed home to Lancashire where 'he was like a fish out of water'.[46] In fact, the story is untrue; far from being romantic, Valette's life was dogged by tragedy. His French wife, Gabrielle, who as his model inspired his most sensitive drawings, died from tuberculosis in 1917, and their only son died just before his twenty-first birthday only a year later; his brother was killed in a car crash and his sister, an eccentric, was confined to an asylum. The artist himself suffered for many years from the kidney disease which eventually killed him.[47]

Valette's following among his pupils was almost reverent, so intense was their devotion to their unusual teacher; as a result he was viewed by his colleagues with suspicion and envy: he was dedicated to pure art in a school more preoccupied with the commercial; and he inspired an admiration they could not hope to engender. 'He was rather shunned by the other masters and this, if anything, seemed to attract Lowry to him,' says Sam Rabin. 'And Valette, for his part, seemed to be drawn towards Lowry as a person. They had a warm regard for each other.'

Sir John Rothenstein's record of Lowry's words of gratitude to his master reflects that warmth. 'I cannot over-estimate the effect on me at that time of the coming into this drab city of Adolphe Valette, full of the French Impressionists, aware of everything that was going on in Paris. He had a freshness and a breadth of experience that exhilarated his students.'[48]

To Maitland Lowry expressed himself rather more simply. 'He gave me the feeling that life drawing was a very wonderful thing, as I saw it done by himself and his friends. I had not seen drawings like these before—for artistry. They were French life class drawings, and he painted and drew in the same way. I was fascinated by it, and whilst I never drew in that way—I couldn't have done, it wasn't my way of drawing—I greatly admired him and they helped me very much. They were great stimulants.'

It was not, then, what Valette taught Lowry, but how he taught him—or that he did not teach him at all. Lowry gained not so much from the instruction of the master as from the enthusiasm he generated—in much the same way that, in the heyday of the Slade under Tonks, the assembled exuberance of Augustus John, Stanley

Spencer, Gwen John, Wyndham Lewis and William Orpen generated a veritable plethora of talent. It was enough—it was more than enough—for Lowry that Valette had faith in him; it was, after all, the first time that anyone had displayed any such thing. And it was to be a very long time before he was to encounter such faith again.

With an uncharacteristic glimmer of pride, Lowry described, some fifty years later, how 'once when I felt like giving it all up' Valette went, unbeknown to Lowry, to visit Robert Lowry. He pleaded with the father to let the son continue with his classes 'because he thought I had something in me'.[49] Repeatedly throughout his life Lowry was to threaten to 'give it all up'. He never did, of course; he couldn't. 'Whenever I was completely fed up something always happened. It made me think it was destiny.'[50]

The truth had less to do with destiny than with the needs of the man. He was addicted to his art and was 'doomed to paint on compulsively.'[51]

4 'A job for life'

In the winter of 1908 Robert Lowry was impelled, probably for the first time, to make an honest appraisal of his future prospects. For nearly thirty years, or at least since his marriage, he had lived in the confident expectation of a promotion which, without specific promises, he had allowed himself to believe to be inevitable. Not only his household budget, but also his indulgence of his wife's pretensions, was based on this expectation; they had lived to the limit of their income, without savings or provision for the future, in the belief that such improvidence was justified: he had been a loyal and, within his capabilities, competent servant of the firm of Jacob Earnshaw and Son. And although he was still, after so many years, employed in the mundane collection of rents and penny insurance,[1] he had lately been entrusted with certain responsibilities connected with the management of the estates of the Dean and Canons of Manchester.

Robert found much to admire in Jacob Earnshaw and embraced many of his causes. Earnshaw was a noted philanthropist, a founder of the Band of Hope and treasurer of the Anti-Narcotic League.[2] (Robert Lowry never smoked. His son smoked cigarettes as a young man, although not within breath of his mother; but when he was twenty-three he fell asleep with a cigarette burning in his hand and 'nearly set fire to the bed'. Laurie did not smoke again.[3])

Jacob Earnshaw's death, in October 1908, was not unexpected; he was seventy-one years old and had been ill for some time. Already his son, John Alfred Earnshaw, an architect and surveyor some eight years junior to Robert, was the more active member of the firm. Robert, along with half the dignitaries of Manchester, attended the

funeral and settled back to wait for the offer of a partnership. The
months passed. The invitation never came.

Whether he ever found the courage to ask John Earnshaw (who
bore a remarkable resemblance to Lowry's savage portrait *The Man-
chester Man*)[4] to clarify his position, is not known. But with the realiza-
tion that he was not to be made a partner came a sense of deep dis-
appointment in himself from which he never recovered.

Already there was resignation in his bearing, the now unkempt
droop of his moustache accentuating the unhappy droop of his
eyes, half closed behind gold-rimmed pince-nez. These character-
istics are more noticeable in photographs than in Lowry's portrait
of his father, a painting which suggests withdrawal from life more
than disillusionment—possibly because his son recognized the
effect rather than the cause. A sense of resignation can be seen
in Lowry's infinitely more sensitive portrait of his mother, done in
the same year, 1910, 'from life',[5] and painted with a compassion he
never showed for his father. (Lowry's portraits of his parents hung
on the wall of his house at Mottram-in-Longendale until the day
he died. Although he had bequeathed them many years before to
Salford City Art Gallery, he refused to be parted from them during
his lifetime[6] even for restoration work.[7])

By the spring of 1909 Robert had accepted that strict economies
were now essential. With some difficulty he explained the situation
to Elizabeth: it was obvious they could no longer live as they did,
or where they did. The rent on the house in Pine Grove had risen,
the previous year, by ten per cent to eleven shillings a week[8] and
a further increase seemed imminent. Robert was then earning under
£100 a year; when he died, twenty-three years later, he was still
on a clerk's wage: £130 per annum, of which ten shillings was pay-
able in income tax.[9] There was the maid to feed and to pay: Pollie,
the girl who had replaced Lucy when she left to get married 'with
the gift of a lovely flower vase from the Master and Mistress',[10] was
slightly more experienced than her friend; she had worked for some
years for Mary Shephard and was now entitled to six shillings a week,
a shilling more than Lucy. She soon noticed the frugality of the
Lowry household: 'At the Shephards we buttered the bread quite
thickly; at the Lowrys we spread it on, then scraped it off again,
so there was just the merest taste on each slice.'[11] Then, of course,
there were the medical bills to pay, treatment in the home and visits
to the surgery, and the cost of a hoard of patent remedies for every-
thing from asthma to rheumatism—he suffered from lumbago[12]—
which Robert collected for his wife and for himself.

As early as 1907 Robert had persuaded his son to leave Thomas

Aldred and Son in an attempt to 'better himself'.[13] Accordingly Laurie had found a new post as a claims clerk in the Cross Street branch of the General Accident Fire and Life Assurance Corporation where he had been taken on, three days after his twentieth birthday, at an annual salary of £46 16s.[14] Now, in 1909, he asked for an increase and was granted an additional £5 4s. per annum, bringing his weekly wage to exactly twenty shillings.[15] In fact Laurie's earnings were irrelevant to the family, except as a measure of his standing within the world of commerce. He did give his mother a small amount towards the cost of his food, but the greater part of his weekly income was spent on pencils, paints, brushes, paper and fees for his art classes. It may have been at this point, a period of economic pressure in 1909, that Valette went to the father to plead the son's cause. 'We all knew he had problems at home,' said Sam Rabin. 'His father was very discouraging.'[16]

There was little now to keep the Lowry family in Victoria Park, within tantalizing sight of what might have been. Tom Shephard was ailing and no longer much of a companion; his devoted wife, Mary, was concerned only with her husband's care. Will was preoccupied with his preaching; and Annie was absorbed in the running of her glass and china shop in the Wilmslow Road. Comparatively late in life the kindly Mary Lowry, who had worked so hard as matron of the charitable home in Rusholme Road, found herself a husband, James Shelmerdine, and moved to London. She had always worried for her nephew, and now only saw Laurie when he could be persuaded to visit London for an occasional weekend. Robert could not bring himself to tell his sister of his financial difficulties or of his failure to achieve a partnership. As Mary wrote to Laurie after Robert's death: '... he has always been most reserved both in home and business matters, I have often wished it was not so ... I do not even know if he was Chief Clerk or Partner with Mr Earnshaw.'[17]

Only the diminutive Lizzie Anderson remained a frequent visitor to Pine Grove; but she lived off the Oldham Road, almost opposite Bennett Street Sunday School, and from there one side of Manchester was as accessible as another. Her sister, Mary, had married a traveller, Frederick Davis, who had several modest properties which he let as an additional source of income; Robert was his adviser in such matters and visited them regularly at their home in Higher Broughton, on the Salford side of town.

John Topham and his family had settled in Pendlebury where, in Station Road, they had found a Victorian villa that suited both their needs and their income. Ironically, soon after their arrival in

Station Road, John Topham died, leaving his wife Jane, a school-teacher, to raise their three children; she stayed only briefly in the north before leaving for Hampshire. And, not much later, the Davis family departed for Worcestershire, leaving their Manchester interests under Robert's management.

Robert, observing the spacious proportions of the Tophams' house, discovered also that the rental was that vital ten per cent less than in Victoria Park. The penalties for such an economy were the loss of a smarter address, the inconvenience of a longer journey to work (he had already sold his bicycle) and the substitution of a horizon of mill chimneys for green trees.

The decision was made. Robert announced that they were leaving Victoria Park 'to be closer to friends—for business reasons'. The family was not deceived. 'They moved because they had to find somewhere cheaper,' said May Shephard. 'They left for financial reasons.'[18]

And so, on May 4th, 1909—a date Laurie was to remember with absolute accuracy all his life—the Lowrys moved to 117 Station Road, a four-bedroomed, four-storeyed semi-detached house with a rateable value of £22 a year and a gross annual rent of £26.[19] At that time it was more elegantly known as Number Five Westfield after the terrace in which it stood, on the peak of a slight incline from industrial squalor.

They had moved not merely to the other side of town, rather to the other side of life: the dark side. There was no escape from reality here, no peripheral illusion of grand living, even behind the heavy lace curtains at their windows. It was all around them, intrusive and insistent: the acrid smell of it, the dismal sounds, and the sights—mean cottages grovelling in the shadow of tall chimneys and turbulent humanity, cowed by poverty and by toil, forever scurrying by their door. And over it all, night and day, winter and summer, hung a cloud of smoke that, dropping soot from darkened skies, insinuated grime into the very pores of the skin and contaminated the clothes of all who lived beneath its pall.

Here Laurie, lying in his bed in the early morning, heard for the first time the sounds of his mother's childhood: the clatter of clogs on cobbles and the imperious summons of the factory hooter. He never forgot those sounds; in his last days he would recall them with the physical ache of nostalgia, and in his imagination would hear them again in the wailing of the wind as it swept in from the Derbyshire hills.

The house itself was, initially, quite bright and airy, with high ceilings and tall windows; but it soon acquired the aura of gloom

with which Elizabeth, according to visitors, endowed any home in which she lived. She, of course, hated it. She hated the surroundings; she hated the people; and she hated the loss of social standing. She withdrew from this alien world, gathering her resentment around her like a shroud. She played the piano less; she stayed in bed longer; she rarely went out; and she entertained hardly at all. She missed the company of the young maidservants to whom she had become accustomed; now there was only Ellen, a pleasant enough body, who cleaned for them and persuaded her friend, Jemima, to take in their washing for a shilling a week;[20] but both women had husbands and children and were unable to give Elizabeth their undivided attention.

At first Laurie hated it too, but with familiarity came acceptance, then affection, and finally obsession. He conceived a personal vision in those squalid homes and sordid lives, and was to paint them with a compassion that transcended mere understanding: his genius lay in his passionate desire to reveal this vision, not as a social commentator, but that others might see and remember the beauty he saw.

If Robert had been a successful and prosperous man and they had not moved to Pendlebury would his son have painted as he did? 'That is a question I have often wondered about,' said Lowry. 'But I don't know. I lived in the residential side of Manchester—a very nice residential side—and then I went to live in Pendlebury—one of the most industrial villages in the countryside mid-way between Manchester and Bolton. At first I detested it. And then, after a few years, I got pretty interested in it and began to walk about. Vaguely in my mind I suppose pictures were forming, and then for about thirty-odd years after that I did nothing but industrial pictures. That is how it all happened. I wasn't brought up in it.'[21]

Such a basically simple assessment of Lowry's vision of an industrial England that is no more, is possibly the most accurate he ever gave. With the passing of the years and the probing of the critics, the story of his artistic awakening became delightfully romanticized, encapsulated into one glorious moment of revelation and related by his acolytes in tones usually reserved for a visitation by the Archangel Gabriel. 'I was inspired by its beauty. At first when I was young I did not see the beauty. I used to go into the country, painting landscapes and the like. Then one day, suddenly I saw it.'[22]

The most popular and the most frequently repeated version of the Lowry revelation concerns an afternoon in 1916 when he missed a train to Manchester. 'I remember that the guard leaned out of the window and winked at me as the last coach disappeared from the platform. I was very cross about that. I went back up the steps. It would be about four o'clock and perhaps there was some peculiar

condition of the atmosphere or something. But as I got to the top of the steps I saw the Acme Mill, a great square red block with the little cottages running in rows right up to it—and suddenly, I knew what I had to paint.'[23]

Sir John Rothenstein records the same event yet more dramatically. 'One day he missed a train from Pendlebury, and as he left the station he saw the Acme Spinning Company's mill. The huge black framework of rows of yellow-lit windows stood up against the sad damp-charged afternoon sky. The mill was turning out, and hundreds of little pinched black figures, heads bent down (as though to offer the smallest surface to the whirling particles of sodden grit) were scurrying across the asphalt square, along the mean streets with the inexplicable derelict gaps in the rows of houses, past the telegraph poles, homewards to high tea or pubwards, away from the mill without a backward glance. Lowry watched this scene (which he had looked at many times without seeing) with rapture: he experienced an earthly equivalent of some transcendental revelation.'[24]

In 1957 Lowry was to recreate that moment for the television cameras in a documentary[25] that began: 'This is a film about a man who became an artist because he missed a train.' When a friend later taxed Lowry about it—'It must be true, it was on television'—the old man laughed and said: 'Oh, you don't want to take any notice of that. I only did it to please them.'[26]

So many of the legends that were to pursue him, and occasionally rebound upon him, were perpetuated by the artist's desire to give an interviewer a 'good story'; he liked to accommodate their preconceived notions, many of which had, after all, emanated either from his own mouth or from his tacit acceptance of ideas that others placed before him. Frequently a visitor would leave the artist only to realize, when the door had shut behind him, that the only firm opinions which had been expressed were his own; Lowry had done no more than interject a polite 'Do you think so, sir; do you really think so?' As a commentator observed in 1971: 'He seems consciously to avoid analysis of his own work and accepts whatever gloss the viewer cares to put on it, as though avoiding examination of the well-springs of creation.'[27] Or as Robert Wraight once put it: 'He is (and knows it and plays the part for all he's worth) God's gift to art reporters.'[28]

On Tyne Tees Television in 1968 Lowry produced yet another version of the revelation. 'The whole idea started in m'mind on the walk Saturday night from Farnworth to Bolton and that's how the idea came in m'mind to do it. And in those days there was a colliery at Kersley and there was the thump, thump, thump of the engines as you went past that colliery and that was it. That's how it started.

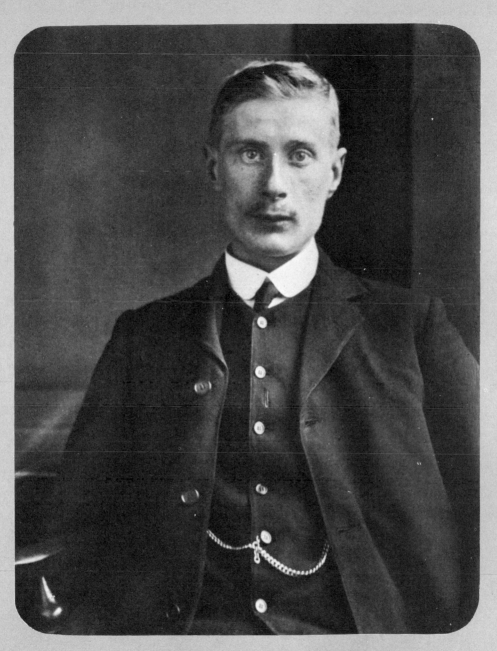

An Edwardian Gentleman – Lowry in his
early twenties posing for his friend Frank
Joplin Fletcher, whose portrait the artist later
painted. *Collection: Philip Fletcher.*

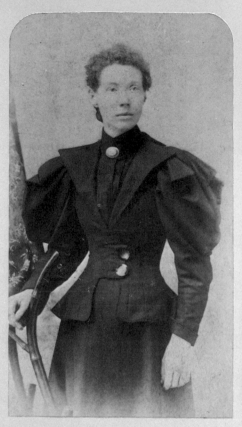

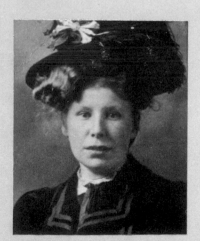

The young Elizabeth Hobson in the style of dress she favoured. *Lowry family album*.

The young rent collector, Robert Stephen Lowry, before disappointment aged him. *Lowry family album*.

Lucy Snarr, the parlour maid who made the meat and potato pies the young Lowry so enjoyed.

Elizabeth Hobson,
her cousin Annie Hall and
sister Mary. *Lowry family album.*

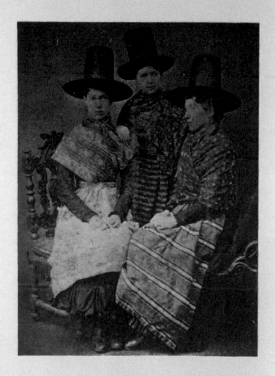

Lowry as a child.
Lowry family album.

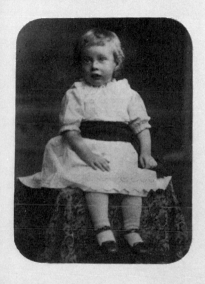

Family friends. Back row, left to right:
Billy Shephard, Lowry, Bertie Shephard;
front row, left to right: unknown,
Thomas Moore, W. H. Shephard, Robert
Lowry. *Lowry family album.*

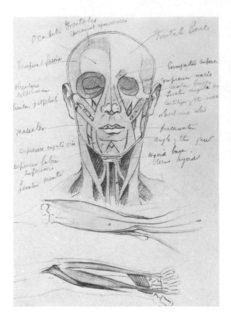

Art school drawing from Lowry's sketchbook. *Lowry estate.*

Oil nude (undated) painted by Lowry during Manchester Art School days. *Private collection.*

Albert Square, Manchester (1910) by Adolphe Valette, the art teacher who exercised such a great influence on Lowry. *Manchester City Art Gallery.*

The Lodging House (1921). Pastel. Possibly Lowry's first sale. *Salford City Art Gallery.*

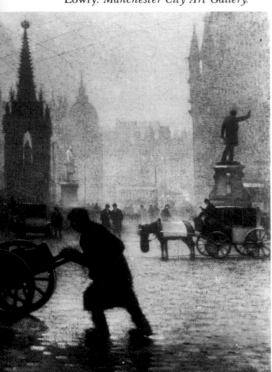

That's where the *first* idea came of doing it ... and that was about 1912 or 13.'[29] Here he was placing the beginnings several years earlier than he had done before. He was right to do so: his first *Mill Worker*,[30] a delicate pastel, is dated 1912, and a pair of oils of the morning and evening view looking south to Pendlebury from Clifton Junction[31] to a tentative horizon of factory chimneys was done as early as Easter, 1910, within a year of the move. 'There are no figures in them—I was only then turning from landscape to pure factories: 1910 to 1920 was the period of genesis.'[32]

Maurice Collis, in his poetic monograph *The Discovery of L. S. Lowry*, which refers as much to the public's discovery of Lowry as to Lowry's discovery of his subject, records the artist's words to him. 'I was with a man and he said, "Look" and, there, I saw it. It changed my life. From then on I devoted myself to it. I have never tired of looking. It is always fresh.'[33]

There may, indeed, have been such a man, and such an incident. Or perhaps that man was Valette, not literally out walking with his pupil, but metaphorically at his side, urging him, as he urged all his students, to look, to observe and to see 'with the eye of the artist'; even Fitz, instructing him to 'seek out the form of things'. Lowry may well have *determined* to record the industrial landscape for posterity at such a moment, although the idea had obviously been germinating in his mind almost since his arrival in Pendlebury. But the commitment to his vision, the decision to go ahead with his task, was not lightly made. As a student of masters who encouraged individuality, and an observer of public attitudes, Lowry was abundantly aware that, in order to command any sort of attention, an artist needed—if not genius which Lowry never *knew* he had—a personal theme, an originality of subject.

He told Frank Mullineux: 'An artist can't produce great art unless he has a philosophy. A man can't say something unless he has something to say. He can see things that a camera cannot see. A camera is a very wonderful piece of mechanism but an artist has his emotions, he has his feelings and he puts those feelings into any work he is doing. If he feels strongly for his subject he will do it the better ... a man can do it more vitally than a photograph.'[34]

He sometimes claimed a theatrical source for his inspiration. Indeed, in the second decade of the century Lancashire playwrights were doing much the same for the industrial north on stage as Lowry was trying to do on canvas: or, as he himself expressed it, 'trying to put it on the map'. He declared himself to be much affected by the play *Hindle Wakes* by the *Manchester Guardian* critic Stanley Houghton, and one can imagine the sensory bells of recognition

which must have rung in his receptive mind when the curtains opened to reveal the backdrop of mill chimneys against which the drama was played. He cannot have failed to see the irony of a situation that allowed dramatists such as Houghton, Harold Brighouse (*Hobson's Choice*) and Allen Monkhouse (*The Conquering Hero*)— and indeed Miss Horniman's Repertory Company at the Gaiety where such plays were first presented—to achieve the desired impact in their medium while he, with identical aims, made none in his. While plays which dramatized the day-to-day drudge of working-class life began a revolution in the theatrical world comparable to John Osborne and the 'kitchen sink' at the Royal Court in the '50s, Lowry's pictures, which revealed the reality of the industrial north, were virtually ignored. Later, when he was urged to design sets for the Unnamed Society, a deeply committed band of amateur actors in Manchester,[35] he 'didn't feel able' to accept.[36]

The year 1910 was no more than twenty-three days old when Lowry received a severe blow to his precarious image as a rising man of business. As far as his family knew, he was doing well at the office and promotion could not be long delayed. Then, in January, came a letter from Charles Collin, the Resident Secretary at General Accident in Manchester. '... It is with great regret I have to inform you that your services will not be required....' After two-and-a-half years as a claims clerk in their Cross Street offices, Laurie had been made redundant. It was, he assured his anxious father, no fault of his. He was not the only one to go in the current 'reduction of staff'. As Mr Collin, softening the blow of dismissal, wrote: 'I have no complaints to make against you. Should you require a reference any time I shall be happy to give you one, and assist you in obtaining another situation.'

Laurie did require a reference; his father demanded that he require one, if only to lessen the slur of redundancy that, while not directly impugning his son's character, at best implied he was the soonest spared. Elizabeth was more understanding; but Laurie must look for another position, she insisted, if only for his father's sake. 'You can't just do nothing,' she told him. 'Nothing' to her was art, as indeed it was to Robert.

A week after his notice had expired, Laurie was given a testimonial to the effect that he had 'fulfilled his duties satisfactorily.... He is honest, straightforward, willing and a good worker.' One could hardly have asked for more for an employee whose mind was more often concerned with the finer points of line and form than with the estimates of loss.

It took until March for him to find himself another position. Answering an advertisement in the *Manchester Guardian*, he applied and was accepted for the post of rent collector and clerk with the Pall Mall Property Company in Brown Street. In the corner of his letter of application (March 21st, 1910)[37] it was noted that his father was with Earnshaw's, the estate agents; there is no indication whether this was a help or hindrance in getting Laurie the job.

They started him at 22s. a week and, after he had collected his tram fare from the petty cash, he was dispatched that first day on his rent rounds. His duties soon took on a regular pattern: Longsight and Old Trafford on Mondays, Hulme and Higher Broughton on Tuesdays, Withington on Wednesday mornings, and the remainder of the week employed as a cashier in the front office.[38]

Although it was some time before he appreciated the fact, it was a fortuitous change of employment; he was no longer condemned to the dreary monotony of five days a week confined to a desk— and he had landed with a firm of exceptional indulgence. 'As long as his work was done, no one ever queried the hours he kept or the time he spent out of the office. No one ever remarked on the fact that it took him nearly three days to collect rents which could have been gathered in less than two; or that he was frequently late; or that he spent much of his time drawing portrait heads on the back of office notepaper.'[39] After the impersonal bustle of General Accident, the Pall Mall Property Company was, for a man of noted shyness and little dedication to the world of commerce, a particularly pleasant place in which to work. 'When you started they told you that, as long as you didn't fiddle the books or pocket the rents, you had a job for life.'[40]

And that is exactly what Lowry got: a job for life. He stayed with the company until 1952, retiring at the age of sixty-five with a pension of £200 a year. He gave his colleagues no opportunity for an emotional send-off. 'I'll not be in tomorrow,' he announced casually after forty-two years.[41]

Now Lowry was not simply living within sight and sound of his vision; he was working in it, tramping the streets, entering the homes of his people, talking with them, observing their problems, their expressions, their ways, and fixing them in his mind's eye with an accuracy and a compassion that was to remain with him for half a century. As John Read so rightly commented in his 1977 BBC Television documentary: 'He painted what he did because its character was stronger than anything else he knew, and it was right there on his doorstep.'[42] Even Lowry once admitted: 'I have put many of my tenants in my pictures.'

Rather to his surprise, he found he enjoyed the work itself: the tenants were not, as he had supposed, begrudging of his demands for their money. If they had it, they would hand it over, meeting him on the doorstep with a friendly word and an enquiry after his health. If they had none that week, as was more often the case, they would say so. 'I've nothing for you, but come in and have a cup of tea.'⁴³ These were forthright people, without pretension or, for the most part, guile, and he liked them for it. When the rent books were full he took them home and preserved them between bundles of art school drawings, still with the occasional note in a semi-illiterate hand between the yellowing leaves. 'Please excuse me being late [with the rent] as I have started at the Mill and will send it as soon as possible.'

He was still something of a strange figure, and barefoot children followed him on his way, mimicking his lolloping gait and calling rude names from a safe distance. They were quick to discover that when, apparently by accident, he dropped a penny, or even a six-pence, on the cobbles he never stopped to retrieve it; he merely sneaked a backward glance to make sure his carelessness had not been overlooked, and the ensuing scrabble of grubby hands brought a great smile to his face.⁴⁴ Such antics, of course, only increased his following, until his progress through the poorer streets resembled not so much the rent man's round as the passing of the Pied Piper.

When he saw a sight that attracted him he would stop in his tracks and, oblivious to the craning audience of unwashed children who crept nearer emboldened by his preoccupation, would sketch on any piece of paper that came to hand—the back of an envelope, a rent book, or a tattered wrapping from his lunchtime sandwiches. (Later, when invited to functions he had no wish to attend, he would remark: 'Send me the invitation, 7″ by 5″ please; I shalln't come but I'll use it to draw on.'⁴⁵)

Two-and-a-half days a week he sat behind mounds of ledgers in the front office of Pall Mall. There, within immediate view of callers at the front counter, he fell prey to the ragged pedlars who would come seeking custom for their wares. He never failed to buy from them, taking a delight in expending the petty cash on extra pencils for the office and, once in a while, purchasing from his own pocket matches or bootlaces, hiding them hurriedly away with a muttered excuse: 'Never know when they might come in handy.'⁴⁶ It was as if without such explanation his actions might be considered rashly charitable. While at times extravagantly generous, he was at the same time protective of his reputation for stringency: asked, in the affluent '60s, when he last weighed himself, he replied: 'About forty

years ago; I don't have money to throw about on weighing myself, you know.'[47] Again, thanking a friend for a cheque, he explained the absence of a receipt: 'It looks a bit too beastly business-like ... and then there is the 2d!'[48]

Human behaviour was a source of constant fascination for him, and the greater the peculiarity, the harsher the circumstances, the stranger the appearance, the more Lowry was intrigued—not with mawkish curiosity, but with an empathy that amounted almost to self-identification; he seemed to recognise that in every man, himself included, are the seeds of his own destruction. 'I always have had to curb the grotesque in me,'[49] he once remarked; and, often, when faced with a particularly emotive beggar: 'There but for the grace of God go I.'[50]

In the last twenty years of his life, when his people had emerged to stand alone from their industrial background, he was to devote himself to painting the strange, the deformed and the derelict. In the office, when one such caller had left, he would ponder aloud: 'There's a tragedy for you. What a terrible thing. To see a man once so rich and now so poor. What do you think went wrong? How did he get like that?'[51] Half a century later he was still wondering: '... all the time I'm thinking about what happened to them and how they got in that state. Some people shoot themselves, some people drink themselves to death and other people go like that, taking the line of least resistance. The sad thing is, we can't do anything about it. And this could happen to any of us if we were faced with a crisis. I feel certain all of them had a crisis of some sort which they weren't quite proof against. In many cases it could be drink alone but I think in many cases it's more than that—shock very often, I should say. Well, I am very sorry for them. I wonder about them. And when you talk to them, very often, in most cases, in fact, they're very interesting people.'[52]

Lowry soon became firmly established as the office character. In a 'uniquely happy office'[53] his idiosyncrasies were indulged with affectionate amusement: for example his outbursts of frustration when he mislaid his pince-nez, which he had invariably shut between the pages of a vast ledger. Lunchtime callers would find him alone, feet on desk, quietly munching sandwiches in the outer office. 'We're all at lunch,' he would say, 'you'll have to come back later.'[54]

Having accepted the image in which others saw him, it was as though he had decided to indulge their conception of him; if they believed him to be 'different' or 'strange' or 'odd', then that was exactly what he would be. In the same way, in the years of renown when the reporters and the television people came knocking at his

door, anticipating a 'simple homespun character, belonging to the world of cobbled streets and brass bands',[55] that is what they found. One such, who had glimpsed beneath the façade, remarked: '. . . if he thinks he is being cast in that role, his inner demon of perversity will make him act the part. The Lancashire accent broadens, the blue eyes glint, and one is in for some merciless poker-faced mickey-taking.'[56]

By the time Clifford Openshaw, a fifteen-year-old lad, arrived at the office in 1928, Lowry was forty. He was given the task of showing the new boy the rent round, a job which he did with remembered courtesy and kindness. Openshaw, his awareness of his surroundings dulled perhaps by life-long exposure to grinding poverty, saw it all as if for the first time. He found himself moved by his companion's boyish enthusiasm and curiosity, the eyes that never ceased to search behind and beyond the superficial landscape of their journeys. He was impressed by the mutual respect between the rent man and his tenants, and he determined to emulate his instructor's acceptance and tolerance. He admits his friend did have occasional moments of irascibility, usually in the office when someone had failed to identify himself clearly and his payment had been recorded in the wrong ledger. But 'that was just Lowry letting off steam'—a phrase often used by Lowry himself. It is noticeable how often those who knew the artist well would fall subconsciously into his patterns of speech—a mixture of Dickensian rhetoric, de la Rochefoucauld cynicism, and dry Lancashire humour.

As they walked the streets, Lowry would entertain the youth with tales of his footballing days, adding: 'But I just wasn't quite good enough to be chosen to play for England.' But he never spoke of his painting. Openshaw also met Lowry's father, whom he described as 'a quiet man'; by then Robert wore his resignation like armour, much as his son wore his eccentricity. As a devoted child, deeply attached to his widowed mother, Openshaw recognized the bond between Lowry and Elizabeth. 'I got the impression,' he said later, 'that she was probably the only person in the whole world who understood him. And I think that is what he felt too.' In rare moments of seriousness Lowry advised the youth: 'Don't be like me. Don't build your life around your parents. Marry and make a life of your own.' Openshaw never forgot those words; but he did not take Lowry's advice.

It was on their journeys together that Openshaw also observed how Lowry appreciated the innate humour in people for whom life was far from easy, and how he admired the fatalistic philosophy of his tenants. 'I am sure those people were a darn sight happier than

I was; and far happier than many today who have far more,'[57] Lowry was to say in the '70s. He never sought to analyse their attitudes, any more than he sought to analyse his own; he simply observed them and portrayed their idiosyncrasies with naked candour. It was this honesty in his work that made it, initially, so distasteful to those to whom such people and such places were the most familiar; the truth disturbed them. It was as if, in his pictures, they were suddenly confronted by a mirror that stripped their illusions and exposed them to the reality of their lives. Lowry never tried to romanticize the dark north, nor to imbue it with 'Turneresque hues' as Valette had done.

Many years later, when his work had received the beginnings of recognition in the south, John Rothenstein, who had lived in the north and had escaped it, found himself '... simply riveted by the sheer likeness with which Lowry had captured certain aspects of the industrial north ... he has extracted from this appalling wilderness pictures of surpassing beauty.'[58] But at that time the vision was only in the mind; ahead lay the years of distillation from eye to canvas. Already he had conceived the set; now he had the cast: 'The buildings were there and I was fascinated by the buildings. I had never seen anything like them before. But I was fascinated by the people who lived and worked in them. A country landscape is fine without people, but an industrial set without people is an empty shell. A street is not a street without people ... it is as dead as mutton. It had to be a combination of the two—the mills and the people—and the composition was incidental to the people. I intend the railways, the factories, the mills to be a background.'[59]

The particular style that has made Lowry's characters as instantly identifiable as his chimneys was not a spontaneous development; it evolved painfully, over many years of disciplined experimentation, acute observation and constant exposure to the influences of his new environment. 'The scenes were all around me. I could see them every time I went out of the house ... and I was worried, at first, because when I drew from life they looked alive, and when I drew them out of my head they didn't.'[60]

He took these early attempts, done in the icy seclusion of his parents' attic, to the School of Art to show Valette. The master hated them. 'We didn't see eye to eye at all about my paintings; I didn't show them to him again.'[61] Then he tried for a reaction from Professor Millard, at that time Head of Sculpture at the school. 'Why,' said Millard, 'they all look like marionettes, and if you pulled the strings they would all cock their legs up.'[62]

It was an observation bizarre enough to appeal to Lowry's sense

of the ridiculous. 'Do you know,' he confided to Maitland, 'there was something about these things that cocked their legs up when you pulled the strings that I rather liked.... I tried to get them to look like human beings and I couldn't. I could do it when I did them outside, but I couldn't do it inside. And that went on and on until I forgot all about the cocking their legs up when you pulled the string thing and I thought—well, you'll just have to do them like this. And that was that.'

Later he was to rationalize the evolution of the Lowry figures. 'I look upon human beings as automatons: to see them eating, to see them running to catch a train, is funny beyond belief ... *because they all think they can do what they want* ... and they can't, you know. They are not free. No one is.'[63]

And to Maitland's probing he responded: 'I must have felt that, then; inside; instinctively. Yes, I think so.'

'Well, you know, I was looking at some of your early pictures and it seemed to me that they were probably more life-like than some of your later ones. The later ones, it struck me, were more ...'

'Automatic?'

'In a way. More symbolic....'

'I think that's very true, because I've done some people as automatons.... And I gave way to it. I thought if they look like automatons, well, they look like automatons, and that's the end of it.... I was disappointed at first, but after that I didn't mind.'

'It had nothing to do with their character, or what they did, or their social status?'

'Oh no, nothing at all. Just a pictorial aspect.'

'And later on still, they became a little more symbolic? And as time went on this seems, to me, to have increased, you know.'

All this talk of symbolism was beginning to bore the artist. He habitually avoided any conversation that hinted at an *inner meaning* in art—or one that looked as if it might lead to such conclusions; he was not above teasing even his old friends, in order to deflate pomposity or pretension. Now, in response to Maitland's latest comment, he grunted: 'Yes. I think so. And, let's face it....' He paused, dramatically, for maximum effect. 'The dogs' tails have lengthened as time has gone on. Now, had you noticed that, sir? What do you make of that, sir?'

Despite his refusal to accept great significance in his work—'I just turn it on like a tap'—Lowry was anxious nonetheless that his friends, if not his critics, should appreciate the workmanlike way in which he had researched his subject. He wanted them to know that, as well as embarking upon the task which was to identify him, at

the very least, as a chronicler of industrial reality, he had made strenuous efforts to ensure that his ideas were original. He did not want to be a second anybody, but the first Lowry, and thus he revealed much of the ambition he otherwise denied. To Maitland he said: 'At first I disliked it [Pendlebury], and then after about a year or so I got used to it, and then absorbed in it, then I got infatuated with it. I began to wonder if anyone had ever done it. Seriously. Not one or two, but seriously. It seemed to me that it was a very fine industrial subject matter. I couldn't see anybody at that time who had done it.... Oh, I didn't just go off and do it. I researched it properly. I found that nobody had done it seriously. They hadn't made a job of it—so I tried to do it as well as I could.... If anyone had done it before, I wouldn't have done it.'[64]

Maitland replied: 'I think you would have done something else if you hadn't done that. Painting was in your system and you had to paint.'

Lowry's reaction was characteristic: 'Do you really think so?'

As the conversation progressed, he persistently refused to admit to a dedication that might imply too great a purpose; he delighted in Rothenstein's appraisal of his attitudes to his art and interpreted them, somewhat inaccurately: 'Well, Rothenstein once remarked, in his book on the British painters, that the strange thing was that I wasn't dedicated.'

Maitland was outraged: 'Well, I think that's nonsense.'

'I don't think it is. I kept on going, but I wasn't on fire. I wasn't dedicated. I did it because I couldn't stop doing it, but I was not inspired. It was always a job to me. Always been a job. A laborious job.'

'Well, any great work always is ... bless my soul.'

'No, but listen.' He lowered his voice significantly. '*They* like doing it.'

But later that same November day, in Maitland's home in Burton-on-Trent, Lowry elaborated on the theme, without apparently realizing that he was only confirming his friend's opinion. 'I didn't want to become dedicated. I wanted to put the industrial scene on the map, but I certainly did not expect to keep on.'

'Well, it all depends on what you mean by a dedicated artist.... It meant a great deal of hard work and continued work and you couldn't have succeeded if you hadn't given it all you had got.'

'Well, I mean to say that my ambition was not to be an artist. My ambition was to put the industrial scene on the map because nobody had done it.... And I thought it a great shame. But I did

not expect to keep on working at it all my life as I have done. I
will admit that I've worked a lot just for something to do. And I'll
tell you this, there is nothing that makes the time fly more than when
you are working on something.'

'But there must be some inward compulsion.'

'Well, I wouldn't have done it all if there had not been some
inward compulsion. I didn't like work. I never did like work. The
inward compulsion called me to do the industrial scene.'

'That's my point of view. . . .'

'Well, don't blame me for it.'

'It all depends on what you call dedication.'

'Well, what is dedication?'

'Somebody who gives all their effort, and all their energy, and
all their undivided concentration towards their goal. Surely that's
dedication?'

'Well, if you like. In that case, yes. But there was no dedication
afterwards for me.'

The two men had been arguing semantics. Lowry would admit
to a dedication solely when applied to the accomplishment of a job
of work; it was the imputation of a dedication to art for art's sake
that he resisted. He never involved himself with the art establish-
ment; he had only a few friends who were themselves artists; and
he rarely attended exhibitions or fashionable private views—except
when the painter was one whom he felt needed the encouragement
of his presence or his pocket. He disliked the pretensions of what he
called his 'trade'. 'I am not an artist,' he would say, 'I'm just a man
who paints.' Or, as he would sternly correct his friends: 'Not
studio—workroom, sir.'[65]

Having proved his case, Maitland was emboldened to move on
to an examination of the similarities between Lowry and Brueghel.
Maitland was careful to make it clear he was drawing no compari-
sons in style, only in the choice of subject matter. It was not that
Lowry failed to admire Brueghel, of whose drawings he had been
known to speak in tones approaching ecstasy;[66] it was simply that
he was inclined to bridle at suggestions of influence on his style. On
this occasion, with the question properly phrased and neatly attri-
buted to absent critics, Lowry was happy to respond; it gave him
the cue for a point he rarely failed to make in any discussion about
his beginnings:

'Oh, it is common sense. He did the industrial scene as he knew
it in his day and I did it in my day, so it is natural that critics make
comparisons between his work and mine. It jumps to the eyes. When
he was alive he saw the industrial scene around him and he did it.

Now four hundred years later I saw the industrial scene around me and I did it. And with him, people said, "What are you doing these things for? Nobody wants pictures like this," and, funnily enough, they have said the same thing to me.'

Indeed they did say the same things about Lowry. His mother, who saw no beauty in his pictures, said it. His fellow students, who did not understand them, said it. The public, with their refusal to buy them, said it. Local councillors, regarding them as 'insults to the people of Lancashire',[67] said it. And the Manchester Academy of Fine Arts, with its scorn and laughter, said it.[68]

But once the vision had been distilled, its sharpness captured in his mind's eye, he became fascinated and absorbed by it 'until it had him almost enslaved'.[69] Lowry was, according to Rothenstein, 'to an extraordinary degree, dependent upon it'.[70] He was also inordinately faithful to it. For nearly thirty years—from 1910 to 1939, when he had his first London exhibition—he painted on without recognition or understanding. Despite the derision of his peers and the apathy of his friends, he never compromised; he continued to work in his own way 'sustained only by his vision and the conviction that what he was doing was worth while'.[71] He might have been deeply hurt by his repeated rejection, but he never allowed himself to become bitter or disillusioned or resentful. 'I was hoping that people would get to like these things sooner or later,' he said in 1968,[72] 'but I didn't feel I could expect them to buy them. Nobody asked me to paint them.'

5 'He never amounted to anything'

'WE NEVER NOTICED the Great Slump,' Lowry once remarked con-
versationally to Hugh Maitland as he sat sprawled untidily across
the couch in the embracing comfort of the Professor's drawing-room.
The remark was not entirely accurate; Lowry and his mother might,
indeed, have failed to acknowledge the Depression, but his father was
abundantly aware of it. Burdened with debt, Robert tried by every
means he knew to preserve the status quo. Borrowing from friends
and family, on life insurance and from money-lenders,[1] he was taking
from one to return to the other.

Maitland was not unduly surprised by the artist's unsolicited
observation about the Slump; he had already noticed that matters
of public moment, not least of them that other major disaster known
as the Great War, had apparently passed by without interruption
or alteration in young Lowry's life. When questioned about his part
in the war by younger men, he evaded the issue, channelling his re-
sponses into familiar patterns of rejection. 'They wouldn't have me,'[2]
he would say wistfully, as if all that he had most desired at that
moment in 1916 when his conscription papers had dropped on to the
mat at No. 117, was to join his compatriots in the mud of Flanders.

One friend, the mill owner and collector Alick Leggat, was to
elicit some typical Lowry responses which titillated the imagination
yet precluded further enquiry:

'What did you do in the war?'

'I was rejected.'

'What for?'

'I don't know.'

'What do you mean, you don't know? You had a medical, didn't you?'

'Yes.'

'Well, didn't your mother ask you when you came home? The first thing a mother would say would be "Did they take you?" and you would say "No" and she would say "What was wrong with you?"'

'No, she didn't. And I didn't—know. But ...'

'Yes, go on.'

'Some time later I met the fellow who examined me....'

'Yes....'

'And he looked at me in astonishment and he said "Good God, are you still alive?"' [3]

He had, indeed, been declared unfit for active service after a medical examination at Bury Barracks on April 10th, 1916; [4] he was classed as Grade 3B and exempted from all but garrison duty. But the nature of his disability was utterly prosaic and in no way could be considered a threat to his continued survival. He had flat feet. [5]

The family knew the nature of the problem but, sensing that the matter caused him some embarrassment, did not discuss it with him. Cousin Billie, who had been refused for the same reason, understood Laurie's discomfort in the face of the departure of so many of their acquaintances; indeed Billie's brother, Bertie, had been taken in 1915 from St John's, Oxford, as soon as he had finished his mathematics finals (he gained a 1st class honours degree) and was now the subject of his mother's anguished concern, recorded daily in her diaries; he was to serve four years before being invalided home with a bullet in his lung. The rejected but by no means dejected pair, Laurie and Billie, continued their customary lengthy hikes into the countryside, reflecting, no doubt, on the irony that allowed two such dedicated walkers to be declared unfit to join men for whom marching was the order of the day.

Lowry's physical impediment did not, of course, exclude him from non-active duties and on August 22nd, 1916, he received a letter instructing him to present himself for such service at Bury Barracks the following Monday. The news was not well received, either by Mrs Lowry or by her son. That same morning he went to Pendleton Town Hall, where he told a clerk that he had been assured of at least two months' warning of a call to home duty. The clerk was not helpful; no evidence could be found that Lowry had been declared medically unfit. [6] Considerably worried by the sudden threat

of disruption to the well-ordered pattern of his life, Lowry turned to the most eminent man he knew: his father's friend and Justice of the Peace, Oswald P. Lancashire. Mr Lancashire was sympathetic and at once offered to write a letter explaining the matter fully. He informed the officer in charge at Bury that for 'my young friend Laurence S. Lowry' to present himself on Monday morning would mean 'a loss and inconvenience both pecuniary and otherwise'.[7]

The Army's reply was not preserved, but it would seem the matter was shelved. Lowry, now twenty-eight years old, was not called again, and the ordered routine of his industry, both commercial and artistic, was quickly restored. In later years he romanticized this rejection, telling friends that he had dearly wanted to serve his country and that he had lost many close friends in the trenches. One, whom he painted as a schoolboy in a cap, he said was killed in Flanders. And yet, James Fitton, who observed Lowry at night school, maintains that the Great War appeared to make little impression upon him. 'I remember one night as we were leaving the school together we saw a Zeppelin going over. It was an awesome sight and one I'll never forget. We stood staring at it until it disappeared from our sight and, shortly after, saw a great glow on the horizon and felt the ground tremble beneath us as it unleashed its bombs on north Manchester. Years later I reminded Lowry of it, but he could not recall it at all.'

Curiously enough, the foundation of the comradeship between Fitton and Lowry was their mutual unease in company. Fitton's discomfort was no more than adolescent shyness; Lowry's went deeper, an innate isolation of spirit that was to be mistaken, in later years, for the enforced loneliness of the recluse. In reality Lowry was never a recluse: he simply kept his friendships—and there were many—separate from his public image. He rarely spoke of one friend to another, nor did he habitually introduce them. He actively disliked chance meetings that exposed one to the other. Thus each enjoyed the belief that he was unique in his friendship with the artist. He valued his friends, and they were important to him. In his seventies and eighties he was to maintain that they were one of the few remaining pleasures in life, that they sustained and comforted him in his declining years.

In their background Fitton and Lowry could not have been more diverse. Fitton was born in Oldham; his mother was a weaver, his father a planer in the iron works. 'My father was a sensible man who found out what I wanted to do and helped me to do it.' On a Friday evening, on his way home from work, his hard-earned pay packet in his pocket, James Fitton Senior would stop at the local

Penny Bazaar to buy his younger son a roll of sugar-paper on which
to draw. The boy's political awareness was tutored as much by the
environment of poverty as by the frequent presence in their home
of his parents' friends: Keir Hardie, Annie Kenny and the Pank-
hursts. In contrast to his own precocious education in such matters,
he found Lowry to be politically naïve. Like war and the Depression,
politics did not seem to come within the compass of Lowry's inter-
ests. He was aware of external events, but not stirred by them; he
found nothing in 'causes' to inspire a deep commitment. He
supported the Suffragette Movement passively, as did his parents,
but only because he felt that 'it didn't seem fair. There was no
reason why, if they had to pay rates, they shouldn't have the
vote.'

Interestingly enough, in Fitton's case, it was Christabel Pank-
hurst who, impressed by a cartoon the boy had drawn, persuaded
him to take his work to the Manchester offices of the *Daily Citizen*,
Britain's first Labour newspaper. Failing to get the job he sought,
he took one as an office boy. He was then fourteen and just starting
at art school. 'I immediately palled up with Lowry,' he recalls,
'because he was a very silent man and, in those days, I was very
shy.' Fitton, unlike Lowry, was awarded a scholarship and was thus
relieved of the payment of fees: 7s. 6d. per term. Lowry was now
earning £2 a week, his wages having been increased that year from
£78 per annum.

An indication of the peculiarly relaxed atmosphere of the school
under Richard Glazier is evident in the fact that Fitton, despite his
youth, was soon allowed into the life class. Only minimally awed,
and certainly unaware of the assumed threat to his virtue, Fitton
worked on, happily oblivious of the concern his presence was to cause
the guardians of the city's morals. He was spotted eventually by the
Bishop of Manchester on a surprise visit to the school and was sum-
marily ejected, together with Bert Wilson, a student of the same age.
Valette apparently exerted his influence, and the pair were quietly
returned to the life class. Only after Glazier's death, in 1918, was
a new rule introduced that 'students under 18 should not be admitted
... for drawing from the nude female model.'

In the evenings after class the odd couple—Fitton still a gangling
youth, Lowry a lurching, disco-ordinated figure—would stroll to the
docks where Fitton later took a job. They would walk mostly in
silence, each deep in his own thoughts, pausing sometimes at a dock-
side stall to take a cup of cocoa or, in summer, a beaker of Vimto,
a curious brown liquid whose origins remained a mystery. Ahead
of them both lay a night's work: Jim loading great bales of goods

for Hong Kong or Batavia, Lowry alone in his attic painting until
his father dimmed the light. The following morning Jim would sleep
until ten and spend the day drawing; Lowry was awake by seven
for a day at the office where he would arrive sometimes late, fre-
quently bleary-eyed. At the weekends they would meet in the porti-
coed entrance to the school in All Saints for a day's sketching, at
the Cathedral, at Daisy Nook or Boggat Hole Clough. Jim would
draw the trees, Lowry the chimneys. Once when it was raining
Lowry suggested they went to the theatre. 'I assumed we would be
going to Miss Horniman's,' recalls Fitton. 'Instead he took me down
to Hulme Empire to see Fred Karno's troupe, where he laughed until
the tears ran down his face.'

As Fitton matured, he became aware that his friend was seem-
ingly lacking in the ambition with which he himself was now fired.
Fitton left Manchester in 1922, in tears and clutching a bundle of
his drawings, lured from the north by the greater opportunities of
London. He was twenty-one years old; Lowry was thirty-four and,
Fitton observed, 'quite unmotivated by ambition'. It seemed to him
that his friend's world was encompassed by his mother's wishes and
that nothing during her life-time would induce Lowry to leave her
side.

'The more I came to know him,' he said, 'the more I became
aware of his mother's dominance of him. She came into his conversa-
tion at all times. My own mother was so very different; a bustling,
active woman who got up to make the tea as soon as I came in. When
I went to Lowry's home it was the opposite. Lowry went to make
the tea while his mother sat in a sort of invalid chair. She was not
a frail woman, nor pale, nor sickly-looking. But my over-riding im-
pression of her was of an invalid. I never knew what was the matter
with her, simply that she was not well. She was not dominant in
the aggressive, suffragette way. But she obviously had control over
him. His father was a recessive figure.... She seemed to dominate
him through her weakness, by her dependence upon him, by her
need. She absorbed his interest and his time.'

At that time the burden was not Laurie's alone, and Elizabeth
Lowry's demands for attention were still shared by husband and son.
Alternately the two men would sit with her, or read to her far into
the night, volumes of poetry or contemporary novels.[8] When at last
she fell asleep Lowry would go to his attic room and paint into the
morning until, concerned as much for his son's health as for his own
pocket, Robert would rise and turn off the gas.[9] It is indicative of
Lowry's Victorian attitudes of parental respect that there was never,
apparently, any argument on the matter; he did not attempt to re-

store the light in defiance of his father. 'He was really quite good,' said Lowry; 'sometimes he would bring me a chair.'[10]

The Lowrys were becoming increasingly isolated in Pendlebury. Tom Shephard, who had been such a stalwart companion, had died in 1910 at the age of fifty-eight after 'bravely bearing'[11] the pain of stomach cancer. Mary, debilitated by the anguish of her husband's suffering and by long hours of nursing, collapsed. Annie was soon at her side, cradling the distraught woman in her arms while Lizzie Anderson hovered in the background making cups of tea judiciously laced with fortifying brandy. Emerging from her self-imposed isolation, Elizabeth travelled to Rusholme to comfort her sister.

She found herself strangely moved by Mary's evident grief, but Laurie, who accompanied her, was noticeably embarrassed; never before had he encountered such undisguised emotion. It disturbed him, as it disturbed his mother. Mary cried, the girls cried, Annie cried, and Will wept for his dearest brother. Even Robert, turning his head away, shed a tear for his friend; Elizabeth dabbed her eyes and retired to the sofa. Laurie, deeply affected by it all, fled the house; he returned some hours later, composed and outwardly calm from a solitary walk, to rescue his mother from an ordeal her constitution could barely support.[12]

Robert remained with Will to advise and console the bereaved women and, in the sad months that followed, visited frequently 'to see how we were getting along'.[13] May, the youngest of the daughters who was then twenty-one, remembered Robert's kindness. 'He was so good; nothing was too much trouble for him; he did everything in his power to soften the blow. He tried to be a second father to us. He was not a happy man himself, but when he was with us he was extraordinarily cheerful, as if to raise our spirits by maintaining his own good humour. He even made mother smile.' Robert's ability to joke in the face of adversity was something his son noted frequently. 'He was very cheerful; not happy—cheerful.'

Will was more concerned with the practical adjustments necessary in a household prematurely deprived of its head. Although Tom had left 'to my dear wife' a net total of £1,820 5s. 1d., Mary was only forty-nine years old and presumably faced many years without a husband to support her; in the event she was to live only another twelve years.

As an explanation for his assertion that he never had a job, Lowry pretended he had inherited a small legacy from a relative. What he in fact acquired from Tom Shephard's estate was a picture: a pleasantly golden highland scene in a fine frame. Because of its place in the home of an artist, it was assumed by visitors to be of some

value. Lowry was amused that people should make such assumptions; it was in fact a page torn from a calendar and framed simply because Tom liked it[14]—a sentiment his nephew applauded: he often remarked that the patrons he most favoured were those who bought for just such reasons rather than as an investment.[15] Uncle Tom's calendar, which revealed its origins with the inscription 'The Scottish Union National Insurance Company' in the bottom right-hand corner, remained on the wall of his Mottram home until it was stolen, together with ten other pictures valued by the artist at £11,400, in June 1968; it was subsequently recovered by Cheshire police after a dramatic midnight chase across lonely moorland.[16]

Heeding Will's advice, the Shephard family moved from the roomy house in Birch Grove, which they had rented, back to 6 Hall Road in Rusholme, where they had lived when the children were young. Lizzie Anderson, a tiny, spinsterish woman with a pinched face, had been on her own for some time now; her parents had died, leaving her to run the once prosperous draper's shop near Bennett Street and to collect the rents of the small properties she had inherited. It was a task considered unsuitable to her maidenly status, so she sold up and moved in with Mary as companion and help. She stayed on for a while after Mary's death with the still unmarried Grace, writing poignant letters to her exiled namesake across town, filled with nostalgia for the lost days of Christmas within the 'charming circle'.[17]

Of Mary's girls, only the timid May and the fiercely independent Grace remained at home. Ruth, or 'Mollie' as they called her, a woman of both beauty and intelligence, was in college at Oxford after obtaining a General Arts degree from Manchester University. There she met and married the dashing Arthur ('Billie') Dyer Ball, an undergraduate five years her junior who was destined for high places in the Colonial Service.[18] Their only child, Denys, was born in Hong Kong, from where Grace returned, travelling on the Trans-Siberian Railway, on doctor's orders to England in 1926; she died in London a few months later at the age of forty-three.[19]

Grace, whom her nephew described as 'very Lancashire', never married; she became one of the first women to be taken on the staff of a bank.[20] Curiously, cousin Billie, son of the unworldly Will, also went into banking after taking a degree in economics at Manchester University. Bertie, who left both Oxford and Mesopotamia covered in glory, became a teacher and later a headmaster. Bertie had a lifelong admiration of his cousin Laurie and, when Lowry had his first London show, Bertie wrote to his brother: '... what pleasure we have

in his success. It is good to think that some of the nice people get a little recognition.'[21]

May was considered to be a strange girl; she could often be found at the tram horse stables in Fallowfield where her enthusiasm earned her free riding. No one was very surprised when she 'ran off with'[22] a chicken farmer, a Scotsman named Donald Bell whom she subsequently married. But the match was not a happy one and the couple separated several years before he died in 1927. Ironically it was Laurie who most often described May as 'rather odd', telling tales of her arrival in Station Road with her dog and a chicken on the end of a piece of string. She, predictably, denied the tale, adding that she took her favourite hen out 'in a basket'. Secretly, Laurie rather enjoyed such eccentricity and used to send holiday postcards addressed to Charles, her cat, with polite enquiries about his health and welfare.

Elizabeth despised May for her meek ways and cultural deficiencies but Robert, basking in the role of favourite uncle, encouraged her visits. Laurie, struggling to respond to her obvious affection for him, merely tolerated her presence. Grace, on the other hand, he found an agreeable lunch companion on a working day. She of all the girls was the least given to sentiment or displays of emotion. But although this suited him in theory, it was a distinct disappointment when it came to her response to his paintings. She viewed them with a detachment that reflected neither enthusiasm nor pride in her cousin. When he gave her one of his Lytham yacht scenes, painted in memory of childhood holidays, she gave it away and did not conceal the fact from him. May, too, presented her *Yachts at Lytham* to a neighbour and told Laurie what she had done.[23] It was no more than he had come to expect from his family, and such actions were to be incorporated into the saga of his early disappointments. 'First I painted landscapes that nobody wanted....'

From his earliest days at Pall Mall Lowry had enjoyed a close friendship with the company's first Secretary, George Parker Fletcher, then still a bachelor and, like Lowry, a man devoted to music, the theatre and hiking. It was not until George was, to his own surprise, ensnared into matrimony by a peremptory audit clerk, one of the few women to enter that office, that the considerable rapport between the two men became somewhat strained. Dorothy Fletcher made no attempt to disguise her disapproval of her husband's associate, who persistently embarrassed her by accompanying them on outings in his ancient raincoat, or by vigorously rubbing his back against a convenient lamp post during moments of conversation in the street.

But George had a younger brother, Frank Joplin Fletcher, a pho-
tographer who studied his craft at Manchester School of Art and
who eventually took an office on the third floor of the Brown Street
building which housed Pall Mall. He was only five months younger
than Lowry—George was twelve years older—and their tastes were
admirably matched. Together they went to hear the Hallé at the
Free Trade Hall, where Paderewski had recently played, and
attended the first performance of Grieg's posthumous quartet, especi-
ally composed for Brodsky after Grieg's visit to Manchester. They
went to the Hippodrome where, as James Agate once remarked, the
audience 'laughed with all the gusto we as a nation reserve for our
worst jokes'.[24] They went to see Miss Horniman's Repertory Com-
pany, and the Gaiety, and the young Sybil Thorndike in *Hindle
Wakes*. And they went to the Beecham proms, which the audacious
Sir Thomas had actually started in late summer 'when football was
beginning'.[25] The great conductor's magnificent, if financially em-
barrassing, season of opera was to become a talking-point for the
friends for years to come; what had astonished commercial Man-
chester was not that Beecham had lost money over music, but that
the money he had lost had been his own.[26]

George, who was perspicacious and shrewd in business, shared
with Lowry a manner of some diffidence in the presence of women,
particularly dominant women. Frank recalled with amusement the
day a gushing friend of Dorothy's called and, having warmly
embraced the wife, turned to do the same to the husband. 'George
cringed, literally, a look of consummate horror on his face, as if he
were about to be devoured by a hungry panther.'[27] It was a reaction
they could well imagine Lowry displaying in a similar situation.
Neither were men who welcomed physical contact. Lowry once
excused himself by saying: 'We were all cold fish'[28]—a description
he usually reserved for his father.

In pre-Dorothy days—and even post Dorothy, when she failed
to incarcerate George at home—the three men would tramp for
hours across the Pennines, pausing only to rest on the dry-stone
walls while Frank captured the moment with his new-fangled
camera. These were not just traditional Sunday afternoon ambles;
they thought little of hiking twenty miles from Hazel Grove, where
the Fletchers lived, to Disley and back, Frank and George resplen-
dent in bowler hats and carrying umbrellas, Lowry in his fashionably
floppy cloth cap.

When Frank married in 1922 he had the good taste to choose
a lady of considerably more tolerance than her sister-in-law. George
had married during the war, an event which Frank insisted

'would never have happened if I had been around to look after him'.[29] Frank's wife Mary not only accepted Lowry's friendship but encouraged his visits and tolerated, with an amused smile, his disruption of their household. She learned to circumnavigate his chair, where he would sit—and from which he would occasionally slip— with the base of his spine perched on the very edge in order to read the newspaper he had spread before him on the floor. She managed to avoid the hazards—the spectacles which flew through the air when, twirling them between thumb and forefinger, he became carried away by the force of his argument and lost his grip; and the flaying walking stick with which, on swinging round for a final farewell, he would floor those nearest to him as if they were skittles in a bowling alley.[30] She never objected to their noisy debates on the relative merits of the current music hall stars, from Dan Leno to George Formby senior, nor even when Lowry deliberately provoked his friend by extolling the qualities of Jessie Matthews, a singer whom Frank found quite unappealing. And she forgave Lowry's insistence on invading their young son's bedroom to play trains, where he would 'suddenly change the points at a critical moment causing an awful pile-up', much to Philip's chagrin.[31]

But what did, apparently, cause a certain cooling of the relationship was Lowry's portrait of her husband. He completed it in 1919 as a 'special surprise'[32] and presented it with much ceremony on his birthday. Frank disliked it intensely, feeling that it made him look too severe and uncompromising; Mary agreed. Instead of achieving pride of place over the family fireplace, it was put behind the wardrobe of their spare bedroom in Granby Road, face to the wall. 'They never had it up,' Lowry told Maitland. 'Nobody liked it ... and that was a portrait done in an attempt to get it very like him to please him, and I gave it to him for his birthday. It was up in the attic, against the wall. Yes, up in the attic, against the wall....'[33]

Lowry failed to mention to Maitland that the house was otherwise 'littered'[34] with hung Lowry works—seascapes, street scenes and a breathtakingly beautiful flurry of yachts; their appreciation of these pictures was unimportant to him in the face of such active dislike of a portrait intended to please. For a man with an abiding lack of conviction in his own ability, the pain of rejection was never cured by acceptance; Frank's portrait became a symbol in the saga of early struggle. 'I painted portraits that nobody wanted....'[35]

In the office and with office friends, Lowry rarely referred to his painting. When he did, it was with such nonchalance that they accepted at face value the minimal importance he put upon such activities; for nearly fifty years they regarded him as a rent collector

who painted, rather than a painter who collected rents. In his younger days he had pretended that such work that they did chance to see was not his, but that of his 'brother Tom'. 'He would bring in a canvas on its way to the framers and prop it carelessly against his desk, leaving it there so long that we had to warn him to move it in case a cleaner stuck her broom through it. If we asked to see it, he would show it as the work of his brother; whether this was so that we would feel free to comment—which we did—or because he had so little confidence in himself, we never knew.'[36]

('Brother Tom' and 'brother Fred'—neither of whom, of course, existed—made frequent appearances in Lowry's anecdotes. Callers at his Mottram home were often told: 'I'm Fred. It's my brother Laurence you want and he's away.' Once, when dining in a restaurant with the Mullineux family, he passed the time between courses doodling on a paper napkin; signing it 'Fred', he presented it to his friend's young daughter with the words: 'There, you are the only person in the world with an original Fred Lowry.')

In Openshaw's first few years at Pall Mall he was attending art classes and would arrive in the office next morning eager to talk of his previous night's lesson; 'but not once did Lowry suggest that he himself was an artist, possibly because he never seemed to believe himself to be one. He listened to me with interest and looked at my work with only the kindest criticism. Even when we did become aware of his life outside the office, he always implied that his painting was merely a way of passing the time, and that he never took it seriously. Looking back on it I wonder if he were not deeply hurt by so many dismissive attitudes; why else would he have pretended that it meant so little to him?'

Thus Openshaw ascribed Lowry's reluctance to present himself as an artist as due to lack of self-confidence induced by constant rebuttal; others, who encountered it in his later life, called it modesty. John Rothenstein believes it to have been humility: 'No painter whom I have known has been more consciously aware of a sense of privilege, amounting almost to a sense of wonder, at being a painter.'[37]

The portrait of Frank Joplin Fletcher remained behind the wardrobe until after his death in 1955, when his son, Philip, presented it to Salford City Art Gallery. Lowry had failed to respond to letters breaking the news of Frank's death to him; in a mood of some disappointment in his father's old friend he did not attend the funeral, send flowers nor yet condolences; and he was to repeat his negligence when George died, in a state of advanced senility, at the age of ninety-one in 1967. Philip was hurt and bewildered by the apparent

lack of feeling from someone he remembered as warm and lovable. 'Once could have been excused as carelessness,' he said, bitterly paraphrasing Oscar Wilde, 'but twice was too much.' He was not aware of the complicated compartmentalization of Lowry's life, which caused him, for instance, to abandon all business connections when he retired from business life. Even had Philip known, quite possibly he would not have understood; many who knew Lowry far longer and far more intimately failed to comprehend his need for such protective reflexes, and retained, after his death, an illogical bitterness at being excluded from the secret.

The extent to which Lowry succeeded in separating the facets of his life is illustrated by Philip Fletcher's reaction to the artist's eventual recognition: 'We were very pleased for him. But we were surprised. We had always regarded it as his hobby.' And it is ironic that Philip's Uncle George, the man instrumental in obtaining Lowry a pension, did so because 'he felt his friend needed the money'.[38]

The Fletchers were by no means unique in their attitudes to Lowry's work. The memory of the acrimonious argument that inevitably followed any mention within Lowry's family of his industrial paintings, lingered on for half a century among those who had heard it. 'More than anything it was embarrassing—to hear Elizabeth going on about the ugliness of what her son was doing, how sordid it was, how devoid of beauty and how unnecessary. She never seemed to have a good word to say for them. It was the only time we ever saw Laurie oppose her—oh, not in anything he said, he sat there and accepted it all while we blushed for her. No, it was in his continuance of his work that his defiance lay. In the face of such exquisitely displayed distress we would have expected him, as the dutiful son that he undoubtedly was, to have abandoned the mills and returned to the landscapes and the yachts. It was, after all, as she kept repeating, only a little hobby.'[39]

Lowry spoke of her inability to see the beauty he saw only in abstract terms. 'All the relations laughed at them. But the family were very good: they said, "He can't help it, you know, and it keeps him out of mischief. He's not fit to do anything else, so he paints pictures." '[40] His artistic achievements had such minimal impact within the family that they were hardly mentioned. It was only after Lowry's death that Ruth's son, Denys, became aware that he was in any way connected with an artist whose work he greatly admired. The family solicitor, Alfred Hulme, recalls being in the Western Desert during the Second World War when he received a letter from his father which said: 'Your friend Laurence Lowry is

becoming quite successful—as an artist of all things.'[41] And in 1977 Harriet Topham's step-daughter, a contemporary of Lowry's who had known the family intimately until the '30s, searching her long memory for a recollection of him, remarked: 'Oh yes, Laurie. His mother was a brilliant pianist, but he never amounted to anything.'

PART TWO

The men who laughed at Lowry

'The notice which you have pleased
to take of my labours, had it been early,
had been kind.'

Dr Johnson

117, STATION ROAD,
PENDLEBURY,
Nr. MANCHESTER.

1 'All' and painted'

ONE OF LOWRY's latter-day anecdotes, told with all the panache of
an old time music hall comic, concerns a certain high dignitary of
Manchester at the turn of the century. A man of some substance and
consequent influence, he was entrusted with the task of showing a
distinguished visitor around the City Art Gallery. The tour was not
going well. Finally, confronting a particularly large canvas by the
revered Lord Leighton, the host desperately sought the appreciation
he felt the work deserved. Turning to the visitor he announced with
pride that it was 'all 'and painted, all 'and painted'.

The story, although possibly apocryphal, is repeated in at least
one history of the City,[1] less as proof of philistinism than as an
indication of attitudes 'still paramount in a community which owes
all its wealth and power to the success of the products of its machines'.[2]
Stressing the point somewhat bitterly, this particular historian con-
tinues: 'The worst feature of the machine-made era was certainly
the rise to power of the class who made their fortunes therein, for
they had no sense for a work of art, perhaps financially worthless,
but of a beauty which gave it singular value. They insisted on their
full money's worth and naturally refused to buy what was good for
them, but only that which they considered good, in other words,
showy, vulgar and pandering to their uninspired taste. Among other
things it meant the complete neglect of local art, for these people
went to London for their fashion and there got little but what was
considered adequate for the provinces.'[3]

In the telling of the tale Lowry never presumed to add such comments, annotating it simply with his chuckles. Such attitudes were only too painfully familiar to him; he had come to accept them, without rancour, as a part of the landscape of his origins. If he felt pain when he encountered them he did not display it; he never assaulted the bastions of ignorance but retreated behind the protective layers of his diffidence. He recognized it for what it was: the price of progress, an inevitable corollary of the Industrial Revolution and the resultant worship of pecuniary rather than aesthetic idols.

In Manchester it had long been thus. When the City Art Gallery was opened in the summer of 1883, C. P. Scott, the then editor of the *Manchester Guardian*, noted the presence of the Pre-Raphaelite painter Holman Hunt, whose magnificent religious painting *The Shadow of Death* had been presented to Manchester by Sir William Agnew. In a letter to his wife, Scott wrote that the great man was seated next to an alderman of the city who, during the dinner, scribbled a note to his opposite neighbour asking: 'Who or what is Mr Holman Hunt?'[4]

The first exhibition of the Manchester Academy of Fine Arts—a body of professional men founded in an atmosphere of cultural enthusiasm engendered by the Great Art Treasures Exhibition—was staged at the Gallery; it was notable not so much for the critical acclaim it inspired as for the lament that the value of pictures sold amounted to only £2,300 as against £6,000 at Liverpool and £4,000 at Birmingham.[5]

It was part of the constitution of the Academy that only those men who earned their living as either artists or architects were permitted to join. The despised amateur was, in fact, excluded long after women had been accepted. Nine ladies were admitted in 1884, but on limited terms and without voting rights. The subject of the admission of amateurs was first mooted in 1865 and speedily dismissed; the matter was to be raised again many times before their eventual acceptance half a century later. The Academy was in those early days happily secure in its non-parochial image, with the proud possession of such illustrious members as Sir Edward J. Poynter, who became President of the Royal Academy in 1896; Alfred Waterhouse, R.A., who designed the Manchester Town Hall; and Ford Madox Brown, who decorated this edifice with his frescoes—and whom Lowry described as 'the greatest artist Britain has produced outside Turner'.[6]

The status of the Academy declined as many of its members left Manchester for the greater rewards of London and beyond. Several attempts were made to reinvigorate the body, but by 1913

matters had become desperate. The annual exhibition had produced such adverse criticism that it was now obvious that something drastic had to be done. Again it was proposed that amateur painters be invited to join 'to help in the work'.[7] The proposal was 'vehemently opposed and summarily rejected'.[8] Instead new regulations were passed: no white frames and no deep mounts were to be allowed— innovations that did little to improve the quality of the actual work displayed. At last in 1917 the constitution of the Academy was changed: amateurs were to be admitted. The decision was accepted with ill-concealed dismay by some members, who regarded such a step as a devaluation of the establishment.

Almost immediately Lowry, now over thirty, applied for student membership. His work was examined by the Academy Council and, in the winter of 1918, he was accepted into the life class. Upon payment of his subscription of two guineas he was permitted to attend classes each Monday and Friday evening. The fact that he was accepted at all is some indication that his life drawings, a compulsory part of his submitted portfolio, were not as weak as some of his fellow students believed. These were not men who would look with any special indulgence upon the work of a rent collector; he had earned his place.

At these classes, however, Lowry found none of the joyful enthusiasm or reciprocal respect he had so enjoyed with Valette. The student group had, in fact, been experiencing almost as many problems as the parent body. When, in 1902, they had been given notice to quit their premises in Brasenose Street, the move to two rented rooms at 16 John Dalton Street was welcomed with the devout hope that 'the change of environment might put new life'[9] into the classes. But 'it soon became evident that the unhappy atmosphere persisted. Recriminations and counter-recriminations were bandied about, student taught student and little good work was produced.' An Associate Member who had been receiving the sum of £4 a term to act as tutor announced he could no longer continue without help; none was forthcoming, so he resigned. By the time Lowry arrived in John Dalton Street, Dr John Edwards had been engaged to teach anatomy but, according to Academy records, only a few of the twenty-five students attended his classes. Those who did complained of 'the pungent smells, the lack of models and the unbearable cold'; this last fact no doubt failed to concern Lowry, accustomed as he was to his unheated attic in Pendlebury.

Several factors had prompted Lowry to join this unhappy band. Initially there was the encouragement of his ageing teacher, Reginald Barber, who was constant in his interest in Tom Shephard's nephew.

Although he was now no longer Vice-President of the Academy, and ill-health prevented him from giving lessons, he was still a regular exhibitor, as indeed was his wife. He was part of the lobby that had pressed for the admission of amateurs and, now that it was at last possible, he was anxious for his pupil to take full advantage of the innovation. Furthermore the opportunity had come at a time when Lowry himself was seeking new stimulus. The old order at Manchester School of Art was changing; the headmaster, Richard Glazier, who had combined with Valette to introduce the 'free and easy'[10] atmosphere of the classes, had died; Valette was ill, frequently absent and in 1920 was to resign his new post as Principal Master of Painting. (Like the little group at John Dalton Street, Valette had complained of the discomfort of the life classes; but here it was not freezing temperatures but the 'stuffy overheated'[11] air that distressed him.)

But the predominant reason for Lowry's incursion into the hallowed realms of the professional was undoubtedly the fact that, at the age of thirty-one, he had yet to exhibit or, more important, to make a public sale. It was a factor that had not gone unnoticed or unremarked upon at home. And, as he later confided: 'In those early days I was constantly trying to justify myself to my parents.'[12]

Now, as a student member of the Academy, Lowry had the right to present his work for inclusion in the Annual Exhibition at Manchester City Art Gallery. Accordingly, in February 1919, he submitted three works. All were accepted: *Portrait of an Old Woman* catalogued at 15 guineas, *Landscape* at 6 guineas, and *Pencil Drawing* at 4 guineas. By comparison, although a much-praised portrait of Mrs Henry John Hill by Reginald Barber was unpriced, an earlier work *In Summertime* was listed at 200 guineas. In the catalogue Lowry's forename was spelt 'Lawrence' not 'Laurence', and in a later exhibition they recorded his surname as 'Lowrey' rather than Lowry—a mistake which is repeated to this day on some Manchester City Art Gallery post-cards. It is unlikely that such trivialities upset Lowry; when, in the '30s, the French press recorded his name variously as 'Lowky', 'Lowny' and even 'Lowsy' he included the event in his anecdotal repertoire with delight. 'They called me "Lowsy"—do you think they might have a point, sir?'[13]

Only the *Manchester Guardian* review mentioned Lowry by name. Their critic, Bernard D. Taylor, was on the whole not enthusiastic about the show. He was preoccupied with mourning the loss of the landscape artist Fred Jackson who, after his death the previous year, had been awarded the singular honour of no less than four rooms of

the Gallery devoted to his work. Taylor wrote: 'It must be said that the Academy cannot stand such losses without a much greater inflowing of new and vigorous life than is evident in this year's show.'[14] But, that said, he went on to review the pictures, commenting in passing: 'There are good portrait heads by Messrs Barber, Lowry and Roberts.' It was the first recorded praise for Lowry's work.

The *Manchester City News* reviewer, while effusively praising the work of the more established (professional) Academicians, added tartly: 'There is some work here that we are not attracted with and had it not been included the level of the exhibition would have been raised. But possibly there are rules that give all members the right to be accepted.'[15] This last remark, a pointed dig at the new arrivals, provoked a prolonged debate in the letters column of his newspaper, published under the title 'What is an amateur?' Inevitably no conclusion was reached, but at least it was conceded that membership did not necessarily guarantee an artist a space on the Gallery walls.

Unhappily, Lowry's nominal acceptance into the ranks of the professionals did little to increase his prestige at home. He might have received an honourable mention, but he had failed to make a sale. (Ironically his *Portrait of an Old Woman* (1910), which Taylor alone praised, now hangs on those same Gallery walls on permanent loan; initially priced at 15 guineas and not sold, when it was lent by the artist to the Gallery for a retrospective exhibition of his work in 1959 it was insured for £7,500.)

Not only did he not make a sale but, according to the hearsay recollections of today's Manchester Academicians, his work was not well regarded by his contemporaries. While some merely sneered, others laughed out loud. Indeed one member of the Art Gallery Committee of the time, a Mr Maxwell Reekie, later Vice-President of the Academy, was to be remembered less as an artist than as The Man Who Laughed At Lowry.[16] He was a big Scotsman with a big voice, and such a marked propensity for the wearing of the kilt on grand occasions that some of his colleagues threatened to appear at their traditional *conversaziones* attired only in woad. He painted Scottish castles under azure skies and, admiring those who did likewise, formed a close liaison with Forrest Hewit, another nondescript painter also reputed to have 'laughed at Lowry'.[17]

A third member of the Academy's derisive clique, James Chettle, a man with inordinately large red ears who painted pleasant watercolours, came eventually to be regarded by Lowry with some affection despite his unhappy knack of saying the wrong

thing at the wrong time. (Some years later, at the opening of an exhibition at Salford City Art Gallery, Chettle was heard to remark that he had in his breakfast room a drawing of Lowry's—'which I gave him' Lowry interjected—with a cat in it that 'looked like no cat on earth'. Lowry, seated just in front of the speaker, barely turned his head to remark quite distinctly: 'It's a dog.')[18] Lowry's amused tolerance of Chettle's gauche ways could have been due to the fact that, in 1935, Chettle became the first amateur to achieve the Presidency of the Manchester Academy.

Lowry's fund of apocryphal yarns was littered with tales of the amateur triumphing over the professional. It was one of his favourite themes. He relished the spontaneity of amateur artists, the innocence with which they painted what they wanted to paint rather than the commercial or the acceptable. 'They have a naïveté and an approach that the professional, or the amateur that becomes professional, loses after a time. I find far more pleasure in an amateur's work, or a local art society, than I do in a proper show. With the amateur you don't know what you are going to see ... but in the art trade you've a pretty good idea. I remember once I wanted to do a bridge, a transporter thing across the river—was it Runcorn or Widnes?— and I went with friends and made this drawing and then tried to do it. I found it very difficult. Then, by chance, I went to an art exhibition by children in Hyde and a girl of about eight or nine had done something there on the same sort of subject. I said: "Great Scott, after this it is no use me attempting to do it." Wonderful, it was a wonderful piece of work.'[19] In Newcastle in 1968 he dragged a television crew to the town's public convenience to see the paintings of Sam, the attendant there. 'I don't care if he's the lavatory man or the King of Siam,' he remarked, 'I like his pictures, they've got something.'[20]

Much of the derision and laughter may have come later in Lowry's association with the Academy, when his commitment to his industrial vision was total. But, presumably because of the way in which his work was received in 1919, he did not apply for membership the following year. He was not to exhibit with the Academy again until 1932, when *they* asked *him*. By then his resistance to scorn had been buttressed by limited acceptance, if not acclaim, in London and Paris; and he was enough of a name locally to be included in a contemporary novel about an itinerant artist by Howard Spring. 'There are only two painters in Manchester with any guts at all— L. S. Lowry and myself.'[21] Spring, who came to enjoy a 'comrade-ship' with the artist, had perceived the very essence of Lowry's spirit: courage. Such a belief he had made his character express

because it was his own, and he knew it to be quite out of tune with popular opinion of the time. As he later explained, he had heard specific criticisms of Lowry's work that 'assume Lowry is a well-meaning amateur who has failed to do what he set out to do. Nothing could be further from the truth.'[22] Spring, who was the first but by no means the last to equate the art of Lowry with that of Dickens, was, immediately after the First World War, a reporter on the *Manchester Guardian*, and thus came to see the poorer streets of Manchester and Salford much as the artist had done in his rent-collecting days. It was this exposure to the reality of his surroundings that helped Spring to the conclusion that Lowry was 'one of the most romantic of contemporary painters. For what is romance but the normal experienced with awe?'[23]

Despite his perception, Spring, at that time, was in no position to communicate his belief in the artist to the public. Lowry did not know of it. He only knew that the Academy laughed at him, his friends laughed at him, his family laughed at him; and his mother, who could so easily have cushioned him from the disappointment of that first exposure to the world of the professional artist, only reacted with embarrassment when anyone was misguided enough actually to offer money for the fruits of her son's curious hobby.

Her basic attitude is implicit in Lowry's version of his first sale. 'A child in St Anne's—well, she was seventeen—she was going to the art school there and she came one day and the most amazing thing— she wanted to buy a drawing of mine. Well, to think of anybody wanting to buy a drawing of mine in 1919. I couldn't believe it.... And my mother said: "Eh, you mustn't buy them. He'll give them to you—if you want them, dear." She was a friend of my mother's family. "Oh," I said, "Pet...." I called her Pet in those days; she was a nice girl, she lives in Bolton now. "Oh," I said, "Pet, you can have the whole lot if you want them. They are no use to me now I've done them." "Oh, I couldn't do that," she says. "I would like to buy one, but I can only give you 7s. 6d. for it," which is the equivalent to about 4 guineas now. My mother said: "You must have it, dear." "No," she said, "I must really buy one." Oooh, she was a nice girl. So she got one and took it off. The family were shaken at that. Selling a drawing for 7s. 6d. My God. They had never heard of such a thing.

'They couldn't get over it—couldn't sleep for weeks. And then the next time—this is very serious, you know, I'm telling the truth, which is a strange thing to tell these days—she came again. She wanted to buy nine more. She could only afford to pay 7s. 6d. for

each of them. I said to her: "Look here, take the lot of them. I don't want the money. They are no use to me at all." They'd be drawings that would have been out in the world now. "I can't take them, it wouldn't be right," she said, "because you will be heard of some day. I'm certain of that." I was flattened then. I nearly had a heart-attack. And she took nine—that made ten. And then I did a little painting there, you know, little ships on the sea. . . . I was thirty-two or three then. She saw this and liked it very much, so she went into real money for that and paid me thirty bob for it—which would be equal to £10 now, easily, oh easily. It wasn't a bad price then, you know.

'And that was that. And then I came home. And then I was fed up, and I got all the drawings I had and put them on the dining-room table in the sitting-room and I said: "I'll burn these bloody things tomorrow. Burn the whole damned lot." Oh yes, I was serious. And that would have been the end of me, you know, because I would be about thirty. And then Geoffrey Bennett arrived—the Rev. Geoffrey he is now. I said: "I am going to have a nice little bonfire somewhere in the back garden. Come and see." "You're not," he said. "I am," I said. "Come and see. They are no use to me. I'm sick of it all." So he said: "Well look, I'll pay you what I can for them, because you mustn't do that. There's some very good drawings there." And I said: "You can have them." "Oh no, I won't do that," he said. "I'll pay you for them. How much do you want?" he said. "Take the lot," I said. And he did. He's got them up in his house now, and he was offered £7,000 for them not so long ago. . . . That was the beginning of it, you see, and then nothing happened for a long time.'[24]

The arrival of Geoffrey Bennett, today the owner of a comprehensive collection of Lowry's works, was, in Lowry's mind, the first in a series of timely events that became a conspiracy of fate determined to keep him going: 'Just when I was feeling low something always seemed to turn up.' The saga of his early endeavours, as he related it, is dotted with such happenings, like milestones along the way, all coming at the psychological moment of depression, and each one demonstrating a previously unexhibited faith in him. Taylor's review, Bennett's interest in the line drawings, his discovery by Alex Reid which led to his first London show in 1939, Dr Laing's purchase of the industrial scenes in the '40s, and, in the '50s, the arrival of one of his most addicted collectors, Monty Bloom, who displayed a then unique fascination for the single figures 'just as they were about to be put on a bonfire. . . .' Said Lowry: 'It made me think it was destiny.'

It would seem, though, that it was Lowry's own determination, his dedication to his vision, that gave destiny a nudge. According to Bennett's clear recollection, the event occurred just as Lowry told it; but it happened thirty years later. He remembers vividly the sight of Lowry coming to the door of his Mottram home—which he did not move into until 1948—the drawings clutched in his hand. And he remembers Lowry's words: 'What did you want to come so soon for?' On such visits Bennett invariably received the same greeting.

Bennett was then living in Maryport, where he worked as a bank manager, and on occasions went into retreat in Yorkshire. 'The next day I would catch the 9.15 a.m. train from Huddersfield and arrive in Mottram about 10. On this morning—I can't remember the exact date but it was definitely in the '50s—he had this bundle of line drawings that he was going to burn. They had been done in about 1921, on the very cheap paper that he then used; they were yellow and brittle and some were dog-eared. When I took them I told him I was only looking after them for him, that they were really still his. Some years later I was offered a lot of money for them and, being in need at the time, I mentioned it to Lowry. He refused to take them back or to accept even a part of the money for them. He would not hear of it.'[25]

Bennett is one of many among Lowry's true friends who admit quite freely to the influence of Lowry upon their lives. The benefits of his friendship were varied: some, like Bennett, speak of the financial advantages; others talk of the way he affected their thinking, their attitudes to life, or of the simple pleasures of mutual companionship; the younger ones speak of the broadening of their personalities under his tutelage, and artists mention the faith he gave them in themselves. Some, among the sycophants and hangers-on who surrounded him in later life, remember only his withdrawal, his peculiarities, and complain, without understanding, of the deceptions he perpetrated upon them.

Probably Lowry's own account of the part his friends played in his so-called destiny was biased by the fact that, while he welcomed genuine interest, he abhorred patronage. He preferred to sell to an impoverished admirer than to a wealthy patron of the arts; and in later years he would rather give a painting to an appreciative caller than sell to a shrewd investor. He was to have many disappointments. 'I am always getting people coming along: from what they all say, from the date of their birth they have been pining for one of my pictures (that is the general cry) but they haven't much money— could they have one cheap? The place is full of them. In Sunderland they even popped up at breakfast time as they wanted to be sure

they could catch me in.'²⁶ 'And so you give them one and the next week it turns up at Sotheby's.'²⁷ But he refused to change his ways, adhering faithfully to the maxim 'It is more shameful to distrust one's friends than to be deceived by them', and, indeed, marked this passage from the sayings of the Duc de la Rochefoucauld in a volume which he kept beside his bed. 'I can never resist testing the market,' he would say.

Geoffrey Bennett, of modest means, was an admirer and an early buyer of Lowry's work; but not until 1933—fourteen years after Lowry said '. . . and then Geoffrey Bennett arrived.' The young bank clerk was then earning exactly £1 a day and, being newly married, could ill afford to spend great sums on such luxuries as paintings; but both he and his wife admired the Lowrys they saw and told the artist so when they met him by chance in the City Art Gallery. 'How much can you afford?' Lowry asked. '£5,' replied Geoffrey. 'Well, what do you want for that?' 'Anything, something off the floor.' 'Nonsense, I'll do you one; what do you want on it?' 'A street scene, with a lot of people and some dogs.' Bennett could have asked for nothing to please Lowry more. He got his picture—*Wesley Street, 1934*—and Lowry got his £5. 'He would have been in his forties then,' recalls the Rev. Geoffrey, 'and he was still glad to get £5 for a picture.' The collector has that picture to this day. 'After that I acquired several things from him, but I never paid great sums for them . . . I was indeed an early buyer, but I did not realize, at the time, that he regarded my interest as crucial, or even important. He did not show it at the time.'²⁸

In the '30s, the attitudes of the professionals of Manchester had progressed hardly at all from the "and painted' days of Lord Leighton. They were still sneering, still dismissing Lowry's art as a joke. Everything in those years had conspired to make him *feel* an amateur; and in 1933 his determination not to be dismissed as such was, if anything, even stronger than it had been in 1919 when he first suffered the full force of professional disdain.

Lowry did not speak of his feelings about the early reception of his work. He seemed, in fact, to banish the memory of the experience from his mind, consistently referring to 1932 as the year in which he first showed with the Academy. He never exposed his emotions. He merely stated fact, without comment: 'My friends all laughed at me and asked "Why do you keep on painting those ridiculous pictures?"'²⁹

His parents must surely have perceived the scars in his silence and in many traits of his personality: his championship of the amateur, his dislike of pomposity, and his refusal to criticise other artists

save those who by death or renown were beyond injury. Hal Yates, a colleague with Lowry on the Academy's selection committee, noted how little he liked the task, refusing to decry any work that had been submitted; he found something good to say about each one. He disliked judging art contests and usually refused to do so, saying: 'I don't feel qualified to judge.'[30] Even before his affluent days he was known to dealers as a man who would buy the work of a struggling artist—at times he would pay more than the asking price and then present the painting to a public gallery in the hope that this would help the artist. Asked once if he did not object to the work of abstract painters he retorted: 'Who am I to have any objection to anything? Everybody has the right to their own viewpoint. I have no right to object to what anybody does, have I?'[31]

He preferred Munnings ('more alive')[32] to Stubbs ('too stodgy'). (At the Royal Academy Lowry once said to Munnings: 'I must congratulate you on your pictures. I admire them immensely.' Munnings replied: 'I wish I could say the same about yours but I dislike them intensely.')[33] He delighted in the fact that 'when Munnings was alive and the critics were so scathing about him each time he had a show ... by 5 p.m. on a Friday night they were all sold out.'[34] He could happily say, 'I don't like Rembrandt,' adding enigmatically, 'he's too real, too great; he's so wonderful that he disturbs me.'[35] But when a group of students questioned him on the validity of the work of his contemporary Carel Weight, he replied sharply: 'Anything is valid if you want to do it.'[36]

On June 7th, 1933, there appeared in the *Manchester Evening News*, under the headline 'Academy Honour for Stockport' and a photograph of a smiling Lowry, an article which both pleased and annoyed the artist. The tone of the story was complimentary, the list of his achievements comprehensive and the reporting of the facts accurate—too accurate. The cause for celebration was the acceptance by the Royal Academy of two paintings of local origin—*A Street in Stockport* and *The Procession*—and their present eminent position in the Royal Scottish Academy in Edinburgh. But, in his enthusiasm to give the reader every detail, the unnamed writer revealed something that had never before appeared in print. 'Mr Lowry is the assistant secretary to a well-known Manchester firm of property and estate agents, and he does much of his work in the evenings.... Art to Mr Lowry is the antidote to a day of strain at a city desk.'

Having sent out for a paper, the force of the artist's anger when he read the offending words is remembered by his Pall Mall colleagues to this day. 'He was furious,' recalls Openshaw, 'absolutely raging. He grabbed his coat and threw it across his shoulders, jammed

his hat hard on his head, took his stick and stormed down to the newspaper offices as if he was going to set about them physically. What he said there we don't know, but when he returned he sternly instructed us that never, never again, was anyone to mention his job in connection with his art. He had told the paper people, he said, that he wanted no such details to appear again; they were irrelevant to his painting. Until that time I had not realized how strongly he felt about it. It seemed he feared—and quite rightly—that many professional artists in the city would use the fact of his job to label him an amateur, a so-called Sunday Painter.'[37]

After Lowry had recovered from his anger, he and Openshaw laughed to think that he had been elevated in print to the position of assistant secretary to the company; he was then still book-keeper and cashier and was to remain so until he retired from Pall Mall. (After his death Openshaw once described him to a journalist[38] as the Chief Cashier—'but only because I thought it would make him sound more important.'[39])

Never again in Lowry's lifetime was his rent collecting, or indeed any of his previous positions in Manchester offices, mentioned in print. The *Evening News* honoured the artist's request and, curiously, no other newspaper, either then or subsequently, gleaned the information from their cuttings libraries.

That such a secret should have been preserved so successfully throughout the artist's lifetime is a tribute to his dedicated pursuit of an ideal: to be judged by the art world on merit alone, to be viewed not as an amateur or a professional, as a rent collector or a lavatory attendant, as a recluse or a sybarite, but as an artist. The cause he felt to be just, and in that cause anything from mere evasion to downright deception was fair. He never understood why a man's private life should have any bearing upon or relevance to his art, and on that principle he was to conduct all future interviews, no matter how intimate or trustworthy the listener.

Most of his friends at this time were aware that he led a double life. Those who knew him as a businessman saw his painting as a side-line; those who knew him as an artist, albeit an unsuccessful one, accepted his office life as his means of livelihood; and because his art was regarded almost universally as unimportant, there was nothing astonishing in the fact that the one was accomplished in spare moments snatched from the other. The Fletchers inevitably knew of it, but they were not part of the art world and had no occasion to speak of him to other artists. Geoffrey Bennett, strangely, did not know of it, never having thought to ask him, in those early days, how he supported himself. He, with many others, assumed he

had a private income and Lowry did nothing to disillusion him. At the Manchester Academy they knew of his double life and there were some, like Maxwell Reekie and Forrest Hewit, who made much of it; but in the face of his acceptance elsewhere, their scorn was ignored. At Salford Art Gallery they must have known of it once, but with the passing of time and curators the knowledge was forgotten. In the '70s, the Director of the Gallery, Stanley Shaw, finding himself in charge of the largest collection of Lowrys anywhere, became if not intimate at least conversant with the artist, but learned of his job only by chance. An elderly businessman who had hardly known Lowry remarked one day to the Director that the artist had been a rent collector in the City. Shaw was incredulous but, being intrigued, decided to mention the tale to Lowry when next they met. The old man listened without comment to the story, an enigmatic smile on his face. When Shaw had finished, he opened wide his fading blue eyes and said: 'Now isn't that curious. What does it mean, do you think? I wonder whatever gave them that idea?' And together the pair laughed to think how such a curious tale should have come to be told.[40]

Hugh Maitland, who had not met Lowry until 1939, also heard such rumours in the '70s. Instead of confronting his friend, he first checked his facts, enlisting in his task their mutual acquaintance the late Donald Rayner, then Secretary of the Manchester Academy. It is interesting that, although both Rayner and Maitland were active members of the Academy, it was not there that they discovered the truth. Ironically, it was the painting that the artist had presented to his old company on his retirement that led them to his former place of employment. Here they found Openshaw still working. After some hedging, he confirmed the facts but, explaining Lowry's feelings in the matter, persuaded Maitland not to reveal them in the artist's lifetime. Maitland, an honourable man, readily agreed; but he could not resist a little probing at their subsequent taping sessions. His questions produced a piece of standard Lowry prevarication:

'I've an idea, I don't know why, this may be all haywire, but I've had an idea that you were probably doing something in the estate way that took you out and around and got you into houses, and saw some of these interiors. You've always had a very accurate knowledge of streets and places.'

'Well, for many years—in fact until about ten years ago—I used to rummage round all the back streets of every town I went to. Oh yes, and in Pendlebury I did a lot of that.'

'But this was just mooching around?'

'Well, yes. I helped people. I had a friend, he died some years

ago when he was ninety-one years of age,[41] who I liked and I did a
lot for him.'

'What sort of stuff?'

'He was in the accountancy business. . . . In fact, I did feel that
. . . I was going through a phase and I intended . . . really, if I could
have got the industrial scene out of my mind, of joining a friend and
going for the stockbroking.'[42]

Lowry had denied nothing, confirmed nothing. He had told no
lies, revealed no secrets. Maitland, who, it should be remembered,
was working on the artist's biography with his declared approval
and co-operation, had expected nothing different; he knew his
subject. As he wrote later: 'He thought that one's private affairs did
not come into it, only "the work" mattered. This point of view was
not open to discussion and further talk presenting another side did
not lead to any relaxation. I agreed with him that biographical detail
of an intimate nature was not necessarily relevant to an understand-
ing of the artist's œuvre. On the other hand the main currents and
influences in an artist's life might well be enlightening with regard
to his creative activity. However, this cut no ice and the possible
interest of posterity in the artist as a person was not even considered.
. . . On occasion he could be wilfully misleading. This was not so
much from any motive of deception or mendacity as from the opera-
tion of a volatile and powerful imagination which readily came into
play, especially if by intuition he wished to conceal something or to
present an image of himself for public purposes.'[43]

Lowry was fortunate, in some ways, that the bulk of the inter-
viewing came after he had retired in 1952. But one man, the gentle
sophisticate Maurice Collis, had come to Manchester in May 1951
to write his touching monograph *The Discovery of L. S. Lowry*. Collis,
however, was more concerned with confuting the assessments of the
artist by others. One had called him 'primitive' (*Time and Tide*), a
second 'almost childish' (*The Star*), a third 'self-taught' (*Apollo*) and
a fourth, Michael Ayreton, had said much the same, only in French:
peintre de dimanche. Already in 1943 Collis had decided he was a 'little
master', and had formed his opinions of the man on their first meet-
ing. 'One was immediately aware of his great integrity, his unworld-
liness, and devotion to his art, qualities far more important than
social graces and which would have won him staunch friends. And,
indeed, he longed for friends, for his heart was tender. He did not
really want to be a recluse. But his sensitivity was too extreme; he
had not a particle of self-assurance.'[44]

They were impressions that Lowry did nothing to diminish or
destroy throughout their days together in Manchester; they already

knew each other moderately well, having lunched together in Shaftesbury Avenue and gone to galleries and to the Royal Academy while Collis prepared his notes for the shows. This new meeting was characteristic: 'Lowry had written to say he would meet me, but he was not at the station. I had told him the wrong time; I was there half an hour too soon. Knowing that he would appear at the appointed moment, for he was careful and punctilious, I sat down quietly to wait. . . . The station had fallen very quiet; so few people were about, it hardly seemed I was in Manchester, the hub of the cotton trade, but in some old forgotten corner. Before an enchantment there is always silence; the world seems to ebb away. Such was the feeling in the air when I saw Lowry coming towards me. He is a tallish man, rather thin, with a big nose and white hair, a haggard face which, nevertheless, is youthful. His mouth is sensitive, his gestures agitated, and his eyes shrink and yet are piercing. . . . It was this distracted being, at once gentle and abrupt, kind though in sort a little fierce, whom I saw approaching. When he perceived me, and that I was waiting for him, though at once I protested it was my fault for giving him the wrong time, he was upset and with concern led me tenderly to a taxi.' [45]

Collis wanted only to see the man and to discover, at his side, the places he had painted. He wished simply to write a book that would put him in his rightful place at the forefront of British painters. He was a man after Lowry's own heart, a man who accepted an artist on merit and, having judged him to be a genius, probed no further into his privacy than a polite enquiry as to how he passed his day. Lowry told him: 'I get up, not so early, perhaps, but not too late, and work at my painting until half past twelve. Then I take the bus into Manchester. I do that every day. After lunch I walk about, often down the Oldham Road or to other corners I never grow tired of. I get back to Mottram in time for a late tea, which is my last meal in the day. After tea I start painting again and continue far into the night.' [46]

This was, indeed, to be the pattern of his later days. But at that time, in May 1951, he had still eighteen months to go before his retirement. He had carefully edited his recital for Collis, to omit any reference to work other than painting. Such, however, was the depth of the critic's feeling for the artist that, had he lived to learn the reality of Lowry's situation, he would have changed his opinions not one jot. He would have understood the deception, had he ever considered it as such, and applauded it.

In later years Lowry was to become adept in the preservation of his secret. Once he had retired, he shut the memory of those

years into the recesses of his mind, so that in truth it was as if they had not happened. He cut himself off from those who might have reminded him of them and manœuvred friends and acquaintances into specific compartments. Those who did not know never met those who did; and those who did were apt to find they no longer knew Lowry. In most cases the reason for such deliberate segregation was obvious; they might have spoken of him between themselves. With Bennett the motive is not so clear; it can only be that Lowry, in the light of their long association, assumed that Bennett knew.

Once the 'Reverend Gentleman' (as his friend liked to call him) decided while passing through Norfolk to call upon David Carr, one of Lowry's few artist friends. When he mentioned his visit to Lowry, the painter was irate. 'What did you want to do that for?' he growled.[47] And when visiting Maryport with Tony Ellis, a friendly curator from Salford, they passed by the door of Bennett's bank on the main street without so much as a word from Lowry.[48] When still later friends, the Marshalls of the Stone Gallery in Newcastle-upon-Tyne, remarked to the artist that they had seen Bennett, Lowry would inevitably worry them: 'What did he say, what did he say?' until they had repeated every word of the conversation. 'And,' says Tilly Marshall, dramatically lowering her expressive voice, 'there was real fear in his eyes when he asked.'[49] After Lowry had died, the Marshalls were once debating, as they often did, the reasons for Lowry's long deception. 'I can't think why he didn't tell me,' pondered Micky. 'It wouldn't have made any difference.' 'Oh, I don't know,' said Tilly, 'remember when we first met him, what you used to say about amateurs.' Marshall reflected a moment. 'You have a point there,' he said. 'Perhaps Lowry had a point.'

With the Marshalls Lowry had certainly been dogmatic about his lack of occupation other than painting; in the '60s, and in front of television cameras, he stated: 'I couldn't go out in the morning ever after and get down at half past nine with an attaché case and an umbrella in my hand and a bowler hat on my head. I couldn't do it.'[50] In November 1966 he quite specifically told the critic Edwin Mullins: '... and every now and then I felt thoroughly fed up and I'd say, "This is ridiculous; I'll take a job." But I didn't like the thought of going to the office with a bag in my hand at half past nine every morning.'[51] The same year he told Barrie Sturt-Penrose, writing for *Nova*: 'I was willing to try anything rather than take a humdrum job, sir. I've always been a lazy man at heart, thinking of the time when I can sit back and do nothing.'[52] And the following year he said much the same to Michael Hardcastle of *Life* magazine:

'Before 1945 I'd been living on capital; the sale of one painting might keep me for a year. I never needed much.'[53]

There were clues along the way that, with hindsight, indicate more than was realized. When the subject of Van Gogh's suicide in the face of the rejection of his paintings was raised, Lowry would grunt and comment: 'He should have been more patient, sir.' And of Chatterton he said: 'If he could not sell his poems he should have taken a nine-to-five job.' Frank Bradley, a Manchester Academician and full-time architect, once complained to Lowry that he had not enough time for painting. 'Nonsense,' came the comment. 'If you want to do it you will find the time. Other artists do.'[54]

Lowry's later patron, Monty Bloom, like Collis, was so committed to the artist that he would not have cared if he were rent collector or roué; but to him Lowry once made an almost Freudian slip. 'One of the best articles ever,' he said, 'was an *Evening News* thing in 1933.' The name and the date were quite distinctly recorded on tape.[55] Had Bloom cared to look it up, all would have been revealed; it was almost as if Lowry *wanted* Bloom to know; perhaps he could not resist 'testing the wicket'.

Eventually, in August 1976—six months after Lowry died—it was the *Manchester Evening News* that broke the story. The article was written by Frank Whalley, a young journalist who had known Lowry for seven years, and yet only discovered the secret by chance, after his death. Now that it was no longer rumour but established fact, the details were quickly incorporated into the catalogue notes of the Royal Academy's grand tribute to their belated Member in 1977. James Fitton, who had been elected to the Academy before Lowry— and had indeed lobbied votes for his old friend—was initially amused, later disgusted, by the resultant fuss. He explains: 'I had often mentioned his job here, in the Academy, and certainly when he was elected, but they didn't believe me. They said it was only rumour. But when it all came out they immediately revised their opinion of him; and some of the criticism was very, very dodgy. Some said: "Ah, now we know why he never painted shadows— because he painted by electric light." That is the stupidest thing I ever heard. It is rubbish. Others said: "Ah, we knew he was really only an amateur." This is really the most foolish kind of criticism. And it was, I think, one of the reasons why he kept his job quiet.'[56]

John Read made much the same comments in his 1977 BBC Television documentary: 'Even though he was the recipient of three honorary degrees, had the Freedom of the City of Salford, and sold a picture to the Queen, his secret was undiscovered until the day he died. Lowry was quite happy to contribute to all the false

assumptions. Possibly he feared that if he were caught out, he might still be regarded as an amateur—a weekend painter not to be taken seriously. Perhaps, secretly he feared that *that* was the truth, in spite of all his fame.'[57]

2 'The intimacy of affection'

AFTER THE débacle of the 1919 exhibition at Manchester City Art Gallery it was a full two years before Lowry ventured to show his work in public again—this time in the company of amateurs.

In the months between the two exhibitions he had struggled not to adapt or abandon his vision in the pursuit of popularity, but to achieve mastery of his medium. 'I wanted to get a certain effect on canvas. I couldn't describe it, but I knew it when I had got it. My painting is all a question of fiddling about until you get it right. It is not an intellectual reaction, it just comes.'[1] But in those early days the indescribable effect he sought did not always 'just come'. All too often it eluded him, and there were few to whom he could turn for advice or constructive criticism.

The brusque Billy Fitz had died in 1915. Barber was no longer teaching. There was nothing in the Academy classes to tempt him to return there. And the influence of Valette, as we have said, was waning, the old professor's interests now dissipated in his illness, the death of his wife and his own increasing preoccupation with painting. 'We didn't see eye to eye in painting,'[2] Lowry remarked. He had now been doing 'the life' at Manchester for 'twelve solid years'[3] and the composition of the classes had perceptibly changed. Older students, returning from the Great War, now dominated the attention of the masters with their maturity and their impatience to recapture former fluency. There were, too, many younger, brilliant students who 'drew quite cleverly'; curiously, as Jim Fitton recalls, 'not one of them was to survive, artistically'. Nonetheless, at the time, they were star pupils and among them Lowry, with his dogged determination to go his own way, was yet more of an oddity. 'They didn't think much of me,' he said, without rancour. 'When I told

them I was going to leave they tried hard not to look too happy about it.'[4] At other times, paraphrasing an old music hall cliché, he would say: 'I left by popular demand.'[5]

In reality Lowry left the Academy in All Saints because he felt instinctively that he had been there too long. He did return to Valette later, when his ailing master had been given part-time posts at the College of Technology and Bolton School of Art; but they were never to re-establish their earlier relationship. Lowry had no real wish to abandon the benefits of the life class and, throughout his life, continued to feel the need to renew the stimulus of younger days. As late as 1968 he told an astonished group: 'Fifteen years ago I felt I would like to go back.'[6] He would then have been sixty-six years old.

So, 'for the benefit of a laugh'[7] as he once put it, and lest his audience might feel too high a sense of purpose implicit in his dedication to instruction, Lowry started intermittently at Salford School of Art where Bernard D. Taylor, the critic who had written a first kind word of him, taught the life class. At Salford the atmosphere was 'very restrained',[8] with none of the exuberance that Lowry had enjoyed at Manchester. There were at that time only seven or eight pupils in the life class and none of the colourful characters Valette had employed as models. Here the models were plainer and, reputedly, sadder, like Miss Buxton who 'drooped all over and should have given up years before'[9] (she was about Lowry's age).

There was one girl whom Lowry drew—*Woman in a Hat* (page *XIII*)—and gave the drawing to a master, Percy Warburton, with whom he later became friendly; but she was a fellow student. Apart from Warburton, whom Lowry liked because 'he let me get on with it',[10] the night classes were dominated by the handsome Mr Mowells, a dedicated lady-killer, whose practised charm somewhat over-shadowed the diffident Taylor. A pedantic man, a bachelor with 'a long, thin, sorrowful face that, when he was teaching, looked more sorrowful than ever',[11] Taylor was, or so his students remember, 'a poor teacher, not forceful enough, but clever and an excellent critic.'[12] His *Manchester Guardian* colleagues described him as one 'whose taste welcomed the new men but whose style reassured the old'.[13]

It was to him that Lowry took 'one or two pieces I had done of crowds in the streets in front of an industrial scene'.[14] They were, as the artist admitted to Maitland, 'very confused, with the ground and the figures getting rather mixed up together'. He was aware of their shortcomings but he had 'worked very hard on them' and was not

prepared for Taylor's reaction. 'This will never do,' declared Taylor. 'You'll have to do better than that.' And he held them up for Lowry to see against a dark background where their dingy confusion was immediately apparent. 'Can't you paint the figures on a light ground?' he asked. 'How do I do that?' said Lowry. 'That's for you to find out,' came the reply. Lowry was irate. He picked up the pictures and trundled off. 'I didn't like it a bit. I went home and I did two pictures of dark figures on an absolutely white ground. Just a plain flake white ground. I was very annoyed. Very cross. I said to myself: "That'll teach him. That'll show the old bird." I took them to him and plonked them down in front of him. And do you know what he said? He said: "That's what I meant. That's right. That's perfectly right."'[15] Said Lowry: 'I could have killed him.'[16]

It was a technique Lowry was to use all his life. He explained: 'My job first of all was to get these figures standing out from the background, because the interest in the picture was in the figures and you had got to do the background artificially light to throw the figures up. You had to keep it very white, almost chalky white if you want, because the picture was worthless if the ground and the figures merged together.... You can always drop white a little but you can't lift up, you can't paint white on black but you can always drop a white ground, and in time you know that it won't be chalky white, it will be a cream colour. But my job in those early days— and it was a job—was to paint these figures—and I have done a lot of figures in my time—on a ground that would always be distinct. That was my big job.'[17]

In 1924 Lowry conducted an experiment that fascinated his father; it was, he said, the only aspect of his art that interested Robert Lowry. He described it, in the '60s, to the critic Edwin Mullins: 'I remember I got a little piece of wood and painted it flake white six times over. Then I let it dry and sealed it up; and left it like that for six or seven years. At the end of that time I did the same thing again on another piece of board, opened up the first piece I'd painted and compared the two. The recent one was, of course, dead-white; but the first had turned a beautifully creamy grey-white. And then I knew what I wanted. So, you see, the pictures I have painted today will not be seen at their best until I'm dead, will they?'[18]

For Lowry, the dedicated student, the validity of Taylor's advice was something to be constantly explored and investigated. He once saw a painting by William Strang that was 'so dreadfully chalky that I wondered how they had allowed it in the show'; then, in 1955, at the Walker Art Gallery in Liverpool he saw, by chance, the same picture again. 'It was gorgeous. The white had dropped. It was perfect.'[19]

On the last day of October, 1921, an exhibition of pictures opened in the offices of 'a very clever architect',[20] Rowland Thomasson, at 87 Mosely Street, Manchester. Thomasson and his friend Tom H. Brown, both watercolourists, exhibited thirty pictures between them; Lowry showed twenty-five oils and two pastels. 'It was,' he told Maitland quite categorically, 'the first time I was ever shown in public.'[21]

Thomasson, said Lowry, 'was really very good indeed'. But he was quite unconcerned with the business of painting, regarding it simply, as Lowry professed to do, as a hobby. 'We persuaded him once or twice to send to shows. They always got in and he always got notices. But it didn't affect him in the least.'[22] It was an attitude Lowry applauded, possibly because it was one he would have liked to emulate.

The exhibition continued for two weeks. 'I didn't sell one,' Lowry would recall. 'Not one.'[23] The largest, and most expensive, of the oils were priced at £25; the smallest was 5 guineas. Today many—if not all—of those unsold pictures of 1921 form a valued part of collections all over the world. Item No. One in the catalogue, *The Lodging House* (page *IV*), a strong pastel listed at 10 guineas, was bequeathed to Salford City Art Gallery, where it now hangs in the permanent collection, insured for £1,500. Intriguingly, it came to Salford from a Mr J. H. Aldred who left no information as to how or when it had come into his possession (Lowry's first job was with the firm of Thomas Aldred and Sons of 88 Mosely Street, directly opposite the office where the exhibition was held). Item No. Two, a poetic oil which demonstrates some early experimentation with flake white and is now called *Sudden Illness*, was sold by the artist to the collector Monty Bloom in the '50s; in 1972 Bloom sold it at a London gallery for £4,000 but, two days later, finding he 'missed it too much' bought it back again for £6,000.[24] *Hawker's Cart* is in the Royal Scottish Academy, Edinburgh, and *Pit Disaster* went to Geoffrey Bennett in Carlisle; *A Doctor's Waiting Room* was bought by Salford in 1959 (its value has risen from 10 guineas to £7,000); and *Coming Out of School* was bought by the Duveen Fund for the Tate.

The Quarrel Lowry gave to Howard Spring. When the artist first offered a picture to the writer, Spring wrote: 'I don't like accepting, as a gift, the thing by which a man earns his bread: yet, when such a thing is offered in the spirit of comradeship which I detect in your letter, it becomes the most intimate and precious gift of all. As to the choice, may I leave that to you? Whatever you send I shall deeply value it, both for itself and because it will be a link in comradeship.'[25]

Three hiking friends on the
Pennines at Lyme Park: Lowry,
George Parker Fletcher and
Frank Joplin Fletcher.
Collection: Philip Fletcher.

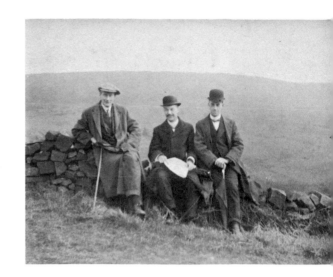

The rent collector in the streets of
Salford. *Photograph:* John Bull.

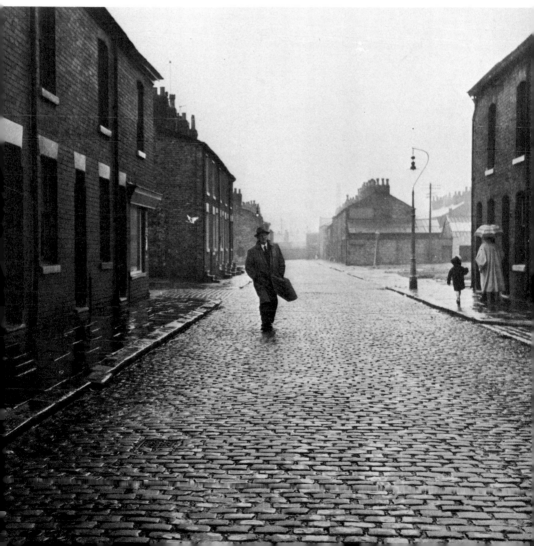

Elizabeth Lowry, from
Lowry's sketchbook.
Lowry estate.

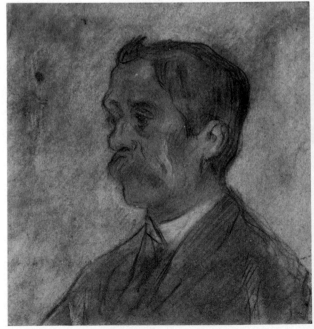

Robert Lowry.
Lowry estate.

Sailing Boats (1930) was painted by Lowry
for his mother. Lowry would never part with
it, and it was on his wall when he died.
Lowry estate.

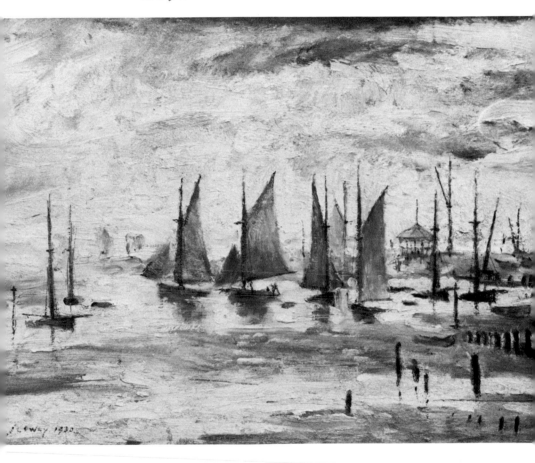

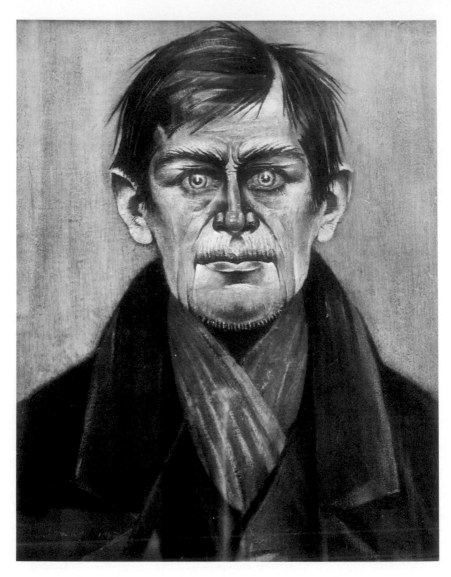

The Man With Red Eyes (1938), painted
by Lowry during his mother's illness, a year
before she died. *Salford City Art Gallery.*

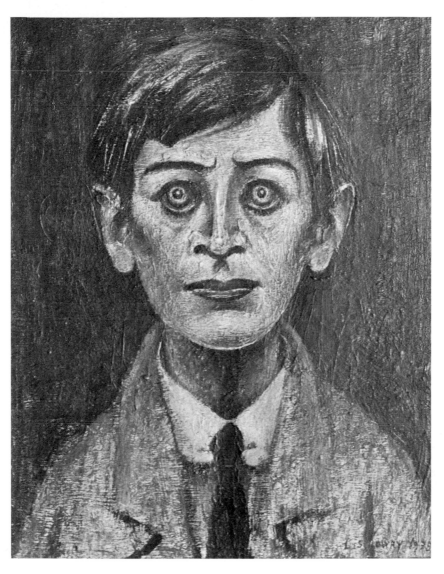

Boy in a Yellow Jacket (1935). 'I put myself
into a lot of these heads – they were reflections
of my feelings at the time,' Lowry told
Monty Bloom. *Collection: Martin Bloom.*

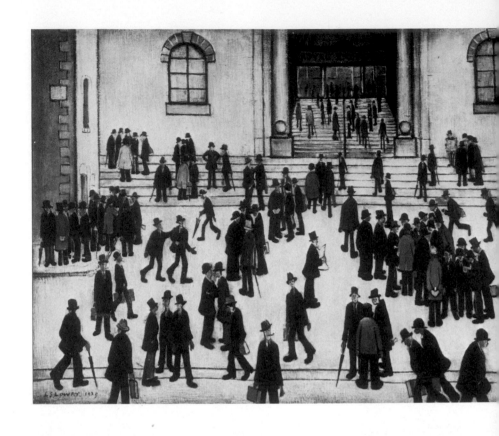

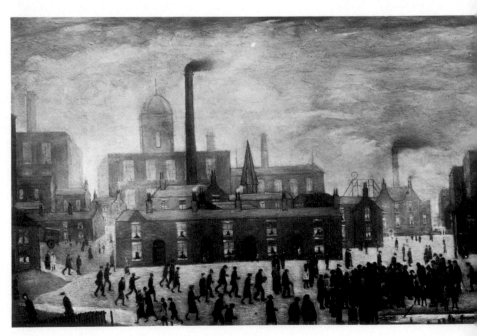

X

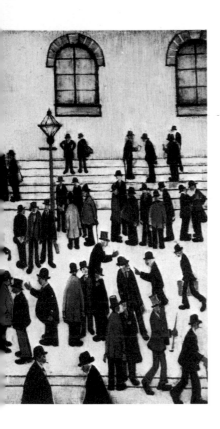

Royal Exchange (1939), painted as a commission following Lowry's first London exhibition at Reid and Lefevre in 1939. *Private collection.*

An Accident (1926). Of this picture Lowry wrote to Manchester City Art Gallery in 1930: 'About the paint – it was done on wood on a white ground – laid in solidly at one shot – then the roughness scraped off and the whole gradually worked up in detail to the end. No oil used, or varnish – I do not use either. Have not varnished a picture for a long time...As to the subject. It was a case of a woman found drowned (suicide) some years ago in Pendlebury...'
Manchester City Art Gallery.

Election Time (1930). Exhibited at the Salon des Artistes Français, 1930, nine years before Lowry was given an exhibition in London. *Private collection.*

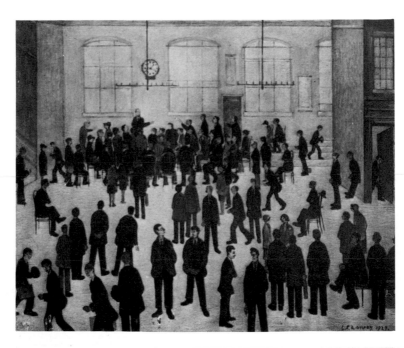

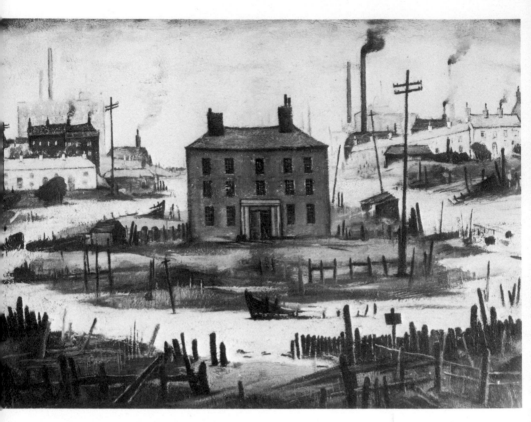

An Island (1942) of which
Lowry wrote to
Manchester City Art
Gallery in 1948: '*An Island*
is an old house long
uninhabited, falling
further and further into
decay...I seem to have a
strong leaning towards
decaying houses in
deteriorated areas...'
*Manchester City Art
Gallery.*

Pencil sketch of Lowry's
mother. *Lowry estate.*

A month later Spring received *The Quarrel* and wrote to Lowry: 'It is all that I could have wished and more than I cd. have deserved. If I had personally gone through all your pictures, I feel I cd. not have found one that wd. more vitally express what I take to be your view of Manchester and Manchester people.' He signed the letter 'Yours in all friendship.'[26]

Many of these early exhibits were to be shown again and again before they found a home; many Lowry worked on over the years, re-dating them and re-showing them. 'I never waste anything,' he told Maitland. But they were all basically the same pictures that hung unsold in his home town in 1921.

What made the event memorable in Lowry's mind was the notice he received in the *Manchester Guardian*, a newspaper which, by virtue of the excellence of its writers and the refusal of its editor to be influenced by the estimates of merit traditional in Cottonopolis, had become the arbiter of artistic worth for the intelligentsia of Manchester, if not the country. On the morning the exhibition opened —a date Lowry remembered with absolute accuracy half a century later—the reviewer, Bernard Taylor, devoted more than three-quarters of his allotted half-column of space to Lowry alone. He wrote:

'The third contributor, Mr Laurence S. Lowry, has a very interesting and individual outlook. His subjects are Manchester and Lancashire street scenes, interpreted with technical means as yet imperfect, but with real imagination. His portrait of Lancashire is more grimly like than a caricature, because it is done with the intimacy of affection. He emphasises violently everything that industrialism has done to make the aspect of Lancashire more forbidding than of most other places. Many of us may comfort ourselves a little with contemplating suburban roads, parks, or gardens in public squares, or with the lights and colours of morning or sunset. Mr Lowry has refused all comfortable delusions. He has kept his vision as fresh as if he had come suddenly into the most forbidding part of Hulme or Ancoats under the gloomiest skies after a holiday in France or Italy. His Lancashire is grey, with vast rectangular mills towering over diminutive houses. If there is an open space it is of trodden earth, as grey as the rest of the landscape. The crowds which have this landscape for their background are entirely in keeping with their setting; the incidents in the drama of which they are the characters are also appropriate. "A Labour Exchange", "The Entrance for Out-patients", "A Main Street in a Small Town", "A Quarrel

in a Side Street", "Ejecting a Tenant" are titles which will give a clue to the subjects of the pictures.

'We hear a great deal nowadays about recovering the simplicity of vision of the primitives in art. These pictures are authentically primitive, the real thing, not an artificially cultivated likeness to it. The problems of representation are solved not by reference to established conventions but by sheer determination to express what the artist has felt, whether the result is according to rule or not. The artist's technique is not yet equal to his ideas. If he can learn to express himself with ease and style and at the same time preserve his singleness of outlook he may make a real contribution to art.'[27]

It is hardly surprising that Lowry was to retain the memory of this review all his life. Here, at last, was one man who not only liked his work but, quite evidently, understood it. There was to be nothing as perceptive, as sensitive, as understanding, written for more than forty years. Taylor was the first to recognize 'the intimacy of affection' —an affection that a later critic, Eric Newton, was to compare with the love of a devoted mother for a crippled child. 'It is her physical imperfections that bring out the insight and the tenderness in him and give him the power to turn ugliness into beauty,'[28] he said.

The depth of Lowry's feeling for his subject, first noted by Taylor, Rothenstein was to call a need, almost a dependence. Taylor was also the first to appreciate the importance of the people over their landscape, an importance that Lowry himself was not fully to realize and develop for thirty years or more. Already the 'sheer determination' of the artist was evident to this critic. And when he spoke of Lowry's vision he could hardly have perceived it more clearly: 'He has kept his vision as fresh as if he had come suddenly ... after a holiday in France or Italy.' It was exactly that. Though the journey had been only from one side of Manchester to the other, the impact of the experience could have been no greater had Lowry travelled from the moon. His personal voyage of discovery, from the blinkered precincts of Victoria Park to the raw reality of home in Pendlebury, and a job that took him to the 'most forbidding parts of Hulme and Ancoats', was, for him, as emotionally traumatic as anything Gauguin experienced on his transfer from an office desk in Paris to the shores of Tahiti. Lowry never travelled abroad; he had no need, no desire. He had made his journey, at the age of twenty-one, when he had seen his vision; he wanted no more, though he lived to the age of eighty-eight.

The *Manchester Guardian* review was, failing a sale, exactly what

Lowry most needed at that time. 'That's what gave me the con-
fidence to carry on,' he said, reminiscing in his eighties. 'That was
very important to me. It was all I had got. The *Guardian* were very
marvellous to me for years and years.'[29] Then quite gratuitously he
added: 'My father took the *Guardian*.'

The 1921 exhibition might not have brought Lowry the longed-for
public sale, but it attracted the attention of several men of influence
in the right places. Contacts were made which, nearly twenty years
later, were to lead him into the art worlds of Paris and London.

Taylor was not alone in finding in his early work much promise
and great originality. The northern critic had mentioned the Mosely
Street show, and his enthusiasm for what he had seen, to James
Bone, the London editor of the *Manchester Guardian* and brother of the
artist Muirhead Bone. As a critic Bone had experienced some
difficulty in coming to terms with the work of the Post-Impressionists
but, making a visit to Mosely Street on Taylor's recommendation,
he found no such problems: he liked what he saw and said as much
both to Taylor and to Lowry. From that time the *Guardian* was
constant in its support of Lowry and in its exposure of his work.
When, in 1926, they produced a prestige supplement to celebrate
Civic Week they asked Lowry for permission to reproduce three of
his pictures: the literary editor, Arthur Wallace, was so taken with
them that he asked the artist if he might buy one: 'And he *did* buy
one—so I threw another in'[30]; with a note asking him to accept it 'as
a souvenir'.[31] Only Lowry could respond to a sale, at the age of
thirty-nine, with the offer of a free souvenir to celebrate the event.
So delighted was he with such obviously genuine appreciation that
the memory of the pleasure it gave him endured well into the years of
renown. As with Bennett, he felt that any financial advantage that
might incidentally ensue was no more than a just reward for a
rare demonstration of faith. After Wallace's death the picture, *A
Manufacturing Town*, came up for sale at Christie's and Lowry was
asked if he was not bitter that the man's family should receive a large
sum of money for something that had been given; he denied any
such resentment with vehemence. 'It was no sacrifice to me. No one
would give tuppence for them. Nobody would look twice at them.
Mr Wallace enjoyed that picture all his lifetime. I'm very pleased if
his family will be helped by the sale. He was a very nice chap, very
helpful to me. Good luck to his family with it. I'd like them to do
well out of it.'[32]

A certain Mr W. H. Berry, at that time Director of Oldham
Art Gallery, had also been along to the Mosely Street show and

thereafter made it his business to keep in touch with the artist and his painting.[33] By 1923 the relationship had become such that Berry invited Lowry to visit him one Sunday for lunch at his home on Hill Top Road, Cheadle Hulme. It was there that Lowry met Berry's wife, a striking woman deeply involved with the art world of London, who commuted each weekend between Manchester and the capital; her name was Daisy Jewell and she was head of the framing department of James Bourlet and Sons, Fine Art Agents extraordinary. Their ensuing friendship and her unswerving faith in this un-heralded artist were to be greater than either of them could have hoped; the results of her active encouragement and her systematic efforts on his behalf were not to be fully realized for nearly twenty years—and even then only really understood by the members of her staff.

Now Lowry's journeys to London to see 'Aunt Lowry' in Cricklewood were combined with visits to the sumptuous showrooms in Nassau Street where Daisy Jewell presided, a figure of some awe and influence, behind an impressive mahogany desk on which stood the Bourlet Buddha. The effigy, made of soapstone, had become a symbol of good luck to artists, who touched it so often that today it is worn smooth, and the desk on which it stood is visibly de-pressed by the pressure of so much hope. Miss Jewell was quick to introduce Lowry to Armand Blackley, a director of the company, who, having absolute faith in the judgement of his forceful head of department, supported her enthusiasm. In 1955, when Lowry was elected an Associate of the Royal Academy, Blackley wrote con-gratulating him: 'I wonder, in those far off days when we had the pleasure of seeing you at Nassau Street, if ever you thought this would happen. Both Miss Jewell and I did, and it is very nice to see honour given where honour is due.'[34] Lowry replied: 'Yes, I not only never for a moment thought this would happen, but I often wondered whether I would ever sell the pictures, except odd ones every few months or so. In fact I frequently wondered why I kept on painting these mill scenes. . . . You and Miss Jewell seem to have been right.'[35]

But all this was thirty years later: in the '20s and '30s Lowry was not among Bourlet's more distinguished clients. Indeed his name is not even recorded in the leather-bound visitors' book, which includes more contemporarily illustrious callers—Sickert and Moore, Butler and Sutherland, Lord Northcliffe and King Hussein, Laura and Harold Knight, and Jack Yeats who added a drawing to his name.

Bourlet's standing in the art world was pre-eminent; they

framed, packaged and transported great works, entertained inter-
national collectors in their showrooms, organized loan exhibitions,
hung at the Royal Academy and were sole agents to the finest
salons, including the French: Major Blackley was an Officier
de l'Académie de France. At such exhibitions Lowry's pictures were
usually accepted—something of an achievement at a time when more
than a thousand were submitted and more than three-quarters
refused—but they rarely sold, being returned again and again to
their cubby-hole in Bourlet's warehouse. But still Daisy Jewell kept
on sending them to show upon show, until her staff, whose job it was
to stack and re-stack them, would greet each new request with the
unspoken thought: 'Oh no, not bloody Lowrys again.'[36]

While they liked the man—'he had no money but equally he
had no pretensions'[37]—they failed to appreciate the artist. For such
as Bert Jones, an apprentice framer who began working at Bourlet's
for 7s. 6d. a week at the age of fourteen and rose to succeed his head
of department on her death, Lowry's paintings were too painfully
close to the reality of his own impoverished childhood. For Fred Ball,
who started with the company as a clerk answering telephones and
is now a respected consultant, they were 'quite horrible'. As he
explained it: 'A lot of us were poor and life was a struggle. Having
been brought up to think of things in terms of beauty, I wanted
something different in art—I saw the sort of things that Lowry was
painting every day at home in Camberwell, outside our front door:
the women in the coarse aprons and flat caps going to the corner
shop to get a jug of porter....'[38] In the showrooms they hardly
noticed the humble painter from Manchester, absorbed as they were
by the sight of Roger Fry, with his cravat and his silver-topped cane,
'playing the artist';[39] or the arrival of Munnings, or the gentle Laura
Knight, or Winston Churchill come to invite Daisy Jewell to
Chartwell to help him select his submissions for the Academy.

As young men they had cherished memories: Fred working with
Epstein to organize the shipment of his works abroad, Bert hanging
canvases at Burlington House with Sir Gerald Kelly carrying his
step-ladder two paces behind. They could hardly have been im-
pressed by the mundane sight of Lowry in his raincoat, seated on an
antique gilt and brocade chair beneath crystal chandeliers, quietly
munching sandwiches from a paper package while Miss Jewell talked
earnestly and smoked hand-made black Turkish cigarettes with gold
tips. In a world in which eccentricity was synonymous with flam-
boyance, the incongruity of the company did not occur to them, nor
apparently to Daisy Jewell. 'Artists were a bit frightened of her,'
recalls Bert. 'She was a very domineering sort of person. But,

strangely, although he was very quiet, Lowry never seemed intimi-
dated by her. She pushed him and pushed him. They made a strange
sight: Lowry so shy and so untidy, Miss Jewell, with her auburn
hair plaited into ear-phones round her head and her immaculate
tailored costumes with always a flower rosette on her lapel.'[40]

Often, on a Monday morning, Daisy would arrive in Nassau
Street bearing yet another industrial scene which she and her sister
Doris, who worked for an art establishment in Bond Street, had
carted back between them on the train after a weekend in
Manchester.[41] And so the stock of Lowrys grew; each month there
would be a letter from Miss Jewell suggesting a forthcoming exhibi-
tion to which Lowry might contribute, enclosing an entry form for
him to complete; and, a week or two later, a gentle reminder to
return the form to her 'as soon as possible'. So throughout the '20s
he exhibited widely: in the Irish Salon in Dublin; with the Royal
Society of British Artists; at the Paris Salon and the Salon d'Automne;
and with the New English Art Club—then more prestigious than
now, a place for modern painters at a time when Nevinson was
considered modern. Lowry delighted particularly in his acceptance
by the New English, a club which had remained stubbornly non-
academic and non-establishment, despite early controversy and com-
plaints in such papers as the *Pall Mall Gazette*, which called the New
Critics 'peevish' and the New Artists 'defiant' because they were
making so little headway. He identified strongly with a club that,
at the turn of the century, had held out against the urge to 'choose
popular subjects to make their pictures popular';[42] it had been sug-
gested that they should give the British public what it wanted,
pictures of dogs and babies, instead of pursuing 'a wanton search
for the squalid and the ugly'.[43] It could have been Manchester talk-
ing of Lowry.

At these exhibitions Lowry had been shown but he had not sold.
He was, however, learning to accept rejection gracefully. In 1928
he had several pictures accepted by Goupil, the gallery used by
Theo van Gogh to exhibit the pictures of his brother Vincent. They
showed them in their window 'but unfortunately without result'.
Lowry instructed Bourlet's to collect his works and wrote himself to
Goupil expressing 'my thanks and appreciation for the kindly way
you have treated me in the matter and for the trouble you have
taken'.

There were some sales, of course. Not many and not for large
sums, but 'enough to keep me going'. Lowry told of one sale,
elaborating the event into a typical anecdote, which concerned a
mysterious buyer who sent a cheque, not for the asking price of

£21 but for 35 guineas; he insisted upon remaining anonymous, and Lowry speculated often on his possible identity, but he was unable to inform the purchaser of his error if such it was.

As a result of Daisy Jewell's persistent activity on his behalf, by the end of the '20s Lowry was becoming known and admired in Paris. There, in 1928, while Manchester still laughed, his pictures were immediately accepted and were exhibited in both the Paris Salon and the Salon D'Automne whenever they were offered. A French magazine called *Mediterranea* named him first among 'le group anglais' exhibiting that year in the Paris Salon: it was a group, they said, 'qui sait trouver, dans les portraits ou les figures comme dans les paysages londoniens, une délicatesse particulière, un sentiment de fraîcheur et de jeunesse particulier, une pointe d'observation humoristique du caractère le plus nettement britannique.'[44] And further: 'Lorence Lowry expose deux toiles qui sont d'un observateur amusé et d'un peintre délicat.'[45]

By 1931 Lowry was included in the *Who's Who of European Painters*,[46] and described as a specialist in industrial scenes. Soon after the Salon of that year—in which he had exhibited *A Hawker's Cart* and *Going Home from the Mill*—he received a letter from the dealers and art publishers Edouard-Joseph of Paris. He responded to their enthusiasm with reservations, based, it would seem, solely on financial worries. He wrote:

Dear Sir,
Many thanks for your letter. I have asked Messrs. Jas. Bourlet and Sons Ltd. of Nassau Street, London, where I keep my pictures, to send to you 'Going to the Match'; it is framed, but without glass, and I hope it reaches you safely.

I have never had any of my things lithographed or engraved. (Is this expensive?) As although I do a considerable amount of exhibiting there doesn't seem to be a demand for this class of work, at present at any rate. If I thought I would not lose anything I would not mind considering it however.

I much appreciate what you say about a Paris Exhibition, but am afraid this would require further consideration *as it would be a very expensive matter getting my things over there.*[47]

The exhibition never materialized. According to Lowry he did not receive a reply to this letter, nor any subsequent communication from Edouard-Joseph. He was understandably put out by this lapse after such initial interest, and took it as an indication of lack of genuine intent. 'I thought it was shabby,' he told Edwin Mullins years later. 'I was then forty, and no dealer had ever approached

me before. He said he was going away for a few weeks and would get in touch. He never did. Many years later I asked a gentleman who I thought might know about him. "Very sad, wasn't it?" he replied. "Oh, didn't you know? He died." Yes, he'd been going in for an operation when he wrote to me, and had passed away a week later. I've never judged a man for not answering letters since.'[48]

Although Lowry was hung in the Salon for five consecutive years—and never refused—he had neither the time nor the inclination, nor indeed the money, to travel to France to see his pictures exhibited; but when by chance a friend happened to be in Paris at the appropriate time he invariably asked him to have a look at his 'things' for him. In the autumn of 1930 he wrote, enclosing ten francs, to a young acquaintance, May Aimee Smith, who had also been a pupil of Valette's in Manchester and was now studying in Paris. On Armistice Day, 1930, she wrote: 'I easily found your paintings, thanks to your clue; they are in gallery 11, and very well hung, one above the other, the rectangular one being below. I like them v. much, especially the quaint dame in the queer hat and long coat in the lower picture—the frames look O.K. and are none the worse for wear, but Bourlet's ought to be told to remove ticket numbers from previous exhibitions, there is one in the corner of one of your pictures. I see we are sharing the exh. with Mr Forrest Hewit ... and also Mr Knight of Bury Art School has a print, but [I] was unable to find either. It is a very good interesting show and well arranged, no overcrowding and all the decorative stuff kept well away on the ground floor—some of it is hideous, beds made of steel piping, with "decorative" eiderdown, exactly like those life-saving jackets one sees on the channel boats! I've two large engravings in, still-life. You ask have I sold anything? Do you think it's likely? I'm afraid *not*—I've had the rottenest selling year possible, and begin to despair of ever getting any payment or recognition of a pecuniary order. I hope things go better with you in that respect. How did you go in the last exhibition in Manchester at the Gallery? I hear my friend, Mr Chadwick, dropped a few bricks again.'[49]

Miss Smith had experienced her own problems in Manchester and was only too well aware of the blinkered attitudes of the art establishment; although she was to receive a measure of success as a wood engraver, the respect she commands today, limited though it is, came only after her death. She died in Stockport, in the '50s, almost destitute.

Lowry was, at that time, exhibiting in Manchester with the Society of Modern Painters, a small group founded in 1912 by their old master Adolphe Valette, with Rowley Smart and Margaret

Nicholls and members of the Sandon Studio Society in Liverpool.[50]
Originally called the Society of Modern Artists, they held regular
exhibitions at the Salon Gallery off Oxford Street, Manchester,
organized by the Secretary, Peter Chadwick, who, with Reekie and
Hewit, was in imminent danger of joining the league of the Men
Who Laughed At Lowry. As Miss Smith had heard, even in Paris,
he had now further irritated certain members by suggesting that,
if they could not sell their pictures by orthodox means, they should
hang them in the local cafés in the hope that they might attract
buyers among the diners. The suggested asking price was 2 guineas
per picture. Lowry was not, apparently, among those who took
umbrage at the suggestion. 'I am thinking of tucking a couple of
drawings under my arm and tottering to his place in Oxford Road
some fine morning,'[51] he wrote to a fellow member. Even at regular
exhibitions in the Gallery, the asking price for a Lowry was only
marginally higher. He was at that time showing there at prices from
4 to 10 guineas; in 1931 *Election Time*, which had been hung in the
great Paris Salon the previous year, was listed at 5 guineas; and the
gloriously comic *An Arrest* was only £4 14s. 6d.[52] Lowry showed
sixteen pictures, all for sale, and the other exhibitors were Margaret
S. Nicholls and Hannah Ritchie, some of whose works were priced
higher than those of their colleague. No sales were recorded for
Lowry, a fact which seemed to do nothing to diminish his eternal
hope. 'Sometime I shall sell a picture, if I keep on showing with the
Modern Painters long enough,' he wrote to a friend. 'The thought
of that makes my poor head go round and round and if I do I shall
send you a wire or come up in a car or do something rash and startle
you out of your wits.'[53]

3 'The happiest years'

A SIGNIFICANT résumé of Lowry's progress in the '20s is contained in a short article which appeared in the *Eccles Journal* on Friday, July 15th, 1927. 'A Pendlebury Artist's Success', the headline announced, and 'Mr L. S. Lowry's Picture for the Tate'.

'The work of a Pendlebury artist is to be represented in the Tate Gallery, which is, of course, the national gallery of the works of British artists. The Duveen Fund has bought *Coming Out of School*, a study in oils, by Lawrence (sic) S. Lowry. Mr Lowry resides at 117 Station Rd., Pendlebury, and is, one believes, the first local artist to be represented in the Tate Gallery.

'He has not, until recently, exhibited very widely, because, as he told a *Journal* representative this week, he was still working out the problem of how to present on canvas the scenes he saw in the industrial environment of Lancashire. His work belongs to no definite "school" of painting; it is very individual in treatment and method. He has tried, he said, to represent scenes not as a photographic record but as their meaning occurred to him. All his recently exhibited work is industrial in character. When Mr Lowry first came to Pendlebury, he was, he declares, depressed by the squalor of some of the things he saw. Later, however, he began to see something behind the apparent drabness of the poverty, and, leaving portrait work, of which he had done a large amount, he began to apply himself to the problem of how to treat industrial scenes as he observed them. He does a considerable amount of sketching but not as a basis for his painting. He

paints entirely from memory and his sketching is done solely for practice in drawing. Mr Lowry studied at the Manchester and Salford Schools of Art for many years. He devotes a very considerable part of his time to Art and indeed, has always done so. The public will have a greater opportunity of seeing his work in the near future as he intends to exhibit more widely than he has done in the past.'[1]

The article is significant on two counts: it shows that Lowry was not, at that time, the unknown he later pretended to have been; and it demonstrates the very reasons that prompted such a pretence—the crippling disappointments that to his mind amounted almost to public humiliation and were to linger, as did the laughter of the Manchester Academicians, in his mind forever.

Four months earlier, reviewing the Duveen Fund's inaugural exhibition at Leeds, *The Times* art critic had recorded his belief that it was the wider exposure of artists such as Lowry that made the Duveen scheme worthwhile: 'There are two pictures, both by the same artist, Mr Lawrence (sic) S. Lowry, which, without any such intention, might serve very well to indicate the advantages of the scheme. They are called *A Lancashire Village* and *Something Wrong*, the latter representing the emotional effect of what may be an accident and may be a crime upon the population of a typical industrial town. If the scheme should succeed in bringing contemporary works of art of good average quality into the knowledge and reach of the inhabitants of such places it will do something that has never been done before.'[2] This was praise indeed in an exhibition for which 1,400 works had been submitted and 345 selected.

But this particular purchase was not all that it was represented to be. It would seem that the *Journal* had been somewhat over-enthusiastic in assuming that the picture would go automatically to 'the national gallery of works by British artists', simply because the scheme was operated from Millbank. The fund, created by the newly ennobled Lord Duveen who, as plain Joe Duveen, dealer, had made a fortune demonstrating the validity of his own premise that a priceless work of art at any price was a bargain, was, in fact, set up for the purpose of buying works by contemporary British artists for presentation to museums and furnishing touring exhibitions; only a very few got to the Tate. *Coming Out of School* was not hung there until 1949,[3] long after Lowry had been specifically bought by the Tate for the Tate, and the thrill of its arrival on such hallowed walls tempered by the prolonged delay. Lowry, being Lowry, took the twenty-two year gap between rumour and fact as an indication that the great

gallery did not want the thing, no matter what Duveen's advisers might have thought. He was now faced with the embarrassment of explaining the misconception to friends who rushed to congratulate him. 'I hope it is the beginning of the recognition and success that you deserve without any doubt at all,'[4] wrote one friend, Harold Timperley. Lowry was quick to disabuse him of his illusions; it was, he said, not triumph but rejection in another guise.

'He did have a rough time,' Timperley's wife, Edith, recalled. 'He had no emotional support at home and negligible recognition in the town. The only thing he wanted was to be an artist; it was the only thing that roused him to animation. He would say, bitterly, that he wasn't appreciated. He craved to be appreciated.'[5]

Lowry had known Harold at Manchester Art School and had met Edith in 1920 on a visit to London; he was, she remembered, 'a tall, gangling man who seemed strangely embarrassed by the presence of a small white parcel which dangled incongruously from his finger on a piece of string'.[6] Soon after the chance encounter Lowry became a regular visitor to their flat in Whalley Range. 'We knew all the nice people in Manchester: the literary ones and the people who *did* things. Lowry seemed to relish the atmosphere, the conversation, the gaiety. He would turn up at our musical evenings with Neville Cardus, the *Manchester Guardian* critic, and Thomas Bird, another dear friend, who earned his living producing highly coloured labels for bales of brilliantly decorated cottons for the African market. I would play the piano, Harold the fiddle and Neville and Thomas would sing; Lowry just listened, but with obvious enjoyment. Even then he was a restless man and, unless there was music, he would be up and down, pacing the room with that lolloping stride, wielding his stick and pounding at things for emphasis. Sometimes he would arrive and order: "Now Edith—knit", as if he craved the semblance of domesticity. I remember him once being very annoyed because he had asked Neville to arrange for him to go into the press box for a big cricket match at Old Trafford and Neville had said: "If he wants to go, he can go on his own." I got the impression that Lowry wanted to be made something special of, but Neville wouldn't do it: he didn't want his beloved cricket made into something grotesque.'[7]

Lowry's image of himself was, at that time, somewhat different to the way others saw him. In later years he was to tell friends that he had been, in his youth, a 'snappy dresser' and contemporary photographs confirm the fact. 'He had a curious personal vanity,' Edith recalled. 'I remember him being quite delighted with a photo I took of him once—he thought it made him look handsome.' When

Edith completed her first novel *The Mink Coat*, under her professional name of Edith Brill, she sent him a copy. He read it, liked it, and wrote to her: 'My Father and Mother have both read it and our views coincide for once!'[8] Privately he told her that he had guessed that she had used him as a model for her hero, an artist named Philip Carless. The author was astounded. 'He was certainly *not* in my mind when I wrote it. Having been brought up amongst artists or would-be artists I was fully aware of their characters.'[9] But it is interesting, in view of Lowry's identification with Edith's hero, to note her description of the man in whom he saw himself:

'She did not find his patronizing words offensive, for he had the gift of making the most personal remarks sound interesting, also she admired him. She knew his was not a shoddy mind like the minds of Claude and Claude's friends, if occasionally its extravagance was beyond her. She admired his appearance, his big clumsy figure in baggy tweeds, his large head showing a high wide forehead, with fairish hair growing thin on top, but thick and curly at the back so that from behind he looked a younger man. His appearance at first glance suggested the undergraduate; he liked to stroll indolent and bareheaded, pipe dangling from his lips, a book bulging out of his pocket, an old striped muffler, one of his dearest possessions, round his neck. He had never lost his early love of abstract ideas and passionless analysis passionately conducted, and the word "life" was seldom long out of his conversation. His eyes, under wide arching brows, were remarkable, large and round, hazel in colour, with specks of green, and were often the only feature people remembered of him. They seldom looked kind or friendly, or even interested, and they gave no indication of his thoughts or mood. Phil, like Tiger [a cat], was a solitary creature, though his range of acquaintances was wide, his friends many. He had theories about women, mainly derogatory. He thought they were responsible for cheap music, cheap emotions, and often said so. Their unorthodox ways of coming to conclusions annoyed him, and he never spoke twice to a domineering woman if he could avoid her....'[10]

All this time their paradoxical friend was presenting to the Fletchers and to his colleagues at Pall Mall the image of a man for whom art was no more than a hobby; and he was presenting it convincingly enough to be believed; yet in the easy intimacy of the Timperley social circle he revealed something of the ambition that was devouring him. It would seem, though, that only Edith fully understood, but her understanding was tempered by a natural loyalty to

her husband. 'Harold was a giver; Lowry was a taker. All Lowry
really wanted was to be encouraged. He yearned for success although
when it came it did not do for him what he had hoped it would
do; it was too late. In those days he would get enormously depressed.
On one such occasion, when he was particularly low, I persuaded
Harold to ask Lowry to do the drawings for his *Cotswold Book*. Harold
was reluctant; he wanted someone who knew and loved the country
to do them.'[11]

Lowry indeed had made no secret of his inability to appreciate
conventional beauty. 'To my loss, country lanes have been foreign
to me somewhat for quite a while past—for alas my recreation seems
to have developed into drifting amongst all the back streets, etc.,
I can come across. I don't know what your Naturalistic Nature will
think of an outlook like that!' he wrote in a letter to Timperley in
1929.[12] Nonetheless, Edith got her way with her husband. 'I talked
him into it. I wanted to give Lowry some tangible encouragement.
I wanted to *help* him—you know how you are when you are young.
I hadn't realized then that this was an old song, that he sang it to
everyone; nobody loved him, nobody wanted his painting, nobody
understood him.'[13]

With Harold, if not with Edith, Lowry maintained the bantering
attitude of uncaring, placing the emphasis of his ambition upon
financial success rather than artistic recognition. 'I hope the LSD
side of it is turning out all right,' he wrote in 1929. 'It's the very
devil is the LSD side of all this, don't you think?'[14] And again, in
1931, when *The Cotswold Book* was published: 'We must pray for
1000's of sales for you and then you'll get fat and try a Rolls Royce
or two!'[15] Timperley joined in the game; he wrote: 'Beware! Soon
you will be going about wearing two fur coats, smoking two cigars,
having two wives—!! Your Lancashire scenes may even become
popular, and then what would you do?'[16]

Timperley was aware that a few years previously Lowry had had
a brief and quite untypical flirtation with the more conventional
trappings of success: he had confessed to a temporary obsession with
the motor car. As he told one interviewer: 'I was very bothered about
a car in 1924. "Mother," I said, "if you'll buy a car I'll drive you
out." But she didn't take to the idea. Oh no, not at all. "We'll wait
till your father comes in." When Father came home he just said three
words: "The man's mad!"' That short exchange apparently closed
the subject; Lowry never did learn to drive, nor buy a car. 'It
bothered me at the time, but I don't think I should have made a
driver. No, I don't think I should.'[17]

When the young Timperleys left their flat in Mayfield Road for

an old stone cottage with low ceilings and heavy beams near Romilly, Lowry's visits continued, although he invariably left in time for the bus that would get him to town for the Pendlebury connection and home to see his mother to bed. Often he took with him bunches of flowers which Edith pressed upon him for Elizabeth. Mrs Lowry's reaction to the gift was hardly the most gracious: 'Mother was greatly pleased with all those flowers,' her son once wrote, 'but said it was a great shame to cut all that number from your garden.'[18]

The musical evenings continued too. They were something Lowry was long to remember with nostalgia: 'You could both beguile the evenings with folk duets (piano and fiddle) if you had nothing you wanted to do better,'[19] he wrote, proposing a visit to them in Surrey in 1944; and again, the same year: 'I long to hear that violin with piano accompanyment (I don't think I have spelt that word right, but never mind, the devil take it). It would help a poor fed-up weary, worn out, melancholy pedestrian through this hectic battle of life very greatly.'[20]

Then there were outings to the pantomime, where 'the boys would laugh till the tears fell down their cheeks' and would nudge the diminutive Edith in their mirth so hard and so often that by the end of the evening she would be bruised 'black and blue'.[21] At the City Art Gallery they would gaze for hours at the paintings of Rossetti and the Brotherhood and joke about 'all those daft ladies laying about in their baths with all that hair'.[22] The debate continued in the Gallery tea room until 'waitresses fidgeted for us to leave, then we would go home and talk the hours away—for art was all that mattered.'[23] They were, indeed, so fascinated by the Pre-Raphaelite women and studied them so avidly that, said Edith, 'they could have both gone away and reproduced them without ever looking at them again'.[24] But, while Jim Fitton declares Lowry's affection for Rossetti's women to be an extension of his 'evasion of reality',[25] Edith believes it to have been based on an admiration for the 'technical excellence' of the artist.

Edith found the compartmentalization that was already evident in Lowry's life hard to accept; she was hurt when, having believed him to be friendless, she arrived with Harold to spend an evening at the home of a certain professor at Manchester University, to find Lowry firmly ensconced in the best armchair eating macaroni cheese. 'We had assumed he had no friends at all, because that was what he had led us to believe; not in so many words, but by implication. He had never spoken to them of us. He didn't like us finding him there. He didn't want to be discovered. He was like a little boy with treasures that mustn't be exposed, as if only so long as they

were kept secret did they retain any value. His deceptions were all a part of his queer sort of protection against the world. Even if you had been quite intimate with him, you couldn't ask him personal questions. He wouldn't have it. He must have spent a lot of time covering up—and for what?'[26]

In the years of unrewarded endeavour Harold Timperley, his misgivings tempered by his wife's compassion, was to prove a loyal and steadfast friend to Lowry. Their first—and, as it transpired, their last—book together had not been hugely successful; it was well received, much praised, but moderately bought. Two of Lowry's drawings for it were reproduced in the *New Clarion* with a review of the book by H. E. Bates, but it made no money.[27] Privately both Lowry and Timperley felt hard done by. With an advance of £50 from his publishers, Jonathan Cape, Harold had paid his friend £30 for the twelve pencil drawings. Years later Lowry was to confide in Maitland that he had been 'out of pocket' by the arrangement.[28] After royalties had been computed and the advance deducted, Timperley as author received only £10 more than he had paid the artist.

They had both put much time and care into the publication, as Lowry's letters of the time testify. There was much discussion of the quality of reproduction in proof ('My parents like the proofs and do not agree that they are not dark enough'[29]) and great hopes for the future ('Let us hope for thousands of sales to make us both rich'[30]). A secret they both guarded assiduously during their respective lifetimes was that Lowry's drawings were all done from photographs.

Despite their mutual disappointment in *The Cotswold Book*, when Timperley came to plan his next, *The Shropshire Book*, he again commissioned Lowry to do the illustrations. When they were done the publishers did not want them; they asked for photographs. Harold was embarrassed on Lowry's behalf and, rejecting Dent's decision, trundled both manuscript and drawings round a succession of alternative publishers. Tactfully he broke the news to Lowry: 'And now about the Shropshire drawings. Dent's didn't like them well enough, after all. They still want photographs. I was rather surprised, but of course there's always the chance that what one considers to be certainty is not. Anyway, I'm going to send the m.s. and drawings out to other publishers now and see what happens. I want the book to have the drawings, not photographs. Do you feel like drawing the remaining two subjects? Or do you prefer to wait until a publisher decides to accept? I think it would be better if you did them soon, as a publisher likes to have the complete thing in front of him. But you say if you would rather leave them.'[31]

Initially Timperley had been enthusiastic about the project. 'You have certainly made what I think are some striking drawings,' he wrote. 'I can see them in the book already. These are somewhat on the sombre side, though I expect you have allowed for lightening of tone on reproduction. I am sending three more for you to wrestle with. Get stuck into them!'[32] And again: 'Yes, they will do—in spite of the dancing cheerfulness and gaiety which pervades them! I thought the Hope Dale one—that with the little fields—would be about as much as your patience would stand. I'll let you have the next batch in a day or two.'[33] The Shropshire pictures, too, were done from photographs; and, in the event, it was photographs that were used—'Gammers and gaffers,' commented Edith, 'which was the very image we were trying to get away from.'[34]

Apparently the rebuff did not greatly disturb Lowry; he had, by this time, become sufficiently inured to failure to make little display of his concern, even to the perceptive Edith. But soon afterwards his relationship with Harold—by then living in Surrey, where he was working as a schoolmaster—and Edith began to wane; his later recollections of the collaboration were not particularly warm.

In the '70s, shortly before Lowry died, Edith Timperley became so irritated by the judgement of writers and critics who confused the artist's solitary spirit and innate sense of privacy with the loneliness of a recluse that she wrote a letter to *The Observer* in an attempt to correct the popular misconception. When it appeared in the columns of that paper, she received a note from Sir John Betjeman: 'Don't fret yourself about Lowry, my dear,' he wrote. 'He was always a loner.'[35] And in 1977, in a final tribute to the artist, he added: 'The loneliness of Lowry doesn't make one shiver. It exults in the vastness of our surroundings.'[36]

There were so many warm, and in certain cases enduring, friendships in Lowry's life that it is hard to understand how he came to be seen as a recluse; it can only be that it was with those very people who wrote about him that he most displayed the compartmentalization that puzzled not only Edith but so many who knew him well.

At the same time that he was cementing his relationship with the Timperleys, he was embarking upon a friendship that, although at first no more than casual, became the most enduring of all. It was in 1926 that Lowry, then thirty-eight years old, and Geoffrey Bennett, thirteen years his junior, first came together. Bennett was a clerk in the Foreign Department of the Spring Gardens branch of the London and County Westminster Bank where Lowry's cousin Grace Shephard also worked. Regularly once a week the artist would

arrive at the bank at lunch time to take Grace for a meal. 'He would come in through the rotating doors, his mac billowing behind him, his trilby pulled hard on to his head, and stand, shuffling his feet, until she was ready. He was a friendly soul and would chat to us who worked in that part of the bank. We knew he was something of an artist.'[37] And then Grace would arrive and the pair would disappear, sometimes meeting the young Openshaw on his way back to the Pall Mall office after a break. Openshaw remembers Grace as 'a pleasant-looking woman'; Bennett's memory is of 'a spinster with all the connotations of that word; but a pleasant soul, if unremarkable in either looks or manner, and with an easy sense of humour'.

If Grace's attitude towards her cousin, who had by that time achieved a small measure of success, seems surprising it was not in the least astonishing to Bennett. 'We at the bank would talk of Lowry's work, but we were interested simply because he was Grace's cousin. But when we went to look at his paintings in a gallery she had no pride in him at all. Why should she? His work was considered a joke. It had not been accepted. In those days the accepted subjects for art were nice views, portraits, maybe groups of people, but posed not casual—very formal. Lowry's work was nothing of the kind; it was totally unconventional and, as such, more of an embarrassment to his family than a source of pride, even had they been the sort to feel such a thing. They found nothing in his artistic endeavours to make a noise about.'[38]

In those early days Bennett and Lowry did not visit each other's homes, nor try to expand their relationship, each being too preoccupied with his own life. The clerk, still a bachelor living with his sister in Levenshulme, was in love with a beautiful young mezzo-soprano whom he had heard at the Houldsworth Hall one lunch time and who was much praised by Hamilton Harty, then conductor of the Hallé. But suddenly, after six years in Manchester, he was posted to Leicester and separated from his Alice. In 1933 he was returned to Knutsford in Cheshire, and in the same year Geoffrey and Alice were married. When Alice met Lowry she was, like Edith Timperley, intrigued by this strange man and, according to her husband, 'quickly achieved a total sympathy with him'.[39] She always made him welcome in whatever house they lived, encouraged his interest in the baby son they adopted in 1939, and acquiesced when her husband chose to spend their meagre savings on a Lowry painting. So the friendship blossomed and endured.

The basis of their friendship is explained by Bennett thus: 'Mr Lowry and I had an affinity which is rare between two people. It was a sympathy, an understanding. I could understand him per-

fectly, and I think he understood me, because our background, our upbringing were so similar. There was no fuss about our friendship. We simply accepted each other. He liked my views and I admired what he did. I recognized in him many of the influences that had so affected my own development. We were both born in a generation of parental rule. Parents had enormous control over their children, a control that young people today can hardly conceive. You had to obey your parents, despite the fact that, at this time, parents had a scathingly poor view of their own progeny. I experienced it, just as he experienced it: nothing he did gained the admiration of his parents in the same way that nothing I did gave any seeming pleasure to my father (my mother was already dead). This is one of the pathetic aspects of the early Edwardian days, an aspect that gave me, and I am sure gave Lowry, an awful inferiority complex. If Lowry's parents gave him no due for any achievement, they were not special in that.' Bennett sees himself and Lowry as kindred spirits, 'struggling to escape down this long dark tunnel to find our self-respect'.[40]

By Lowry's standards these were happy days; he had hope, he had faith in his vision, and he had friends. In retrospect he was often to say: 'The years from 1924 to 1932 were the happiest of my life.'[41] At times he would give this as an explanation for the fact that, as the critic Mervyn Levy put it, 'his basic imagery is rooted in the twenties'.[42] Another critic, writing in *The Studio* in January 1928, observed that his work at that time had qualities which made it difficult to forget. 'It is penetrative, incisive, stinging and may even be sarcastic. There is something almost Olympian in the observation ... where fly-like congregations of busy humans are seen from above, little legs half bent in the effort to get on; little heads full of little personal concerns.'[43]

Then, as always, Lowry's concern was centred on his painting; when he was asked once what he did when he was not painting he replied: 'Thinking about painting',[44] rather pleased at the neat way the response rolled off his tongue. In fact there were many other activities to absorb his energies; trips to London, outings with the Fletchers and the Timperleys; the days in Pall Mall enlivened by an easy rapport with young Openshaw; and a reciprocally warm working relationship with old Mr Astbury, the cashier whom Lowry was to replace when he retired in the early '30s. Astbury was the first man in the company to receive a pension, thus setting a precedent by which Lowry benefited.

And then there were the holidays Lowry so enjoyed: at Easter and at Whit to Lytham; in the summer to the coastal resorts of Wales, until 1927 invariably with his mother and, occasionally, his

father. By this time travelling with Elizabeth was becoming some-
thing of a trial, her debility restricting their visits to 'people we
knew'.[45] As Lowry told it to Maitland: 'I last went away with my
mother on holiday in 1925. The doctor wouldn't let her go away
from home after that . . . he said frequently before, long before 1925,
"If you go away, go to people you know." . . . Then, after 1925, he
said to my father, "I don't want your wife to go away again at all."
So she didn't.'[46] It would seem, however, that some attempt was
made to get her away at Whitsun the following year, the year of
the General Strike, and that she did get a week or two at Lytham
in 1927. The lack of trains prevented their Whit holiday in 1926
for, as Robert wrote when he cancelled their booking: 'Mrs Lowry
could not travel by road owing to her state of health and I should
have to come and go several times.'[47]

'After that,' said Lowry, 'I had to start going away on my own.
I set out all over Great Britain. . . . Previously we had gone a lot to
the Fylde—to Lytham St Anne's—and to Rhyl for our proper holi-
day. But, afterwards I went on my own because Mother couldn't
go and Father wasn't interested in holidays at all.'[48]

By 1927 Elizabeth's health had become such that more help was
needed in the house than the maid Ellen could provide or Robert
could afford. It was a need they found the widowed May Bell (née
Shephard) more than willing to supply—for the payment of just four
shillings a week.[49] May was at that time somewhat impoverished and
increasingly depressed. Her marriage had ended in separation in the
early '20s and her husband returned to Scotland where he died, leav-
ing no will. As his sole heir May received what was left of his gross
estate: £211 13s. 5d. Her favourite sister, Ruth, had died in 1926
and now only she and Grace were left. In the late summer of 1927
Grace and her companion, Lizzie Anderson, suggested to Elizabeth
that May might be the solution to her current problems. Elizabeth
was not overwhelmed at the idea: she didn't like animals and was
aware that her niece might wish to bring some of her pets. She also
regarded May as unpredictable, irresponsible and over-emotional:
she still remembered the embarrassment of May's grief at the time
of Tom Shephard's death.

When May herself put the idea to Robert he declared he would
need to discuss it with his wife, but he was impressed by her apparent
devotion to Elizabeth and, a few days later, he wrote to tell her
that she was welcome to come to Pendlebury. In her prompt reply
from the Cheshire poultry farm where she was working May assured
him that she would 'do all in my power to be a comfort to Auntie
. . . and trust she will realize I am there for *use* and not be afraid

of asking me to do anything'. She added: 'There is one thing, Uncle, and *please* do not even mention it to Auntie if it would worrie (sic) her but I have had my dog Rab with me here and he sleeps in an outbuilding. I do love him but should quite understand if you say there is no convenience ... I buy dog biscuits for him.'[50]

In the event, the demands of Elizabeth were to prove too much for her. After a little less than a year in Pendlebury, May returned to her home at Carterton, where further unhappiness awaited her. In the winter of 1928 the diminutive and gentle May, now forty, met and fell passionately in love with a dashing young engineer, Hugh Mortimer Eddowes, M.C., from Rhodesia. He was a handsome figure of a man, with a fine military bearing, fair hair and a moustache neatly waxed in the fashion of the time. On a sunny June day, in the historic country church of Minster Lovell, they were married. Five months later Hugh Eddowes was dead. He left his bride financially secure, his money well invested in Rhodesia; but emotionally she was bereft. In her later years she clung increasingly to the memories of her childhood when she and her cousin Laurie had played together, writing to him with earnest reminders that they had 'only each other left'. After he died, she recalled: 'He was like a brother to me. He was a good sort. We all loved him, but my mother more than any of us. She felt so sorry for him. Aunt Elizabeth was not a warm person, not a giving person. When I first went to live with them, I was a bit scared of her. I was scared she would send Rab away. She didn't like him and wouldn't let him in the house. Then, one Sunday morning, I returned earlier than expected from church and found her with him on her knee. She was petting him. She told me she thought he was lonely. It never happened again; but I liked her better after that.'[51]

In the spring of 1930 Lowry was given a one-man exhibition in Manchester which would seem, on the surface, to have been extremely successful. Lowry did not consider it to have been so, although he sold every picture—and to people of discernment, of standing and of worth. 'A Collection of 25 Pencil Drawings of Ancoats made by Mr L. S. Lowry at the special request of the Manchester University Settlement' was presented at the Round House, Every Street, on Tuesday March 25th and Wednesday March 26th. The notice of the event announced also that there would be an address from the Dean of Manchester.

It was the late Professor J. L. Stocks and his wife Mary who, together with the saintly Hilda Cashmore, Warden of the Settlement, had persuaded Lowry to do the drawings. The price of each

was 3½ guineas unframed, 4 guineas framed. Again the exhibition was well reviewed by the *Manchester Guardian*, with two reproductions spread across five columns and dominating the Miscellany page. Taylor had died in 1928 and the review was unsigned.

'These later drawings show a firmer grasp of slum landscape. They are better balanced, more deliberately composed; they do not depend so much for their effect on the moral sentiments to which they give rise. It is not that he has lost the almost oratorical power of his earlier work. "Johnson's Building" and "The Cliff, Palmerston Street", are studies in populous desolation as moving as any that he has done. but he gets the effect now without reliance on a convention.

' "Canal Scene" is a splendidly composed drawing, grimy but classical in its well-evolved simplifications; and in "Beswick Fair" there is a brilliant relationship between the garish booths and the mills beyond them. A strange *tour de force* is "Stony Brow", a steep, empty, cobbled road; and for those who like a gentler mood there is a refined drawing of the Round House in Every Street.'[52]

By the Wednesday they had all been bought: by Professor Stocks and his wife (later Baroness Stocks), by Hilda Cashmore and by Mrs E. T. Scott, wife of the Editor of the *Guardian*; by Professor Weiss, by Professor Clay and others. *Stony Brow* was still being argued over by Miss Margaret Pilkington, Director of the Whitworth Gallery, Manchester, and Mr Lawrence Haward, Curator of Manchester City Art Gallery, who, complacent in his experience of Lowry's un-saleability, had not thought to go until the second day. On the statement Lowry received from the Settlement, both names were listed beside this item (priced at 4 guineas) with an obvious question-mark.

On April 3rd Haward wrote to Lowry to explain how the situation had been resolved: 'I found that most of the drawings which I wanted to submit to my Committee had already been purchased when I came up the next day, but I have persuaded Miss Pilkington to offer to the Rutherston Collection your drawing of Stony Brow which she had earmarked.' This was the first acquisition by Manchester of a Lowry. They followed this initial purchase in September with the acquisition of *An Accident* (pages *X–XI*), a superbly evocative oil painted in 1926. They knocked Lowry down from the exhibited price of 30 guineas to £21, a bargain which Lowry seemed happy enough to accept—he did not 'want a pound or two to stand in the way of a sale'.[53] In 1976, just after his death, the Gallery insured *An Accident* for £10,000.

In that same letter to Lowry Haward also tried to compensate for his tardiness. 'Meantime,' he wrote, 'I wonder if you will consider my suggestion that you should at your leisure make one or two studies of Piccadilly as it is today with the sunk garden, the loafers, the ruins, and all the rest of the mess and muddle.' After writing to confirm that he would be free to draw what he wanted to draw—'Have you any special views in mind or any particular size of drawing or will you leave these matters to me?'[54]—Lowry produced exactly what Haward had asked for. When they were done he left the drawings at the Gallery, with an eager note[55] to the effect that he would be interested to receive Haward's comments. The curator's reaction was not what Lowry had hoped for and was couched in far from tactful terms: 'I think they are very interesting in so far as they do give a glimpse of the kind of people who are found at that site today, but I wonder whether you could not have a shot at a drawing embracing a wider field of vision. I had in mind the sort of view of the site and the public using it that you would get from a first floor window of Lyons' Popular Café.'[56] Lowry did not 'feel inclined'[57] to make any further drawings. He wrote: 'Had you told me, when I asked you had you any special view in mind, I would have acted upon it, but under all the circumstances I am afraid that I cannot spend any more time on this subject.'[58] In his draft copy he had added, and scored out, the words 'and after you had left the choice of subjects to me'.[59] That was Lowry retiring hurt from the fray, a hurt that was only minimally assuaged by the purchase, two months later, of *An Accident*.

The Ancoats Exhibition made a gross total of nearly £60, an achievement which, apparently, gave Lowry little pleasure. He felt the price of the pictures to have been set too low. It was not, he told Maitland in 1970, 'the price of a bricklayer or a navvy. It wasn't, you know.... One of my drawings that I did about that period brought £625 a bit since and I got 3 guineas!' He paused reflectively. 'But I was pleased to do them. I suppose it was something that someone was noticing them. I sold one to Manchester. I was very pleased to [have] work there. I've never seen it since. I suppose they are all in the cellar because they don't like me in Manchester.'[60]

Professor Maitland wrote later: 'Whatever Lowry may have thought of such modest successes at the time they have for him in retrospect a somewhat bitter flavour. It was no doubt a mark of some accomplishment that his pictures were shown, but sales and status did not ensue.... Similarly on the Cotswold drawings he recalls that he was out of pocket. That such points should be remembered so accurately after so many years and after achieving renown would

suggest that at the time he was experiencing both intensity and frustration. Likewise he does not look back with pleasure or satisfaction on the fact that Manchester was to buy a picture for a public art gallery, and later bought others, but thinks he has been neglected on the whole by Manchester as compared with some other places, a point which he seems to feel keenly.'[61]

This supposed inability to attract either attention or a market for his work was, in those years, less than is generally believed; but it is a belief Lowry propagated himself, not in a deliberate attempt to distort the truth nor, indeed, as an exercise in self-pity, but because it was what he believed to be true. If, in retrospect, Edith Timperley could call it 'his old song', at the time when she knew him best, she instinctively recognized it for what it was—a cry from the heart: he felt himself to be a failure. He *felt* neglected, misunderstood and under-rated; and nowhere more so than at home in Pendlebury, the very place of his motivation. He had come, painfully and slowly, to accept the rejection of the outside world; he never did learn to accept the rejection of his mother. He fought it constantly, yearning to hear her praise. 'I'm a perfect fool to keep on; I'm a lunatic; don't you think?' he would prompt. She would answer in the way she always did: 'Well, you never can tell.'[62] And he would seize on her tepid words and repeat them to others as examples of maternal encouragement.

It would seem that Lowry's father was more aware of his early success than his mother. He wrote of his son's achievements in tones of pride and joy, judging by the response of his friends: '. . . and please tell Laurie from me he is a brick. There are not many who can pick out a line and say I shall go through with this to success *and do it* like he has done, it is almost phenomenal, I think, and I congratulate him and you and Elizabeth *very warmly*,'[63] Fred Davis had written from Stourbridge soon after the 1919 Manchester Academy show. Robert kept cuttings of his son's reviews in the newspapers, marking them with the thick-nibbed pen he always used and preserving them between the pages of his own rent books.

On occasion Lowry would admit that he owed 'one of my best pictures' to the efforts of his father; it was Robert who had directed his son to St Simon's Church, with the surprisingly perceptive comment that it was 'right up your street'. Perversely Lowry ignored him: 'Never do today what you can put off till tomorrow. I never do what I'm asked to do at first. And then he said: "You'll really have to go and see that St Simon's Church. It's your cup of tea and it's going to come down very soon." So I went up and made a drawing and went again in another month's time to check up on it, and it

had gone absolutely flat. The only time my father was ever interested in my art.'[64] Robert's 'only time' of interest, according to Lowry, had been concerning the experiment with flake white on board; but this unexpected example of paternal involvement showed a singular understanding of his son: as Lowry remarked later to Maitland, the church was 'a piece of particular isolation in a thickly populated area'.

It would seem, in fact, that there were at least two occasions of specific interest and several on which the financially struggling Robert recognized the worth of his son's work: when money was short he would reward the services of Ellen, the housekeeper, or Jemima, the laundress, with Lowry drawings. 'And many a Monday they finished up at the pop-shop, when the kids were little and times were hard.'[65] According to the recollections of the two women's families, it was a habit Lowry himself was to emulate in his own impoverished days after his father's death. Such was his acceptance of the worth placed upon his pictures by their recipients that he showed no more than momentary surprise to learn that, after Ellen died in 1956, her daughter Lily gathered the drawings together 'with the other rubbish' and burnt them in the back yard. Jemima's son, Jack, also made a bonfire of his mother's Lowrys when she died, an action which he now, understandably, regrets. 'We knew where she had got them from—when he was having a lean time he would say: "Will you take a picture instead this week"—but they were dirty and grubby,' he excuses himself with a wry grin.

Elizabeth's attitude was constant: she believed her son's art to be no more than a rather curious, if not actually unseemly, indulgence, and regarded his industrial scenes as quite without merit. In desperation he once asked: 'Well, what would you *like* me to paint?' She replied: 'Little boats at Lytham.' And that is exactly what he did paint for her, a special picture to give her pleasure (page *VII*).[66] She found the result to her taste: her son declared it to be his mother's favourite and kept it on his sitting-room wall, beside her portrait, until the day he died.

There were times when Lowry felt her assessment of his capabilities to be justified. In 1939 Gordon Phillips ('Lucio') of the *Manchester Guardian* wrote asking if Lowry would be interested in writing art criticism for the paper.[67] He showed the letter to Elizabeth and 'she laughed and laughed and laughed'. When she had recovered herself sufficiently, she remarked: 'You could never do it, Laurie. The show would be over before you could get it properly phrased.'[68] He told the tale without rancour as an example of her opinion of him.

When he did sell anything, the purchase, he said, was greeted by his father with near hysteria or the comment: 'This can't go on— it will go to the lad's head',[69] and by his mother with bewilderment. That his need to justify himself to them both was more important than success is indicated by the fact that, in his own words, the happy years ended in 1932, the year his father died. But also in 1932 he was first accepted by the Royal Academy; to a man less concerned with proving himself to his parents, such an event should have marked the year as one of happy achievement.

Although he refuted it, the fact remains that, by the early '30s, Lowry had experienced some measure of success. He *had* sold, exhibited, and received the qualified understanding of some critics. At the time he had no desire to conceal the facts. When asked, specifically, of his artistic achievements, he spoke of them openly and with tempered pride. He wrote to Timperley, in response to a request for information to include in the credits for his book, that he was 'a regular exhibitor at the Paris Salon, the Salon d'Automne, the New English Art Club under the Duveen Scheme, an exhibitor by invitation at many Corporation galleries, at the Royal Scottish Academy and the Royal Hibernian Academy in Dublin, had just had an invitation to submit a picture for the Canadian National Exhibition in Toronto, had drawings and paintings illustrated in various periodicals, a picture bought by the Duveen Fund and one oil painting bought by the Rye Art Gallery'. Hardly a catalogue of failure; and this was written on July 15th, 1931.

Yet he could still say, and often did, 'for thirty years I painted pictures that nobody wanted', and talk of the years before the '40s in terms of unrelieved failure. In truth, that was the way he remembered them. It seemed that way to him because it seemed that way to Robert and to Elizabeth.

 4 'We knew nothing of this'

ON WEDNESDAY February 10th, 1932, Robert Stephen McAll Lowry died of pneumonia in the presence of his son at 117 Station Road, Pendlebury. He was seventy-four years old.

The family had been aware that Robert had a cold at Christmas but, accustomed as they were to the cry of wolf from Elizabeth, had not thought it to be serious. His death came as a surprise to them all, none more than Laurie. Since the New Year he had watched his father get progressively worse and, unaware of the pressures upon him, had been astonished to see him rise from his bed to return to the rent rounds for which he was still responsible.

Although Robert was a slight man—he was 5 feet 9 inches tall and weighed only 10 stone—he had never been seriously ill and, apart from a touch of lumbago in his earlier cycling days, rarely complained of his health. He had been confined to bed with a chill briefly in the winter of 1930 and, as Elizabeth was also 'sick' in bed, Laurie was prevented from celebrating the New Year with friends; but Robert had quickly recovered and now refused to pamper his chesty cough. Elizabeth complained loudly that he was foolish to go out so soon, and Laurie remonstrated as far as his Victorian ethics of parental respect would allow. Robert ignored them both. 'He would not be told—he got up and went out and that was the end of him,' Lowry later told a young friend. 'He came back and he went to bed and he never got up again.'[1]

The event, announced the next morning in the *Manchester Guardian*, was to change Lowry's life. His mother, now seventy-three, took to her bed. She remained there for the next seven-and-a-half years totally dependant, physically and emotionally, upon her only son.

It was a burden willingly undertaken and meticulously performed, but it was to drive him to the brink of derangement.

Laurie sketched a simple cross for the stonemason to copy in granite; it marks Robert's grave in Southern Cemetery on the south side of Manchester, where both Laurie and his mother now also lie; he paid the sum of £7 10s. for planting and care in perpetuity.[2] Both the site and the manner of the burial had been decided by Elizabeth, who had bought the plot some years before from her sister; but Robert's own sister Mary, herself confined to bed in London with shock and bronchitis, was not happy with the arrangement. She sent her husband, Jim Shelmerdine, to Manchester—where he put up in the city to avoid inconvenience to the bereaved household[3]—with instructions to discuss the matter with Laurie. Upon his return with news of Elizabeth's condition, Mary wrote to her nephew withdrawing her objections. 'If you have not already mentioned it, Laurie.... You know how I feel about it, but I do not wish to say or do anything that would upset or distress her.'[4]

Lowry had not felt close to his father for many years, if indeed he ever had. He called him 'Dad' and maintained a kind of distant joviality with him in company, almost as if he were a mere acquaintance; he displayed no evident grief at the loss, only concern for its effect upon his mother. 'He died very suddenly, though he had been unwell for some time. Mother is very ill just now.' Robert was, by all accounts, not a deep man and had little in common with his son; although he read avidly, his tastes in literature were not for the Restoration dramatists nor the poems that Elizabeth and Laurie so enjoyed, but rather for ghost stories, detective yarns, tales of adventure and religious tracts. Devout as he appeared to be, he used his religion with more show than feeling, pontificating at home as much as in the pulpit. 'You'll see it happen, you mark my words,' he would announce from behind the pages of the *Guardian*. 'See what, Dad?' queried the son. 'The end of the British Empire,' he would reply in doom-laden tones.[5] He had no time for new-fangled ideas; they had no motor car, no telephone, no phonograph, and only after his death did Laurie bring a wireless into the house as a companion for his mother's empty days. Robert was stirred to anger by what he considered unnecessary pandering to modern fashions, and once complained for weeks of the folly of his employer John Earnshaw, who had sold the handsome mahogany bench at which the clerks worked and replaced it with 'utilitarian rubbish'. Laurie's memories of his father were not particularly affectionate: 'He was a queer chap in many ways.... Nothing moved him. Nothing upset him. Nothing

pleased him. It was as if he had got a life to get through and he got through it.'[6]

The view that Laurie held of his father was not always shared by others; the letters of condolence that arrived in Pendlebury were full of sympathy and kind words for the departed. From Aunt Lowry in London: 'There is nothing I can say that will tell you how deeply I grieve for you and with you in this heavy sorrow. I cannot imagine you two in the home without him. I am glad he did not know he was leaving you but, oh, I do wish I could have seen his dear face once more, but the shock of your wire, the bronchitis, and the bitter cold made it utterly impossible.'[7] From Mary Davis in Stourbridge: '... The loss of one so good and kind is great. It is indeed irreparable, but you must try to take comfort in thinking of the long years you have spent together and the blessing of the help and comfort which he bestowed on you.... How nice for you to have Laurie at home; he will be a comfort to you and help you all he can.'[8] And there was a typically rambling note from May in Carterton: '... I know so well what these partings mean; they are at rest and our reunion at the longest cannot be far off, but how hard it is to bear....'[9]

Left alone with the bedridden—or 'bedfast' as they say in Lancashire—Elizabeth, it fell to Laurie to sort out his father's papers, still neatly filed and stacked in the antique desk which stood in a corner of the darkened sitting-room, with the clocks his mother had inherited from the Hobsons and the cupboards of glass and china she had collected under the guidance of Annie Shephard. What he found there shocked him profoundly. The extent of his father's debts and the evident financial difficulties he had endured for nearly a decade were greater than either he or his mother could have imagined. With the documents, the angry letters, the demands of the money-lenders, and the outstanding IOUs now arrayed before him, Laurie realised for the first time how tenuous a path Robert had trodden between solvency and bankruptcy. The discovery did nothing to soften his memories of the old man; he could think only of the shame his mother would feel.

His own financial awareness had come to him some years before when, at the age of thirty-three, as he told young Openshaw, he had woken one morning to face the fact that he had not saved even the price of his funeral.[10] From that day he began investing—'Not stocks and shares, mind you; play for safety'[11]—in deposit accounts and with the company that employed him, Pall Mall.[12] His mother had systematically put her small return from the Hobson properties in Manchester Ship Canal shares.[13] Lowry could well have loaned or given his father the necessary funds had Robert ever brought himself

to ask. That he had not done so only made the great divide between them the more obvious.

It was apparent that Elizabeth knew nothing of her husband's debts, which extended even to friends and, worse, to Robert's young nephew Willie Hobson, son of Elizabeth's elder brother, Edward. Whether Laurie told her—which seems probable from his letter to his solicitors saying 'we knew nothing of this'[14]—and what her re-action was on hearing of the disgrace, he never revealed; he never spoke of his father's debts.

Robert's problems had begun as early as 1923, even before the Depression. He wrote first to Willie Hobson, who was then work-ing as a window cleaner in north Manchester. Willie's prompt response displayed the same eager deference as May had shown in her willingness to serve the demanding Elizabeth. It would seem that Robert had much the same ability to inspire loyalty and affection as his wife and, indeed, his son. 'As for interest,' Willie wrote, 'you can give me the same as the Post Office gives, viz. $2\frac{1}{2}\%$. I would not take any more. As for the Principal you can pay it back either monthly or quarterly, whichever suits you best.'[15] He remained Robert's affectionate nephew and was to remain so throughout the ensuing correspondence, although neither debt nor interest was ever repaid. By 1925 Willie had become concerned: 'I am sorry to write this letter to you, but I beg respectfully to remind you that it is close upon two years since you borrowed that money from me, and which you proposed to repay in monthly or quarterly in-stalments. But I have not received anything from you yet. Fifty pounds is a lot of money for one who has to work hard for it, and I hope you will kindly give the matter your kind attention.'[16]

Robert's immediate reply laid the blame on Elizabeth's worsen-ing condition; so sad a picture did he paint that Willie was embar-rassed by, and apologetic for, his own demands; his father, Edward, he wrote, would be along to see the invalid the very next weekend—'... he did not know she was so bad or he would have come before.'[17] Willie did not raise the matter again and when Robert died, seven years later, in his letter of condolence to his dear aunt he referred to Robert as 'so brave and good and kind that ... I shall consider it a privilege to come to the funeral and I appreciate your kindness in asking me.'[18]

Robert had employed the same tactics, the same excuses, with his old friends Frank and Emily Ward of Southport. Mr Ward, how-ever, was not as complacent as young Willie. His letters had become over the years, from the time of the first loan in 1925, increasingly irascible. 'Your continued silence is inexplicable,' he wrote in April,

1931. 'I do not wish to say anything to hurt your feelings. It is not the delay of payment, as the way you have treated the matter which has hurt so. When I last saw you, early in December, you asked for postponement until the end of the month (which, of course, I readily granted) but when I rang you up at the end of Jan. you put me off by saying you had written and sent something but there was no letter until two or three days later. What does it mean, Robert? It is so contrary to your usual open and straightforward dealings. I have said to Emily more than once, when I begin to doubt Robert I shall doubt myself.'[19]

When Robert died a total of £41 was still outstanding to the Wards; there was £50 owing to young Willie and an incredible total of £250 to John Earnshaw. The rent was unpaid, and the gas bill, and there was an overdraft at the bank of £4 9s. 3d. There was no explanation as to how the debt to Earnshaw had accrued, only a peremptory letter which explained the reason for Robert's refusal to nurse his cold in bed. When first taken ill, Robert had sent his rent books and an apology for his illness to his employer, John Earnshaw. Four days before his death he received a reply so curt that it had the effect of sending him out into the streets. It was now apparent why he had 'got up and gone out'. '. . . Are there not one or two properties you could go to on Tuesday?' wrote Earnshaw. 'I don't know how I am to get to them on Tuesday with all the others. I am very sorry you are ill and, of course, you must act on the Dr's orders, however inconvenient it may be. . . . This is going to be extremely awkward for me but of course it cannot be helped. I hope you will soon be well and that Mrs Lowry is better. It is most unfortunate that both are ill.'[20]

After Robert's death Earnshaw approached the son for repayment of the debt. He was not the first, nor, indeed, the last. The more that was revealed to him, the greater became Lowry's concern. He even wrote to the family to discover if there were more as yet unclaimed demands upon the estate. Aunt Lowry replied from London: 'If you mean have I had any monetary transactions with your father, I have not. He has always been most reserved both in home and business matters. I have often wished it was not so.'[21]

Though Robert had been well past the accepted age of retirement, he was still a humble clerk at Earnshaw's, the honorary title of chief clerk being allowed him more in consequence of his long service and position of seniority over the younger men. In his part-time capacity he earned, at the time of his death, just £130 per annum,[22] exactly half his son's current salary at Pall Mall. He left to his 'dear wife' a gross total of £534 4s. 5d., mainly in the form

of insurance policies, on all five of which he had borrowed heavily; there was furniture to the value of £25 and £1 2s. 5d. in his pocket. The house was not theirs, but rented.

By April Lowry had repayed every penny of the debts; he wanted to hear no more of the affair. On the 16th of that month his solicitor, Alfred Hulme—who had gone post-haste to the house where Elizabeth made her will—wrote to inform him that the Inland Revenue wanted to know the exact details of the disposal of Robert's estate. Lowry explained each item individually, adding: 'If it is additional duty they are after and there is likely to be much correspondence and expense, let us pay it and have done with it.'[23] He enclosed receipts for every item. 'They had to be paid,' he explained.

Lowry mentioned his problems to no one, certainly not to his colleagues at Pall Mall who assumed his increasing distraction to be the result of grief. From observation of the two men together, they had thought that father and son had enjoyed little companionship but, seeing their friend under evident stress, now concluded that the bond had been stronger than they had believed. In fact, of course, the bonds were few; Robert had not tried to probe beneath his son's façade of insularity, nor to compete with the emotional demands of his wife upon their child.

All the same, there was considerable sympathy for Lowry. One of the Topham girls, Gertrude, wrote: 'And you—we *do* feel for you, all alone with all this responsibility. . . .'[24] And his aunt 'Pollie' (Mary Shelmerdine or 'Aunt Lowry') was equally understanding; she alone, it seems, recognized the particular therapeutic value for Lowry of his painting and the pride his father had felt, but not communicated, in his son's achievements. Two months after Robert's death, Lowry had two pictures accepted by the Royal Academy. Although this was his first acceptance by the Academy and was a major milestone in his artistic career, he was so preoccupied with the effects of Robert's untidy departure from this world that the event seems to have passed him by without undue celebration. Only at Bourlet's, from where the paintings had been submitted, did their acceptance cause any excitement. 'Pollie', thanking Laurie for sending her a photograph of Robert—'I sit and look at it by the hour'— added: 'This is a Very Great honour, my dear. *Two* pictures in the Royal Academy. Your father would indeed have been proud. Uncle is going down on Saty to see what time the R.A. is open and the best way for me to get there . . . I am thankful you have your Painting, Laurie, for you will not care to go far away from Mother . . . it will take you out of yourself a little.'[25]

For the next seven years Laurie did not, indeed, dare to go far

from his mother. He became yet more detached from the world around him, still further withdrawn, his life divided between his filial duties to the querulous old woman upstairs, the demands of his job, and his need to paint. She was difficult and trying, resented other helpers, and complained of his absences as if they were based on wilful neglect. She wanted him constantly at her side so that presently he painted only when she was asleep. He became haggard and drawn, his hair now noticeably white, his cheeks sunken, with bags under his eyes. In the office they worried for his health and for his mind, observing his condition with affectionate, if unspoken, concern. He would listen to no one, refusing all invitations that would take him too long from home, referring to his incarceration as 'my present difficulties'.[26] In London the Jewell sisters noted that he now came only fleetingly, on a cheap day-return train ticket, dashing away at four to catch the train that would return him to his mother's side.

Ellen Dunbabin attended Elizabeth faithfully each weekday, cleaning the house and cooking the lunch, but although Lowry was lavish in his acknowledgement of his debt to her—and visited her frequently at the time of her own fatal illness—Elizabeth had never a word of praise but complained of the woman's inefficiency and her inability to lift the invalid in her bed. Soon she developed ulcers which she would allow only her medical adviser, Dr T. Mills Popple, and her son to bathe and dress. She would rise from her bed only momentarily. Once Walter Greenwood (author of *Love on the Dole*), who lived nearby in Salford, called upon the artist and, knowing that he worked in an attic room, persisted with his knocking for several minutes. Finally, the window of the front upstairs bedroom was raised and the thin face of Elizabeth Lowry appeared, her white hair hanging in a single plait before her. 'Go away,' she shouted. 'But I came to see your Laurie,' the writer called. 'He's out. Go away. Leave us alone,' came the reply as the window banged shut and the lace curtains once more obscured the dark interior of the room.[27]

For the children of the district the neglected 'semi' in Station Road, half hidden behind a miniature jungle of overgrown weeds, became a house of terrible fantasy, around which tales of witches and hobgoblins were woven and repeated in whispers to the little ones in their beds at night. One day thirteen-year-old Jack Gallagher, son of the thrice-widowed laundress Jemima Dickman, was dispatched, much against his will, to return a parcel of clean washing to No. 117. Timidly he tapped on the door, which was opened by a slim, dark girl. As she reached out to take the bundle a tall,

black figure loomed out of the gloom of the hallway and stopped to stare at Jack. The boy, his mind filled with the stories he had heard, dropped the package at the girl's feet and fled, convinced he had seen a witch. The figure was only Lowry in his office suit, but Jack ran as fast as his legs would carry him away from Station Road, where the trams clattered and clanged behind him, to the comforting squalor of 'ell and 'eaven Street—so-called for the lock-up police station on one side and the Chapel on the other. He never returned, no matter how his mother cajoled or threatened; and from that time he and the other youngsters crossed over the road to pass by on the other side.[28]

No longer did the local children follow in Lowry's footsteps, but observed him from a distance as he walked, his head buried in his collar, his mouth moving in silent speech, his hand trailing along a wall as a child rattles iron railings with a ruler. On the tram in the mornings, and in the evenings returning from Pall Mall, he would sit deep in his own thoughts, rarely talking to or even noticing the travelling companions whom he had once greeted with a smile.

On one such occasion a local shopkeeper and Methodist lay preacher, Enoch Leatherbarrow, was amused to see Lowry confounded by the demands of an inspector for his ticket. 'But I've eaten it,' declared Lowry after a glance at the chewed remains in his hand, and promptly paid a second time for his journey. When the inspector had departed, somewhat startled by his meeting with a grown man who ate bus tickets, Leatherbarrow, hardly able to keep a straight face, glanced at his neighbour to find that he too was convulsed with laughter. Together the two fifty-year-olds chortled their way to Manchester, and from that time on they conversed regularly.[29] After some months Lowry, in so far as his nature would allow, came to confide in Leatherbarrow. With him, and with Edward Kent, a pottery artist who worked for Pilkington's, Lowry would walk for hours across the Irwell Valley,[30] along mossland paths now devoured by greedy motorways.

Now in his nineties and living with his wife in a home for retired lay preachers, Leatherbarrow remembers Lowry's emotion at that time rather than his words. He recalls the depths of the man's disturbance and of his feelings of personal inadequacy in the face of his mother's increasing demands.

Almost of their own volition—for he was doing little to promote them at this time—Lowry's pictures were slowly attracting tentative notice. In 1932 he had shown again with the Manchester Academy, and in 1934 he accepted an invitation to join their ranks. In the same

year he was elected a member of the Royal Society of British Artists, after exhibiting with them in 1933. His work was now travelling the length and breadth of England. *A Hawker's Cart* had been to Rochdale (1931), *Going Home from the Mill* by invitation to Southport (1932), *The Lodging House* and *A Football Match* to Bradford (1933). Oldham, where W. H. Berry was Director of the Art Gallery, had bought *The Procession* for £16 from an exhibition in 1934 at the Arlington Gallery, in whose magnificent marble halls the R.B.A. held their prestigious shows; there, in 1936, six Lowrys were included in a mixed exhibition. That same year two of his works, *Street Singers* and *In Salford*, were selected 'from the Royal Academy and other London exhibitions' for a show at Huddersfield Art Gallery; three more, *The Playground*, *Broker's Shop* and *Market Square*, were shown in the spring exhibitions of works by Lancashire artists at the Harris Museum and Art Gallery, Preston.

The fact that Lowry could now put R.B.A. after his name did not increase his selling price; at Preston his pictures were listed at 30 guineas (Sickert's *King George V* was £400). All this time he was exhibiting regularly with the R.B.A., the New English, the Royal Institute of Oil Painters and the newly formed National Society. From the R.B.A. exhibition two pictures had been bought by one of Lowry's earliest collectors who, until he retired to Dublin in 1948, had an apartment in The Albany and a house in the Lake District; when he left England, among the few works he took with him, as Daisy Jewell proudly reported to the artist, were his Lowry paintings. In 1932 Lowry had decided, much to Miss Jewell's 'regret', not to submit again to the French Salons, but to send instead to the Royal Scottish Academy. In 1934 the Scottish Academy bought a work, and two years later Salford were to follow suit. That summer they acquired the picture his father had instigated, *St Simon's Church*; it was their first Lowry and it cost them £20.

Salford, under their Director, Mr A. J. M. Maltby, had been displaying an interest in Lowry for some years; Maltby had been himself to Bourlet's to meet Miss Jewell and to see Lowry's work there, and had subsequently put Lowry's name before his committee. In 1931 at a show by indigenous artists at the Peel Park Gallery, his paintings and Sam Rabin's sculptures were greeted by the local press as the work of a 'talented pair already on the road to fame'.[31] Lowry's four 'typical Salford scenes', they observed, conveyed 'with remarkable truthfulness of expression the everyday life which we are accustomed to seeing in the city'. His painting *Excavations at Manchester* was included in a 'Summer Exhibition of Recent Paintings by Eminent British Artists' at Salford in 1934 and, the following

year, his pictures were hung side by side with works by Lucien Pissarro, Stanley Spencer, Sir John Lavery and Richard Sickert.[32]

On January 14th, 1935, a *Daily Telegraph* critic singled out Lowry for praise from those 'with established reputations' at the National Society's annual exhibition. T.W.E. wrote '. . . the chief interest lies in the indication of a younger generation's aims.' (Lowry was then forty-seven.) 'British painting does not naturally run to schools, and the best canvases are the most individual, like L. S. Lowry's industrial towns.'

But in those years, a time of the beginnings of a recognition that he both desired and denied, came new savage pictures, born of the distress that was for seven years an inescapable feature of his daily life: paintings of gaunt men with gaunt faces, their features stark and staring, infinitely disturbing in the anguish of their eyes; bleak landscapes, violently scarred, and sensuous empty hills crowned by a single black monolith.

In this era came also a pitiless self-portrait, *The Man with Red Eyes* (page *VIII*); a fearsome parody of John Earnshaw, *The Manchester Man*; the deeply evocative *Boy in a Yellow Jacket* (page *IX*); and a study of controlled despair, *Head of a Man*, which, in the emptiness of the eyes, might well have been his father. Then there was that grim composite *The Lake*, all black and swamp green, with blood-red posts standing like gravestones in the wasteland of industrial destruction; and *A Landmark*, a painting of desolate isolation now known as the earliest of his 'lonely works'.

Lowry acknowledged freely the emotions that possessed him at that time. In the '50s, to Monty Bloom—who had bought *Father with Two Sons* and hidden it from his family until he thought the moment propitious for its acceptance—he explained himself: 'I think I reflected myself in those pictures. That was the most difficult period of my life. It was all right when he was alive, but after that it was very difficult because she was very exacting. I was tied to my mother. She was bedfast. In 1932 to 1939 I was just letting off steam.'[33]

To Maitland, in the '70s, Lowry used the same phrase: 'I did them to let off steam. I was out of my head in those days, out of my head, you know.'[34] He spoke not with the jocular undertones that marked earlier references to the lunacy of continuing to paint mill scenes for a non-existent market; this time his voice was earnest, serious, resonant with the memory of past despair.

'Oh yes, I was out of my head,' he repeated to Bloom. 'And yet, curiously, I did my best work then.'[35]

5 'What is there left?'

LOWRY WAS approaching his fiftieth birthday with the realization that, to his mind, he was no nearer to recognition. He was still delighted with a sale 'once every few months' but had yet to show a financial profit against the rising cost of materials, frames and travel. Early in 1937 he had complained to the Timperleys: 'Art, so far as I am concerned, is devilish dull. No money in it. Plenty of bills in it. That's where you writers have the pull, a bit of paper and a pen and you're all right. I'm getting old and will come and see you as soon as I can crawl.... Matters still about the same here, though my mother is much weaker, I aren't so bad. I feel rather better than I did—there was room for that.... I fear the desire to do all the work has left me for ever and ever.'[1]

In the office he was alternately exuberantly jolly or quietly morose; the staff accepted his moods with affectionate understanding, aware that such vagaries of temperament were an indication of the emotional stress in his home life.[2] He still accompanied the young Openshaw to the theatre, the Fletchers to the Hallé, his old master Percy Warburton to the pantomime in season, and the faithful Leatherbarrow for walks across the Moss.

In London, however, Daisy Jewell was as pressing as ever, her faith in his worth apparently undimmed by the persistent refusal of the London art world to see in Lowry what she saw. Now she was

asking for yet more work—not, she hastened to add, because the Bour-
let stock had been sold, but because all the pictures they held had
already been exhibited extensively; finding fresh work to show was
becoming a worry. 'Could you arrange in the circumstances,' she
wrote, 'to send us one or two new ones down by passenger train?'[3]
She knew he could not make the journey to town unless it was abso-
lutely necessary.

Her efforts on his behalf had not slackened during the years of
frustration, and when, early in 1938, she heard that A. J. McNeill
Reid, a director of the exclusive Lefevre Gallery off St James's, was
to call at Nassau Street, she prepared for the visit in what seemed
to her staff to be a quite extraordinary manner. Some time before
the dealer's expected arrival, Bert Jones in his white apron came
through from the workshop to check that all was in the state of
meticulous order that his superior demanded. He saw that there were
a few pictures standing face inwards against her desk, including two
Lowrys which had that morning been returned—unsold as usual—
from an exhibition. As he began gathering them together Miss Jewell
stopped him. 'Leave Lowry's,' she ordered. 'I'll attend to those.' Bert
Jones was astonished; it was unthinkable that Miss Jewell should
put them away herself, climbing ladders in the dusty warehouse, or
that they should be left lying casually around. 'Nothing was ever
allowed to remain in the showroom when it was not actually being
viewed,' he recalls. 'Miss Jewell was punctilious about such things.
They must have been left there for a reason. It couldn't have been
a mistake. Miss Jewell didn't make mistakes.'[4]

McNeill Reid takes up the story: 'I had been persuaded to go
to Bourlet's to see the work of an artist who did not sound very promis-
ing,' he recalled in 1968. 'My attention began to wander and I spotted
through an open door a small picture sitting on a chair in the adjoin-
ing room. I went through and saw a very lovely little street scene
with masses of figures in it—signed L. S. Lowry. I asked Miss Jewell
. . . who L. S. Lowry was and she said: "Oh, he's a Manchester art-
ist." "Well," I said, "could you send down half-a-dozen, say, to the
gallery tomorrow morning, and if my partner MacDonald likes them
as much as I do we will have a show." MacDonald did like them.
I wrote to Lowry and, naturally, he was absolutely delighted because
he was in despair feeling that nobody would ever want his pictures
at all.'[5]

Lowry could hardly believe the news. His own version of the
momentous event stresses Miss Jewell's surprise as much as his own.
'Mrs Berry [Daisy Jewell], who was in charge, smiled, perhaps a
little sadly. "He's a Manchester painter called Lowry. We've been

sending his pictures to the shows for years. They're always hung—and they always come back." '6

This time, however, they did not come back. Miss Jewell had found for Lowry a persuasive champion and one with a fine reputation within the trade. Both McNeill Reid and his father, Alex Reid, were known to have done much to help Sir William Burrell build his outstanding collection of nineteenth- and twentieth-century French painters and were credited with a keen eye for fresh talent. Reid Senior had brought to Glasgow—from France where he shared student rooms with Vincent van Gogh—the first exhibition of sculpture by Rodin, including *Le Penseur* which had been refused by the council of a Paris suburb.[7] The son, named after his godfather, the American artist James McNeill Whistler, was said by grateful patrons almost to have bullied them into buying pictures by artists in whom he had faith.[8]

In May he wrote to Lowry confirming his intention to give him a one-man show the following January, his first in London. 'We hope that between now and the time of delivery of your pictures ... you will be able to paint some very good canvases which will please the critics and the public,'[9] he wrote. Lowry was somewhat startled by this comment; with the limits upon his time it would have been impossible for him to have produced twenty or thirty new pictures in seven months. At times he might have as many as twenty canvases on the go, but he had always been careful never to release a painting until it met with his own stringent approval. He would put a picture away for months, even years, returning to it time and again until he saw the way to complete it to his own satisfaction. 'I am not quite clear,' he wrote immediately to Reid. 'As I understand you would want all fresh things. My idea is to show eight or ten fresh ones (they are pretty much on the same lines as the ones you have seen) with the remainder chosen from what are with Messrs Bourlet. A small show; twenty-four or twenty-five in all. We had better be clear on this point. Do you agree to a Show on these lines?'[10] McNeill Reid did agree.

In the intervening months Lowry fretted and worried, dashing to London on day trips and consulting Daisy Jewell every step of the way. He could not believe that, even now, something would not happen to prevent this, his first London show. Miss Jewell wrote frequently to reassure him, advising him on the time and manner of his attendance at the forthcoming private view and sending him a list of critics whom, like good fairies at a christening, she recommended should receive personal invitations at home and direct from the artist. Included among the favoured sixteen was Eric Newton

of the *Sunday Times*, a critic who, with Jan Gordon of *The Observer*
(and later Maurice Collis who did not see the 1939 show) was to
become one of the artist's most constant advocates. He wrote: 'Mr
Lowry has formulated his own creed and consequently he will fit
into no pigeon-hole. His vision is personal to himself ... and owes
nothing to any other artist. Like Cézanne he has gone straight to
life ... and his only concern as an artist is to translate his attitude
to it into paint. He belongs to no school, but he may ultimately be
the founder of one.'[11]

At the other end of the critical spectrum, *Time and Tide* found
Lowry crude, awkward and primitive. As Collis pointed out twelve
years later: 'In reading what was said ... one has to bear in mind
how exceedingly difficult it is to judge a new style, because an origi-
nal work looks odd at first sight. Even if you like it and think it is
good, it is hard to be sure how good it is, because it upsets current
theories. In 1939 it was particularly difficult for English critics to
say how good Lowry was because there was no common denominator
between his style and that of Paris. They were quite unused to such
a phenomenon.'[12]

If Collis found his colleagues in confusion and judged them to
be obtuse or lacking the courage of their own convictions, no such
accusations could be levelled at Newton, who by 1945 was calling
Lowry a master, a mystic, a poet; but the conversion was by no
means universal and there were still some who found him naïf, child-
ish or primitive. None, however, went quite so far as the *Spectator*'s
Michael Ayreton who wrote in that year: 'I resent the Lowry auto-
maton so fiercely that I must concede part of his actuality by the
very degree of my revulsion, but I am inclined to think that some
part of Lowry's convention rises out of his inability to draw the
human figure.'[13] Lowry was accustomed to criticism and had learned
not to take exception to it. In later years, however, he could not
resist having a little fun at Ayreton's expense. His friend Monty
Bloom was in the habit of following the prices achieved at Sotheby's
or Christie's; discussing such matters with him Lowry would ask,
in mock innocence: 'How much did Mr Ayreton's picture fetch, can
you tell me, Mr Bloom?' 'Oh, about two hundred pounds,' Bloom
would reply. After a short pause Lowry would resume: 'And can
you tell me, Mr Bloom, how much that picture of mine fetched?'
'Something over two thousand, Mr Lowry,' Bloom replied. Again
a pause, then: 'Isn't that interesting, sir,' Lowry would say, his blue
eyes sparkling with mischief. 'I wonder how that can be, don't you,
Mr Bloom—because I can't draw, you know, I can't draw.'[14]

Even more important than the notices—there were twenty-seven

for the 1939 show—were the sales; he had had reviews before, but sales had not ensued. On this occasion they were less than McNeill Reid had hoped, but far more than Lowry had imagined possible. They totalled sixteen at about £30 each, plus a definite commission for a further painting for a Mr Beddington of Shell Mex. Miss Jewell, who rang Reid each day, wrote often to keep the artist informed of the state of play, commenting: 'Quite a number have been acquired by collectors', or that Lord Bearsted had bought the one from the window.[15] The best news was that the Tate were interested: 'Mr Reid felt that if the Tate Gallery buy they would probably only do so at a reduced price. I have therefore suggested that it would be better to allow them to have it for £15 rather than to lose the chance. In view of your remarks I felt that this action would meet with your approval.'[16]

John Rothenstein had only newly come to the Tate and had there undertaken some enthusiastic reorganization. As he records in his memoirs: 'I was convinced that a number of British painters then active or recently deceased were of greater significance than either critical opinion or that of the general public allowed.'[17] Accordingly he denuded three rooms of all that was 'flashy or drab' and hung a collection of works by, among others, Sickert, Steer, Augustus and Gwen John, Stanley Spencer, Paul Nash—and Lowry. He commented: 'Today when a number of these artists have long figured respectfully in public collections and histories of art this may seem an unadventurous assembly of pictures, but I derived the liveliest satisfaction from the sense of doing some justice to the most serious British painters of the time, most of whom had hitherto received a very meagre measure of public recognition.'[18] He confessed himself to have been 'simply rivetted'[19] by his sight of Lowry's work in Lefevre and 'very much moved by the exhibition'.[20] As a result he persuaded the Tate Trustees to buy *Dwellings, Ordsall Lane, Salford* (1927), a picture which was later joined by the artist's preliminary sketch which he presented to the Gallery. 'Your offer was accepted with pleasure,' the Directors wrote to Lowry in 1951, 'and I was asked to thank you for your generous interest.'[21]

Lowry's fears for the intervention of fate in the plans for his first London show proved to have been ill-founded: Reid had not succumbed to an early death or a change of heart; the skies had not fallen on St James's. The exhibition had been, on all counts, successful and the seeds of future recognition were well sown. The harvest of popular acclaim and sales should, in the normal way, have followed quickly. Another exhibition was, indeed, promised, and after writing both to Lefevre and Bourlet's to confirm the sincerity of Reid's

declared intent, Lowry began painting for the event. He even dispatched 'the head of the awful man'[22] to Bourlet's and received Miss Jewell's comment: 'I wonder what the critics will have to say about him?'[23]

It was now, however, that fate intervened in the shape of World War Two. Lowry came to realize that minds and bodies were occupied elsewhere; even Reid was to desert him temporarily, writing to inform him that the gallery was to close 'for an indefinite period . . . I feel I would be much better employed making munitions than standing about in a picture gallery.'[24] He concluded: 'We will, therefore, I am sorry to say, have to cancel your show which was fixed for next spring.'[25]

Lowry was now nearly fifty-two years old and he was going to have to wait once again for the art world to give him his due. The prospect was discouraging, and he feared that after his brief excursion into the exalted realms he faced months, or even years, of renewed obscurity. His depression was now greater than ever, as if having once tasted sweet success his former life was too bitter to endure.

Lacking both confidence and self-esteem, he could not know that it was no more than a postponement. Although it was to take until the '40s for him to realize a profit on a year's work, until the '50s for popular acceptance, and until the late '60s for high prices, the tide of rejection had turned. Reid without any doubt knew it; Daisy Jewell, with infinite faith, knew it; even the detractors of Manchester, knew it in their hearts. Only Elizabeth Lowry in her sick-bed, looking with uncomprehending eyes upon the paintings of her son, denied even the possibility of it.

Publicly Lowry said: 'I had some very good notices of that show and it made me feel that I had justified myself to my mother. . . . She was the only one left.'[26] But privately he admitted: 'And then Reid had a show and my mother couldn't understand it.'[27] At home the show had changed nothing; and his mother's assessment of him was his assessment. Having been raised in the belief that she had an instinctive eye for beauty, he acknowledged her judgement to be true and valid. If she saw only ugliness in what he did, then ugliness there must be, despite what others said; only her conversion to his vision would bring him fulfilment.

At last, on October 12th, 1939, in the most momentous year of his life, she died, uncomprehending and unhappy to the end. She had lived to her eighty-third year, her hold upon life as obstinate as her hold upon her values and her hold upon her son. She died as she had lived, a spoilt, stubborn, petulant woman who, even in

death, refused to recognize what others now freely acknowledged: that her son was a great artist who had brought, had she had the wit to see it, much honour to her name. By her death, without recognition, she had robbed him of joy in that honour, deprived him of motive for ambition and denied him the pleasure he most sought: her pleasure in him. Where now was glory in success if she was not to know of it? What now the reason for sales if she was not to marvel at them? What now the purpose in anything, even life itself, if she was not to share it?

'It all came too late,' he would say, spurning honours and acclaim. 'It all came too late for my mother to know of it.' And yet it *had* come in time for her to know it, if she had wished to know.

After her death he locked her room and, a full year later, painted a picture of it from memory: a sterile, empty room with an empty bed draped with a counterpane of purest white. When the funeral was over and the relatives dispersed he returned to the office, a solitary man whom none could comfort. 'What is there left, what is there left?'[28] he asked Openshaw time and again, and the younger man, who still had his mother at his side, could find no words of consolation.

In that week, on a bleak winter's day when the wind lashed the sparrows off Princess Street, Harold Timperley found his friend hunched on a seat before the Pre-Raphaelites of Manchester City Art Gallery, his eyes half blinded with unshed tears. Fearing for his sanity, Timperley took him gently by the arm and led him unprotesting home to Cheadle Hulme and Edith.[29]

For three weeks Edith cared for him, feeding him though he knew not what he ate, playing the piano for him and watching gratefully as the tension eased from his face, if only so long as the music continued. She walked with him for hours across the golf links by their house, her short legs striving to keep pace with his long strides. She rose early, noting that he had barely slept, and sat with him through the morning drinking cup after cup of tea. She shopped for him, buying shirts and lending him pyjamas. He did not paint, nor even talk of art or ambition or any of the things that had once obsessed him. He had only one cry: 'What is there left, what is there left for me now?'[30]

The relatives, the Shephards and the Hobsons and the good people of Pendlebury, had sent their condolences couched in words of relief at the passing of his great burden; they wrote in praise of his dedication to duty and marvelled at the constancy of his care. He could find no comfort in such thoughts, seeing only empty days in an empty house stretching before him to eternity.

He had remained with his mother to the end, refusing to leave

her for so much as a night, until at last he had been given an ultimatum by her doctor, Mills Popple:[31] 'Take a break or have a breakdown.' Reluctantly he obeyed, travelling far north to Petershead and Thurso and Berwick-on-Tweed. He wrote to his mother daily, sometimes twice or three times a day, telling her of many things, of people and places: 'I watched the fishing fleet come in out of the mist very slowly one behind the other for hours, 200 of them. I have never seen anything like it.' But never a word about his painting. Now that she was dead he had all the time in the world for holidays and did not want to take them, all the time in the world for painting and did not want to paint.

'I had no need to paint after she died,'[32] he said years later, still surprised by the strength of his need to prove himself to her. 'There was no longer any *need*.' He cannot have meant that the legacy he had received from her, a net sum of £1,028 16s. 4d., had relieved him of the necessity to paint. Had he considered the money to be an incentive to idleness he would have given up his office job, and this he did not do.

Slowly he recovered, or seemed to recover, leaving the Timperleys with embarrassed thanks and promises to take care. But thirty years later he was still saying: 'I had no interest in life after my mother died ... her death made all the difference to my life.'[33]

He returned, alone, to the bleak house in Station Road; he moved his paints and his palettes from the attic to the dining-room and hung his parents' portraits in the parlour, with his painting of himself as a young man in a flat cap. He had put them there, he told visitors—lest they thought him vain or sentimental—to keep the wallpaper from falling from the walls.[34]

He wound the family clocks, the Tompion Elizabeth had inherited from her mother and the lesser timepieces she had acquired over the years, only spasmodically, so that although they ticked companionably in unison, their chimes bore no relation to the hour or to each other. 'They are company,' he said.

Jemima still did his washing; Ellen still came to tidy and to cook—'the worst rice pudding in the world,' he said, cajoling Edith Timperley to cook a better one.[35] And when, that summer, the faithful daily went to Blackpool for a 'bit of a rest and a change' he took himself off to the County Hotel at Lytham, boasting to married friends of 'the freedom of the happy bachelor'.[36]

It was, he said, no time to be 'bothered with' pictures, what with air raids and blackouts and 'bombs falling within half a mile of the house'.[37] For once in his life he was more concerned with physical and mental, rather than artistic, survival.

As Openshaw observed, he was preoccupied with death 'but his sense of humour always saved him'. 'There'll be only undertakers at my funeral,' he would say, 'and even they will be discussing City's chances next Saturday.' When in rare moments of despair he thought of ending it all, he dismissed such thoughts with the assertion that 'it would have been an awful messy business for whoever found me'. But he was never to forget those feelings: 'I know what it is to want to commit suicide. I can understand how people do. Life can get too much and you feel "Why not? It is only hastening the end."'[38] When depression passed he could look with compassion upon the strange, sad figures who came, without his bidding, to inhabit his later canvases. He could say with feeling: 'There, but for the grace of God, go I.'

In his solitary state he turned more to music—'It has saved me, oh it has saved me'—and less to reading: 'I never read much after my mother died.' No longer having her to read to, there seemed to be no purpose in it. He placed music above all the arts, with literature second and the visual arts a poor third. 'Music is the only thing,' he once said, 'that can take me over to the other side.' It was both solace and stimulus: 'I get up feeling low and I listen to Mozart or Bach and it does the trick.'[39]

Although he clung to the familiar memories of his home, refusing to leave it for another six years, he sought temporary escape more often, travelling through the country by bus and train. At weekends and on holidays he would go to the Central Station in Manchester, taking a train at random and finding himself mildly astonished to be in towns where he had never been before and would probably never go to again. Sometimes he would decide he did not really want to be there at all, but 'I managed to get through the day all right and then I went back'. One day he boarded a bus which happened to be going to Blackpool where, he decided, he certainly did not want to go. 'I'll tell you what,' he announced to the startled conductor, 'I'd like to go to Lytham.' And so when the bus arrived at Preston the conductor 'took charge of me, like a father taking charge of a child, and led me carefully to the Lytham bus terminus saying all the time, "This gentleman wants to go to Lytham".'[40]

It was many months before the desire to paint came back to him. It came slowly, more as a means by which to occupy his empty hours. When he began to work again it was without undue enthusiasm, until all of a sudden the compulsion returned and art became a therapy to ease his grief.

'It was the only thing I had to do. I worked to get rid of the time, even now I work for something to do. If things had been natural

as they were years ago I wouldn't have done the paintings. My mother's death did it. I feel it yet . . . I miss her yet.'[41] He was eighty when he spoke those words. 'To be perfectly honest,' he went on, 'I've not cared much about anything since she died. I've nothing left and I just don't care. Painting is a wonderful way of getting rid of the days.'[42]

PART THREE

The image of Ann

'They are not real women,
they are dreams....'

L. S. Lowry (of Rossetti)

1 'Never had a girl'

A BACHELOR of fifty-two, Lowry lived on alone in the old house while the dust gathered on the silent piano and the cobwebs frayed on the tall ceilings. He seemed almost to merge into the gloom of the cluttered interior, so that house and man became as one, the darkened windows in the weathered façade echoing the shuttered eyes in his sorrowful face. Over both hung an aura of neglect, a mood of resignation, as if each had served a purpose that was no more.

To those who worried about the state of his health and mind there seemed only one solution to his loneliness: marriage. Friends and associates had accepted that so long as his mother lived such a union could not have been contemplated; she would never have accepted another woman into her home, and he would not have left her. 'Her dominance successfully prevented any thought of marriage,' says Fitton. 'While she lived he had no need for another woman,' says Edith Timperley. 'His mother absorbed all his thoughts and all his time,' says Lucy Snarr. Elizabeth herself had told Mary: 'Laurie will never marry.'

But now, or so it appeared, the way was clear and the benefits obvious. His friends waited in confident expectation, though without any specific candidate in mind; perhaps a kindly widow, or a homely spinster, a woman who would welcome a home and a gentle husband. Lowry never married. What did transpire was something very different and is, perhaps, one of the most intriguing and mystifying features of his life.

There had been throughout his early years a succession of friends who were girls, rather than girl-friends in the idiomatic use of the phrase; but the significance of such relationships can only be surmised in the light of later events. As with so many aspects of his life, his stories of them became anecdotes to be related with either pathos

or humour, according to his audience. He was adept at assessing the expectations of his interviewers and skilled at tailoring his attitudes and his recollections to meet them; although occasionally he liked to shock, he did not like to disappoint. And, as John Read observed: 'The actor in L. S. Lowry never once got his roles or his audiences confused.'[1] Thus with the passing of time and the increase in curiosity about all aspects of his life, questions as to the cause of his celibacy became frequent and intense. The answers he provided varied from the humorous ('who would have me?') to the blunt ('never known passion').

'There was a girl at art school,' he once confided to his bachelor friend Gerald Cotton. 'After the class I would go down with this young lady, who was very, very clever, to the railway station. There we would part. She would go on to the Oldham train and I went down the subway for the Pendlebury train. We did this quite often. At the end of each summer I would say: "See you again next term." Then, one October, she didn't come back. I never saw her again.'[2] He smiled ruefully, forestalling further questions.

'But about ten or fifteen years ago I made exhaustive enquiries for her in Oldham. She was so clever I thought she would have been heard of. I could find no trace of her. I would have liked to have seen her again.'[3] And he shook his head sorrowfully as if the frustration of this one friendship had condemned him to life-long bachelorhood. 'She did not want to see me.'[4] He paused then, brightening, and launched abruptly into the moral of the story: 'You see, being very wise, she had *given it all up*. No one knew of her.'[5]

He had embarked upon his favourite theme concerning the triumph of the amateur over the professional: the brilliant virtuoso who turns his or her back on proffered fame, opting rather for a life of happy obscurity. It is curious how many of the girls in his life did, or were said to have done, just that.

In the '60s, telling the same tale to Edwin Mullins, the artist added an extra touch of poignancy: 'I have never been married. I've never had a girl, in fact,' he began. 'There was *one* girl: at art school. One October she wasn't there and that was the end of it. I think I must have been what they call a "cold fish". Even now I usually prefer to be by myself.'[6] He was then nearly eighty.

Sam Rabin now believes he remembers the girl in question. And Frank Mullineux, a later friend, feels that he has identified her from drawings Lowry did at art school. 'There was one head that was drawn with more warmth and feeling than the others,' he says. 'The others were just models; this seems something special. I asked Lowry

about it once and he agreed he had been fond of this girl; he was intrigued to know how I had divined his feelings.'[7]

James Fitton, who probably knew Lowry better than anyone at the school, was not very surprised by this story. He has no doubt that in such a situation Lowry would not have attempted to develop the relationship. 'He avoided any friendships that would have impinged upon his personal solitude.' Fitton's surprise lay only in the discovery that Lowry was ever interested enough in a girl to pursue enquiries about her in later life or, indeed, that his attachment was such that he was to retain the memory of her into old age. Lowry himself admitted: 'My temperament made me very unsociable although that was not my wish. It was good for me to meet people there.'[8] And to Mullineux he had said: 'I had no desire to go with anyone else of my own age. I went about a tremendous lot on my own.'[9]

Fitton further recalls: 'I was very young and very impressionable. The School of Art was full of good-looking girls and I was always falling in love. But Lowry might have been in a room with a bunch of retired policemen for all the effect it had upon him ... whereas me, I would be prostrated by them all. The others would tease me about my amours, but not Lowry. He would listen when I spoke of them; he would tolerate my chatter; but it didn't seem to impinge upon his mind simply because the sexual urge was not there. I formed the impression—and it is one I retain to this day—that Lowry was an asexual being: a kind of neuter. He was interested in, and affected by, women, but only in the way that he was interested in, and affected by, people. He persistently avoided any area that might demand involvement.'[10]

Another Manchester student, Dora Craston, believed that if she had offered Lowry any encouragement he might have responded with more than the casual friendship they enjoyed during her years at the school. A beautiful girl with a frank, open face, a wide smile and luxuriant hair that she never cut, she sensed that he was attracted to her, although he displayed it neither by word nor deed. On her very first day at the school she had encountered Charles Holmes, an impoverished trade-mark agent attending the night classes, with whom she had promptly fallen in love; and from that moment she had no wish to encourage any suitor but Charles, whom she married in 1919 despite the objections of her well-to-do family. Although Dora had divined her attraction for Lowry and sometimes hinted obliquely to her daughter, Margaret, that if things had been different she might have become Mrs Lowry, she qualified the statement with the opinion that Lowry 'was meant to be a bachelor'. After the

death of Charles, in 1956, she met Lowry again and spent many hours in the City Art Gallery coffee shop discussing with him the problems of interesting the local art establishment in the work of unknown artists, such as her late husband. It was a subject dear to both their hearts and one which had preoccupied Lowry, on his own behalf, for many years. Once, emboldened by a commission to write an article on Lowry, she raised with him the enigma of his personal isolation. 'Why,' she asked, 'do all your figures stand apart from each other, no touching elbows—even the children do not seem to mix nor huddle together in play?' He replied: 'Because, dear lady, every human being stands alone in the last extremity. And that is how I see it.'[11] Casting her mind back to those art school days, she felt she knew the answer to her question before she had asked it.

Muriel Orton, however, another colleague of his student days, observed none of the repressed sexuality that Dora sensed in Lowry. 'He had none,' she states categorically. 'Not a scrap. You could have slept in the same room as him and—nothing.'[12] Muriel was at the Salford School of Art with Lowry in the '20s. She was very much a modern young lady, with her mousey hair cut in a short bob and her liking for 'Army Club' cigarettes which she daringly smoked in public. Although her family were 'quite well off' she wanted to live as other art students and frequented the tiny café beside the school rather than 'posh places like the Kardomah', the currently fashionable place for young people to lunch. There, perched uncomfortably on the only three chairs in The Tuck Shop, she and Lowry and another student called Fred Makin would eat meat sandwiches and drink 'the cheapest coffee in town' served in thick mugs.

Being gregarious by nature, Muriel Orton worked at establishing a friendship with Lowry. 'He was not very sociable. He was basically shy and it was not easy to break those barriers. You had to go halfway to meet him. He had not the slightest bit of sex-appeal; nothing would convince me that he ever had a sexual relationship. He was enormously attached to his mother; she always came into the conversation. He never spoke of his father; I wasn't even aware the father was still alive then. Lowry was regarded by the rest of us as an oddity—because he was odd. He always looked so untidy. His hair was cut in a prison crop, half an inch all over; his clothes looked too big for him and his trousers as if they needed hoisting up. He refused to wear the art school overalls. I used to tease him about his drawing. I would say: "You are no good at it, you know." And he would reply, with a little grin: "Well, I can't be, can I, if you are always top." '[13]

Many years later, in the '50s, long after she had become, at

twenty-four, the first woman to set herself up in business as a textile designer, Muriel Orton was walking along Mosely Street, Manchester, when she saw the familiar figure, hands in pockets, in an old raincoat and trilby, coming towards her. They went for a coffee together. 'Tell me, Lowry,' said Muriel, as direct as ever, 'why do you paint as you do? I don't like it.' He looked at her for a long moment, then, peering at her, his head stuck forward like a tortoise emerging from its shell, he replied: 'Well Mew-riel, I don't know any other way.' Miss Orton departed, believing she had discovered a great truth.

In retrospect Fitton is surprised that Lowry did not marry. 'There must have been women in the same physical condition as he, women who wanted not a lover, but a companion. Lowry would have been a very caring companion. He was an eminently gentle man. But, possibly, his mother's dominance prevented marriage.'

Lowry himself had a different explanation for his bachelor state. 'I was obsessed with painting; I couldn't have gone on as I did and been fair to a wife. When I painted seriously I painted not from ten till four, you know, but from ten till about twelve or two o'clock in the morning. You couldn't do that to be fair to the wife.'[14] Asked how he felt when faced with a typical domestic scene, 'with children and all the rest of it', he exploded into laughter and retorted: 'I feel that I'm well out of that.'[15]

It was a subject his friends frequently broached—a habit common with most married men when faced with that incomprehensible being, a bachelor who is obviously not homosexual—but they rarely got a revealing response. Once, when walking across Swinton Moss with a young artist friend, Harold Riley, Lowry spoke of a girl of whom he had been fond and who lived nearby, in one of the many farmhouses that once flourished within sight of Station Road.

'Did you court her?'

'Oh no. I enjoyed her company. I liked her. But I never spoke to her of feelings.'

'Did you tell your mother about her?'

'My mother knew her. She came to help me with my mother sometimes ... she was an invalid, you know.'

'And did you tell your mother how you felt about her?'

'Oh no. My mother was not the sort of woman you could discuss feelings with. I would not have spoken to her of that. She would not have liked it.'

When the friend, an incurable romantic, pressed him further, he added abruptly: 'She died when still a young girl— of the 'flu. Her name was Ann.' Together the two men walked on until they

reached a farmhouse built in 1887, the year of Lowry's birth. It was here, he announced, that Ann had lived; and he stood pensively while his sentimental friend captured the moment with his camera. Lowry told the same tale to the critic Mervyn Levy, giving the date of her death as 1913.

Clifford Openshaw, who came into his life in 1928, heard of yet another girl: Maud, the daughter of some dear friends of his mother. They lived at Lytham St Anne's and Lowry visited them often during the time that Clifford knew him well. She died, as far as Openshaw can recall, in 1930. Clifford remembers vividly the artist telling him that she was a dancer, but when on the verge of fame had 'given it all up'. One story of her premature retirement tells of her encounter with a 'very famous producer' who offered her instant stardom in return for her services on the casting couch. Young Maud, of course, virtuously declined and withdrew to St Anne's. There she played tennis—'not very well'—and the piano, rather better. It is interesting that Lowry drawings of around this time feature many young ladies with tennis rackets, most of whom wear hair in a single plait tied with a bow.

Further stories of Maud tell of her distaste for the sordid reality that lay behind the greasepaint and the glitter, and of Lowry's one visit back-stage: ' "You won't like it, you know, you won't like what you see," she warned me. And I didn't.' To Tony Ellis, a Salford curator interested in writing a biography of the artist, he confided that Maud had died tragically young: 'She came to my father's funeral and she caught a cold and died. She was twenty-six.'[16] He was specific about the date, adding that, as a firm believer in reincarnation, he was impressed by the fact that his god-daughter Ann was born at that very time.

By the '60s the same stories of the girl at St Anne's were still being told, only now her name was Ann. She lived, Lowry said, in St George's Square; he took another friend to the spot and again posed for a photograph outside the house where she had lived, No. 8. 'It's just the same,' he sighed, as he stood on the doorstep, gazing at the house with wondering eyes. He added that she was a very wayward girl and 'extremely rude to her parents'. The two of them would go for long walks and when they returned her parents, who would be sitting sedately in the drawing-room, would enquire: 'Where are you going now?' 'Mind your own business,' retorted Maud as she swept through, adding imperiously: 'Come along, Laurie.' And he would follow her upstairs where she would play the piano for him for hours while he sat wondering at a girl who spoke to her parents in a way that was quite foreign to him.[17]

It is curious, however, that local records reveal no Maud or Ann resident in the Square at that time, and surviving families cannot recall a girl of either of those names who died in that decade. For nearly half a century the Clementson family lived at No. 8: George and Muriel and their two sons and three daughters. Of the girls, Joan died in 1905 aged eleven, Muriel Constance died in 1927 aged forty-three, and Doris, now a widow, survives. She says: 'Neither I nor any of my family ever knew L. S. Lowry.' Constance joined the Land Army in the First World War and, liking the work very much, stayed on at the Fylde farm where she was employed and remained there until her death. Without Doris's statement it would be easy to read significance into Lowry's many paintings of 'A Fylde Farm'; but Constance would have been three years older than Lowry—hardly the young girl of his stories—and she never trained as a dancer.

Once in the '20s, while on a visit to Manchester City Art Gallery with her husband, Edith Timperley came across Lowry in the company of a young girl. 'She was very small—smaller than me and I'm barely five foot. And she was younger than me. I was twenty-one. She was very pale and very sad; her features were fine, her face intelligent and sensitive. She had about her an air of faded gentility. She appeared nicely dressed until you looked closely at her; she had on a blue serge coat which the wind went right through—it was no wonder she looked half starved with the cold. It was obviously her only respectable coat, but quite unsuitable for the weather; I found her pitiful. This slim child haunted me for days. I have never forgotten her.

'Some time later, when the boys were taking me to the Christmas pantomime, I suggested to Lowry that he brought this girl with him. He said he could not. If he went out she would stay at home with his mother; Elizabeth could not be left and it was this girl, apparently, who sat with her when both Lowry and his father were away.

'I was surprised, initially, to find Lowry in the company of a young woman. He had never mentioned her to us and yet there was an obvious bond between them. He treated her with immaculate concern.'[18]

In the distressful days of 1939, while Lowry fought for his sanity in the sanctuary of the Timperleys' Cheshire cottage, Edith tried to discover someone who would care, as she had cared, for their friend in his need. She enquired about the frail, delicate child who had so impressed her on that one meeting. 'Oh,' said Lowry, 'she's dead.

She came to my mother's funeral and caught a cold—and died.'[19] His distress was so great, his words clipped with pain, that Edith asked no more. But she formed the impression, and it is one she retains to this day, that 'it was the double shock, the double blow of the death, not only of his mother but of this girl as well, that nearly sent him over the edge.'

Throughout his life Lowry continued to develop a sequence of relationships with young girls, almost one a decade, all of whom bore a striking resemblance to each other. So great were their similarities, according to his reminiscences, that in the minds of those who heard him speak of them they merged into one being called Ann. The truth was that there was not one girl, but many, each of whom featured briefly in his private and personal image: an image of Ann.

Each in her own way and in her own time was undoubtedly important to him, although the women in question, adopting a kind of humility they seem to have acquired from him, cannot now believe themselves to have been so.

It seemed as if he were perpetually seeking an ideal; yearning to recapture, or perhaps to discover for the first time, the personification of a girl who would remain forever young, forever innocent and vulnerable. As each one failed him through the inevitable progression of time and experience, there was always another to take her place. 'Subtly he always let you know that,' says one of them. 'I always knew there was another Ann around the corner.'

2 *The Wren*

THROUGHOUT HIS life Lowry found kindness easier to give than to receive. Even in those early days, before the sycophants had gathered, he was grateful to, yet bewildered by, those who offered friendship or hospitality without hope of reward. He would wonder, frequently and aloud, why anyone should concern themselves with the welfare of a useless old man, as he now professed himself to be. 'What can I offer them? What do they want? Why are they so good?' he would enquire of Edith, when relating how a neighbour had invited him to lunch or supper.

With the Timperleys and the Fletchers, and indeed with Openshaw and the Bennetts, he was at a kind of ease, the pattern of his behaviour with them well set on long-established lines. He had ceased to test the sincerity of their friendship with displays of eccentricity or irascibility; their acceptance of him was understood. But the Leatherbarrows were more recent acquaintances and only as a result of Enoch's evident concern for his bereavement did he begin to accept their friendship. The long walks across the Moss led to invitations to supper at their home in Station Road and eventually to Sunday lunch, after which the day would pass in inconsequential conversation and games of push-halfpenny with the children.

At last, uneasy at so much receiving and so little giving, Lowry asked the Leatherbarrows if he might take Kathleen, their thirteen-year-old daughter, to the pantomime. They were touched by his

eagerness to please and readily agreed. They thought that he might be bored by the company of a girl forty years his junior, but noticing his childlike delight in youthful pleasures, worried no further. It was, nonetheless, an undertaking Lowry viewed with some trepidation, and when the great day arrived he acted, according to Kathleen, 'like a cat on hot bricks'.

Lowry's outing with Kathleen Leatherbarrow to the Palace Theatre, Manchester, early in 1940, was the beginning of a friendship that was to endure until her marriage in 1948. They met only once again after 1948; but when the artist died, nearly thirty years later, her photograph still stood on his piano and a portrait he had painted of her in Wren's uniform remained, despite offers for it, in his studio. Kathleen, now a chiropodist working in the West Country, was surprised and touched by the sentiment implicit in the preservation of her memory. She had observed no particular emotion in their relationship, only the happy enjoyment of each other's company and their reciprocal delight in youthful pleasures. 'I felt almost as if he were enjoying my childhood vicariously, as if, perhaps, he had had none of his own. There was a sadness within him that I could not define, almost as if he had missed out on something that he could now never recapture. He was a vastly unconventional man, fettered by the innate conventions of his nature and of his upbringing, and, as an unconventional child myself, this appealed to me. There always seemed to be, in him, a little boy struggling to get out.

'Looking back, I wasn't aware of him being any particular age, simply an adult and, in that, unusual in having time for me. He never treated me as a child, but as an equal. Even though I was so young he took notice of my opinion and, in fact, seemed to value it. He was so genuine himself that it seemed that only in young people, who had as yet not discovered the need for pretension or guile, could he find the same honesty. If I saw a picture he had done that I didn't like I would say so, when he asked, and that fascinated him. "What's wrong with it?" he would pester. "What don't you like about it?" If it was one of those horrible heads, I would answer: "Well, it frightens me," and he would nod, gravely, as if I had made a statement of great profundity. He often said that those heads "just happened", that he didn't set out to paint them but that they appeared on the canvas almost as if he had nothing to do with their creation. And they frightened him too.'

After the first outing, the pantomime became an annual event until Kathleen, at the age of eighteen, joined the WRNS. There were evenings at the Leatherbarrow home and invitations to tea at Lowry's sombre house. 'When he came to us for supper he used to

spend so much time talking to me – I always stayed in if I knew he was coming – or playing push-halfpenny on the dining-room table for hours, that my father would joke about Lowry being more my friend than his.' As Enoch Leatherbarrow remarked later: 'He had a strong liking for Kathleen. They were drawn to each other. I often felt he was drawn to me because of her.'

If Kathleen's father accepted the relationship as an innocent means of bringing light into the life of a man in deep depression, her mother Lillian had, initially, certain natural reservations. 'You should not call upon him alone,' she cautioned; but her daughter was a rebel and continued to visit Lowry whenever she wished. 'He behaved immaculately at all times,' she recalls. 'Young though I was I would have soon noticed if there had been anything fishy about him, and I'd have run a mile. I can't remember him ever putting a foot wrong. On that first outing he had asked me to bring a school friend, which I did, and whenever he actually invited me to the house a friend was invariably included. He made an enormous fuss of us when we went to tea; there would be cream cakes, masses of them, and chocolates, all laid out on a trolley in the front room. He would make the tea himself, whistling as he did so. He had a marvellous way of making one feel very special.

'Sometimes, if I arrived unexpectedly, he would be in his painting clothes; he would stand halfway round the front door saying: "You'll have to wait while I change." And then he'd dash off—he went everywhere at the double—leaving me on the doorstep until he had made himself presentable. Occasionally I would turn up on roller skates—which horrified Mother almost more than me going on my own—and he would invite me in, without turning a hair, as if it were the most normal thing in the world to sit in someone's front parlour wearing roller skates.

'When I called for him at his office in Manchester he looked very sheepish, almost as if he should not really have been there; but then he always looked sheepish if one came across him unexpectedly in unfamiliar surroundings or other company.'

It was in 1945, shortly before the end of the war, that Kathleen left home to enlist. Lowry wrote to her frequently, but her leaves were short and, by this time, her parents had moved from Pendlebury. The friendship began to wane. On her first visit home she had given Lowry a photograph of herself in uniform and signed it: 'With much love from Kathleen'. He did her portrait from this picture and from his memory of her and, although he gave her parents signed copies, he never parted with the original.

Two years later she took Jim, the man she was to marry, to visit

her friend. Only Jim retains a clear memory of the encounter; the artist, who took him to see his work, was still pondering aloud the mystery of the strange heads. 'Why do I do them?' he queried many times; and 'What do they mean?'

After the wedding, in 1948, she lost touch with him. Then, in 1962, the Leatherbarrows wrote to Lowry inviting him to a midday meal at their new bungalow in Flixton. He arrived—much to the astonishment of Lillian, who had sent him a list of bus and train times—in a taxi; he had travelled in it all the way from his home at Mottram-in-Longendale. 'It was the first sign we had ever seen in him of wealth,' Lillian commented. 'We were so pleased to see how famous he had become and yet, apart from the taxi, how little he had changed.' Kathleen, too, had come to see her old friend, bringing with her Dennis, her eldest son, then aged eleven. The boy and his grandparents were full of his exams, which he had recently sat in an effort to get a place at a Direct Grant grammar school. Dennis was worried that he had not done well enough. Lowry intervened. 'You don't want to concern yourself with exams,' he told the boy emphatically. 'They are no use to you at all. There is more to life than exams.'

Kathleen and Lowry never met again. She did, occasionally, think of writing to him from her new home in the West Country; 'but I never did for fear he should think I was only doing so because he was now so successful'.

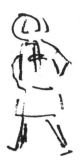

3 The Infant

As THE STRENGTH of Kathleen's friendship faded, so Lowry's relationship with Margery Thompson flourished. She was the classmate chosen by Kathleen to accompany her on that first treat and was fourteen when she met the artist; she, too, was unconventional—or 'bonkers' as Kathleen puts it—dark, slim and lively.

'I have never forgotten that first outing,' Margery recalls. 'He seemed to enjoy it as much as we, except that he was enormously worried by the responsibility of taking out two young girls. He was so worried, in fact, that in the taxi on the way to the theatre he opened the car door too soon and banged it, quite hard, against a lamp post. The driver was *not* pleased, especially when Mr Lowry, in his embarrassment, insisted that it had not happened. After the show he took us for tea at the Squirrel Restaurant in Oxford Street, which I thought was marvellous because the waiter drew our chairs out for us to sit down. I found it frightfully grand, with its tall ceilings and potted palms, and, he told me later, it was not just my childish imagination: it really was like that.'

In the years that followed there were tea parties and concerts and exhibitions and more pantomimes, until there grew an understanding between the girl and the man that remains for Margery a treasured memory. She came to call him 'Pop', though very much later and after she had married; he called her 'The Infant' as much, she says, as a reflection upon the difference in their ages as 'to establish that he had no designs upon my person'. In her teens she would tease him gently about his chances of 'getting off with' her widowed mother, a woman of culture to whom she was extremely close. 'He didn't like that one bit and would mumble about it all being nonsense

because he was far too old for her; she was, in fact, just three years younger than him. But I soon realized he didn't like such jokes, that he was uncomfortable in the face of expectations of role-playing that he was unable to fulfil; I soon stopped.'

Margery saw his house in Station Road, with its soft gas light and blazing coal fires, as a place of infinite mystery and fascination, where they spent afternoons filled with laughter. She remembers particularly the way in which he escorted her, upon leaving, to the bus with 'a kind of old world courtesy that came naturally to him'. Once he asked her if she would play the piano for him but, sensing that his mother had played it last, she declined. She was to remain curiously sensitive to his moods and feelings. 'Sometimes, if I hadn't seen him for a while, I would seek him out. But if I found him with a crowd of people, say in Ridgway's Café where he often went, I would never go up to him and say "Hello" as one would with others. I would go and sit at another table and wait for him to come over. I never thought that this was odd; it seemed a natural thing to do and yet I would never have behaved that way with any other friend.'

He took her to concerts to expand her appreciation of music and afterwards would ask her intently: 'What did you think of that?' She rarely knew what to say. 'Most times I would wait for him to express his opinion then, after a suitable pause, bring it out as one of my own. I am sure he knew what was going on. There was always an air of amusement about him. He wasn't laughing at me, but at life. He was always surprised by life; he never lost his sense of wonder. At times he would almost parody himself: "Child," he would say in doleful tones, "there's nothing, nothing left. Now get on with your tea."

'He was always quoting de la Rochefoucauld at me, things like "Friendship is just a business arrangement", which hurt. I took such maxims personally. I thought he meant him and me. I was possibly too young to appreciate that, in many cases, for him it was true: so many of his friends were clients first, friends second.

'When I knew him he used to wear a battered raincoat and, when we went to concerts, it would get rolled up in a bundle and shoved under the seat. Once he took me to tea in the Midland Hotel, the sort of place he did not frequently go to. Too pretentious. Suddenly, without warning, he took the lid off the tea pot and stirred the tea noisily. Everyone turned round, with raised eyebrows. I was young and must have shown my embarrassment. "These people," he said, "don't know me and I don't know them. It doesn't matter, does it?"''

He encouraged her interest in painting, giving her occasional lessons in his studio with his brushes and paints. Once she did a painting of a house which he liked and wanted her to finish. 'But there was a misunderstanding and I did not realize how eager he was; I thought he was humouring me and so I never bothered. I did not understand, then, how important it was to him to have someone who took art seriously. It was only years and years later when he asked me why I had never finished it that I believed he really had thought it good.' But her grandfather—an architect who designed Blackpool Tower—had been a moderately successful watercolourist and, like her mother before her, she could not find the temerity to compete with his memory.

In the '50s Margery became engaged. She introduced the young man to Lowry who treated him with exaggerated respect; all his life he was known to address men, no matter what their age or station, as 'Sir' or 'Mister' but, in this instance, Margery sensed a resentment in his attitude. He continued to keep her boy-friend at a distance until one day, while he was struggling with a picture of the Tate Gallery, Margery suggested that Geoff could take a photo of it for him. 'Would you really?' he said, surprised; and, when Geoff readily agreed, he grinned and joked: 'Don't let John Rothenstein see you.' They got on better after that.

Margery had told Lowry of the engagement without any idea of the reaction it would inspire. 'I had no worries about telling him,' she recalls, 'because I did not realize how attached to me he was.' He went to the wedding in 1954 and 'behaved atrociously', she recalls. 'He was absolutely dreadful, storming about the reception room complaining about the service and the food and everything. His behaviour shocked me. But the next time I saw him he was his old self. He did not actually apologize but he explained himself with the words: "Look child, if you want anything, money or anything, all you have to do is ask me. But don't ever ask me to socialize; that I cannot, will not, do."

'But he really never stopped testing our relationship. He was eternally trying to get the lid off, making provocative remarks to see just how far he could go. Once when he was visiting us in Southampton, when the children were very small, I remember being particularly tired and overwrought. The trouble with his visits, much as I loved them, was that he was a very demanding guest and I always tried to give him hotel service. On one particular evening we had just sat down to dinner when he announced that he fancied having the sweet first and would I, please, go and get it. I didn't actually burst into tears, but my eyes filled and, when he saw this, a look

of shock and shame came into his face. He was full of remorse. He never meant to hurt; it was just that he never really believed that anyone cared enough for him to be upset by anything he did.'

After that the relationship continued by correspondence, with only an occasional visit by Lowry to Southampton. He rarely replied to her letters. She says: 'He used to write copious, copious letters while I was in the Forces, about all sorts of things, concerts that he went to and how he couldn't concentrate on the music there, that he would rather listen to it on the radio, because the shape of the gentleman's nose would be too distracting; and about pictures, about my work, about my family which he used to visit. So, later, when he didn't reply to my letters I didn't mind because he had been so good about writing to me all those years before. One time I said to him, did he like getting letters? Yes, he did, but he didn't like writing them. Well, I said, would he like to get letters and not answer them? Oh, he couldn't do that. You see how Victorian he was really? Well, I said, if you don't mind not answering them, I am very pleased to write to you. Oh, all right then. Well, I didn't mean he hadn't to answer *anything*, which is rather what he did. I went up several times to see him only to find the bird was missing.

'But, in spite of all that, I turned up once, after not seeing him for about ten years, and found him in. He looked at me wonderingly. I think it suddenly dawned on him that perhaps somebody did care. But it was too late. He believed it while I was there, with him, but no, it was too late. He had been conned too much and too often to really trust himself with anyone.'

Margery last saw Lowry a year before he died in his old house at Mottram-in-Longdendale. He was complaining, mildly, about the fuss and palaver currently being displayed by certain sections of the art world. Margery, anxious as ever to be honest, even to the point of bluntness, agreed that it was ridiculous. 'You are good,' she said, 'but not that good.' He had his back to her and she could not see his face.

'If it had all happened years ago,' she continued, 'it might have been worthwhile. If there were somebody here who was interested, somebody you cared about to know of it....' It was she now who was testing the wicket. He stopped what he was doing and turned, slowly, to look at her. 'You understand,' he said softly, 'you understand.' She felt then that she did, indeed, understand him; she felt that possibly she understood him better than most.

4 The Office Girl

DOREEN CROUCH was just fifteen when she joined the Pall Mall Property Company as an office girl in 1942. She was an only child, from a poor family, but pretty and bright and eager to learn; like Kathleen, she had a smile of particular warmth and innocence that was not easy to forget.

Clifford Openshaw had enlisted in the R.A.F. some months earlier and both Lowry and George Fletcher had regarded the arrival of a female substitute with some trepidation. They soon warmed, however, to Doreen's open and responsive nature and, finding her receptive, began to encourage her natural appreciation of the arts. 'I didn't know much about music,' she remembers, 'but my mother and I were both fond of it and I had picked up some knowledge from her. Mr Lowry quickly realized this from the odd snatches I would whistle around the office. "That's from so and so," he would say, almost as if he was trying to educate me. Sometimes he would ask: "Have you read so and so?" and if I said: "No", a few days later he would turn up in the office with a copy for me to read.'

She was grateful for his interest and reciprocated when she could by doing Lowry's household shopping for him: 'It was wartime; he didn't like hanging about in town much.' Although Doreen was unaware of it, in the early '40s Lowry was spending two or three nights

a week fire-watching on the roof of Debenham's store, or on Lewis's in Manchester's city centre—an experience which he found 'really quite exciting'. He enjoyed the long hours of conversation with the other wardens, men from all walks of life, and was invariably 'first down in the mornings to sketch the blitzed buildings before the smoke and grime had cleared'. In the office he spoke neither of his nocturnal activities nor of his paintings, despite the fact that he was an official war artist undertaking regular commissions for the Ministry of Information.

Doreen's pleasure in his attentions encouraged Lowry to invite her to concerts, to exhibitions, and to join him 'for long walks across Swinton Moss ... My parents were at work all day and I suppose, in a way, I was a lonely child. I rarely saw my father. He worked very hard. I would trot all over the place with Mr Lowry. We must have looked a strange pair: when I was sixteen, he was fifty-six. I got dreadfully kidded about it but I took no notice. He was very dear to me. And, if I wanted to do any of the usual things, like dancing, I had friends of my own age to go with.' One such friend was young Philip Fletcher, son of Lowry's friend Frank, who, on visits to Uncle George on the third floor of the Brown Street building, could not resist asking the pretty office girl to enliven his leave with an evening at Levenshulme Palais de Danse. 'She was a very bright, cheery girl,' Philip Fletcher recalled. 'And she was good for Mr Lowry.'

By the time Clifford Openshaw was demobilized in 1945, Doreen was well established both at Pall Mall and in her relationship with Lowry. The friendship between the two rent collectors had not waned during Clifford's enforced absence: there had been 'long and full epistles of Manchester life' from Lowry and jocular letters from Openshaw: 'I am due for nine days' leave; we really must do a leg show together....' Now, when he was appearing in one of the amateur dramatic productions he so enjoyed, he would bring two tickets to the office. 'Lowry would bring Doreen to the show and would meet me afterwards, enthusing almost boyishly about the part I had played: "I'd never have known you, it was marvellous—How can you do it? In front of all those people? I never could."'

Doreen recalled: 'It was great in that office. Because it was my first job I never thought there was anything unusual in working with all men, despite what my friends said. Oh, we did have some fun. I remember Mr Lowry sitting there laughing his head off while Cliff chased me round the desk—just skylarking. It sounds barmy to talk about it now like this, but those were difficult times and we found our fun where we could.'

With time and familiarity Doreen, and Clifford too, came to call him 'Uncle Laurie' which, as the young man remarked, 'always pleased him, for the role of a favourite uncle suited him well'. Lowry called her 'child' and him 'lad', although later, when fame and distance had estranged him from them, they both reverted to the formal 'Mr Lowry'.

Three years later, in October 1948, Doreen married and Lowry was a witness at her wedding. 'It was,' she said, 'the only time in my life I ever kissed him. I remember him looking quite astonished when, in the emotion of the day, I went up to him and gave him a warm peck on the cheek. He was not displeased, I could see that in his eyes. He was always very careful to keep his shell around him, but, on occasion, I could see beneath it. There was a look there that I could recognize but if I ever tried to probe, immediately the barriers would come up again. I often felt there were times when he would have appreciated a good big hug—but I never dared; I was undemonstrative too; as an only child I too had a shell and thus appreciated, and respected, his.'

Over the next decade the relationship changed subtly, so that eventually the dependence seemed to be more on his side, less on hers. 'He would come often to our house where he was like one of the family. He would help with the washing-up and play with our daughter, dandling her on his knee and planning great things for her future, talking of sending her to university and paying for her education. He was natural with us. He didn't have to pretend. We knew all about the other part of his life, about his humble beginnings and his job at Pall Mall. He could relax with us. He was, at this time, becoming sensitive to the way people were always wanting something from him. He offered me things, but I always refused and he seemed to appreciate that. I never wanted him to think he was welcome only for what he brought with him. He did sometimes bring a box of chocolates, but never paintings.'

Then, in 1956, Doreen and her Polish husband decided to emigrate to Canada, where they still live, mainly for the sake of the health of their daughter, Christine, who, at the age of four, suffered from bronchitis. In February, 1957, they left and have never returned.

'The last time I saw him, when he was leaving, I was very emotional. We were at the bus stop together and I wanted to get on to the bus with him, anything to delay the parting. I was nearly in tears. He was very serious, very sad. He was getting known then and seemed to have lots of friends, so I said: "You will be all right, you have got everybody inviting you everywhere." He interrupted

me almost angrily. "You don't understand," he said. "You don't understand." Those were his last words to me. He got on to the bus and I never saw him again.

'I wrote frequently from Canada, inviting him to visit us, and he would reply asking when we were coming back or when we were going to send Christine over. He would not come; he seemed to have a fixation about not leaving England. The time passed and his letters became fewer. Then, in 1970, I went to visit Christine who had married and was living in California. She had just had a baby and, on my return, I wrote glowingly of my trip. I was still trying to persuade him to come over and, not wanting him to treasure any false hopes that we would come to him, I pointed out that from then on my holiday time and money would be spent with my daughter. He never wrote again. I fear he thought me unkind. I do hope I didn't hurt him because we had been very close.'

5 *The Clown*

IN SEPTEMBER 1948, a few weeks after Lowry had moved into the bleak stone house at Mottram-in-Longdendale, there arrived on his doorstep 'a scruffy village kid', clutching a roll of her drawings. Her name was Pat Gerrard and she was fourteen years old, a slim, wide-eyed child with dark hair tied in two plaits. She had been brought by her father, Frank Gerrard, a local builder who had been working on alterations to the artist's new home, in the hope of receiving advice for his daughter. That first inauspicious meeting, while friendly enough, gave no hint of the importance and influence their subsequent relationship was to have upon the future of this 'gauche and gawky child'.

'He was very kind,' Pat recalls, 'but I was young and was drawing the usual rubbish you draw then, too influenced by others, too pretty-pretty. I knew the work was hopeless, not from anything he said, but by the things he advised me to do: to go out and draw from life. "Only draw what you know," he told me. He said nothing hurtful; he never did, never about anything. He would always try and lead you; this was his way.'

On that day she saw him as 'very, very big and very jovial in a bantering sort of way'. The house, so different then from the way she had known it, fascinated her. It had previously belonged to her music teacher, and every Saturday morning she had gone there to play Beethoven in the bright chintzy parlour with its white walls and homely cottage atmosphere. Now this 'weird' artist had come, to set the village folk chattering with his demands for walls of the darkest turkey-red, debating for hours with decorators the exact

shade until, in frustration, he had mixed the paint himself. He had filled his new home with heavy antique furniture, and clocks, pictures and cabinets of china hung on every wall; and he had arranged for the installation of a lavatory *separate* from the bathroom 'which knocked everyone for six'.

Pat went out and drew as the artist had advised her and, when it was done, took it back to show him. From that time she visited him each week, straight from school. 'I learned so much from him. He made me draw from the thing, made me observe the real thing first and then adapt it to my own style, but never, never to get my ideas from art books or other paintings. Later, of course, I was to absorb and adopt his own wonderful philosophy of dealing with the art world. He would tell me of artists continually sponsored by the Arts Council, artists who were forgotten the minute they died. "You can't keep a bad man up," he would say; and "you can't fool the public—it is the public in the end who decide who will live after death; it is the public who bring back an artist after one or two hundred years." He maintained that only if you were totally independent and free from grants would your work be truthful—because you would be doing it out of your own heart, you would be doing it for the right reasons. Often he would set things up for me to draw, there in his workroom, and would sit quietly while I did it, almost as if it amused him to watch someone else working so hard. And then we would talk and talk until suddenly it was midnight, and a ring would come at the front door and there would be my Daddy, worried sick, wanting to know where I was.'

Pat stayed at Hyde Grammar School, still undecided whether to be artist, actress or writer, until, making a first tentative commitment, she went, at the age of sixteen, to Manchester School of Art. After two years there she decided to try for a place at the Slade and, collecting together all the work she had done, went once more to ask Lowry's advice. 'He looked at my work carefully and without speaking. Then, quite out of the blue, he said: "I'll write you a note to the Slade and put it in with the one from your Art School." I'm sure that had more than anything to do with me getting in there.'

Over the next three years the relationship developed, Lowry writing long letters as if to a child, with instructions to eat properly, to behave herself and to work hard. He visited her in London and took her to concerts, to the theatre or by steam train to Brighton for the day, to marvel at the Regency façades and to explore the wonders of the pier. Pat was no longer 'a scruffy village kid'; she had grown to be a beautiful woman, the natural joy in her smile enhanced by an abundant wonder at life, an insatiable curiosity

that was constantly refreshed and renewed by human contact. Lowry expanded visibly in her company but was strangely protective, rarely introducing her to other acquaintances, but keeping her to himself.

'I was washing-up in a café in the evenings, to help pay my way through college, and sometimes he would be a bit annoyed if I was not available; he would make a great point of taking out one of my friends, one of the other girl students at the Slade, just so that I understood I was not important to him. But if I knew he was coming I would arrange to be free: we would go often to the Festival Hall; he adored string quartets and loved to speculate on the relationship between the four men—"Did you see the dirty look they gave each other when they brought on their chairs?" In his younger days he would go, after a performance, to stand at the stage door and watch the musicians coming out, and was fascinated to see them so often all get into separate cars without even speaking to one another. He was enormously interested in everybody, in everything; one wouldn't have known it—he didn't sit and stare at people, he just soaked it all in. Because he was so much alone he could observe that much easier; he was always telling me: "Be by yourself and observe; you can only do it if you walk alone."

'After the concert, or the theatre, we would walk all the way back to the Little Acropolis off the Tottenham Court Road, where I would have a Greek dish and he would have lemon sole and chips. I wasn't used to going to restaurants and, at first, I would chat away to the waiter until he said to me sternly: "You do not speak to waiters, Pat." It was quite a difficult thing to please him, in the end, because he wanted a hundred per cent attention a hundred per cent of the time. He was very demanding and a very powerful personality.'

When she left the Slade, at the age of twenty-one, Pat became an art teacher in Altrincham, Cheshire; then, two years later, in 1957, she married Brian, a young scientist, and moved to Knutsford. 'He was not so much upset that I had married, more that I had moved away and could no longer just pop in to see him. On the other hand, he did tire of people; he tired of everyone sooner or later. Each friend had his or her allotted span in Mr Lowry's life and when it was done, he moved on. I don't think anyone was important to him after his Mummy died. I did, at one time, flatter myself that I might have been; but although he enjoyed my company and the fun we had, I don't think any of it really *mattered*. He was fiercely independent. I remember him telling me a story—he made everything into the most marvellous stories—of going to stay in a very rich house where they bossed him about like mad and programmed

his every movement. Finally one evening about ten o'clock he announced: "They'll be missing me down at the Swan", and off he went to the local pub and booked himself in there for the night. "I wasn't going to have anyone dictating to me," he told me. They thought, because they had commissioned him to do a picture for them, that they owned him. No one owned Mr Lowry.'

He went to her wedding, arriving wreathed in smiles in a sports car driven by her bridesmaid's boy-friend—'He always loved a fancy car'—and was 'very sweet throughout, talking to people and generally being very, very nice'. A few weeks later he visited the newly-weds in their home; he gave them a settee—'I never give a wedding gift straight off, I like to see how it is working out first,' he said. From that time he became a regular guest, establishing with the. gentle Brian an almost immediate rapport.

In 1962, and again in 1963, in 1964 and in 1970, Lowry went to Ireland on holiday with Pat and Brian. 'He adored Ireland from the very first moment; he was enthusing as we came into Dun Laoghaire, standing on the prow of the boat as he had all through the journey, with his hat plonked on his head and the brim rippling in the wind like a wave. And he didn't stop enthusing the whole week. He loved the buildings, the incidental eccentricity of people and places; the shops with only potatoes in the windows—"Is it an art gallery, Pat?"; the drunks creeping along the walls—"Look, look, Pat, there's another of my figures"; and the waitresses who plonked the soup in front of him with a cheery "Ach, that'll do ye good". After that, every time we had soup he'd say: "Ach, that'll do m'good." We developed a sort of shorthand for our private jokes so that just a key word would set us off into helpless laughter. Oh, we did have some fun together.

'He did tease me, though. When we went to pick him up for the Holyhead ferry I remember him opening his door with a doleful face and saying: "I can't go", which was just great when you had booked hotels and organized everything to a hair's breadth. I played along and said: "Forget it, kid. I'll just come in and say hello before we go." And as soon as I got in I saw his case there ready. He was just having a joke. After a few minutes' chat he said: "Well, we're ready, aren't we? Where's the car?" Sometimes, if I was tired and he said he couldn't come after all, I would just say: "Oh, bloody hell", and he'd smile and pick up his case immediately. He had got what he wanted—a reaction.'

Instinctively Pat felt her relationship with the artist had changed yet again: 'I was no longer the scruffy village kid, nor even the student; I was his jester, his clown.' She is, indeed, endowed with

an abundant sense of fun, and conversation with her is punctuated with bursts of infectious laughter that bring tears to her eyes.

'He came to visit my lodgings in Islington when I was at the Slade. I was with a very strict, very correct couple, Irish Catholics who were really kind to me. One day Mr Lowry asked if he could see my room and the landlord said: "Certainly not." Mr Lowry thought that was wonderful—"What do you think they thought we were going to do up there?" he kept saying afterwards, with great guffaws of laughter.

'Once he came to Knutsford, and our house was in chaos because I was preparing for an exhibition, and so I had booked him into the Royal George. But when we got there they hadn't a room for him and sent us across to a little private hotel. Brian carried the bags and I spoke to the landlady, who immediately assumed that Brian was the chauffeur and Mr Lowry had picked me up in Manchester. She showed us up to the room and shut the door on us. Well, we were rolling about, crying with laughter, and the next morning when I went to see him he was still crying, laughing about it. I think he was titillated by the thought that someone assumed he had picked up a woman. He loved saying naughty things, picking up a plate of his favourite lemon cheese tarts and saying mischievously: "Can I tempt anyone to a tart?"

'I suppose in a way we did look incongruous together, me with my back-combed hair and elaborate eye make-up. In Ireland I often used to see people eyeing us curiously, and I would nudge him and together we would speculate about them speculating about us. Mr Lowry was fascinated by my make-up, particularly my eyes. He would watch me intently, putting it on in the car, asking: "Why do you do that?" or saying: "Put on some more black stuff." He was disappointed I didn't wear nail-varnish; he loved long red nails.

'I had a friend, a girl called Valerie Boughey who was voted Miss Cheshire Rose; she was a sensational beauty, very slender, very black hair, very black eyes. She called one night when Mr Lowry was with us. I didn't know she was coming—he used to get cross if he thought you were using him as a social appendage. For once he didn't get angry. When she had gone he kept saying: "What a stunner, what a beauty." He never forgot her. I would often tell him: "Miss Cheshire Rose is in America now," or "Miss Cheshire Rose has married." I came to know his "type", his "Ann figures" as I called them, and would spot them for him; sometimes in a café when the waitress had gone, he would nudge me and say: "That was a good one, Pat." There was nothing sexual in his interest. He had no real understanding of sexuality, because, I believe, he had no experience

of it. I remember him being obsessed with a play called *The Devils*, starring Dorothy Tutin; he went to see it at least half-a-dozen times and was always talking about it. But the sexuality in it baffled him; I think he kept going to see it in the hope that one day all would magically become clear to him. I don't think it ever did.'

As the years progressed Pat came to see the increasing strain that exhibitions put upon the artist. 'He would be trembly and watery-eyed for weeks afterwards. They really made him awfully poorly. Sometimes, if it had been a big show, he would get an attack of the shingles. Each exhibition took so much out of him, but he never showed it to those outside. He never let on how much he *cared*.

'Often he would advise me: "Don't have a show yet, Pat." I tried to explain to him that I couldn't wait, that after a year or so of working I had to have a public reaction. I needed it. In the end I think he got fed up trying to slow me down. I had had twenty-one exhibitions and he couldn't understand why I went on. I dedicated my first London show to him and, although I had, of course, asked his permission first, when the time came it embarrassed him. He didn't come to the show. In the same way, if I ever booked a table for him in the name of Doctor Lowry he would get very angry with me and shout at me. He hated anything that smacked of pretension or pomposity.

'But when I dedicated my Salford show to my father, his reaction was quite different. He came to the opening, even though he had been ill, and was really sweet to me all evening; I'm sure he did it out of respect and affection for my Daddy's memory. And just as he was leaving, he came over to me in the middle of the gallery and kissed me on the cheek. I was so astonished and touched; he was not a man who liked personal contact and that was the only time in my life he ever volunteered a kiss. Latterly, in old age, he enjoyed a goodbye peck but he never returned it.'

Ironically, as time passed and Pat's dedication to her art, and the demands for her work, increased, the man who had done more than anyone to encourage her came to resent her preoccupation in much the same way that he had resented the lack of it in others. If they were sitting quietly together, on the sea-front or in the window of a Sunderland hotel, he would shout suddenly: 'Stop it', and knock the sketch book from her hand. His behaviour puzzled her, but she accepted it as she accepted him, because she loved him and he had given her so much.

Lightly she said: 'I think he really only wanted me around to cook his lamb chops for him. He often said that a good meat and potato pie was worth a hundred pictures.' Then, more seriously, she

added: 'Or perhaps he was trying to protect me. He didn't want me to be hurt by the art world as, I believe, he had been hurt. He didn't want me to *care* too much.' Lowry would have been the first to see beneath the protective shell of Pat's almost eccentric exuberance and to perceive the reality of her vulnerability.

She says: 'He left me a marvellous legacy: the memory of so much happiness, the sheer pleasure of his company and the privilege of sharing the thoughts of such an incredible mind.'

6 The Artist

IN NOVEMBER 1955 a young painter called Sheila Fell had a first exhibition at the Beaux Arts Gallery in London. Lowry went to the show with a friend, arriving rather disgruntled at having stepped into a puddle as he got out of the taxi. He grumbled audibly as he climbed the stairs—'First puddles, now stairs, why ever have I come?' He bought two large paintings and asked to meet the artist.

Sheila was just twenty-three years old, an ethereal, dramatic-looking girl with long, dark hair which she wore loose or sometimes plaited in a single coil over her shoulder. Her eyes were outlined with heavy black pencil, as was the fashion of the day.

A meeting was arranged outside Tottenham Court Road underground station one lunchtime early in 1956. Sheila was surprised to discover that 'we somehow recognized each other immediately', and she liked him instinctively on sight. Communication, however, was 'difficult, stilted' at first, as the two artists warily performed the ritual gambit of introductory conversation. They decided to lunch together at a small Greek restaurant of Lowry's choice in Bloomsbury. He had lamb chops; she had octopus, a fact that intrigued him almost as much as the amount this diminutive girl could eat: 'I was a student and always hungry.' He watched her devour her meal with fascination, asking about her work, her studies, her circumstances and her home in distant Aspatria, a Cumberland village he already knew from visits to Geoffrey and Alice Bennett. She

was somewhat on her guard, not knowing what to expect or indeed what was expected of her, but grateful for his interest; she thought he looked rather like Jacques Tati, with the same almost zany sense of humour.

Suddenly, and very abruptly, he leaned across the table and said: 'Look here, Miss Fell, how are you off for money?' She said she was all right. She always said she was all right, although, of course, she was not. 'Well,' he went on, 'I would like to meet your parents. I like your work and I would like to help you. Would £3 a week be agreeable?'

Sheila was reluctant to accept help. 'I wanted to struggle as I knew he had struggled. But, with some persuasion, I took him home to Cumberland and introduced him to my parents. Somehow it was all arranged between them, almost as if I had nothing to do with it. I got the feeling that he could have, would have, given me more, but he didn't want to make things too easy for me. He knew me very well. Right up until the time he died, he knew me very well.'

That summer and for many summer afterwards, Lowry 'hung his hat and his walking stick on the railings' at the bottom of their garden. Most times he came by arrangement but 'sometimes he would arrive unexpectedly for the odd weekend—once in his carpet slippers, by taxi, all the way from Manchester'. It was, Sheila said, 'the beginning of a long and, for me, very enriching friendship. Knowing him changed my life because, had it not been for him, I think I would have just gone down. Nobody liked my work. If he hadn't come into that first exhibition and bought, it would have been a total flop. He was the one person I could rely upon to buy and to keep on buying. We never did drift apart,' she said. 'Ours was the sort of relationship that renewed itself every time we met.'

He applauded her work both privately and publicly whenever the opportunity arose, and often when he had bought one of her paintings he would present it to a gallery—he sent one to Australia —so that she might become known to a wider audience. On Tyne Tees Television in 1968 he said: 'If you asked me seriously what artist did I like best of artists painting today, I would say Sheila Fell. The poetic qualities of a landscape, a mountain landscape, she's lived amongst it, born amongst it, and the quality is so poetic it attracts me very much—more than anybody else today. I think she's a very sincere artist.' On the same film she said of him: 'He's given me a lot of confidence—the thought of Mr Lowry working away all those years, in that sort of isolation, and without any pretensions and in complete honesty, just helps really in my own attitude. Whenever we talk about painting we only talk in this sort of way: he says things

like: "Nobody ever asked us to paint", which is a very chastening thought. If something hasn't gone right and I want to destroy it, he'll say: "Oh, pull it through, if you work at it long enough you can always pull it through." Very basic, commonsense advice.' As he wrote to Monty Bloom from Sunderland in June 1967: 'Sheila Fell's show is on and is doing very well, and up to now fifteen pictures have been sold—I am very glad and she must be very pleased about it.'

When Lowry was in London he would call upon his young protégée and together they would go to exhibitions, to the theatre and to concerts; they had similar tastes in music—Bellini, Donizetti, Mozart, Schubert, Vivaldi. Most times Sheila would choose where they went, not always with notable success: once they went to hear Verdi's *Macbeth* at Covent Garden which brought, from the old man, a number of loudly embarrassing comments. 'She's taking a long time to die, isn't she?' and 'Hasn't she gone yet?' and, when the last act had barely begun, 'Shall we leave now?' On another occasion she suggested they went to a new production of Pirandello's *Six Characters in Search of an Author*, starring Ralph Richardson. 'If that is what you wish, then we'll go,' he said. 'I'll get the tickets.'

He was, Sheila recalled, 'bowled over' by it. 'He went back to see it time and time again. Twice more with me, many times on his own. He painted the small girl in it, with her long dark hair, he painted the Six Characters; he talked about it endlessly, analysing it, wondering at it. It absolutely fascinated him.'

There was, indeed, much in the play to attract Lowry—and much in the author. Pirandello once remarked that he had no life outside his writing, and, like Lowry, he would sadly affirm that for himself he was nobody; he was whatever you wished him to be. He once wrote to an American critic: 'A man, I have tried to tell something to other men, without any ambition, except perhaps that of avenging myself for having been born. And yet, life, in spite of all that it has made me suffer, is so beautiful.'

The play, as Frederick May observed in his introduction to the Heinemann Drama Library Edition, is 'an ironic tragedy, the tragedy of man tormented by the enigma of personality, perplexed by the impossibility of arriving at truth, and forever questioning the nature and the purpose of existence ... he achieves intelligence only to recognize that he can communicate with no one, not even with himself, and that no one can communicate with him—that he is, in the fullest sense, alone'.

It was, Lowry told Mullineux later, 'the only time in my life I have been strongly influenced by a play. I went to see it nine times.

By the third visit I had become interested in the child with long hair. By the fourth I thought: "I'm gone, I'm gone—I'm bats about this child." Then I became interested in the six figures. I had got it bad. The visual aspect of those characters fascinated me. Then the child had to have a rest after such a long run and the second child didn't impress me like the first. Years before I had seen *Hindle Wakes* and that was an influence, an artistic influence; but this play was different, it affected me, it mesmerized me.'

Observing his reaction, Sheila later wrote: 'When the six characters moved en bloc, very slowly, in their black Victorian clothes, from back to front of stage, he was enrapt.' Curiously, when he came to paint the child he gave her modern dress, although still with the Pre-Raphaelite cascade of hair, and made her short and plump, rather than slender and ethereal. He gave the paintings to a later protégée, Carol Ann Lowry.

Since his death Sheila has found it difficult to disassociate his loss from the loss of her father, who died at about the same time. 'They were similar, in a strange sort of way, and they got on extremely well. He loved my father's stories of village life and his jokes, which he would make him repeat time and again and at which he would laugh until the tears ran down his cheeks, as if he had never heard them before.

'When he was in Cumberland with me we would go out together while I was doing seascapes, really big ones out in the open air in the wind, and when we carried one back to the car and put it in he would clamber in after it with his walking stick and his hat and sit there proprietorially and proud, as if he had done the work himself. Mostly he would just sit and watch or go for a walk; sometimes he too would draw and once, when we had worked all day, sitting facing Skiddaw, I looked to see what he had done: it was an industrial landscape.

'I miss his wit; I miss his humour; I miss him. He was a great humanist and no one ever seems to mention that. To be a humanist one has first to love human beings, and to be a great humanist one has to be slightly detached from human beings after having had great love for them; which is exactly what he was.'

After Lowry died, Sheila Fell, now a Royal Academician, was asked to contribute a few words to the R.A. catalogue for the 1976 Lowry exhibition. She wrote: 'My admiration of his work was and is enormous; but also of him as a man. As a companion he was marvellously humorous, inquisitive, mischievous as a child and gentle, but he was more than that: he had great shrewdness and understanding. In short, he was unique.'

7 · *The Godchild*

ON LOWRY's seventieth birthday, November 1st, 1957, there appeared on the front page of the *Manchester Guardian* a photograph of the artist with his latest work: a portrait of a girl, dark, slim, her hair parted in the centre and drawn severely behind her ears, her full mouth displaying just the hint of a smile. It was, he announced, the first portrait he had painted for nearly thirty years; he had done it, he added, because 'she insisted that I did'. Five months later, when the painting had been accepted for the Royal Academy's Spring Exhibition, Lowry was again photographed with the portrait.[1] The artist, in his paint-bespattered working suit—but resplendent in clean collar, tie and waistcoat—was caught by the camera, brush poised in mid-air, grinning hugely as if enjoying some private joke.

Now he was required to give this new work a name. It was, he said, a 'Portrait of Ann'. This only served to increase the reporter's curiosity. With some difficulty he elicited further details of the mysterious sitter from 'the reticent Lowry': she was twenty-five years old, lived in Leeds and was 'the daughter of some people who have been very good to me'. Almost as if to excuse the style of the portrait, he added: 'She is a modernist who did not want her picture to be realistic—it had to be stylized.' The sitter herself, he went on, could 'paint very nicely—when she likes'.[2]

The portrait caused the expected stir in the Royal Academy, coming as it did from an artist who, by this time, had become firmly fixed in the public mind as a primitive portrayer of northern land-

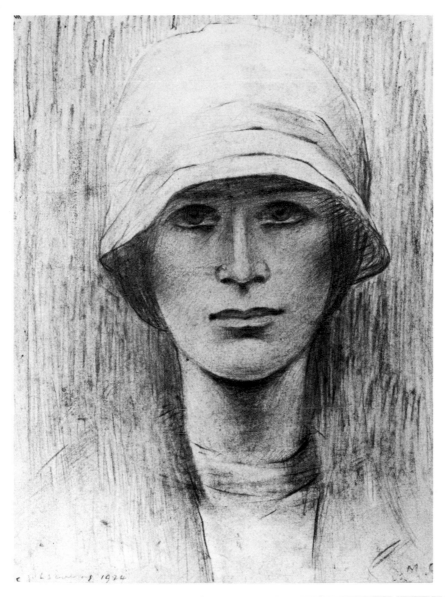

Woman in a Hat (1924). An early example
of the woman with the face of Ann. 'She was
Ann's mother,' Lowry told Hugh Maitland.
Note the mysterious initials 'M.C.'.
Private collection.

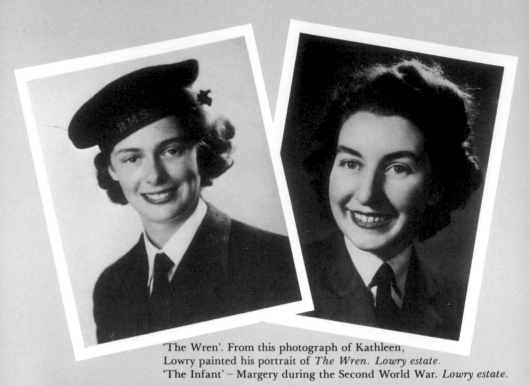

'The Wren'. From this photograph of Kathleen,
Lowry painted his portrait of *The Wren*. *Lowry estate*.
'The Infant' – Margery during the Second World War. *Lowry estate*.

'The Office Girl' – Doreen before her
marriage and emigration to Canada.
One of the many photographs of
Doreen in Lowry's possession.
Lowry estate.

XIV

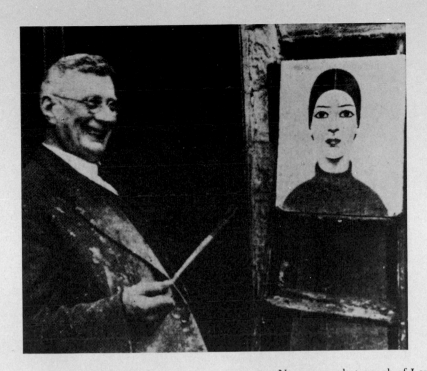

Newspaper photograph of Lowry with his first *Portrait of Ann* – and with an expression which seems to indicate some private amusement. *Photograph:* News Chronicle.

'The Clown' – Lowry with Pat on the steps of a hotel in Sunderland during one of their many holidays. *Lowry estate.*

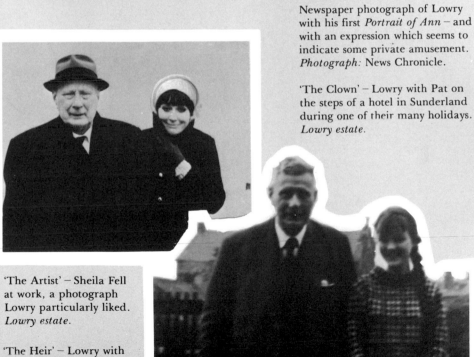

'The Artist' – Sheila Fell at work, a photograph Lowry particularly liked. *Lowry estate.*

'The Heir' – Lowry with a young Carol Ann on holiday in Sunderland. *Lowry estate.*

Six of the
drawings Carol
found among
Lowry's private
work after he
died. 'They
were,' she says,
'images of Ann,
not any one of us
specifically, but
perhaps with a
little bit of
all of us.'
Lowry estate.

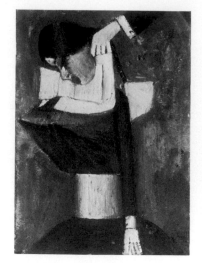 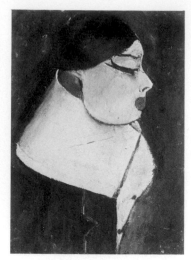

scapes. The critics, as usual, were divided; one found it to have a 'crudely stylized face',[3] another commented, apparently by the way, that the artist had 'never been in love'[4]; and yet another found it gave her the impression of 'an impassive yet wilful woman' and added that Lowry had told her that Ann was 'the only person who can tell him what to do'.[5] One encounter pleased Lowry greatly. 'A gentleman bore down on me, a very nice gentleman, I didn't know him. He said: "Excuse me, sir, are you Mr Lowry?" I said: "Yes." "Well," he said, "I admire your portrait over there." I said I was very glad. He was very appreciative. And he said: "My name is Russell Flint." I always liked him after that.'[6]

For the first time Lowry was experiencing the curiosity of those who look at a portrait to know about the sitter; in the same way generations of art lovers have wondered eternally about the origins and nature of the Mona Lisa. Good-naturedly, more often than not, Lowry would oblige: she was, he said, his godchild. Her name was Ann Hilder; at least, the name he gave *sounded* like Hilder—or it could have been Ann Hilda. In 1959 when the portrait was included in the Manchester City Art Gallery's Retrospective Exhibition of Lowry's work it was listed in the catalogue as 'lent by the sitter'. Although in the Gallery archives there is considerable correspondence relating to the borrowing of the other exhibits, there are no letters to or from Ann. So far as anyone there can remember, the picture was brought by the artist himself who gave her name, for the index of lenders, as Miss Ann Helder.

In this way Lowry's godchild, Ann, was introduced to the public. To his friends she was no stranger; although none had actually met her, they had heard stories of her many times. At least two of his friends, however, had heard of her in another guise: they believed she was the girl from Lytham St Anne's.

Pat Gerrard, when still a child, had often asked about the young girl with the long black plait whose picture had hung in his front room over the piano from the time of his arrival in Mottram in 1948. 'She was a young friend of mine from Lytham St Anne's,' she was told. 'She died when she was still a girl.' And Pat remembers: 'He cried when he spoke of her. I was very moved, and very sad for him. He took me to see the house in which she had lived and there were tears in his eyes when he looked at it.'[7]

Frank Bradley, the friend who had persuaded Lowry to move to Mottram where he himself lived, also observed two small pictures of a girl with dark hair 'scraped back' and, in one profile portrait, with a long plait. 'This girl, he said, was a pupil of his mother's. She died when she was twenty-five; he often spoke of her. It seemed

that he had never forgotten her. And, strangely enough, although there were a number of young girls in his life—in a nice way—every time he did a painting of one of them they all seemed to resemble this Ann. He seemed haunted by her as if he was continually searching for her, for a girl in this image.'[8]

Looking at these portraits many years later Edith Timperley remarked: 'Although the features are stylized, eyes and lips accented quite unlike the girl I remember in the Manchester Art Gallery, yet the general feel of the pictures, a sadness and patience, almost a resignation, do remind me of her.'[9]

Over the years the face of Ann—and there must be twenty of them—became progressively more mask-like, the eyes heavily outlined in black in the fashion of the '50s, the mouth sulky, the expression stern. As the artist once observed to Maitland, of a late full-face Ann: 'Rather surly-looking it is, only I couldn't help that.' He implied that, as with the 'horrible heads', he was not in control of the finished image. She was, like Pirandello's Six, a character in search of an artist.

Ann Hilder (or Helder) thus became a figure of mystery in his life; a girl who, some say, was a figment of his imagination, a composite of his ideal woman, who, because she was a fantasy figure, could never lose her mystery, her youth, or her innocence. But to those who heard him speak of her, graphically and affectionately, she was very much a real person; the girls who saw the animation in his face when he spoke her name and noted the warmth in his voice, came to believe her to be what they were not: important to him.

To the newly married Doreen, the 'Office Girl', he related how he had met Ann's father by chance in London and had come to know the family later; to Margery, he said he had met Mr Hilder at the Waverley Hotel after not having seen him for many years. To Geoffrey Bennett and Alice he said Ann was a 'very refined girl' he had met and taken a liking to. To Maitland he identified her mother as the subject of a painting he had done in 1923 of a woman in a 'white helmet sort of hat': 'She was a friend of my mother's; the whole family were.' The painting in question is a profile portrait of a woman with a plait who does, indeed, bear a remarkable resemblance to the Ann of the '50s. On the back of Lowry's own photographed copy of that painting he has written the initials 'M.C.' (Maud? Muriel Clementson? Or Mrs Mary Charlton who lived, in 1910, at 117a Station Road, Pendlebury, and whom nobody can remember? For a biographer the leads are frustrating.) The picture was painted on plywood board an eighth of an inch thick, backed by one of Peel Park, Salford, but in 1963 it was carefully separated

by James Brooke of Huddersfield. Said Mr Brooke: 'I think his motives for wanting the job done were largely sentimental.' Brooke, too, was told that the portrait was of Ann's mother.

Maitland received a rather more detailed version of the artist's connection with the Hilder family. 'I did once think of joining a friend—well, it was Ann's father—in stockbroking. His father had made a great deal of money and he did too. And the daughter is very well off, without her father and mother.' Had her wealth come from money she had made herself, Maitland wanted to know. 'No, from what she had left her,' Lowry replied; and he added enigmatically: 'She's a very lucky girl—and she's not quite such a lucky girl.' Somewhat baffled by this last remark, the Professor tried a different approach: 'She's not married, is she?' 'No,' said Lowry. 'I wish I'd tried to marry her but I'm eighty-three and she's thirty-seven—there's not much difference there, is there?' 'Well,' said Maitland, 'it's been known to occur before now.' 'Yes,' Lowry replied firmly, 'and it's very foolish.'[10]

This conversation took place in 1970; Lowry had thus put Ann's birth date as 1932/33, confirming his statement to Tony Ellis, many years previously, that his godchild had been born soon after the death of Maud who, it will be remembered, had gone to his father's funeral in February, 1932, had caught a cold and died. Records at the office of the Registrar General in London reveal only one Ann Helder born in that period; she is a fair-haired, married woman living in south London, who has never met Lowry. And the only Ann Hilder born in that era, although she is dark and single and artistic, also says she never knew the artist personally.

The anecdotes about Ann and her family are many; some familiar, some new and intriguing. Ann, so the story goes, was trained as a classical dancer in Italy and 'gave it all up'. The reasons for her retreat from a career in which she apparently showed brilliant promise—'she had very good notices'—are varied. According to Lowry's last housekeeper, Bessie Swindles, who was with him for twenty-two years, 'she didn't like all those men dancers handling her'. According to Doreen, she 'had proved herself able to do it and to succeed at it, and had no need to go on. She had proved her point.' According to Carol Ann Spiers: 'She came from a wealthy family and didn't like to think she might be keeping a girl who needed the money from a place in the company.' The company with which she danced is variously named as the de Basil, the Marquis de Cuevas', and the Ballet Rambert; yet, curiously, no one who was at that time connected with these companies can recall anyone of her name or description. Only Dame Ninette de Valois,

whom Lowry said Ann knew well, feels that 'Ann Helder seems to remind me of someone in our past history'.[11]

According to alternative sources, after her retirement from the ballet Ann occupied herself with painting at home in Pontefract/ working with the poor in Naples/running a business in New York/ doing social work in Reading. She played the piano and was responsible for introducing Lowry to the works of Bellini and Donizetti. 'She brought me some records and said: "I know you don't like this music, but just listen to it for me", and I did, and now I like them better than anyone.'[12] Once, while on a visit to her parents at home in Yorkshire (variously Leeds/Wakefield/the Rossendale Valley/ Pontefract) he heard a remarkable performance by a renowned string quartet in which Ann's father was persuaded to join. Their 'cellist was indisposed that evening, and knowing that Mr Helder was a skilled 'cellist they asked him to fill the breach. His virtuosity astonished them all, none more than Lowry. 'After the performance he quietly put his 'cello away in a corner and never, that I heard, played again.'[13]

In the '50s, Lowry told Margery, Ann had a picture accepted by the London Group; at that time Pat Gerrard was exhibiting with the London Young Contemporaries. And once, when she was drawing a scene in Edinburgh, a rich American came up and bought 'everything she had done'.[14] It was Ann who had first taken him to the Edinburgh Festival 'because she knew people who could get tickets for everything'. She stayed in Musselburgh[15] with her aunt, her father's sister, who had cared for the child during the war years after her parents had mysteriously disappeared for the duration: 'they were involved in very secret work that they could never talk about'.[16] Coming from a wealthy family, she was rather spoilt; when she was twenty-one she asked for a car and was given, by her father, a white two-seater Rolls Royce, custom-built at her request.[17] In this remarkable vehicle Ann and Lowry toured the country; in 1956 he had been to Devon with the Bradleys for a two-week holiday; he liked it so much, he told them later, 'that I took Ann there. She said we could see nothing from the car, so we left it and took a bus.'[18]

She visited him in Sunderland, where he was staying in the '60s, and went unannounced to the Stone Gallery in Newcastle-upon-Tyne, where the owners knew Lowry well. 'Ann came in here the other day,' he announced to them casually over a cup of tea some days later. 'Why ever didn't she make herself known?' they enquired, irritated at having missed a sight of this elusive lady in Lowry's life. 'She wouldn't do that,' he said, 'she's a very private person.'[19]

He told James Brooke in the '50s that he intended leaving her

portraits and his money to Ann in his will; he had, he said, already left instructions to that effect.[20] Years later he told Gladys Brooke, the restorer's sister, that he had changed his mind and was leaving Ann only the pictures of herself. After his death his solicitor, Mr Alfred Hulme, who had also helped Elizabeth Lowry make her will, stated that he had never heard Mr Lowry refer to anyone of the name of Ann Hilder.[21] The artist made no mention of her in his will.

Once he took Ann to visit Doreen, just before their departure for Canada. 'But we must have been at the back of the house, because when he told us they had been, he said they could not make us hear and they had not wanted to knock too loudly in case they woke the baby.'[22] Despite the fact that they had never met, Lowry wrote frequently to Doreen of the girl he called his godchild and of her family. In a letter dated Christmas Day, 1959, he said: 'I envy Mr Hilder; he retired four years ago and seems to be busy doing nothing.' In August, 1961, he mentioned, in passing, that Ann was now twenty-eight years old and in April, 1964, said that she was thirty-one, nearly thirty-two, and looked as if she was going to stay unmarried 'like her father's three sisters and her mother's only sister'. One of the aunts, he often related, lived in Musselburgh, and in April, 1964, he said that it was then nearly two years since she had died. In September, 1965, however, he gave Ann's age as thirty-five—an inconsistency that Doreen believed to have been due to his age. On 10th August, 1960, he sent to Canada a postcard of Pontefract Parish Church and wrote on the back that it was in Pontefract that the Hilder family lived.

In view of such a wealth of detail, it is hardly surprising that Doreen, as indeed do most of Lowry's close friends, believes implicitly in the existence of the Ann of the portraits, exactly as he portrayed her both in words and on canvas. 'I could not bear to think that he might have had to make her up,' she says.[23]

The critics are not so sure; Mervyn Levy accepts the portraits as fantasy, while believing in the existence of Ann Hilder, the godchild: 'They are composite archetypal portraits partly of his goddaughter Ann Hilder and partly evocations of his mother and the daugher of a farmer in Swinton Moss near Lytham St Anne's whom Lowry had met and grown close to on childhood holidays. She was also named Ann, and died when still a young girl in 1913.'[24] (In placing Swinton near Lytham, which is, in fact, fifty miles away, Mr Levy has confused the early Ann with the later Maud, so that they become one person.) He continues: 'Ann was therefore one of the Lowry dream women and played a role in his personal mythology

similar to that occupied by the women of Rossetti, an artist for whose sultry, goitred stunners Lowry possessed a consuming passion.'[25]

Many would dispute that Lowry's 'passion' was for the Rossetti women themselves; more likely it was for the artist's conception of them, for the 'workmanship' of the drawings and the 'painterliness' of the portraits. He did, in fact, explain it to Levy: 'I don't like his women at all, but they fascinate me, like a snake. That's why I always buy Rossetti whenever I can. His women are really rather horrible. It's like a friend of mine, you know, who says he hates my work, although it fascinates him. He's got seven pictures of mine.'[26]

More revealing, perhaps, are Lowry's words spoken to Monty Bloom in 1968: 'The Rossetti women are not real women. They are dreams. He used them for something in his mind caused, in my opinion, by the death of his wife. I may be quite wrong there, but significantly they all came *after* the death of his wife.'[27]

Was Lowry, in fact, like the Pre-Raphaelite poet, using his images of ideal women for 'something in his mind' caused by the death of someone dear to him? Of Ann of Swinton Moss? Or of Maud of St Anne's? Or of his mother?

8 The Heir

EARLY IN 1957 Lowry received a letter from a young girl in Heywood, Lancashire. She wanted to study art; could he help or advise her? He had many such letters in those days of constant exposure in the press and high saleroom prices for pictures painted long ago. In one respect, though, this writer was different: her name was Carol Ann Lowry. Could they, perhaps, be related, she asked?

He told Doreen, on the point of emigrating, about the letter, relishing the mystery of it all: 'What do you think it means?' But he did not reply to the letter. He put it, with the unwanted invitations and the old envelopes he used for incidental sketching, in the bulging wallet he carried in his inside coat pocket. The months passed; Pat married, Doreen emigrated.

One day in the late autumn of that year, alone in Manchester, he sat in Piccadilly Gardens wondering what to do with himself. 'I often did that. I didn't want to go home to an empty house.' An early dusk was gathering so that he could no longer clearly see the motley collection of homeless souls who passed their days on the benches of the square, isolated in the seclusion of their minds and their misfortune. A double-decker passed and, as he glanced at it, the name 'Heywood' on the front became suddenly clear through the gloom, as if fate had thrown the word into clarity. He took out his wallet and, finding the letter from Carol Ann, checked the

address: Heywood Road, Heywood. On an impulse he boarded the bus.

The conductor put him off in Heywood Road and, plonking his hat hard on to his head and turning up the collar of his raincoat against the later afternoon chill, he began to search for the house. At a dry cleaner's shop he stopped; it was Tuesday and the premises were closed for half-day. Quietly at first, then louder and more insistently, he knocked, while the street lamp behind him projected his silhouette grotesquely against the glass panels of the shop door. Slowly the door opened and in the half-light stood a child. She was thirteen years old, serious, slender and dark; her brown hair was drawn back from her face and hung in a single plait over her shoulder.

He stood and stared. Abruptly he said: 'I'm L. S. Lowry. Does Miss Carol Ann Lowry live here?' The girl was astonished. No one had ever addressed her so correctly before. 'I'm Miss Carol Ann Lowry,' she replied with all the confidence she could muster. 'I'm L. S. Lowry,' he repeated. 'Who?' said the child. Then, she remembered, realization dawned: 'Oooh,' she said, and opened the door fully, stepping aside to let him pass through into the living-room beyond. 'As soon as he was in he summed up the situation —two small children (I had a little friend with me), frightened out of their wits. He asked when my mother would be home. I told him seven o'clock and he quickly left, promising to return later.'

He did return later that evening, although Carol barely remembers the second visit; only her childish fear at the sudden arrival of this 'big stranger with his big presence', and her subsequent account of the day's great event to her mother, are imprinted firmly on her mind. Curiously, Lowry persistently told acquaintances who enquired that Carol and her mother had come to his house in the first instance, not he to theirs. Only to a few, such as Monty Bloom, did he tell the true story; possibly he feared the implication of too much sentiment in his journey to Heywood.

From that time in the autumn of 1957, and some months before he revealed his image of Ann to the Royal Academy, Lowry became to Carol 'more than my mother, or my father, or anyone. He made me. He moulded me. He fashioned me in his image of Ann and in so doing made me to a great extent like him. I was sufficiently young for him to be able to do it; and sufficiently malleable. I think he recognized that, right from the beginning. Had I been a different sort of person he would not have been able to change me, to make of me what he wished.

'Looking back, although I was not aware of it at the time, I think I was filling a gap in his life, supplying perhaps his need for a family. Yet ours was never a father and daughter relationship; he was more of a godfather, a fairy godfather who came along with gifts, not merely material gifts, but gifts of character and education. He taught me so much and displayed, by example, the virtues of perception, of humility and of humour. When he found me I was at an impressionable age and of an impressionable nature; I cannot help but feel it was fate that brought us together, that enabled each of us to fulfil a need in the other.'

When Lowry died, nineteen years later, he made Carol Ann his heir; he left her his money, his house and his paintings. Characteristically she withdrew, ignoring the overtures of the art world, to contemplate privately 'what he wanted me to do with it all'. She was amused by the inevitable speculation at the true nature of the relationship between the bachelor artist and the woman fifty-six years his junior: 'No one seemed prepared to accept the truth; they thought I was his illegitimate daughter or even his mistress—he would have been enormously amused at that.'

Carol Ann Lowry was the only child of William, a cotton-spinner, and Mattie, a weaver; she grew up in Rochdale, a quiet, thoughtful girl accustomed to and happy in the company of adults. In 1956, after some years of matrimonial friction, the indomitable Mattie, a woman whose diminutive stature only accentuated her fierce tenacity, left her husband, taking only Carol, the daughter around whom her ambition and aspirations revolved. Life was not easy and money was a particular problem for one who sought to give her child the educational opportunities she herself had never had. She sent the girl to a private convent school and worked doubly hard to pay the fees and buy the uniform. In the daytime, after she had left the weaving sheds, she cooked chips behind the range in a Bury tripe shop, and in the evenings helped out at a nearby hotel. There, one evening, she discussed with a local artist, Harold Hemmingway, her hopes and fears for her daughter who she had noticed was rather artistic. As Carol herself puts it: 'Drawing was the only thing I was any good at. I couldn't do anything else.' On learning their family name the artist immediately advised: 'Write to L. S. Lowry. He's fond of helping struggling artists and, who knows, you may even be related.'

Mrs Lowry went home, found pen and paper, sat her daughter down at the kitchen table and dictated a letter. 'I remember thinking what a silly idea it was,' Carol recalls, 'writing to someone we didn't know. But mother was like that—very ambitious for me. She had

a bee in her bonnet that it would help me. But nothing happened and we just went on with the routine. We never got a reply.

'When, months later, I realized who it was at our door that day, apart from being terrified, I was astonished. I could not wait to tell my mother when she got home from work. I had her tea ready for her as usual and once she had sat down, exhausted, I began prancing about, teasing and tormenting her—"You'll never guess who called today"—until she got cross and shouted: "Who?" "L. S. Lowry," I said. "What?" she shrieked, and leapt up. She not only dusted again, she washed-up again, made the fire again, did everything again, while I hovered round saying: "I've done all that."

When Lowry returned that evening, arrangements were made of which the child was not aware until very much later. He paid her fees at the convent, helped with the rent and arranged for her to attend Saturday morning classes at Rochdale College of Art where his friend Leo Solomon was then Principal.

If Carol was surprised at the precipitous way in which this elderly man entered, influenced and later preoccupied her young life, she cannot remember it that way. 'I accepted things as they came along. Without question. A fourteen- or fifteen-year-old now is very, very aware and questioning in a worldly sense; I never was. Even now I'm not. I still accept things. But then I was even more like that. I was not even aware he was a great artist, not for years. I think the first time it really dawned on me was very much later, when I had left college and was teaching, and I found myself one afternoon sitting with Tom Monnington and Uncle Laurie drinking tea at Burlington House. I suddenly thought to myself: "Here I am in the President's room at the Royal Academy with the President and Uncle Laurie."

'At first—and it sounds awful to say it, but it is true and I must be honest about it—at first he was, to me, just a person with endless supplies of money. He would come and give me, well, not presents right away, but visits to Manchester which was something wonderful. It was an adventure. We would go in by bus and back, sometimes *by taxi*, and eat in restaurants and talk and talk. My father was a spinner and Uncle Laurie loved hearing tales of days in the mill, of me riding on the bogeys of the trucks down the shed and of father coming home to soak his feet and pick out the splinters after working barefoot all day in the steamy heat.

'He seemed to be my friend right away—rather than my mother's. He treated me as a child, but in an adult way. He never talked down to me. Gradually, as I got older, our relationship changed although, again, I was not aware of it. He became someone

whose company I enjoyed, whom I loved, who was important to me, without me realizing it. I accepted him and his presence in my life without question. He was simply "Uncle Laurie"; the name seemed to come naturally after I had called him "Uncle" inadvertently a few times. It's funny, but in all those years of calling him Uncle Laurie and him introducing me, on occasion, as his niece, no one ever said, in my presence: "Well, come on then, how are you related exactly?" I'm sure they must have wondered and I'm sure some must have checked.

'I wanted to check once. And that is the only time in my life I remember him getting really, really angry with me. We were sitting in a café somewhere and I said that I wanted to go to Somerset House and find out; I would have been about sixteen then. He looked at me very seriously and said: "No, Carol, don't do that." "Why not?" I replied, "I want to know." "No," he said, "don't do it." But I went on and on until, finally, he got really cross and thumped the table with his fist and said: "You will not do it, Carol, you will not." I couldn't understand it at the time and then, later on, I found that I didn't want to do it anyway, that it was somehow irrelevant, unimportant whether we were really related. I believe that he had, in fact, checked himself or got someone to do it for him and, when he discovered that we were not, feared the fact might spoil it all.

'He was always, invariably, extremely circumspect in his behaviour towards me. I remember one rather curious incident very specifically; we were on holiday in Sunderland—I would have been about fifteen—and every evening he would escort me to my room at bedtime, see me safely to my door, then return to the lounge. I enjoyed the ceremony of his chivalry, of this protective escort. One evening, just as I was closing my bedroom door, he said to me: "Carol, do you trust me yet?" He told me, years later, that I replied: "Nearly"—although I don't remember my reply myself—which he thought was marvellous because he took it that I understood what he meant. He took it that I knew *nearly* that I had no cause to fear him in any way at all. Looking back I suppose it was strange for me, a child, to go everywhere with him, a man who had been a stranger. I suppose he was aware of this, even if I was not; as I say, I was very unworldly. But he knew what the world would think.

'Very much later, when I was grown up, people put it into my head that he might have felt differently towards me, as a man feels towards a woman, but I absolutely cannot believe it to have been so. I don't think there was ever a physical thing for him, with any woman. He was a passionate man, but not in the way that we understand passion, with all its sexual undertones: he was passionately

involved with the mills, passionately fond of music, passionately involved with his mother.... I never saw any of the possessiveness or jealousies that others talk of. We would discuss together subjects like love and marriage, in relation to me and my future, and he never displayed any resentment, any fears for me, in that respect. In a way he used to shield me from "naughty things" and gave me the idea that he was very prudish, a real Victorian, although, at the same time, I was aware that he was very broad-minded. He accepted, for instance, that people lived together and that they had children outside marriage, and I knew, somehow, that if such a thing had ever happened to me I could have gone to him and he would have helped me to do whatever I thought was right. He would have said: "You must do what you think best, Carol." He only led and guided you, never made your decisions for you; he would never presume to try to sway you, but would simply indicate perhaps by a gesture or a look whether he approved of your actions or not.'

Throughout her years at college—first at Hornsey, where her work was not noticeably successful, and later at Swansea, where she qualified as an art teacher—Lowry wrote to her and visited her and took her away on holiday to expensive hotels in London, or north to Sunderland and Scotland. He gave her a more than generous allowance and, when she began teaching, settled a five-figure sum upon her. He did not tell her that, in 1970, he had made his will in her favour. 'He had given me so much, I didn't expect any more; I wish he *had* told me—I could then have asked him what he wanted me to do with it all.'

From college she wrote to him of her life-style, of her holidays without him, of her boy-friends. 'I'm glad you have a friend of your own age,' he would reply. 'Friends are very very important in life.' He urged her to work hard—'You can do if you will, you know, I feel sure of that'—and, on occasion, prodded her gratitude to his friends for their help—'Pardon my asking, but have you written to Mr Solomon thanking him!' He was not adamant in his sponsorship of her career as an artist; she felt he would have financed whatever training she had chosen. 'Once when, in a fit of childish enthusiasm, I said I wanted to be a doctor, he looked at me with great interest and said: "Do you? Well, I'll help you, you know."' He painted her only once—'A little image in which I can see nothing of me, but my mother can; she enthuses about it; he must have captured an essence of me that only others can recognize.' And yet, he told Maitland, he had often wanted to do Carol's portrait but feared the result would not please her—'and so I never did'. When eventually she gained her Art Teachers' Diploma he addressed her letters Miss C. A. Lowry,

A.T.D.—'He never bothered about his own degrees but he made such a lovely song and dance about mine.' He was, she says, everything a friend, a godfather should be: 'He was always interested and interesting, never boring or bored, was eminently generous, kind and understanding. And he was always *there*.'

When she felt the need to contact her father again, yet feared to hurt her mother, she confided in him and received the reassurance that she must do what she thought right, that it was her life to lead and not her mother's. Curiously, when she did eventually re-establish a relationship with her father, she found in him many of the attitudes to life once displayed by Robert Lowry: 'When I hear of Uncle Laurie's father,' she says, 'I could almost be hearing of my own. I feel deep down that, no matter what people say or how they scoff, we may well be related far, far back.' And, again curiously, Carol seems to have been the one person to whom Lowry presented a sympathetic and understanding view of his own father: 'He always spoke to me of him in tones of respect; perhaps that was because I was a child and he felt I should grow up with respect for my parents, as indeed I did.'

It was, therefore, in complete and total confidence of his understanding that Carol married, quietly and without forewarning, one day in 1974 on the Isle of Man. Despite his age, Lowry had, some months earlier, travelled to visit Carol on the island, where she was teaching, and had met John Spiers, the man she had already decided was to be her husband. 'They did not have time to get to know each other properly,' she says, 'but I wish they had. I feel they would have liked each other. They are similar in so many, almost intangible, ways.' (Carol's husband is more than ten years older than her, a point which is worth mentioning only in view of the fact that Kathleen also married a man many years her senior.)

Carol did not tell Lowry of her feelings during that visit. But he must have sensed them; on his return to the mainland he discussed endlessly the advent of a new man in Carol's life with their friends the Marshalls of Newcastle-upon-Tyne. 'Do you think she'll marry him?' he asked of the perceptive Phyllis Marshall, and when she said 'Yes' would repeat, again and again: 'She didn't say anything. Why do you think she didn't say anything? What do you make of that, Mrs Marshall?'

But Carol had told no one. She wrote simultaneously to both her mother and to Lowry, a day or two before the event, timing the arrival of her letters so that they should arrive too late for objections. Of course she had expected none from Uncle Laurie, only from her mother. Mrs Lowry did not approve of her choice of

husband; no man would have been good enough for her daughter. Carol would dearly have liked to have confided in her protector but, fearing that to include him while excluding her mother would have inflicted even more pain, she did not. It was a difficult decision to make, but once made she felt it to be right. By this time, having reached the age of thirty, she had enough confidence in her own judgement and sufficient determination to follow the dictates of her own heart without deference to her mother's wishes. She had, after all, been well-schooled. 'Do what you think right, Carol,' Lowry had so often said.

When next they met he displayed no resentment, only an apparent understanding of what she had done and why. He seemed, as she had fully expected, to be in complete sympathy with her actions. In retrospect, however, Carol wonders if he was hurt by her exclusion of him from her plans. 'He never said anything to me that indicated, even obliquely, that he might have been; I sensed no change in his attitudes or his affection towards me. But many people have told me since that he was indeed very upset. Perhaps I misjudged the situation, or the strength of his possessiveness of me. I hope I did not. I hope he was not hurt. I would never have intentionally hurt him, not for anything.'

Friends and acquaintances, however, observing that he had not been present at the wedding, assumed a rift. They presumed he would now change his will, but he did no such thing. He left everything just as it was, just as he had decreed in 1970. He remained 'Uncle Laurie' to the end, receiving John and Carol in his home and presenting them with his treasured oil painting of three cows by James Lloyd, an artist they both admired.

Despite repeated prompting from a pressing multitude of interested parties, Carol does not assume her part in Lowry's life to have been more important to him than any other. 'I think,' she says, 'that I was simply the tag-end of what I, for want of a better description, call the Ann thing. I filled a gap when he needed it and, perhaps, had he lived longer or had he been younger when we met, he would have passed from me to another, younger Ann. I was fortunate, enormously fortunate, that I was the last.'

9 *Epilogue to an image*

IN THE GREY, cold days after Lowry's death, when his will was still
the subject of excited and ill-informed speculation, Carol Ann Spiers
received a call from the artist's executors, his old solicitor and an
official of his bank. There were some private things that had been
found in his house and now rested, officially sealed, in the vaults
of the National Westminster Bank in Manchester. It was advisable,
they felt, that she should know of them.

In a state of some curiosity and a certain trepidation, which had
somehow communicated itself from the executors to the heiress,
Carol presented herself at the bank. Ceremoniously she was taken
to the vaults where, with much embarrassment, a collection of un-
seen Lowry works was revealed to her.

There were drawings and paintings, some meticulously finished,
some barely begun, of a young, slender girl, her dark hair drawn
into a single plait. She is dressed as a ballet dancer, a doll, a puppet,
her costume cut low to reveal the sensuous curve of her breasts or
the dark shadow of her nipples. Some are delicate, tender, innocent;
others violent and bloody; in one her head is severed from her body
with a mighty sweep of an axe, in another with a sword, in yet
another with a knife. In one she is prostrate beneath a guillotine,
her head half-separated from her body. In some the collar of her
grotesque costume is monstrously huge, like an instrument of
medieval torture, so that it strangles her, twisting her head into atti-
tudes of agony. She is always alone, the presence of a man only occa-
sionally indicated by the hand that wields the weapon. Only in one
oil is another presence suggested, a shadowy, ghostly shape who

stands behind, less an observer than a puppet-master, a man who pulls the strings.

As she stared silently, almost in shock, Carol, the girl he had protected from 'naughty things', felt herself flushing, silently appealing: 'Oh no, not Uncle Laurie. Please, dear God, not from Uncle Laurie.' Then, with an awful chill of sudden recognition, she felt herself go cold, the tiny hairs on the back of her neck bristling at the thought: 'My God, it's me. They are me.' She had observed, on at least two of them, her own distinctively retroussé nose, the unmistakable upward tilt that distinguished the profile of the tortured girl from the more classic features of the Coppelia-figure throttled by her theatrical yoke. She felt her blushes deepen and glanced surreptitiously at the two men to see if they had seen what she had seen; their faces were official, impenetrable. Then, as she still stared, not liking to dwell too long on any of the paintings that now lay before her, a new thought dawned. 'No,' she told herself, 'it's not me. It's Ann.'

It was only days later, when she was able to look privately at these strangely beautiful yet enormously disturbing works, that she was able to think clearly about them. She says now: 'They are not me explicitly. And they are not Ann the Godchild. They are the dream figure—the image of Ann that haunted him more than anyone, more than any one of us, realized. They are the essence of his real, his secret, his private image of Ann, whoever or whatever she was; the one who somewhere, sometime in his life, hurt him dreadfully. Or perhaps it was all of us, each in our own way, who hurt him.'

Thus Lowry's Image of Ann takes on a new importance, revealing in his hidden paintings a fearful frustration and dreadful pain of which he could not speak. Such a collection, from the brush of an artist renowned for his vision of the Industrial Revolution, is something so inconceivable that, when whispers of their existence—inevitably greatly exaggerated—were murmured among his friends, the majority denied the authenticity of them. 'He could not have done them,' said Pat, vehemently, 'unless it was for a joke.' She had not seen them. 'I don't believe they could be his work,' said Sheila Fell, deeply distressed by one drawing she had seen reproduced. Only Carol accepted them as his; she had no alternative. She knew where they had been found; and there was no denying his immaculate workmanship. Later she was to find among his private papers similar violent sketches, on the backs of Christmas cards or bills, and torn segments of tortured figures painted on both sides of heavy cardboard, which she painstakingly tried to fit together in an attempt to discover the secret of Ann. It was an impossible task.

A year or two after his death she was able to contemplate them rationally and honestly. 'I know there is a lot of me in them; there is an essence of me in the same way that Edith Timperley can see an essence of the girl she met in the later portraits of Ann Hilder. There is a little bit of each one of us in his secret drawings; or, perhaps, a little bit of her in each of us. But who can say which of us was the source, the original, the true Ann?'

And so, despite much research and many questions, the truth of the origins of Lowry's image of Ann remains, as he would have wished, as much of an enigma as her creator.

Who or what was she? Was she the first Ann, the girl from Swinton Moss who in dying young retained her innocence? We know so little of her, save that he was 'fond of her', and that she had the patience and concern to help him with his mother. And was she the slight, dark girl who opened the door to receive the laundry from young Jack Gallagher so many years ago?

Of Maud, who sacrificed her career to preserve her virginity, we know slightly more and yet nothing that can be confirmed or verified. Maud was a rebel and resisted parental authority (so too was Kathleen, and Margery). She played the piano, as did his mother; and tennis, like the many '20s girls with their plaits and bows of his early drawings. She was a dancer, and so it would seem was Ann Hilder (Sheila Fell also trained for the ballet in her youth).

The frail, gentle child whom Edith met has no name, but she is the first of whom we have a physical description. She was small and dark and ethereal, like Margery and Pat and Sheila and Carol; and, according to the portraits, like Ann Hilder. She was vulnerable and sensitive like Carol Ann, and he treated them both with 'immaculate concern'.

Then there is the mysterious 'M.C.' who, he told Maitland, was Ann's mother. There is indeed much in her of Ann of the portraits—but also much of the good women of the Ancoats Settlement, of the early warden Hilda Cashmore, and Alice Crompton who was his mother's friend. There was indeed an 'M.C.' at the house in Lytham St Anne's where he said a girl called Ann once lived; but the people there insisted that they did not know the artist. In the early records of Pendlebury residents there is a Mrs Mary Charlton listed at 117a Station Road, a number that present occupants cannot identify but suggest that perhaps at that time—around 1910—the house was shared by two families; those same records list a Miss Ann Charlton living in Chorley Road, where Lowry went later. No one, it seems, can remember them.

Strangely, none of the girls tried to identify the nature of their

appeal for Lowry. Today, in maturity, they all use similar words: innocence, childish honesty, vulnerability; and youth, always youth. The darkness of their hair he liked; yet Kathleen was fairish and, she remembers: 'Once when I had been on holiday and my hair had been bleached almost blonde by the sun, he was aghast. "What have you done to yourself?" he kept asking. "Have you dyed it? Will it go back as it was?"' And Carol remembers when at the age of sixteen she had her long hair cut he was obviously upset. 'He said nothing, but I could tell he didn't like it.' Until that time he was constantly asking her to tie up her hair, and the photograph he kept in his bedroom until his death was of her just as she had been when first they met.

The girl in the secret drawings has a plait, as his mother had; also the early portraits of Ann Hilder, the 1924 'M.C.', and the tennis girl of Lytham St Anne's—the childish bow now grotesquely exaggerated like the collar she wears. But she has also the stern regard of the godchild and of Margery. In some she has the innocent smile of Kathleen and of Doreen; and, almost invariably, the theatrically accentuated eyes of Pat and of Sheila.

In the last decade or two of Lowry's life, when his dedication to the compartmentalization of his relationships had become less marked, his friends noted and wondered at the intensity of his preoccupation with the girl of the time. Some, such as the Rev. Geoffrey Bennett, disapproved. 'Has he got a girl with him this time?' he once asked the Marshalls. 'Only his niece,' replied Tilly. 'Ah,' remarked the reverend gentleman, 'that's what he is calling them now, is it?' The last one was his godchild.' Mrs Marshall was fascinated by this facet of Lowry's behaviour, pondering often the nature of each relationship. Pat and Sheila she could understand—they were artists. Carol she saw as a protégée, a girl whom he believed in all sincerity he had saved from a sad, short working life in the mills. Only Ann Hilder did she view—and her views were of necessity based on his words and attitudes alone—in a romantic light, believing her to be a woman of culture and wealth.

But was Ann Hilder any different, any more important than the others? Is she the real Ann? Or do we merely assume her to be so because she alone remains a mystery figure, substantiated only by her name on his public portraits of her? There is no record of her in his personal papers, or in his diaries; no letters from her were to be found in his estate.

In the memorabilia which cluttered his old house there was only one photograph of a girl who bears an almost irrefutable resemblance to the gentler girl of the godchild portraits; yet if, as Lowry said,

she was born in 1932, it cannot be her. She stands, smiling sweetly, a bridesmaid in a wedding group posed on the steps of an unknown church and taken, at a guess, in the late '20s or early '30s. She can be no less than twenty; she is small and dark, her hair parted in the centre and drawn softly behind her ears. On the back of the print there is no name, not even an initial.

Is Ann then a composite figure, as his industrial scenes were so often composite views? Was she a fantasy of the love he never fully knew yet always hoped to find? Was the pain she inflicted upon him a composite pain of a man shackled by the repression of his child-hood?

The influence of Rossetti on his image of Ann cannot be denied. And it was Lowry himself who said of the Pre-Raphaelite paintings: 'They are not real women. They are dreams.'

Was Ann, too, a dream? Or a girl from his youth who abandoned him by her death? Or a later protégée who deserted him by her mar-riage? Or even his mother, whom he saw for ever in her own image: frail, delicate and eternally vulnerable, and who, in the end, rejected him more than any other?

PART FOUR

The battle of life

'Congratulations and honour to you, Sir,
because your work is honourable! The inventions
of your art, full of compassion and wit,
are in the manner of the old masters, and you
are no less worthy of fame and praise than
any other artist.'

Words upon Brueghel's birthday by Lampsonius

1 The dog with five legs

IT COULD almost be said of Lowry, as Hugh Maitland wrote privately, that life began at the age of fifty-two. It was not an opinion the Professor expressed to his friend, being well aware that Lowry would in all probability take it as an indication of lack of true understanding of his real feelings. Quite evidently Lowry himself felt that significant, purposeful life had ended on October 12th, 1939, and that everything from that time on was mere existence, a dutiful fulfilment of the role that fate and circumstance had allotted him. He would admit only that 'my life altered utterly and completely after she [his mother] died. After the end of the Second World War in 1945—in the first part of the war you could not do anything because of the barbed wire all over the place—but after 1945 my life altered utterly and completely.'[1]

His initial reaction had been to *give it all up*: 'I've tried three times to stop. After my mother died ... for three months. And I said I'd have to get something, I'd go mad. And twice since. I can't say what kept me on, but something did. Isn't there, at the beginning of *The Pickwick Papers*, a cab driver who had a cab with enormous wheels and when he once starts off, he can't stop? Well, I'm like that. I can't stop. It's a pitiable story.'[2] Ignoring the self-parody, designed simply to extract the pathos from what was, in truth, a pathetic situation, the fact remains that he was, and always had been, addicted to his art; it was, he said, 'like a drug to me'. This is not to belittle the effect of his bereavement upon Lowry, which was deep and enduring, but to recognize rather the strength of his need to paint.

His art was indeed an effective antidote to the grief he never ceased to feel and he valued its restorative powers. When Percy Warburton lost his wife in the '50s, Lowry wrote in concern to his old

master: 'Are you keeping occupied? To be occupied with something, no matter what, is the great thing.'[3] Therapy was not his prime concern, but he had a new motive for his labours, another disguise for dedication. 'It's a marvellous way of passing the time,' he would announce, adopting as usual the façade of unconcern and adding to the popular conception of him as a primitive dilettante who daubed for want of something better to do—a kind of artist *malgré lui*.

In fact, by this time, the parodox was made, the persona fixed, like a mask an actor wears and cannot shed; nothing that was to happen to him from the time of his mother's death to his own was to change him basically from the man he then was. Fame and fortune were to come, honour and understanding and all that he had once most desired. Films were to be made of him, much was to be written about him and more said; but the effect upon him was as of rain upon granite. He changed a few of his ways, adjusted a few attitudes, bought a few things, but his life-style remained the same—the frugality and abstention from indulgence as seen in the non-smoking, non-drinking, non-womanizing habits of a lifetime. His modesty and humility remained, and his determination to go his own way as an artist. The enjoyment he derived from his observation of what he liked to call the great Battle of Life was enough to bring him contentment, if not actual or lasting joy.

He liked to think of himself as a rock upon which his personality remained invulnerable, but he was not completely invulnerable no matter how hard he pretended to be. His attitude towards the painter Ayreton, his most vociferous critic, is an example: had he not cared what others thought of him, he would have dismissed the man from his mind. He always pretended that he did not read the newspapers, that he did not want to know what was said of him. The truth is that, from the time of his first London exhibition in 1939 to the date of his death, he subscribed to not one but *two* cuttings agencies which kept him constantly informed of world opinion of him.

During the early years of the war Lowry was beginning to feel the first twinges of advancing age. Even before he was fifty he complained of feeling ancient, though without any particular symptoms. Now he was saying: 'My rheumatism is very bad—every time I remember about it it is very bad indeed.'[4] Although he claimed to have been restricted by age and 'barbed wire', this did not noticeably limit his attendance at work, or on Debenham's roof, or indeed in London. He complained that he had nearly broken his left ankle 'and it hasn't been quite the same since'[5] during a blitz in 1941, but he continued to appear regularly in the places where local artists habitually gathered.

By this time the Manchester Academy had succeeded to some extent in overcoming their accommodation problems. They bought a house at 10 Acomb Street as a student centre where members were encouraged to drop in after Saturday afternoon life class for a few words of advice and a cup of tea. It was here that Lowry encountered Hugh Maitland, a Canadian who had been Professor of Bacteriology at Manchester University since 1927. Maitland was now much alone, having sent his wife and children to Canada for the duration, and thus welcomed Lowry's companionship. As it turned out, Mary Maitland, also a skilled bacteriologist, returned to Manchester in 1942 and, from that time until the illness that led to her death, continued to work at her husband's side on the development of a foot-and-mouth vaccine. They published papers on their research, both separately and together, and when in the '60s the Professor was invited to open the Department of Bacteriology at the new University of Malaya in Kuala Lumpur, she went with him, planning everything from the basic curricula to the positioning of the benches in the classrooms. With characteristic resentment at their departure from his circle, Lowry declared such an upheaval 'at their age' to be 'extremely foolhardy'.

Mary Maitland, although very much the academic, was a soft and tender woman of remarkable beauty who found in their new friend a constant source of fascination; it was she who, years later, encouraged her husband to embark upon his Lowry biography. The artist, for his part, was delighted by the medical tales they told and, adopting and adapting them, absorbed them into his own fund of anecdotes.

Hugh Maitland, a very correct man who, like Lowry, addressed even his closest friends as Mr or Mrs, was also a member of the Manchester Academy and had no inhibitions about describing himself as an amateur (although of course he was an eminent professional in another field). He used his painting as a pleasant relaxation from the strain of laboratory work without, as his daughter puts it, 'getting up-tight about it'.

It was Maitland who first introduced Lowry to a man who was to become one of his earliest and most enthusiastic collectors. The relationship of Lowry with Alec and Catherine Laing of Droylesden was initially that of artist and client, but it soon became far more. At Lowry's invitation, Maitland had brought the couple to Station Road in 1940[6] where, without hesitation or haggling, Laing bought three industrial paintings. Lowry was astounded. It was not so much the fact that someone had bought, though in itself this was strange enough, but rather that the paintings selected were industrial scenes.

'No one had ever liked them before,'[7] he said, conveniently forgetting McNeill Reid, Daisy Jewell, Bernard Taylor, Eric Newton and others; but they were critics or dealers and so, presumably, did not count. The nature of the man who had made such a choice was also important to Lowry. Laing was a General Practitioner of private means who already owned a good collection of pictures: a couple of Constables in the dining-room, a Whistler in the bedroom, a Boudin in the living-room.

Laing was an eccentric, and an atheist, who displayed his disbelief with as much fervour as a convert displays his faith. He called his mongrel dog 'Jesus' and delighted in shocking the inmates of Ashton Infirmary, where he was honorary pathologist, by stalking the grounds of an evening declaiming loudly 'Jesus come here', or even 'Jesus, heel'. Letters to Lowry invariably ended with a postscript: 'Trust in the Lord—and starve.' Although not a church-going man, Lowry was a believer: 'I'm sure there's *something*,' he would say. 'There must *be* a God. I can't imagine it's all waste. It's hoping that there's something better later on that gives us something to live for.'[8] With amusement he noted that his friend's protestations became noticeably subdued with advancing age and the disturbing possibility of having to meet his Maker.

Laing's wife, a former hospital matron, was equally unconventional; when she had to have her gall bladder removed she insisted on the operation being carried out under local anaesthetic so that she could monitor progress by means of a mirror. Like her husband she addressed everyone by their surname; the surgeon's name was Oliver Jelly and throughout the operation she demanded repeatedly: 'Jelly, what are you doing now?'

Lowry delighted in their company and, with the Maitlands, became a regular visitor to the rambling old house in Droylesden where the lawn stretched down to the canal. Sundays were spent either there or at the Maitlands' home in Victoria Park, where Lowry would arrive for tea with a couple of his pictures, much as an uncle takes a favourite nephew on an outing. 'He liked to give them an airing, to see them in different surroundings,' commented Maitland.

Now there were new companions to join Lowry at the Hallé; Laing was as knowledgeable about music as he was about pictures and was himself an accomplished violinist, although he refused to play his instrument anywhere except in the bathroom—the accoustics there, he declared from his perch on the edge of the bath, were better than anywhere else in the house.

After Catherine Laing died in the '50s, Alec remarried, at the age of eighty, a woman some twenty years younger than himself.

The second Mrs Laing did not take to Lowry and the relationship faded, but not before Laing had acquired some twenty Lowrys which, when he died, were sold for high prices at Sotheby's. *Good Friday, Daisy Nook*, which Laing had persuaded Lowry to paint—he had in fact taken him to the spot to see for himself how suitable a subject it was—achieved a record price for a Lowry of £16,000 in 1970.

Laing's interest, first exhibited to his recollection in 1940, became an integral feature in the series of events that had served 'to keep me going'. When Lowry related this to Maitland nearly thirty years later, the Professor was sceptical. He had not been aware that he had been instrumental in stimulating his friend's motivation to such an extent. He was, however, conscious that Lowry had begun painting his 'empty seascapes' during a holiday they had spent together in Anglesey in 1942 and recorded it with some pride. Lowry at first declared this innovation to have been inspired by boredom[9] but later, as much with regard for his companion's feelings as for the critics' interpretation of his mood, he translated 'boredom' into 'loneliness'.

Lowry was insistent about Laing's place in his 'destiny' and Maitland reported that the artist was 'on the point of giving up painting and going to live in Berwick-on-Tweed but that the purchase of these paintings by Dr Laing made him change his mind and decide to carry on'.[10] Finding such an assertion difficult to accept, Maitland added: 'He relates with an embroidery of detail that he had a particular house in view and went so far as to have an architect friend inspect it. The house, however, was affected by dry rot and could not be recommended. He knew Berwick and two pictures of subjects from there were included in his first London exhibition. At that time he liked the place but later on he says he came to dislike it. The mere idea of what he states he was intending to do seems to ignore ... possible adverse financial consequences of going to Berwick and the question of his future occupation.'[11]

Maitland could hardly probe for enlightenment: Lowry was not aware that Maitland knew he was working at Pall Mall, and the Professor felt that to have revealed that knowledge would have ended their collaboration. Nor was the artist likely to respond to further questions about reasons for the move; he had said all he wanted to say on the subject. He told Maitland that when he first started visiting Berwick he knew no one there, but later 'got to know people'. A later friend believes that there was yet another 'Ann figure' in Berwick and that she was the lure. (To Doreen, Lowry had often spoken of a girl called Margaret, the daughter of a close friend of

Grace Shephard, who married a man called Peter. In a letter dated September 2nd, 1959, headed 'Berwick-on-Tweed', Lowry wrote: 'Miss Hilder and I are spending a day or two with Margaret and her husband who are as well as might be.' According to Doreen, Margaret of Berwick comes after Maud and before Ann Hilder, and was spoken of quite as frequently and with equal intensity for a brief period.)

Lowry himself put the attraction of Berwick at this time on a less romantic level: he had seen a house, he told Maitland, with 'two pot lions' at the gate, which was so ugly that he immediately wanted to buy it; years later he took Philip Robertson[12] to see it.

'It may be,' Maitland observed, 'that the loss of his mother had engendered a violent and seemingly unreasonable reaction against his situation as he saw it at the time. The purchase of three small pictures [by Laing] appears to be a small matter to have produced so marked a counter-effect. The only point in recording the whole episode is to cite an instance of one of the baffling oddities that emerge from Lowry's personality.'[13]

Again Lowry's determination to endow his patrons with a significant role in his destiny had caused yet another time-slip in his memory; just as he had put the Rev. Geoffrey Bennett's desire for the line drawings thirty years too early in his career, now he advanced talk of the Berwick move by five years in order to give Laing's advent a more rational importance. He had indeed thought of moving further north, but in the late '40s, as he revealed in contemporary letters.

The eventual move from Station Road, the dark house with its memories and the locked room in which his mother had died, was instigated more by circumstances than by a genuine wish on his part. Not long after Robert died the property had been acquired by the late Louis Duffy, a local printer and bookbinder, who established a cordial relationship with his strange tenants. His wife would sometimes visit Elizabeth and received for her pains the gift of a painting; it was not of course an industrial scene, but a conventional and therefore acceptable still-life, done in 1906. Subconsciously Duffy found himself adopting the patronising attitudes of amused tolerance with which most local residents treated the artist. 'Is it any good?' he would ask when they met, indicating the inevitable canvas under Lowry's arm. 'I'll give you a bob for it.' Lowry would grin and reply: 'Not worth it,' as he went on his way.[14] Towards the end of 1946 Duffy began to receive complaints of No. 117 from the immediate neighbours; the garden was overgrown, the windows dirty, the appearance of the house so neglected that it lowered the tone and

value of the terrace. These were matters that had been causing the landlord some concern ever since Elizabeth's death. He and his growing family were confined in a much smaller place, at 72 Chorley Road, and so, with some diffidence, he suggested to the artist that they might exchange houses. The deal was agreed and, in June 1947, Lowry abandoned the home in which he had lived for nearly forty years. 'It was advisable,' he said. 'I was advised to do so. There had been two deaths in the house.'[15]

When the Duffy family moved into No. 117 they found the house stacked with paintings: on cardboard torn from boxes, on bits of old plywood, on the bottoms of chairs. Louis Duffy burned them all. 'I didn't think they were much good,' he observed in 1962. 'This was in 1947 and Lowry didn't have the reputation he has now. All that oil made a fine old blaze too.'[16]

Lowry did not take easily to his new surroundings. Reporting the move to a friend, he wrote: 'I'm now busy looking for a permanent house (I am using this for the most part as a workshop). It is very difficult to find what you want—I got out of a house far too big for me into this one. The penalty of having too tender a heart! I have been in Berwick-on-Tweed a lot lately.'[17] A month later he remarked: 'I'm still as unsettled as ever',[18] and again in August, 'I am no more settled than I was.'[19] In January the next year he wrote: 'I simply cannot get into the sort of house I want. The last one was requisitioned by the City Council: after dallying about for four months or so, they bought it at their own price, so here I am still at 72 Chorley Road.'[20]

Visitors to this temporary staging-post noticed no undue depression at his surroundings, only his acceptance of them with familiar joviality. Margery recalls his relish of the eccentric plumbing and his fascination with the lead piping which inexplicably festooned his front parlour; Frank Bradley recollects his delight in the awful panelling in the hall and his observation that it must have been 'done out of tea chests'. Bradley, an architect and fellow member of the Manchester Academy, was yet another acquaintance from Acomb Street. Almost casually, on a visit to Chorley Road one day in 1948, he remarked: 'Why don't you come and live in our village? Some friends of ours are selling a house that would just suit you.' Lowry knew Mottram-in-Longdendale, a still remote cluster of stone houses on the fringe of the Derbyshire peaks, where Frank and Constance Bradley lived; he had been to visit them on occasional Sundays. He replied that he did not even like the place (to which Bradley observed that, knowing him, such a factor hardly mattered); nevertheless, Bradley remembers the surprising enthusiasm with which Lowry welcomed the idea. 'I felt he was acting on impulse,'[21] he says. Some

saw the removal as a retreat from Lancashire, prompted by the ambi-
valence of his feeling towards the place that had inspired his vision
yet rejected his conception of it. The sale was negotiated and the
move accomplished in August that year. Soon Lowry was reporting
that his new home had a 'marvellous view of an electricity sub-
station' and inviting David Carr to view 'some wallpaper I am
curious to see how you react to. . . .'²²

David Carr, of all Lowry's friends, was possibly the most attuned
to his quirky sense of humour. As his wife put it: 'They saw the odd
side of life together.'²³ The friendship had begun in 1943. Carr was
then twenty-nine years old, the son of a wealthy biscuit manufac-
turer. David had no wish to make biscuits, nor indeed anything
except pictures; when he told his 'family of philistines' that he
wanted to be an artist, his father cut him off with £300 a year in
the confident expectation that, deprived of the accustomed luxuries,
he would soon return to the fold. He never did, but remained a dedi-
cated, if unrecognized, artist until the day he died, two months before
his first exhibition was to be held in New York. He was an extremely
handsome man, with clean-cut, dark good looks reminiscent of Ivor
Novello; he had an abundant exuberance, courage that sustained
him through eight years of cancer, a devoted wife, Barbara—also
an artist—and four children whom he adored.

His introduction to Lowry came about through a letter which
is worth quoting in full: 'I have been given your address by C.E.M.A.
having written to ask whether your picture entitled "On the Sands,
Lytham" was still for sale. I saw it in their summer exhibition at
Bristol where it was priced at £35. Last June I purchased your paint-
ing "The Mill Chimney" from the Lefevre Gallery and would like
to say what tremendous pleasure it gives me. At about the same time
they showed me your Whitweek painting which I should have cer-
tainly bought as well if I'd had the money, for like all people who
sometimes buy a painting my desire for pictures far exceeds my
purse! Not long afterwards I saw "On the Sands" and that started
a pretty conflict indeed! Whitweek or Lytham. Well Lytham has
won, that is if you will sell it to me now and perhaps Whitweek will
follow later. For the last few years I have been working on the same
style of landscape as yourself and being a holder of an M.O.I. permit
(painters as permits, my God!) have had good opportunity for
exploring the so-called hideous parts of London, Ipswich and Bristol,
concentrating almost entirely on the dock areas of those towns. But
unlike you, I try to express my feelings through the buildings alone;
the boats, the cranes, the railway trucks are the monsters who live
in my world and people it.

'Your painting is much more to me than just a decoration on the wall and has given a new vision of town life, and often when not working I wander about trying to see the landscape through your eyes; through the people to their buildings and feel vaguely ashamed of myself for refusing to recognize them in my own work. But it does seem to me that when men build they give their work a character so different from their own souls that I can't begin to fit the two together in a picture. The very problem that you have solved. Please excuse me for talking about my own feelings but I couldn't resist the temptation of doing so to someone who understands the soul, the character, or what you will, of those slums and town fringes as you do, in their queer and often ghastly beauty.'[24]

For Lowry the letter was a revelation; it would seem that at last he had managed to communicate something of his vision. Never before had anyone written to him in such a way, let alone another artist. Immediately he replied: 'There must be innumerable ways of looking at the same aspects of life. A silent street, a building, for instance, can be as effective as a street full of people to me. It is the outlook or message that matters. I see lots of people everywhere, myself, one lot going one way and the other lot going the opposite way as a rule. I sometimes wish I didn't see folk everywhere. True what you say about your own work—you are seeing buildings and so on rather than folk. But, as you say yourself, it is how the subject matter affects you that counts. In my view I should certainly say that if you ever do instinctively feel that folk are necessary for what you are seeking in your pictures, you will start putting them in, you won't be able to help yourself. Simply nature telling you to. I have been that way often myself.'[25]

In this way the friendship began; a further exchange of letters produced a deposit of £5 from Carr for *On the Sands* and a suggestion that they should meet. Lowry responded to the proposal with alacrity: 'It is far better than writing; I can see you agree with me on that.'[26] And so early in 1944, in blitzed, blacked-out London, the two artists came together, Carr infecting Lowry with his energy, rushing the elder man up and down New Bond Street, admiring the Old Masters in the gallery windows and venturing inside to inspect the new. They found much in common, not only in their attitudes to their art but in their highly individual conceptions of humanity. Neither was disappointed in the other. Lowry found Carr so understanding that in November he went so far as to admit in another letter: 'I am glad you still like that Beach Scene. That is what we all want, you know.'[27] It was rare indeed for him to admit to his own desire for appreciation.

On the Sands, also known as *The Beach* (pages *XX–XXI*), was no
conventional scene; it featured bevies of men in bowler hats and
business suits incongruously gathered on the shore, with a policeman
in a helmet inexplicably emerging from the sea. Lowry confessed to
Carr an admiration for the Surrealists 'because they all look so
ordinary'; and to Bloom he confided that he was often tempted to
plonk a mill chimney in the middle of an empty seascape: 'But
they would have accused me of being a Surrealist, wouldn't they?'
And he added, chuckling, 'Salvador Lowry', relishing the coupling
of the two names.[28]

By the summer of 1945 Carr was proposing that Lowry should
visit his home in Norfolk. 'It is kind of you to say what you do about
my coming to see you,' Lowry replied, 'but what would the children
think of me, though?'[29] The Carr children thought Lowry fascinat-
ing; they commented audibly on the way his false teeth threatened
to fall out when he became excited, and quickly learned to identify
and report 'Lowry figures' among the inhabitants of nearby farms,
a trait which did not endear them to the local intelligentsia who
regarded the artist's popularity as a 'passing phase'.

Lowry had postponed that first visit until September, when he
had completed a large—'for me'—picture for the Artists Inter-
national Association show that year. They had asked him to choose
his own subject and he decided to do *VE Day*, or rather his version
of it—an unbelievably busy scene of jollity with not one street party
but many, in which two business men disport themselves on
the roof of a terrace of yellow brick houses and even the Acme
Mill wears a Union Jack. He despatched the finished canvas on
August 23rd, declaring himself now free to go to Norfolk, a journey
which he anticipated with real pleasure: 'I haven't been ever in those
parts and I am looking forward to seeing your pictures too.'[30] He
was so stimulated by what Carr had to show him that, on his return
north, he posted off a selection of pastels and drawings done nearly
thirty years earlier: 'They show in the rawest state my first attempts
at depicting the industrial scene. I should be greatly interested to
know how these attempts strike you. They are all done from imagina-
tion—or rather the industrial ones are and they were the begin-
ning.'[31]

In return Carr sent Lowry samples of his own work: a painting
of men with Munch mouths and bearing billboards declaiming the
imminent end of the world—'The expression in the eyes of these un-
fortunates is positively harrowing,' commented Lowry with relish—
and a weird oil of a middle-aged nude with extravagant folds of
pendulous flesh posing serenely for an artist bearing a distinct resem-

blance to Carr; Lowry kept it behind his sitting-room door and brought it out when visitors called 'just to watch the expression on their faces'.

Lowry had been settled in Mottram no more than three weeks when Carr came to visit him, attracted as much by the 'queer and ghastly' [32] landscapes Lowry promised as by the exciting prospect of visiting 'the Manchester Academy annual show in all its splendour. I couldn't dream of you coming without seeing that! But don't blame me for the effect it will have on you.' [33] Such was Lowry's rapport with Carr—their letters crossed in the post so often that Lowry took it as a sign of telepathy—that he could take a gentle dig at the establishment that had taken so many not so gentle digs at him, knowing that Carr would appreciate the irony. There was nothing he loved better than exploding pomposity, a trait that had done nothing to endear him to the art establishment of the north.

Indeed Lowry's satirical painting *Laying a Foundation Stone* had caused Salford City Fathers to declare his pictures to be an insult to Lancashire. Lowry told the story with relish. His hiking friend, Edward Kent, had persuaded him to attend the foundation ceremony, saying: 'It's right up your street.' 'Well,' related Lowry, 'when I got there and saw those four rows of kids looking a picture of misery, singing oh so piteously, and the clergymen looking at the sky as if they wished themselves elsewhere, and the Mayor weighed down by his chain of office looking as if he wanted to get it over with and get to the match—well, I had to leave. I couldn't stand it. I couldn't help myself laughing. Mr Kent came and brought me back, in case I missed the great moment, the unveiling of this foundation stone for a new school at Clifton, but I had to keep excusing myself to have a good laugh.' He did his picture and showed it to the Mayor—'he, who should have been the most annoyed by it, he liked it very much. He took it in triumph to show to the City Fathers and they were very, very angry.' [34] Their indignation was only increased later, when Manchester promptly bought it. Canon Fletcher, the vicar, was particularly irate. 'You are no gentleman, sir,' he said to Lowry, 'you are no gentleman to make fun of us like that.' Lowry replied: 'I don't pretend to be a gentleman, but I am entitled to paint what I see.' [35]

That he painted what he saw was one of Lowry's most persistent claims in the face of criticism; it was less of a boast than a justification. When Maxwell Reekie accused him of exaggerating the size of people's feet he insisted: 'All the people I see have got big feet.' Later he added that 'people wear smaller shoes these days' and launched into a tale about 'a very nice girl I knew at school, called Dorothy

Smith, who had the most *enormous* feet'. And when, years later, in an otherwise conventional picture he managed quite unwittingly to give a dog five legs, his reaction was much the same. His tailor, Albert Denis, had spotted the peculiarity of the animal when viewing the picture in the window of an art shop off St Anne's Square; he rushed to confront the artist with his discovery, encountering on the way young Cliff Openshaw. Together the two men dragged Lowry to the shop window. 'Well I never,' he remarked, surprised yet obviously pleased that the picture had gone into print without the mistake being spotted. 'And to think I checked it most carefully before I let it go. All I can say is that it must have had five legs. I only paint what I see, you know.'[36]

In the summer of 1951 Lowry received by post a copy of a paper which had been prepared for publication in the *Journal of Mental Science*. The authors, Norman Colquhoun and Harold Palmer, were seeking the artist's comments and observations on their work, which was entitled: 'Pictorial art viewed from the standpoint of mental organization as revealed by the excitatory abreaction techniques of psychiatry.'[37] Palmer was a pioneer in the development of ether abreaction, a technique which encourages disturbed patients, by exposing them to a light dose of ether, to recall their memories. Such patients, Palmer had found, tended to describe what they saw in their mind's eye in one of four very distinct ways; stage three was a stage of disassociation—and what particularly fascinated the psychiatrist was the resemblance between such disassociation in the patients' recollections and Lowry's paintings. His art, Palmer noted, was an 'example of visual imagery corresponding to the third stage of my ether work'.[38]

'We venture to suggest,' wrote Palmer and Colquhoun, 'that he reveals himself as a spectator in a world in miniature and moreover that the position he assumes is that of looking down on this world from a height. He is not making a social comment on man or on his environment, but revealing a type of mental organization which sees the world from the heightened standpoint of a watcher or spectator. Moreover, the spectator himself becomes identified with the scene he is watching; he is not only spectator, but is himself aware of being under observation.'[39]

To Palmer, a doctor who had worked in wartime with the Eighth Army in Cairo, this disassociation stage was not new; he had heard it described many times by soldiers suffering from shell-shock. But he had never seen it illustrated so graphically, and by a man who was neither being treated with ether nor suffering the trauma of battle.

Lowry was immensely taken both with the article and the accompanying letter from Palmer; he read it time and again, opening it so often that the paper split along the lines of the folds and all but disintegrated. He told Carr about it and promised to show it to him 'to cheer you up', and then pretended to have lost it. He told Maitland, too, and said he would bring it with him one day; 'I don't think he ever will,' the Professor observed in his notes. Lowry wanted to know more. Was he 'going off his head?' Was he shell-shocked by the Battle of Life? Was there an explanation for it? A cure?

He wrote to the doctor, proposing that he should visit Palmer and his wife in St Albans. 'To say I was astonished is possibly to put it too strongly,' the psychiatrist recalls. 'But I was certainly flattered that he should travel all that way to spend the weekend with us.'[40]

Nothing Lowry said or did on that occasion, nor on any subsequent occasion, was to change Palmer's impression of him as 'an observer, a spectator' of life. 'Most of us experience this feeling of both viewing and taking part in a scene, but usually at some critical period in our lives,' he says. 'But Lowry experienced it many, many times, seated before an empty canvas on which the images would develop beneath his brush as if of their own volition. He was a severely depressed man; sometimes he would wake in the morning, engulfed in a feeling of awful desolation, and, not knowing how he was going to get through the day, would find himself, somehow, before his easel with perhaps a brush in each hand and no recollection of having painted what he now saw before him.'[41]

As the relationship between the two men was never that of doctor and patient, their conversation was based on friendship alone; Palmer never tried to probe beneath the shell of the artist's natural reserve, and Lowry was eager to talk in general terms. He described the dreams that disturbed his sleep and the peculiar attraction for him of empty houses with empty windows standing in isolation on bleak hills or derelict streets; he would stand and stare at them, sometimes for hours, imagining the joy and the laughter that once echoed within the old walls. Palmer, like Collis, saw in these waking reveries an identification of the artist with his subject, seeing in those desolate buildings an image of himself, yearning to recapture, or create, forgotten days of childhood happiness.

By the end of the '40s, as Lowry approached his sixty-second birthday, it had become apparent even to the most casual acquaintance that the artist was far from well. He suffered from colds and coughs, from rheumatism and a touch of lumbago, none of which he

suspected were the real cause of his persistent melancholia. 'I feel very depressed,' he wrote to Carr on his birthday, 'and I don't feel too well either.'[42] Six months later he wrote again: 'The winter has had a queer effect on me. I can't quite describe it—a feeling of desolation.'[43]

He was constantly seeking to rationalize his depression, to find a reason that he could understand. One time it was his feet: 'I have developed bad feet. I have now great sympathy for those poor souls I see tottering about gingerly as if they were walking on hot bricks—I am fast qualifying, I fear, to become one of those unfortunates. Please don't laugh!'[44] Another time it was the fact that his housekeeper at Mottram had abandoned him to go with her husband to live in Chapel-en-le-Frith. And yet another time it was the village and the house; repeated attempts to leave Cheshire and return to Manchester were being constantly frustrated, until he could no longer decide whether to go or stay; he never did leave. 'Until I can make up my mind what I am going to do,' he wrote in 1954, 'I have made no real effort to get anyone in Mrs Moffett's place. I have got a very honest person in who is keeping this house tidy and so on, that is all—I am practically living out nowadays, just using the place to work and sleep in.'[45] The 'very honest person' was Bessie Swindles, a squat, square Scotswoman, two years his junior, a widow who had gone to help out for a fortnight and stayed until he died. For twenty-two years she cleaned 'The Elms' and did his washing, walking each day of the week in all weathers the half-mile from her house to his. 'Going down's all right,' she said when she was eighty-six, 'it's the getting back that's the problem.'[46]

Such incidental irritations, however, disturbed the good humour Lowry usually showed to the world. His moods varied from exuberant, almost hysterical, joviality in public to terrible despair in private, so that only the closest and most intimate members of his shifting circle of acquaintances were aware of the extent of his disturbance. Most people saw such variations in character and behaviour simply as manifestations of an eccentric personality and dismissed them as such. But, over the long years of their exposure to each other's company, Maitland, with his scientific mind, and Laing, with his medical training, came to realize that the effect of maternal bereavement was deeper and more crippling than even they had at first suspected. He was apparently suffering the depressive effect, in a clinical sense, of a prolonged period of mourning which, when combined with the deep-seated complexities of his personality, produced bouts of severe melancholia. When Maitland came to realize the breadth and depth of the problem, he regretted strongly his

earlier light-hearted ragging, particularly over the painting Lowry had done of the bedroom in which his mother had lived and died. 'Taking after Sickert,' he had teased, 'painting bedstead and bedroom scenes.' Lowry showed no irritation: 'I just wanted to do that,' he excused himself, refusing to reveal the sentiment that had led him to paint such a picture.[47]

There was, of course, no cure for Lowry's state of mind. He had courage and, despite himself, the will to survive; he had his dedication to his art. And he had his friends, each neatly compartmentalized and enjoyed in turn with an intensity that lasted only so long as his particular need for them. There were so many in his circle of acquaintances that it is incredible that he should have succeeded in keeping each relationship quite separate. Not only did his friends not know each other, they did not know of each other. Just as Edith Timperley had done, each assumed him to be otherwise friendless.

There was Cliff Openshaw and his amateur theatre nights; Laing and the Hallé; Maitland and his soirées; and, in deepest Oxfordshire, Cousin May and her chickens whom he visited with dutiful regularity; in 1946 he was obliged to refuse a visit to Ireland with Carr, having promised May he would go to her for his holiday. He stayed with his other cousin, Billie, in Leicester and later in the Cotswolds, and then with Billie's sons Geoffrey and Ronald at their respective universities and homes. He went to Cousin Bertie in Surrey, to the Bennetts wherever they were living, to the Warburtons in Bolton where he met their daughter, Ethelwyn, who told him: 'You can't be very famous; no one at school has ever heard of you.' He borrowed her little box of watercolours 'to try them out' and gave her the result, travelling years later to visit her in college in Yorkshire and to take her to the cinema.

Both Frank and George Fletcher's wives had died comparatively young so for a time the all-male gatherings were resumed each Boxing Day, reunions at which young Philip was included until he married and moved south. For years Lowry went to the historian Frank Mullineux in Worsley each New Year's Day, arriving with his librarian friend Gerald Cotton, who had lived all his life in Pendlebury but had not known Lowry until after the artist had moved away.

He visited three spinster sisters in Shropshire and North Wales, where, enjoying the glow of their maidenly affection, he played the part of the irascible yet lovable old bachelor to perfection. 'He was always pretending to hate the countryside, but he didn't really mean it; he did so enjoy it once he was out in it, like a child in his enthusiasm for it all. He loved our dog and was so astonished when she once jumped up to greet him. "I think she likes me," he said,

surprised, and afterwards would conduct growling matches with her or lecture her on the need for gratitude for having such a nice home.' He had a similar relationship with May's cat, Charles, a stray from the wild whom he admired 'because he walked alone'.

Lowry's acquaintance with the sisters had begun with a letter from them expressing admiration for his work. In much the same way he had responded to a suggestion from a family called Kunzel in Clitheroe that there was good reason to believe that, from way back, they might be related; from the time of their initial introduction he became a cherished member of their family circle. He struck up conversations, which led to later relationships, in trains, on buses, in cafés; he met Philip Robertson, a hatter from Glossop with musical tastes akin to his own, over an 8*s* 6*d* businessman's lunch in a local restaurant.

There were buyers who became friends and friends who became buyers, and there were those who did not know what he was about but wanted to be a part of it, whatever it was. 'Pick me out a good 'un,' they would say, as he told it, 'you know, a good 'un.'[48] That was the sort of honesty he appreciated, and invariably gave them of his best. With him the approach was everything; when a woman with a crest on her Rolls Royce once arrived to demand through her uniformed chauffeur 'a good picture, please', he replied: 'I only do bad ones,' and shut the door.

He valued his non-artistic friends not least for the intuitive advice they offered on his pictures; he was full of anecdotes about this child or that who had told him: 'You can't paint trees, those are awful,' or: 'Take those figures out—they look wrong.' He always did as he was bidden. 'They were right, you know, they were right. It's a queer thing, but most of my help has come from people who don't paint; friends come in and they say: "What are you up to, old chap?" and I show them and ask what is wrong with it. They tell me. "Mind you," they say, "I know nothing about it." And then you get people who paint, staring at it for a long time and can't give you an answer.'[49]

If there was no one else to hand he would ask Ellen, his house-keeper, 'a person who knows nothing about art and cares less'. Once he cornered the local gas man who had come to complain about an outstanding twenty shillings on the account. (He painted by gaslight until he left Pendlebury.) 'Never mind the bill—what's the matter with that picture?' Lowry demanded, steering the man to the easel. 'Well ...' Charles Roscoe hesitated, recalling how 'taken aback' he was. 'Go on,' said Lowry, 'be honest.' 'Well,' Roscoe tried again, 'well, with houses like those, there's always washing out to

dry, no matter what day it is.' 'You're right,' Lowry declared and, while the man watched, he painted in a pair of long-johns hanging from an upstairs window and a line of washing in a back yard.[50] That picture, *The Pond*, now hangs in the Tate Gallery, and each time he sees it Charles Roscoe feels a little surge of almost proprietary pride. For years afterwards the two men visited each other, even after Roscoe had married and moved away to Cheshire.

Friends, Lowry declared many times, were important to him, a great pleasure in his life, the one comfort that was to remain with him when the 'lust for work' had gone. Asked once if he ever left companions in order to paint, he replied with gusto: 'No, I didn't. By gosh, I didn't. I wouldn't have done that for the world. All the time I was working I was thankful when people called.'[51] And this was the man the world came to call a recluse!

As with most of the myths about him, this misconception was self-propagated. But in one sense it was true: he was a spiritual recluse. 'Had I not been lonely I would not have seen what I did,' he told Collis, knowing that while the critic understood his true meaning, the majority would mistake it. Lowry's loneliness was the loneliness of the crowd, the solitude of a man alone in company, a personal isolation of the spirit and of the mind. He was in fact a gregarious, articulate, sociable being, struggling to escape the inescapable: his psyche, his inheritance, himself. 'My temperament made me very unsociable although that was not my wish,' he had said of his youth. He was never truly sociable; despite all his friends he was close to no one. No one *knew* him and he *knew* no one. In all his relationships he remained fast in his citadel with, as Maitland put it, the drawbridge firmly closed.

Obsessive and preoccupying as it was, his painting was not enough to fill the void left by his mother's death: 'Though much comforted by my art, it could not make my solitude less.'[52] And so he sought distraction in company. No gesture of friendship was too tentative, no demonstration of interest too timid, no indication of admiration too distant. He responded as he had with Carr, with the gas man, with the psychiatrist, with an almost embarrassing enthusiasm. Each new overture was tried, tested and found wanting; the fault was not in his friends but in himself. He could not communicate as he wanted to communicate; he could not give fully of himself, as to have done so would have allowed a glimpse behind his mask, a knowledge of the secret of his most private emotions. Even with the girls of his 'image' he could not abandon the practice of detachment that he had learned from the very beginning, from the repression of his childhood and the rejection of his art. 'He could

never confide his emotions,' observed Harold Riley, after knowing
him for nearly thirty years. 'His mother was the one person in whom
he felt he could have confided what was in his heart, yet when he
tried to do so, she cut him off. He shut himself quite firmly into his
own box from that time. It was as if he felt that, if he was open,
people would climb into him and see what he was—and he really
didn't think he was very much.'[53]

Yet he still wanted people around him. He needed their atten-
tion, their appreciation and understanding to boost his damaged
ego; he was self-absorbed almost to the point of self-hate. But when
the full flowering of respect and repute came at last he could not
accept it. At times he could believe sweet words to be offered in all
honesty; but were they in all honesty deserved? All too often he felt
their praise excessive or insincere, motivated perhaps by greed; and
turned away from it, fearing that they were, in truth, laughing at
him still, as they had done to his face not so very long ago.

2 'Must graciously decline'

THE YEAR 1945 was—or would have been had Lowry recognized it as such—one of moment in his career. It was the first year in which he made a financial profit by his art alone; the first year in which he was bought by Royalty; and the first year in which, at his second one-man show in London, the public bought and bought and bought. Despite his fears and Reid's warnings, the Lefevre Gallery had not abandoned him nor had it closed for the duration of the war. In 1943, after many promises and as many unavoidable retractions, they had given him a part in a show shared with the Polish-born artist Josef Herman. It was, as Daisy Jewell remarked, 'good to get a show at all in these times'.

She, as ever, had been busy sending his works the length and breadth of Britain with an almost autocratic disregard for the attendant problems of wartime transport, and she continued to notify him of each sale with proprietary pride: 'I know you will be interested to learn your work entitled "The Clock Tower" has been purchased by Mr Eric Newton. This means two works have been acquired by critics.'[1] (Jan Gordon of the *Telegraph* had already bought one, and Collis was to buy that same year.[2]) Her reports were timed precisely: at five o'clock on Wednesday, February 23rd, 1943, she typed (Bourlet's too were having their staff problems): 'Just phoned Mr Reid and a further work was sold today—"After the Fire". Think that makes a total of six. Was interested to hear he could have sold "The Mill Dam" six times over. Isn't it odd! Your neighbour has still done nothing.' That last piece of information about Herman's lack of sales did not have the expected effect on Lowry; he was never a man to gloat. On his next visit to the show he immediately bought a Herman picture; and in 1955, when they again shared an exhibition—in Wakefield—he again brought one and presented it to Salford Art Gallery.

By the time the exhibition closed, eleven pictures had been sold. After Lefevre had taken their one-third commission and charged one and a half guineas for photographing three works, Lowry was left with a total of £207 0s 6d, an average of less than £19 per picture.[3] It was not, he declared, a profit. He was meticulous in keeping records of the costs and income from his art quite separate from his Pall Mall earnings which were, at that time, £350 a year.

Early in 1944 Lowry was horrified to read that the Lefevre Gallery in King Street had been bombed. He wrote immediately to McNeill Reid offering his sympathy. The dealer hastened to reassure him that the bulk of the pictures had been saved, which meant 'more to us than the loss of the building'.[4] He was sorry to add that Lowry 'shared a little in the bad luck, in as much as the drawing which I told you I would send to Dr Honeyman [a former Reid and Lefevre director, then head of Glasgow Corporation's Gallery] has been so badly covered with dirt that I doubt if anything can be done with it'.

Reid was almost as fervent as Daisy Jewell in his encouragement of Lowry. He fixed a show for him in Edinburgh in 1944 and was very disappointed when only one picture—*Steps in Wick*—was sold. However, as he pointed out, the show got a good notice in *The Scotsman*, a paper not given to reviewing one-man shows in dealers' galleries. Reid had some of the pictures transferred to Glasgow for inclusion in his next show there, in the hope that 'my enthusiasm for your work will manage to effect some sales where others have failed'.[5]

At that time Lowry was painting prodigiously, so much so that in an attempt to stem the tide on a still slow market Reid wrote: 'No, I think for the present you should not send on any more pictures, because when the ones come back from Edinburgh we are going to have a pretty fierce stock.'[6]

Less by popular demand than in an effort to disembarrass the Gallery of this 'fierce stock', Lefevre gave Lowry, early in 1945, his second one-man show. It was an unqualified success, one that not even the diffident Lowry could deny. By February 21st Reid was reporting that sixteen pictures had been sold and two reserved. 'We should get rid of a few more,' he observed, 'but it usually happens that the last third of a show is the most difficult to sell, because everybody thinks that they are the ones that are left over. Not many people have sufficient confidence in their own judgement to realize that very often the best picture may still be unsold.'

Eric Newton was again a discerning reviewer, Collis was at his most laudatory, Ayreton in the throes of his revulsion. Felix Topolski tried to buy a Lowry but, as he offered only £30 instead of £40, Reid would not let it go even to a brother artist. 'The show has been

very satisfactory,' remarked Reid at the halfway stage, 'and I think it has put you well on the map.'

This indeed proved to be the case. The success that had been so very long in coming was at last an undeniable fact. From that time Lefevre were to give Lowry regular one-man shows: in 1947, 1948, 1951, 1953, 1956, 1958, 1961, 1963, 1964, 1967, 1968, 1971, 1974 and, after his death, in 1976. He was to maintain with Reid until the dealer's retirement in 1958, and with his partner Duncan MacDonald, a reciprocally warm relationship. 'If it had not been for Reid,' Lowry remarked in the '70s, 'I would not be painting now.'[7] MacDonald in fact was as enthusiastic as his partner, though as a man he was more direct. 'I told you I would do it,' he wrote,[8] reporting in triumph the sale of yet another picture *The Bridge* from the 1945 exhibition. He added that it was 'so good a work, it should have been sold at the beginning'.

The only point of friction between the artist and his dealers was Lowry's preference for glass over his pictures, a propensity which the cosmopolitan pair regarded as positively provincial. On occasion Lowry would agree that it was unnecessary, then change his mind. MacDonald became frustrated: 'I thought you had *finally* settled FOR EVER that your pictures would look better on the Gallery walls and in clients' houses without any. You must be consistent, even if you change your mind often *as a painter*. I gather Mr David Carr asked you about having glass on his two big pictures, "The Prayer Meeting" and "The Board Meeting". I am bored putting on glasses and taking them off; none of the fine French paintings we sell ever have glasses, nor do sensible people require them in the country. You would greatly oblige me if *you* would write to Mr David Carr telling [him] you believe they would look better in the house without any glasses ...'[9] Lowry did not persuade Carr, nor is there any record of him having attempted to do so. Reluctantly Mac-Donald agreed to do as the buyer wished, petulantly warning Lowry that if 'the glasses get broken on the way or damage the pictures, do not let either yourself or Mr Carr blame us'.[10] On their next meeting MacDonald feared he sensed resentment from Lowry; the artist had disappeared off to lunch with Reid with hardly a word to the partner. MacDonald hastened to mend the rift: 'By the way,' he wrote, 'kindly don't take seriously my leg pulling. That's only meant to make you feel at home in your own gallery. Of course you are right, no one could feel cross with you and I was merely trying to find out whether you, personally, preferred glasses on your pictures, even if we don't.'[11]

MacDonald had good reason to feel particularly well disposed

towards Lowry at that moment, despite the artist's irritating habit
of agreeing with whatever anyone cared to suggest to him—'Do you
really think so, sir?' That day the Queen—now the Queen Mother—
had bought a Lowry, *A Fylde Farm*, during a visit to quite another
exhibition at Lefevre. She was, MacDonald reported, 'greatly inter-
ested in your pictures and stayed a long time looking at them.
She even said that she hoped to come back on some future date
and perhaps buy a more industrial one. Cheers and hurrah!'[12]
The royal sale, as both Lowry and MacDonald observed, put a
good finish to an exhibition from which thirty pictures had been
sold.

The year 1945 was indeed a momentous one in Lowry's career
in that it was the first in which he could claim to have made a profit
by his art—an achievement which might at last have made an im-
pression on the materialistic Elizabeth had she been alive. The year's
profit, however, amounted to only about £20,[13] and it gave him no
confidence in his saleability.

It was in 1945, too, on July 7th, that an astonished Lowry was
presented, before an equally astonished audience, with an honorary
degree at Manchester University. The man who prided himself in
never having passed an examination was now a Master of Arts. The
presenter, Professor T. W. Manson, gave the address, which was
short and very much to the point, ending with a dig at the Man-
chester establishment: 'My Lord and Chancellor, I present to you a
Lancashire artist of rare distinction. Without attaching himself to
any school or subscribing to the artistic dogmas of any coterie, he
has set himself to put on canvas the essential truth about the Lanca-
shire people. His work is marked by a ruthless sincerity which
prevents it from falling into mere prettiness or sentimentality; while
the artist's obvious and deep affection for his subjects ensures that
the picture, however grim, shall never be sordid. He confers beauty
on the seemingly unattractive by the affectionate understanding
which he brings to its portrayal. The quality of his work is increasingly
recognized all over England: only here in his own county and among
his own people is he a prophet not yet sufficiently honoured. That
defect we now in a measure make good.'

The very qualities which had for so long made Lowry an outcast
among his own people had, at last, brought him the kind of recogni-
tion which he had so much desired. He was now fifty-seven years
old, and all whom he would have wished to glory in the honour done
to him had gone. 'I shall not be accompanied by anyone,' he wrote
to the Vice-Chancellor in response to an invitation to bring relatives
or friends to the ceremony.

The unexpected event caused his patrons and acquaintances to take stock of their feelings; could it be that they had failed fully to appreciate him? Laing, content in his patronage, sent a suitably irreverent note: 'Come up and see us soon—don't rust in your cap and gown.... Trust in the Lord—and starve.' Maitland was not sure whether to be proud that the degree had not been conferred as a result of prompting by Lowry's friends, or to regret that it was not. 'It was none of my doing,' he wrote. 'The first I heard of it was when it had been decided and sent on to Senate for formal approval. I don't take any credit myself for having no part in this! In fact I realized suddenly that I had been very remiss in not having done something long ago. However that may be, it did give me quite a lot of satisfaction that the University needed no prompting from me to recognize you and your work in this way.'

The Manchester public remained highly sceptical. As Margo Ingham recalled: 'They continued to treat him with tolerant amusement; they didn't even now take his work seriously and had no inkling of his coming importance. They blinked, took stock, but remained unconvinced.'[14]

Margo, an extroverted and individual local entrepreneur, had, better than most, the opportunity of observing the Manchester art establishment in all its pride and prejudice. She was an artist who married two artists (her third husband was a businessman); she was also a costume designer, ballet mistress, writer, critic and an organizer of all things cultural from poetry readings to art shows. She was a woman who turned, through the force of her personality, mere prettiness into beauty, and she died at the age of sixty with the bloom of youth still on her cheeks. Almost as soon as she and her husband Ned Owen had started the Manchester Ballet Club, where exhibitions were held in the evenings, they adopted Lowry into their midst—as much for his entertainment value as for his enthusiasm for their encouragement of young artists. He joined their selection committee, which included the artists John Bold, Ian Grant and Ned Owen, serving with kindness and endless patience. 'We had the impression,' Margo observed, 'that, given his way, no picture would have been rejected. Nothing was too awful to be given due consideration.'[15]

He seemed to enjoy the atmosphere of their art classes, and accepted Margo's extravagant peculiarities with nonchalance. 'He never minded when I got dressed up daft,' she recalled. 'If he met me in the street and I was all in purple, hair included, with a skirt halfway up my thighs, he never betrayed by so much as a flicker that he thought my appearance in any way remarkable. We would

conduct our usual revolving conversations, encircling each other in the street like stalking cats.'[16]

From the time the Ballet Club became the Mid-Day Studios and moved to a cellar in Mosely Street (where the mice were kept at bay by two cats called Modigliani and Hobbema), Margo had been considering giving Lowry a show of his own, much as a gesture of defiance against The Men Who Still Laughed At Lowry. Such an event should have been no rash adventure; since the London show, he had had one-man exhibitions in Salford, Lincoln, Rochdale, Stoke-on-Trent, Oldham and Liverpool. But Margo was in business to make money; times were hard—it had taken her nearly a year to save up for her first Lowry purchase, a Lancashire mill scene for 9 guineas—and she knew the mood of Manchester; thus she hesitated. Then, in 1948, on a visit to Lefevre, she broached the subject to McNeill Reid; he was enthusiastic; he was sure Lowry would sell. The London Gallery agreed to pay Margo £30 for the use of the room, and to send the pictures to Manchester at their own expense; she expected to make no sales, only to demonstrate her faith in Lowry. Her master-stroke was in inviting the nationally respected critic Eric Newton to open the show and in persuading him to give a talk on Lowry on the BBC Home Service during the run of the exhibition.

Newton was at his most poetic, his most caustic; he praised Lowry and upbraided Manchester, the town in which he had, some years before, worked on the *Manchester Guardian*. 'It is strange,' he said, 'that an artist who was in his early thirties when he began to know exactly what he wanted to paint should have to wait till he was sixty before holding his first one-man show in his native city. It is stranger still when one remembers that almost the whole of his art during those thirty years has been dedicated to that city.' Lowry, he added in emphatic tones as if someone had just suggested the contrary, 'is no inspired amateur. He is a professional in the most exacting sense of the word. It isn't just a question of technique. It's part of his character. If paint is to express a lifetime of devotion it must be handled as though it were precious, put on with enormous respect. Lowry does that and the visionary in him is revealed in the movement of his hands as well as in the quality of his mind.'[17]

Newton 'implored' Manchester to go to the show; Manchester responded, according to Margo, 'wholeheartedly and flocked to buy—much to Lowry's quiet amusement.' The battle was by no means won, but there was a distinct dent in the bastions of provincial prejudice; Lowry, at the age of sixty, was on his way—or so it was now assumed by his supporters at the Mid-Day Studios.

Arriving fresh from his native Hungary, Andras Kalman was less convinced than Margo at the sincerity of Manchester's sudden conversion to Lowry's cause; he had had his own problems with the Manchester art establishment which had prompted him to regard it with something less than affection. In the winter of 1949 he opened a gallery in a basement air-raid shelter in South King Street, where the weekly £2 rent was paid by the regular pawning of his typewriter. By a lot of persuasion and not a little charm, both of which he can display in abundance, he managed to obtain for his first exhibition works by Epstein, Matthew Smith, Lucien Freud, Craxton and Gerald Kelly. Invitations to a private view were sent to every influential name he could discover, from the members of the Art Gallery Committee to the town councillors. On the appointed day Kalman waited in vain for his guests; while the canapés he and his girl-friend had so carefully prepared curled at the edges and the neighbouring shops put up their shutters, he waited. No one came. Not one single dignitary, critic or buyer had either replied or responded to the invitation.

The second exhibition, in which the works were inevitably less auspicious, threatened to be as great a disaster as the first. On the third day Lowry appeared; down the steps he came, buzzing like a blue-bottle round the Gallery, until, summing up the situation, he bought a picture. It was, Kalman recalls, his third or fourth sale. 'It cost him about £20 and I think he bought it only to give my morale a boost. It was the exact opposite to his kind of work, a French picture, Monet-style, of a little girl in a white dress.'[18]

Kalman already knew of Lowry by repute as a 'conversational painter, regarded with great suspicion locally'. Now he was to know the man. Visits to the Gallery were followed by trips across the road for tea at Fuller's, where they ate walnut cake and discussed for hours their own highly individual views on dealers and artists. ('London dealers,' says Kalman, 'consider themselves more important than the artists, sitting in their galleries like the brothel-keepers of Amsterdam.'[19] 'In reality,' said Lowry, 'they are just grocers who sell paintings.')

Kalman became, and remains, fiercely resentful of the establishment's treatment of his friend and attacks such philistinism in his own colourful idiom: 'Art in Manchester was still confused with Bohemian charlatanism; the Mid-Day Studios were full of such people; all basically there to gawp at the nudes. For them art had almost the same connotation as the early porn shops had in the '70s; they came to the classes from their homes in Alderley Edge with their clipped lawns and their Daimlers in the drive, and in these surround-

ings Lowry was a complete and utter misfit. His looks, his inclinations, his life-style, were like a parson's compared to theirs. You had to see that this was an exceptional man; his whole way of life, speaking, eating, were against the norm. From the beginning there was a strong integrity about him—you had to be an insensitive moron not to see it in the man. From his repression came his strength; from his insularity came the power to concentrate upon his direction— on becoming an artist, being an artist, remaining an artist.'[20]

In 1952 he gave Lowry a one-man show. It was not a notable success: 'My two most successful exhibitions in Manchester were the ones I am most ashamed of—Montmartre at Night at £30 a time: a sell out.'[21] As a dealer himself, and one with an enormous respect for McNeill Reid who was, he says, 'everything a dealer should be, a man of compassion with a talent for perception,' he got his Lowrys from Lefevre. He never acquired them direct from the artist, believing that Lowry was 'quite happy and content' with Reid; Lowry was free, however, to exhibit where and when he chose, having always refused to endorse the clause in his Lefevre contract which would have restricted his shows.

For many years Kalman resisted the temptation to try to lure the artist from his gallery, preferring to get his Lowrys from collectors or by outbidding other enthusiasts at Sotheby's or Christie's. But after Reid retired and MacDonald died, believing there could be little understanding between Lowry and Lefevre's new director, the monocled Gerald Corcoran, he did go so far as to offer 'double whatever they give you'; it was an offer Lowry studiously ignored. So began a twenty-year rift between the two galleries. But this was long after Kalman had transferred to Knightsbridge in 1957, having abandoned Manchester where he had not once in ten years been invited into a private home and still felt himself to be regarded as 'a bloody foreigner'.

In those early days Kalman was struggling not only to sell Lowry, but any painter who was not producing 'escapist pictures of the South of France'. He supplemented his income by giving tennis lessons (he played for Lancashire and at Wimbledon) to rich clients to whom, between sets, he sold romantic pictures. 'If you offered them a Lowry they would say: "I can get on a number eight bus and see that bloody sight for tuppence".'[22] He did have some converts, however. Alick Leggat, the Manchester mill-owner who came to know Lowry well and is one of his most avid collectors, bought a Lowry from the Crane Gallery (now called Crane Kalman). This was a small industrial scene for which, 'after much bargaining and argument', he paid £125. 'It was not his taste really,' says Kalman,

The Grand Old Man receives the press in Sunderland.
Photograph: Daily Mail.

And The Grand Old Man receives an academic accolade
with suitable diffidence. *Photograph: Denis Thorpe.*

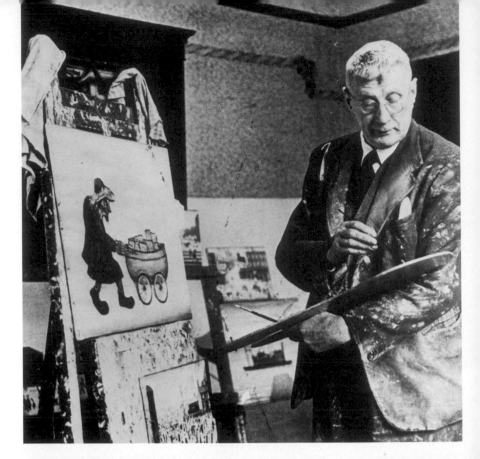

Lowry at work in his studio. *Photograph:* John Bull.

Lowry tours Salford City Art Gallery with his friend Ted Frape, the curator who did much to establish the Lowry Collection in Salford. *Photograph:* John Bull.

Lowry shows his latest work to McNeil Reid, the man who gave him his first London show. *Photograph:* John Bull.

Lowry and Monty Bloom examine a picture. Lowry wrote the caption himself: 'I think he gets his hats from Lincoln Bennett's .'

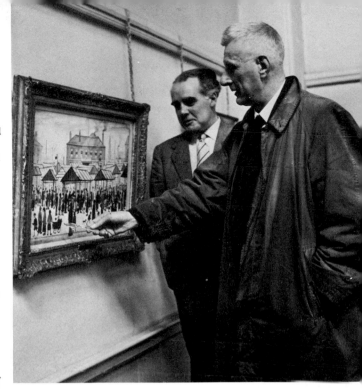

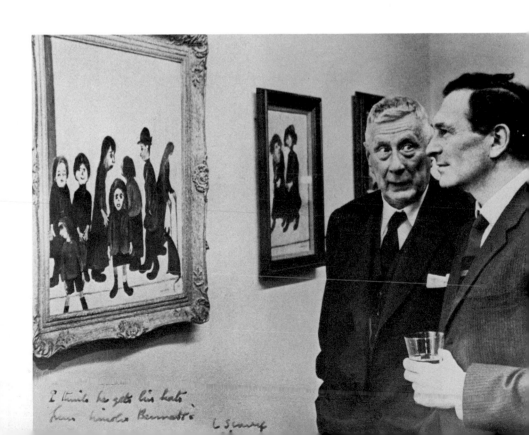

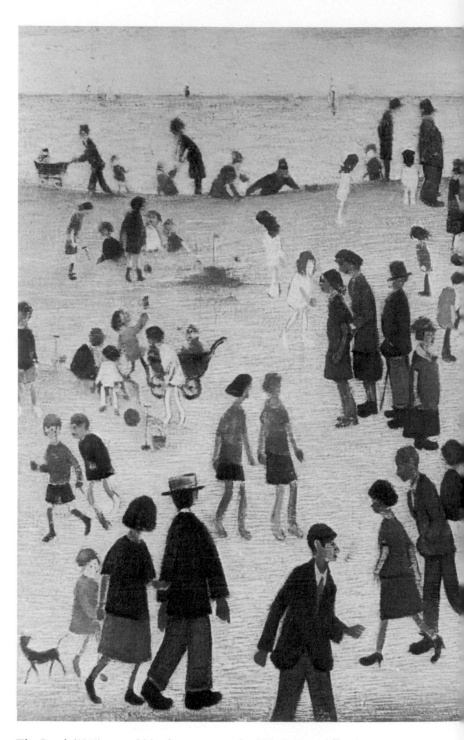

The Beach (1941) was sold in the same year for £30. *Private collection.*

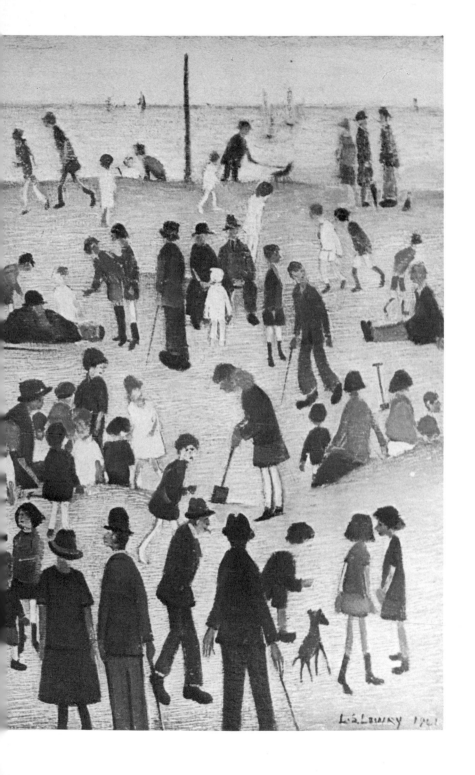

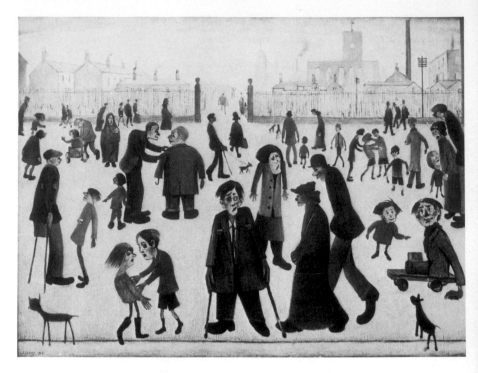

The Cripples (1949). Lowry wrote to David Carr: 'I have operated on one of the gentlemen in the far distance and given him a wooden leg — I think you would approve.' *Salford City Art Gallery.*

Home from the Pub (1944). *Private collection.*

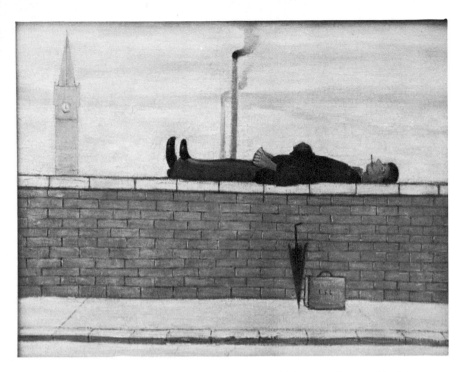

Man Lying on a Wall (1957). Lowry always said he actually saw this sight, but added his own initials to the briefcase. *Salford City Art Gallery.*

Grey Sea (1966). 'It's all there – I never tire of looking at it, but I still don't know the answers.' *Private collection.*

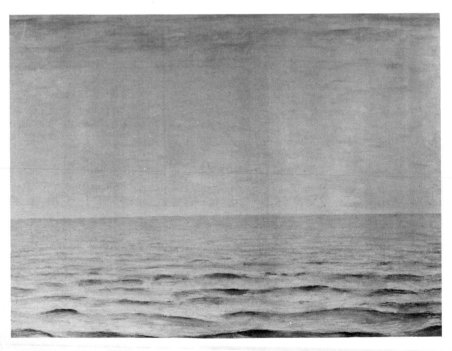

'Why do I do these?'
Lowry once asked Frank
Mullineux. 'You tell us,'
his friend replied. 'I don't
know – do you think I'm
going potty?' the artist
answered. *Lowry estate*.

'but something was drawing him to Lowry. It took many years for him to know what Lowry means.'[23] Fritz Pachd bought *Going to the Match* there, but did not dare to take it home to Spath Road where they 'hung nice bourgeois pictures'; he took it instead to his office, where his colleagues looked at it and wondered, audibly, if he was not 'going off his head'.[24]

In the year that Kalman gave Lowry his one-man show, 1952, the artist reached his sixty-fifth birthday. All this time he had continued to work as cashier and book-keeper at Pall Mall, and he now retired with a pension of £200 a year. Such financial security was obviously essential to his peace of mind, even if not to his actual survival. He was still not entirely convinced that his success would continue—it might well be, as so many still thought, a passing phase, a whim on the part of the public. It was not, in fact, until 1969 that Lowry relinquished his modest pension; having received a tentative proposal from the chairman of the company that the honorary payment be transferred for the benefit of a former member of the staff who had fallen upon hard times, he readily agreed. 'It was very good of the P.M.P. Co. Ltd, to do what they did on my leaving,' he wrote. But only then, seventeen years later, and when he had avoided cashing his pension cheques for some years, did he feel confident enough in the promise of future rewards from his art to give up the security of a regular income.

Ironically, in 1952 one of his works had been bought by the Museum of Modern Art in New York; there is no doubt that if Kalman had tried to sell them in London, Paris or even Canada he would have met with considerably less resistance than he encountered in Manchester in the one-man show that year. Lowry's pictures were by now well-travelled, and in the years to come he lost no opportunity of reminding Manchester of the fact. 'I've been shown in Japan, you know,' he would say in the face of a particular piece of local scepticism.

In 1959 his work was included in the British Group exhibition at the Robert Osbourne Gallery in New York; and again at the same gallery in 1964 in an exhibition called 'The Englishness of English Painting'. Bourlet's had lent several Lowrys to their enthusiastic client Murray Fuller for exhibition in his native land, New Zealand. And the first documentary made about Lowry, by the BBC's John Read, was taken by the film's director to America where he presented it to an appreciative audience[25] of 300 in the Metropolitan Museum.

Lord Beaverbrook, a compulsive collector, had acquired some Lowrys for Canadian galleries, having first borrowed one, by means

that greatly amused the artist, for inclusion in the Dunn Exhibition at the Tate. (This was a show that Lowry remembered principally for the Delvaux he saw there: 'I'll never forget it. Oh my word I would have liked that.... Oh yes.')[26] Beaverbrook had written asking for a Lowry and 'as Reid's didn't seem too keen, we hadn't anything in', Lowry wrote himself saying thank you, but no. Lowry was dumbfounded at Lord Beaverbrook's reply: 'Thank you very much. My wife[27] and I are delighted that you are going to let us have a large picture for the Exhibition.' He took the letter to Reid's, plonked it down in front of them and said: 'What are you going to do about that?' They found a large picture.[28]

In 1955, at the age of sixty-seven, Lowry was elected an Associate Member of the Royal Academy. The telegram announcing his elevation—'... hope you will attend Academy Dinner. Evening Dress with decorations'—lay on his hall table in Mottram while Lowry, in London, went to the ballet with two young friends. When the press reproached him with this lapse, he explained the situation, adding: 'I could not have put my young friends off; youth sets such store by such things.'[29]

The letters of congratulation poured in. Carel Weight, who had been elected at the same time, could have wished for no better companion; '... only in your case, of course, it should have happened years ago'; a 'very old friend' could visualize 'the pride and joy this distinction would have given your Parents'. Mr F. F. Rigby of Stockport confessed a little secret: 'Well, well,' he wrote, 'so the mysterious man I used to meet thirty or so years ago on the train to Daisy Hill is now an A.R.A. I well remember on one occasion when you had left the train at Irlam (was it?) one of the men said: "I wonder what the devil that chap does for a living?" He then related how he and a few others had on one occasion, out of curiosity, dogged your footsteps in the city but that you had given them the slip by stepping into some narrow alley!' James Fitton, already a full R.A., and Fleetwood Walker, who according to Lowry had instigated his election— 'I never asked for it'—combined to send a telegram: 'Hope to see you in tail coat and white waistcoat with cap.' Margo Ingham sent congratulations, adding: 'This will shake a lot of people—old Maxwell Reekie and Chettle will be scratching their haloes! I wonder whether *dear* Mr Cleveland will offer you a one-man show now.'

Dear Mr Cleveland, who had succeeded to Lawrence Haward's attitudes along with his job, did give Lowry a one-man show in Manchester City Art Gallery—four years later. But he did the job properly, making it a full retrospective, a turn of events which caused the men at Salford City Art Gallery no little concern.

All this time Ted Frape, Maltby's successor across the Irwell, and later his assistant, Tony Ellis, had been quietly buying and backing Lowry. In 1951 they had held their own excellent retrospective; by 1954 they could report a total of thirty-one Lowrys in the permanent collection and now, in 1958, they boasted more than sixty. Frape's efforts had not always been appreciated by the ratepayers of the district, or rather by the elected guardians of the ratepayers' interests; the fuss that resulted from the purchase of an empty seascape for 54 guineas in 1954 was like something from *Clochemerle* and was reported by the *Guardian* as such. The cause for complaint rested in the very emptiness of the canvas; if it had had a few figures in it, it might have been marginally more acceptable. As it was, 54 guineas seemed, to Councillor Mrs E. A. Parker, a member of the Art Galleries Committee, to be an inordinately high price for 'three straight lines of colour, yellow or beige for the beach, blue for the sea and grey for the sky, with not a pebble on the beach, not a wave on the ocean, and not a cloud in the sky'.[30] The council had bought 'a pig in a poke', she declared; the remark was greeted by much hilarity and cries of 'It's a seascape, not a pig'.[31] Another objector suggested someone had forgotten to put the picture in the frame and the local press, in sternly upbraiding Frape for his waste of public money, advised that it should be confined, in future, to Salford's deepest dungeons. It was not until Alderman F. Cowin, who knew his colleagues, pointed out that Salford's collection was a financially appreciating investment, that the objectors were out-voted and the purchase ratified. On another occasion Lowry's friend Gerald Cotton let it be known that he could acquire some Lowry drawings of local historical interest which, through friendship, were available at a nominal price; his committee was distinctly reluctant until the librarian pointed out that, in no time at all, the work would have trebled in value; on such terms they bought.[32]

But now Frape was being asked to lend part of this hard-won collection to Manchester who, for years, had wanted to know nothing of the artist Salford considered their own. Reluctantly agreeing to the loan—as one public gallery to another, he could hardly refuse—Frape wrote to Cleveland: 'The news of your proposed exhibition disconcerts me somewhat. Our L. S. Lowry collection has now assumed some importance and is our only claim to notice in the field of art. Alongside our rich neighbour, Manchester, this is a distinctive feature strongly cherished and we had hoped to retain it through permanent exhibition and special shows from time to time, but I am more than a little apprehensive now.'[33] Cleveland saw no reason to apologise. 'After all, it can make no difference

to Salford's outstanding representation of Lowry's work,' he replied.

An impressive collection of more than one hundred Lowry works was assembled, with many of his earliest collectors being persuaded to lend. One such, the film-maker Ian Dalrymple, observed pointedly: 'I am always delighted to lend for a Lowry exhibition, more especially for north countrymen, whose modesty about their men of talent so often extends to ignorance of their existence.'[34] Cleveland composed the introduction to the catalogue himself, commenting: '... to Manchester, the only surprising thing about the eventual widespread recognition of Lowry's stature as an artist is that it was so long delayed.'[35] Lowry approved the collection with the exception of one work: the 1925 portrait of himself in cap and mac looking, as John Read put it, 'like the hero of a working-class play'.[36] 'I was in the gallery the other day as arranged,' he wrote, 'and I had another look at that 1925 self-portrait and I like it less than ever and would really wish not to have it in the show—it would compare very unfavourably with the others, to my thinking. It has lost its colour and needs re-painting. I am sorry, but I really would not like to show that—definitely.'[37]

This was a new self-assertive Lowry, stating his own mind and adding 'definitely' for good measure. He was amused by the deference now displayed where so recently there had been disinterest or scorn. Suspecting that the respect he now met was for his status, for the letters after his name rather than for the quality of his work, he tested the strength and sincerity of it time and again. It was almost as if he were more comfortable in the face of rejection; that, at least, he had known to be honest.

He had been totally nonplussed to be appointed an official artist at the Coronation of Queen Elizabeth II in 1953. He could not imagine what they wanted with him, a man who painted the sordid, not the grand. But he did as he was bidden, more or less, and travelled to Ashford in Middlesex to stay with Cousin Billie's son Ronald (Lowry's godson) and his wife Betty for the week. He left on the great day, provided with 'plenty of grub', wearing the inevitable raincoat, a tiny sketch-pad stuffed with his sandwiches into its voluminous pockets. He grumbled a little before he went, worrying whether the lavatories would be miles away, whether he would be too late, and what on earth they wanted him for anyway.[38] Secretly he rather enjoyed it all. Writing later to Carr he said: 'I did all right on *the day* last week. I fear I didn't get there as early as I ought to have done (six o'clock in the morning was the time they asked folk to be in their places and I would hate to tell you

what time I did arrive). The weather was awful in the afternoon, not so terrible in the morning. I was perched in a stand in front of the Palace—a very good view—in fact it couldn't have been better. What I am going to paint I don't know. Some excellent incidents took place round about which fascinated me but not, I should imagine, what the Ministry of Works want, I am sorry to say. They would have pleased you I feel sure—one gentleman perched up so precariously at the back of one of the stands with a view of nothing as far as I could tell, would have made an excellent picture. He wouldn't come down for anyone, no not even the police. I didn't make any drawings at the time but went back the next morning and did a few, but, as I say, what I am going to paint I don't yet know, but it will sort itself out.'[39] By the end of July he was reporting that he had nearly finished that picture: 'Just a straightforward view from my seat at the top of the Mall,' and by August it was done. He was waiting only for Carr to see it when he came to collect Lowry to take him to the Edinburgh Festival, before sending it off. The Ministry acknowledged receipt of Lowry's Coronation picture and dispatched it promptly to Her Majesty's Embassy in Moscow. Lowry was delighted: 'They all think I'm a Communist, because I paint what I do.'[40] Today it hangs in the second spare bedroom of that Embassy, a spot which Lowry would have surely ranked with Frank Joplin Fletcher's attic wardrobe.

Also in Coronation year, the Football Association sponsored a competition for pictures on a theme, which was won by Lowry's *Going to the Match*; it is not clear how the painting, which was currently on show at Lefevre, came to be entered. 'You were right about that football picture,' he wrote to Carr (October 28th, 1953). 'It has won a prize! I don't suppose you remember, but you insisted in a manner that it would as we were careering along between Preston and Lancaster on the way to the North. I was never more surprised in my life when I heard the news. Someone told me who read it in a paper—I didn't hear officially for some days afterwards. I haven't had an invitation to the show even yet—from reports it seems to be a mixed bag. So now I have lost my record of not having ever won anything.' Lowry had always been particularly receptive to the mood of football crowds and once astonished the critic Mervyn Levy by remarking of a particular crowd: 'They've lost, you know—you can tell.'

When Lowry was in his seventies, honours were heaped upon him. But the incidental and less illustrious ones offered along the way seemed to give him as much, if not more, pleasure—if pleasure

is indeed what he felt at any of them. In 1956, not ten years after he had moved into the district, he was given the freedom of Mottram-in-Longdendale, the village he came to detest. In 1961 Manchester gave another degree (Doctor of Law) to 'an artist too gentle ever to lay down the law';[41] and in the following year he was made a full Academician. In 1965 he received the freedom of the City of Salford, although it was to be another ten years before their university gave him a degree (Hon.D.Litt.), an action which Liverpool emulated the same year. In deference to his age, Merseyside felt impelled to come to him, offering tangible record of their homage over lunch in the Midland Hotel. In 1966 he was voted Man of the Year by the Manchester Junior Chamber of Commerce, a curious gesture to a man of nearly eighty. And next year the GPO put his picture *Coming out of School* on their 1s 6d stamp which, he remarked, 'was very nice of them',[42] a sentiment not shared by certain fellow Academicians who resented his being thus honoured in the company of Stubbs and Gainsborough.

When he was seventy-seven the Hallé Orchestra gave a birthday concert in his honour and invited him to choose the programme. He asked for parts from *Norma* by Bellini; 'not practicable,' they said. He asked for extracts from *Lucia di Lammermoor* by Donizetti; 'no, no, no,' they said, 'it can't be done.' 'Oh well,' said Lowry, 'you choose then.' They gave him Mozart's 'Eine Kleine Nachtmusik' and the Brahms Symphony No. 1 in C minor. They asked if he would mind the inclusion of Hindemith's 'Mathis der Maler'; he didn't know the work, but he agreed, adding politely: 'I don't dislike Hindemith.'

He turned up at the concert with new friends, Philip and Phyllis Robertson, who he insisted should join him in the official party, so that a couple of the assembled dignitaries had to find alternative seats at the back of the Free Trade Hall. Publicly he said he was flattered at the honour done to him; privately, after having first enquired if the tape recorder was turned off ('Yes,' he was told, but it was not), he confessed that he had been 'bored to death'. He had not really been bored, of course, his mind was too full for boredom. It was simply that, at the age of seventy-seven, public occasions disconcerted him as much as they had at the age of seven. For years now he had preferred music in his own home, where he could *listen* to it; in a concert hall his curiosity about those around him, the antics of the conductor, the relationship of the musicians, was too distracting for true musical appreciation. 'Do you still think they are a good band?' he enquired of Mrs Robertson during a restrained performance of the Brahms, a question which he later strenuously denied:

'I'd never have called them a band,' he insisted, embarrassed at hearing his remark repeated among people who considered him an intellectual peasant.

In the same year his birthday was honoured at Monks Hall Museum in Eccles, where his friend Frank Mullineux was Keeper; there they staged a special exhibition for which twenty-five artists, from Henry Moore to Barbara Hepworth, sent their works in tribute, and eminent men, from Rothenstein to Lord Clark, wrote words of praise.

A secret Lowry told to only a select, discreet few, including Alick Leggat who helped him compose his letters and Maitland whom he considered to be his authorized biographer, was that he had been offered, and had rejected, greater honours than all these. The first had come from Harold Macmillan as early as 1955, when he was offered an O.B.E. in the Queen's Birthday Honours. 'In view of your request to be assured that this would be agreeable to me,' he wrote without elaboration, 'I regret that I can only say that, while I appreciate the proposed honour very fully, I would ask to be excused.'[43] A similar overture came from Harold Wilson, who proposed a C.B.E. in 1960. Again Lowry declined. In 1967 Wilson approached him again, this time proposing a Knighthood. 'All my life I have felt most strongly against social distinctions of any kind,' Lowry replied. 'I hope you will understand my feelings when I regretfully say that I feel I must graciously decline this honour.'[44]

Four years later it was Edward Heath who wrote, a tactful letter almost anticipating refusal, offering to make Lowry a Companion of Honour. Lowry was at pains not to give offence, explaining his feelings rather more fully than he had before: 'I have at all times,' he wrote, 'tried to paint to the best of my ability and I would only hope that any rememberance people may have of me when I am gone may be based on my work rather than on any decoration I may have collected on the journey.'[45]

To a man who had been in his thirties, and thus politically aware, in the days of the lucrative sale of honours by Lloyd George—a Prime Minister whom he otherwise greatly admired—such feelings seemed almost too obvious to explain. When he related how he had refused the honours to Maitland—a younger man brought up and educated in Canada—the Professor could not understand the artist's objections. Was it, he wanted to know, because the initial offer had been 'too trivial'? 'Not at all,' said Lowry impatiently, 'they offered me a knighthood and I wouldn't touch it. I think it would be very degrading—very degrading. I think it's laughable. I've very strong opinions about honours. They are ten a penny. They are fifty a

penny. I didn't want it at all. I was shocked. I'm not a Socialist, I'm a good Conservative. But I didn't want a title.'[46]

There was no suggestion that any rejection had been made in churlishness, in resentment that they had been so long in coming; he would have preferred it if they had not come at all. Later, when the press became aware of such refusals, he explained further: 'I've just done in my lifetime what I had to do, as everyone else has to do, and did it as well as I could; so I see no call for honours.'[47] Softening somewhat, he allowed: 'It might have been different if I were fifty and had an ambitious wife.' Or an ambitious mother?

The reporter was sceptical: he reminded Lowry that he had happily accepted membership of the elitist Royal Academy. 'Ah,' said Lowry with a grin, 'but that was good for business.'[48] He was fond of referring to his art as a *métier* on a par with bricklaying or book-keeping and deliberately infuriated certain fellow Academicians by enquiring loudly when they met in Burlington House: 'How's trade?'

He insisted that he had never really wanted to be made an A.R.A.; he had been talked into it by Fleetwood Walker who, Lowry said, had selected his pictures for submission and taken them in himself. Becoming a full Academician was, however, quite different; that was total, unequivocal recognition. 'I oughtn't to have been pleased to get in,' he told Maitland, 'but I was.' And in a letter to Warburton he admitted: 'Yes, I feel very pleased about the R.A., for they did it out of my turn. It goes by rotation and seventy-five is the age limit.' Lowry had been within five months of his seventy-fifth birthday when they elected him. But, just in case his friend might have imagined him to be unduly flattered by such special treatment, he added: 'When I feel up-ish, I invariably think of the Italian Renaissance people and Rembrandt—and that keeps me quiet.'[49]

It was Jim Fitton, apparently, who had lobbied Lowry's case, enlisting support in the voting from his particular friends Harold and Laura Knight. 'They were horrified when they saw what they had elected,' says Fitton, 'but afterwards they became acclimatized to him.'[50] It is significant that it was Dame Laura and her husband who adjusted to Lowry, not Lowry to the Academy.

Thus, at seventy-five, Lowry, the outsider, the oddity, was demonstrably with the establishment; he was not of it, nor would he ever be. He attended just one Royal Academy banquet; it was, he remarked, 'a very curious evening', and he never went again. 'I was a new man and very shy and nervous so they sat me between A. R. Thomson and Vivian Pitchforth. Thomson, you know, is deaf and dumb. Pitchforth is stone-deaf. They spent the whole time writ-

ing notes and passing them to each other in front of me.'[51] Lowry retaliated by devouring almost a full tureen of potatoes which he had persuaded the waiter to leave in his place, a fact which Fitton pretended not to notice and hoped fervently that no one else would either. He went only rarely to private views and attendant cocktail parties, distinguishing himself on one such occasion by replying to a waiter who enquired if he would like a drink: 'That's very kind of you, sir, I'll have a tomato soup.'[52]

Fitton tried spasmodically to bring his friend into establishment circles, just as earlier he had trotted him along to the Café Royal, where Lowry remained aloof and unimpressed. Once, having received from Harold Wilson a suggestion that he should bring Lowry to dinner at Number Ten, he wrote to apprise his friend of this honour; he found it a difficult letter to write, each opening sentence sounding more pretentious than the last: 'Seated next to the Prime Minister at dinner last night...' 'As the Prime Minister was saying to me ...' 'The Prime Minister has asked me ...' He finished it at last as modestly as he could contrive, and sent it off; he received no reply. When next they met, Lowry made no mention of it. Fitton could contain his curiosity no longer. 'Did you get my letter about dinner with the Prime Minister?' he asked as they walked together down Piccadilly to Burlington House. The question appeared to have fallen upon deaf ears. Then, without breaking his stride or turning his head, Lowry remarked: 'Aye, I 'ad thought better of you, Jim.'[53] The Prime Minister's letter of invitation had received Lowry's predictable reply: 'Not only have I a previous engagement for the whole of the previous day, but I must plead that at my age I find such engagements over-tiring.'[54]

There was no political motivation in his refusals; it was, quite simply, against his principles. It is hard to imagine that he would have accepted such an invitation even had it come from Edward Heath, whom he met, and liked, in the Stone Gallery in Newcastle. Politics apart, Lowry seemed singularly unimpressed by Harold Wilson. The Prime Minister had selected a Lowry painting, *The Skaters*, for his 1964 Christmas card, a gesture which would have been better appreciated had anyone thought to send a card from Downing Street to Mottram. Not one dropped through his letter box. 'That's appallingly bad, don't you think?'[55] Lowry remarked. Finding herself face to face with the Prime Minister some four years later, Pat Cooke told him how pleased Mr Lowry had been at his selection. She had chosen the wrong moment. 'If he were that pleased,' retorted Harold Wilson, 'why did he refuse my Knighthood?' When she relayed the story to the artist he was enormously irritated, not at her remarks,

but that she should be found hobnobbing in such company; he imagined her to be treading the establishment path, and that he deplored.[56]

Mr Wilson did, indeed, seem to be somewhat slow in getting the message of Lowry's principles; when in 1975 he wrote offering to make him a Companion of Honour Lowry replied: 'I only ask that I may be allowed to live the remainder of my life in peace free from publicity which would naturally accompany such an honour.'[57]

If such a reaction seems a trifle ungracious, it should be remembered that Lowry was then eighty-eight years old. He was tired. In younger days, perhaps, he could have dealt more patiently with it all, even relishing the irony of it. Now he had retired behind the convenient labels society had put upon him; if, by dubbing him a recluse, they could accept his exclusion from their ranks, then he was happy to be so described. 'I have been thanked enough,' he said. 'People have bought my paintings.'[58]

All his life he was an original, unique in his vision, in his approach to his art, in his attitudes to the Battle of Life. He resisted all blandishments designed to bring him to a conventional and conformist old age and remained steadfastly, obstinately, his own man. 'I don't care tuppence for what they do in London in the art world,' he said. 'It doesn't *matter* to me. I don't think of it. I don't *know* it. All I am concerned with is doing my own things in my own way—as well as I can.'[59]

Thus he continued to repulse the belated courtship of the establishment with what they declared to be a suicidal disregard for the posthumous life of his work. If artistic immortality could be bought only by the surrender of his principles or the adoption of the very pretensions he most ardently disliked, then for Lowry the price was too high. 'The longer the beard, the shorter the art,' he declared, and shaved with a cut-throat razor until the day he died.

3 'There but for the grace of God'

AFTER THIRTY years of 'painting mill scenes that nobody wanted', Lowry moved on. It was irrelevant to him, except as an example of the glorious capriciousness of fate, that the industrials that he no longer painted were now just what collectors and galleries most wanted from him and most expected of him. He did not want to do them and he was not going to do them, not for anyone or anything.

The extent of the public's *volte face* from complete rejection to ecstatic adulation was seen on the day before his seventh one-man show in London on October 11th, 1961. The astonishing scenes that took place were headlined on the front page of the *Daily Herald*. The morning of the private view, the customary hush of the Lefevre Gallery, now in Bruton Street, was rudely disturbed by hoards of 'cheque-waving admirers of the artist': the dealers were anxious to keep something on their walls to show the public and would-be buyers were rationed to only one picture each. It was, as the press announced in excited italics, the sort of thing that 'usually happens to artists only after they are dead'.

It would seem that one of the major causes of the almost hysterical demand for the long-neglected industrial scenes lay in what was assumed to be the artist's perversity, but which it would be more accurate to call his integrity. Now that final acceptance had at last been achieved, he had, to all intents and purposes, abandoned his subject. The vision had faded and died.

Alongside the press report was a photograph of Lowry framed

against his own painting of Piccadilly Circus, a quirky smile tilting the line of his mouth as if he was restraining himself from open laughter only with difficulty. He was now seventy-three years old, a sprightly man whose still-bright blue eyes betrayed more than a hint of enjoyment at the delicious irony of the situation. It was forty years, almost to the day, since his first one-man exhibition in Mosely Street, Manchester, at which not one picture had been sold. Now, within less than an hour of opening, more than a dozen pictures had gone for prices up to £1,000.

It would seem that one of the major causes of the almost hysterical demand for the long-neglected industrial scenes lay in his very perversity; at least, it was assumed to have been perversity; it would have been more accurate to call it integrity. Now that final acceptance had been achieved he had, to all intents and purposes, abandoned his subject.

He thoroughly enjoyed the consternation his decision caused and relished the full public realization that there were, indeed, to be no more industrial Lowrys. A story he liked to tell was of a young man 'who thought he might like an industrial scene, but decided against buying one from me. Then, after his retirement, he came back and said he would have one after all. "Oh no," I said, "you're too late." Ooh, I loved that.'[1] And he would say: 'In London all they want now are pictures with lots of little figures on them, well, there are no little figures on them so they'll have to do without. It's very sad. People write, you know, and say: "I'd like a mill scene" and I write back to say: "I can't do it, and it wouldn't be any good if I did do it." '[2]

This last remark revealed the true basis for his decision: it was not deliberate contrariness, nor vengeance against the public that had refused to recognize him until it was too late. He could paint only that which was in his heart, or 'in my blood'[3] as the mills had been. He was not, and never had been, a commercial painter; he was not in it for the money. The only time he had hoped for recognition through sales had been for the sake of his mother's esteem.

'I have always said I would stop when I had put the industrial scene on the map,' he declared defensively when anyone queried the wisdom of so foolhardy a disregard for the law of supply and demand. 'I said from the very beginning, when I get it established everywhere I'll give it up. I have done it as well as I could and now I have stopped.'[4]

In fact the death of his vision had not come suddenly but gradually, as it had been born. It died in the years between 1948, when he left Pendlebury—the source of his inspiration—and 1952 when

he retired from Pall Mall, in whose service he had seen so much that he wanted to commit to canvas. 'My interest evaporated spiritually in about 1951,' he told Maitland, 'when I realized my work was *everywhere*.'

By 1956 McNeill Reid was almost pleading for them: 'I do not suppose you have any tiny industrial paintings lying about,' he wrote. 'There seems to be a considerable demand for that kind of thing.' Lowry confided to Frank Mullineux, almost in tones of wonder: 'The strange thing is that when the industrial scene passed out in reality, it passed out of my mind. I could do it now, but I have no desire to do it now, and that would show.'[5] Years later, on Tyne Tees Television, he elaborated on the same theme: 'I could have kept on doing industrial scenes, but I don't do them because I don't think I could do them *sincerely* and it tells, you know, in the work.'

Now he had a new obsession: his single figures, his grotesques. The struggling, surging, misshapen homunculi who had lived for so long in the shadow of the mills emerged at last from their background to stand alone, as he stood alone. If he saw them as odd, it was because he felt himself to be odd; if he saw them as different, it was because he felt himself to be different; if he saw them rejected, it was because, despite all his current acclaim, he still saw himself rejected.

'I feel more strongly about these people than ever I did about the industrial scene,' he said. 'There but for the grace of God go I.'[6]

He had used such words before; he had used them in earlier days, in the anguish of mourning, when depressed by the persistence of his detractors or the ridicule of his peers. Such self-identification with the world's misfits was not new; only his ultimate recognition of it in his paintings. He became fiercely defensive of this work: 'I think that this is my best period. I think I am saying more, going deeper into life than I did.'[7]

He had a story to tell about each one of them: the *Man Drinking Water*, like a thief in the night in a public lavatory; the tramp sleeping in splendid isolation on a bench in the National Gallery; the *Man Fallen Down a Hole*; the *Lady in a Straw Hat Without a Dog*; the business-man lying full length on a wall (page *XXIII*), his bowler hat on his stomach, his briefcase by his side (when he painted the businessman he put the initials LSL on the briefcase, just as he had put them on the coffin in his funeral party). And, of course, the *Woman With a Beard*, whom some call *The Working Man's Mona Lisa*, seen on a train from Cardiff to Paddington: 'She had a very nice face, and quite a

big beard. Well, sir, I just couldn't let such an opportunity pass, so I began almost at once to make a little drawing of her on a piece of paper. She was sitting right opposite me. After a while she asked, rather nervously, what I was doing? I blushed like a Dublin Bay prawn and showed her my sketch—the one from which I later made my painting of her. At first she was greatly troubled, but we talked, and by the time the train had reached Paddington we were the best of friends. We even shook hands on the platform. People say: "Oh, but you couldn't have seen a woman with a beard like that!" But I did, you know. They said the same thing about my painting of the bearded lady I saw pushing a pram in Winchester. But I saw her too! Although I'm afraid she wasn't quite so nice. The moment I saw the good lady I pulled a scrap of paper from my pocket and hurried alongside her scribbling away. Well, my dear sir, her language—Oh! it was quite appalling! Oh, terrible! I wouldn't dare repeat what she called me!'[8]

He did not need to seek such people out; he saw them everywhere as, indeed, anyone who spent time in his company began to see them everywhere. On visits to Manchester's Piccadilly Gardens in the company of the young Salford artist Harold Riley he would become almost feverish in his excitement: 'Look, there's one ... there's another ... and look, over there ... quick, you do that lot while I do these....' Then, as Riley recalls, he would collect together the rough sketches and take them away to 'work up' or use as a basis for a painting. Says Riley: 'I might have drawn my view of those people but, by the time he had finished with them, they were very different: they were Lowrys—and he might have added no more than a few strokes of pencil.' On such excursions the elder man was anxious that his companion should understand the nature of the exercise: 'I keep telling you,' he would say sternly, as if the man were still a student at the Slade and Lowry the visiting artist, 'that the thing about painting is that there should be no sentiment. No sentiment.'[9] He was seeing his subject through the eye of the artist, and he expected an understanding of such a view from brother artists.

From Carr, of course, he got it, and far more. On a visit to Mottram he examined the new work with fascination, suggesting a refinement of deformity here, an adjustment of maladjustment there. Then, standing back for a final assessment of a half-finished canvas, he remarked lightly that he could not seriously believe that his friend had ever seen in one place so many grotesque variations of the human form. 'Right,' said Lowry, grabbing his hat and propelling his friend to the car, 'I'll show you.' He described that trip later to an incredulous Gerald Cotton. 'We started about three in the afternoon in Pic-

cadilly Gardens. Up Oldham Street we saw a man on a trestle. "That's only one," he said. Then a while on we saw an old gentleman being helped on to a bus, then a man with one leg, then a man with one arm and, I am ashamed to say, I was quite pleased.'[10] Between Manchester and Rochdale that day they counted 101 memorable figures. A few weeks later, on an excursion to Bury alone, Lowry failed to match that total, observing a mere ninety-three; but, as he excused himself to Carr, 'I can't easily look on both sides, you must admit. On that first journey you took one side and I the other which is an advantage.'[11] The picture, he reported, was coming along well: 'I have operated on one of the gentlemen in the far distance and given him a wooden leg—I think you would approve. I still laugh heartily at the hook on the arm of the gentleman; that suggestion of yours was a master stroke.'[12]

Only to David Carr would he have spoken in this way; he had always encouraged his friend in observations of the 'odd side of life'. When Lowry proposed to McNeill Reid that he should do a painting of the particularly macabre Glasgow cemetery, the Necropolis, Reid remarked that it had rather 'lugubrious associations' but it might, he admitted, 'make quite a good picture—provided one can see the funny side'.[13] Carr saw more than the funny side: 'I find it both amusing *and* repulsive (Barbara can't bring herself to look at it),' he wrote of the original drawing.[14] On another occasion he wrote: 'I recently arrested a lunatic which I feel sure is an experience you will envy me.'[15]

Lowry the actor was skilled at adapting to the company he kept, when such company suited his taste or purpose; like a chameleon he would change, superficially at least, his attitudes or manners to match those of his companions, or of their expectations of him. It was not that he pretended consciously to be what he was not; he was, quite literally, different things to different people. He acted the part so convincingly and so consistently that each thought he alone knew the true Lowry. He fulfilled people's conceptions of him, so that they saw that which they most wanted to recognize in him. They imposed their mood upon him, and he did not like to disappoint. He was the mystic painter to Collis's critic, the cloth-cap hillbilly to Corcoran's Bond Street dealer, the Victorian gentleman to the child in Carol Ann. To the pseudo-intellectuals who came in search of the ethos of his art, he played the simpleton. With Openshaw he was one of the boys, with Laing a connoisseur of music; gregarious with those he liked and a recluse with those he did not. He was the cynic to Riley's romantic, and the romantic to Leggat's cynic. With Maitland he was a sensitive, thoughtful artist, who hastened

to dispel the Professor's growing distaste for the hint of callousness he detected in his friend's obsession with the grotesque and the deformed.

It was with some diffidence that Maitland approached the subject: 'You were saying that you always were interested in the bizarre or grotesque in people, or in events, and this rather attracted you to some of the odd characters that you came across?'

'Yes,' said Lowry, 'I saw them in number. It is astonishing how many you can see when you start looking for them. They were very sick people. They generally seemed to me to be people who had been quite well up in the world and had come to grief through no fault of their own, for some reason or other. They had had a shock that had been too much for them.'

'Well now,' said Maitland, 'were you interested in these people primarily as people who had come down in the world, or partly as characters pictorially?'

'I was interested in them as people who had come down in the world. I was sorry for them.'

Maitland was dubious: 'But that didn't necessarily make you want to paint them, did it?'

'I don't know why I started to paint them. I suppose I started to paint them just because I did start to paint them.'

'Well, you found something odd in them that appealed to your sense of interest and therefore you painted them.'

'I decided I would make a picture—make two pictures—of all the cripples I could think of.'

'I know,' Maitland retorted. 'And I didn't care for it, it didn't appeal to me very much because being medical I didn't take the same attitude towards them as you took towards them.'

'I felt very sorry for them in the position ... in the state that they were in,' Lowry persisted.

'Oh yes,' replied Maitland, 'but you didn't paint them with any sociological end in view. I don't think that there is any compassion, particularly, in those pictures.'

Lowry was surprised. 'You don't think there is?'

'Not compassion.'

'Well, there ought to be.'

'Well, they don't make me feel sorry for them.'

Lowry was still more surprised. 'Don't they?'

'No,' replied Maitland, 'and I can't imagine that you really felt sorry for them.'

'Oh yes I was.'

'You were sorry for them?'

'Well, I can't be sorry for them because probably in their mind they are happier than I am.'

Maitland was triumphant. 'Well, there you are, you see. So there really is no sociological reason to be ascribed to the making of these pictures?'

Lowry was defensive: 'Except that I wanted to do them ... and I wanted to show people that there were these people about. And I was sorry for them, and at the same time realizing that there was really no need to be sorry for them because they were quite in a world of their own.'

'Perhaps,' ventured Maitland, 'you had a certain relish in depicting them.'

Lowry was shocked now. 'Oh no. I thought that somebody ought to do them, and I thought that I would do them because nobody did them. *And all the time I was sorry for them.*'[16]

To Edwin Mullins, whose critic's eye detected in such work Lowry 'at his most humorous' the artist was more expansive, less defensive: 'There's a grotesque streak in me,' he said, 'and I can't help it. That's why I don't dare paint the Salvation Army, which I've often been asked to do. I'm not religious, but they do wonderful work, you see. I can't say why I'm fascinated by the odd, but I know I am.'[17] And on another occasion he elaborated: 'They are real people, sad people. I'm attracted to sadness, and there are some very sad things. I feel *like* them.'[18]

Maitland's inherent distaste for this post-industrial Lowry was by no means unique. His view, in fact, was that of the majority. The public had learned to expect mill scenes, and that was what they wanted. They felt almost betrayed, as if Picasso had suddenly begun to paint Sunday School virgins, or Dali to produce Stags at Bay. Lowry's reaction was predictable: 'Nobody likes them,' he moaned, with a glint of mischief in his eyes. He was comfortable again, back in the familiar role; it was a much easier cloak to wear than this ill-fitting acclaim. And so he went on painting single figures until the stockpile of unwanted work grew higher and higher in the damp, dark back room he called his workshop.

The stage was now set for the arrival of yet another discerning patron, who popped up like the pantomime demon king through a trap door, to declare his faith in the artist 'just as they were all going to be thrown on the bonfire'. Monty Bloom, a Welshman of dark Celtic good looks who hid a shrewd business mind behind a façade of courteous naïveté, was well cast in the role he was to play. His low-key humour was a perfect foil for Lowry's hilarity, his ingenuous manner ideally matched to the artist's own.

The circumstances of Lowry's fortuitous meeting with Monty Bloom could hardly have been more bizarre. Their introduction was effected by a pair of artistic chimpanzees.[19] Congo and Betsy were exhibiting their work in Kalman's gallery in King Street, and Lowry of course could not resist such an occasion. Nor could he resist enthusing extravagantly over the work of the apes: 'Wonderful, marvellous, what fun, what colour—just look at it, isn't it tremendous! Now I really *do* see what action painting is all about. If this is it, well that's fine! And they can't help doing it, can they? That's the great joy; it's so unaffected.'[20] Bloom observed all this with amusement; he could not help feeling that Lowry was taking a dig at someone or something. Could it perhaps be the art establishment?[21]

He was, as it happened, already interested in Lowry's work. Some time previously, while waiting for the nine o'clock news, he had caught the tail-end of John Read's film of the artist on BBC Television; there was something about the curiously haunting pictures that attracted him although he could not have defined it. From that moment he wanted to possess one of those Lancashire scenes so strongly reminiscent of his childhood, although he had never before bought a picture as anything other than an innocuous decoration for his walls. Being a businessman who had made his money building up bankrupt businesses and selling them as going concerns, he found this urge to acquire something as a compulsion, and with no end product in mind, somewhat bewildering. He had not thought of investment, nor of buying with an eye to the future, yet he knew almost intuitively that these strange pictures were 'not rubbish'. Later, much later, Lowry was to tell him: 'your appreciation was instinctive.' After some thought Bloom approached Frape at Salford City Art Gallery, who promised to pass on to Lowry a commission for an industrial picture. That done, Bloom felt free to introduce himself to the artist during a lull in the excitement over the chimpanzees. 'I've got a picture for you at home,' said Lowry, immediately recognizing the name. 'Do you want to see it?' Bloom was indeed eager, and not long afterwards they left together to drive to Mottram.

When they arrived at 'The Elms' Lowry ushered Bloom into the workroom and produced a large industrial which had, in fact, been done some time before. Bloom liked it very much indeed; but as his gaze wandered round the room he saw a mass of separate paintings of single figures that he liked much more. He hardly knew how to tell the artist. 'I like the mill scene,' he began, 'but I think I prefer those. . . .'

'I prefer them myself,' said Lowry, his voice betraying nothing

of what he might have been thinking. He picked up about a dozen and put them around the easel. Bloom selected six and asked: 'Do you want to sell these?' Lowry looked at him sharply. 'Do you *really* want to buy them?' he asked, his emphasis probing the sincerity of his visitor's interest. Bloom nodded; he knew he *wanted* these forbidding pictures. 'Would ninety pounds be all right?' said Lowry. 'For the six?' queried Bloom. 'If you want them, you can have them,' Lowry replied, and promptly took them off his easel and handed them over. Bloom took them away with him that night; they were the first of their kind that Lowry had sold.

Many years later the two of them, who were now firm friends, recalled the moment of Lowry's amazement. 'Nobody liked them at all,' said the artist, 'nobody at all—until you did. And then I was more astonished than I could say. Did I express astonishment at the time?' 'No,' replied Bloom. Lowry nodded. 'I was too startled probably,' he said. 'I was wondering what was going on. I was wondering what was going to happen to them when I was dead. I had sent one of them to Reid's but they had sent it back, wanting to know whether it was finished. Oh, I was very astonished indeed. I was startled. I had said to Mrs Swindles: "I wonder what will happen to all this stuff when I am gone?" I was going to put them on the bonfire, you know. I was, you know. They were sordid, they were what people called sordid. But I am fond of sordid pictures—you are too, very fond of them.' Monty agreed, laughing. 'It's a bad trait,' he said. 'No,' replied Lowry, 'it's a very good trait to have. Getting to the truth in painting is getting near to life. You can't paint those down-and-outs in a sentimental way.' Monty interrupted: 'But you didn't think anyone wanted them.' 'That didn't matter to me,' said Lowry. 'All my life I have done what I wanted to do. It's very funny really; isn't it odd? It's all so true to life.

'People say to me: "You can't see characters as weird as that," but there's not one of them I haven't seen. I saw a woman in Manchester with *two* club feet and she shouted at me: "What the bloody hell are you looking at," and then she started laughing, *he he he he*. Poor old soul. Then one day I went to see my cousin and I arrived a bit early and I went to sit in Birch Park; this fellow came up to me and said: "Can you give me tuppence?" I said: "I'll give you tuppence gladly, but I don't believe you need it because you have been drinking just now." Oh, he was a queer-looking fellow. And he laughed so I gave him something. Anyway, a fortnight later I met him again and, sir, it was like a meeting of Wellington and Blucher. He was very loquacious —until I asked him what had brought him to what he was and he dried up ... we sat in silence

... he had finished with me. One should never ask. The cause is unimportant. It's a fact. And that's sad. We are not blameless ourselves, you know, and probably if we had been through the crisis they have been through it would have happened to us.

'Without knowing what it was, I had an instinctive feeling that the time had come to drop the industrials. Now I feel more strongly than ever that the figures just stand on their own two feet.'[22]

Before they had parted that first evening, Lowry to return to his midnight painting and Bloom to drive home to Southport, the visitor remarked that there were parts of Wales, particularly his birthplace the Rhondda Valley, that he thought were grim enough for Lowry's taste. This appealed to the artist. 'There's a terrace of cottages at Cwm Ebbw Vale I'd very much like to see,' he said. 'Hannen Swaffer has told me that I really ought to do them before they are knocked down.' Monty knew the place and told Lowry he went there quite frequently; 'I'll take you, if you like,' he said, 'how much notice would you require?' Lowry took his H. Samuel twenty-five-shilling pocket watch from his waistcoat and examined it. 'Give me ten minutes,' he said to the astonished Bloom. 'I've only got one suit—and I'm wearing that. I can throw the rest together in no time.'

It was, perhaps, ten days or even ten weeks before the businessman and the artist set off for a grand tour of South Wales. Lowry might have had only one suit, but Bloom had a wife and family and a business to consider. But from that time they visited Wales every six months for the next six years. Lowry could not resist a temporary return to a kind of industrial scene that echoed the foreboding, if not the harshness, of Lancashire; he was to paint some fine pictures of Wales.

'I have laid in a 60″ × 45″ canvas,' he was soon reporting to Bloom, '... my general idea as regards design—but I must get over to Ebbw Vale again as it isn't a subject one can dash at right away. It is a wonderful subject if I can get it satisfactorily.'[23] They did, indeed, go to Ebbw Vale again; and to Abergavenny where the waiter in their hotel affected to believe Lowry to be de Gaulle and addressed him each morning as 'mon Général'. They also went to Merthyr Tydfil, where Lowry painted his biggest picture (63″ × 50″), the brooding composite *Bargoed*; and to Abertillery to see a fortune-teller called Mrs Flook. Lowry admitted to being deeply impressed by her knowledge of him, not that he ever disclosed in detail what she had told him. But he did relate, many times and to many people, how she had described to him the exact house in which his godchild Ann was living in Milan; he had not told her of Ann, he said, far

less that she was working in Italy. He returned to Mrs Flook some months later, taking with him Carol Ann, who was in college at Swansea; she was less impressed by the predictions, which she cannot recall, than by the startling sight of the diminutive seer rushing round her house bearing aloft two blazing pages of the *South Wales Echo* while Lowry shouted: 'Whatever are you doing, woman—you'll set fire to the place.'[24] The good lady was apparently unable to predict when her gas supply was going to run out and plunge her and her clients into total darkness; on each occasion she reacted with evident surprise and would spend frantic moments, first rummaging for a shilling for the meter, then scurrying from room to room with her flaming torch in a desperate bid to re-light the lights before the place exploded.

Monty (he would have been called Montague, but when his mother came to register the birth, she could not think how to spell it) also held the late Mrs Flook in some awe. As a youth he frequently drove his mother to her consultations from which, one day, she emerged in great consternation and immediately began belabouring him with her handbag. 'Who's this blonde you've been taking out—she's no good for you,' she shouted at her astonished son. Monty had indeed been seeing a blonde; he did not do so again.

What Mrs Flook of Six Bells did not foretell was the extent of Bloom's obsession with Lowry's work; he bought and bought, almost to the point of financial distress; he sold two shops in Gorton in order to buy the *Woman With a Beard* and others; he collected everything he could get, from a sketch of Cousin May's cat, Charles, to the artist's impression of his own funeral. It got to the point where he hardly dared to take them home. His patient wife, Phyllis, had tolerated her husband's addiction with initial good humour, but finally she would say wearily: 'But, Monty, where are we going to put them?' He hid them in the boot of his car or sneaked them into the house after dark and stashed them in the wardrobe of the spare bedroom. One he lent to Salford rather than face Phyllis with it. That picture, *Father with Two Sons*, a powerful group of three stark heads, was not finished until 1950 but derived, Lowry said, from the late '30s era of 'letting off steam'. 'I put a lot of myself, of my feeling at the time, into that picture,'[25] he said. Bloom had wanted it as soon as Lowry had described it to him. 'Nobody liked it,' said the artist, ingenuously planting the seed. 'It went on an Arts Council tour of Japan and Canada and then back to Reid's. It's still there. It never sold.' Monty went in search of it. At Lefevre none of the directors could recall having seen it for years. 'Must have been sold,' they said. 'No,' said

the head warehouseman, 'it's in the cellar.' He brought it up and Bloom bought it, still marked at the '50s price: £250.[26]

By the '60s he had sixty Lowrys on his walls and forty more in caches around the house. By the '70s he had by far the largest collection anywhere; larger than Laing, larger than Leggat, larger even than Salford—probably larger than the artist himself. In 1972 it was valued at around a quarter of a million pounds.

Early in 1962 Monty Bloom was approached by Frank Constantine of the Graves Art Gallery at Sheffield; they were organizing a retrospective exhibition of Lowry's work for the autumn and, having heard that Bloom had some of the artist's latest paintings, he wondered if they might borrow a few? 'Certainly,' said Bloom, 'come and take your pick.' Constantine travelled to Southport in search of the odd one or two for an exhibition already distinguished by a picture from the private collection of the Queen Mother. He took forty-two away with him and showed thirty-nine.

It was to be the first time that the grotesques had been shown to the public. They were, Maurice Collis decided, 'solitaries, unable to mix with their fellows and deeply afflicted by their isolation. They are the projections of his mood, ghosts of himself.'[27]

Lowry, despite himself, was inordinately proud of the show. He went to it many times; as often, in fact, as he could persuade someone to run him over. 'I'm going again to Sheffield,' he wrote to Bloom on October 5th that year, 'this time with Mr Alick Leggat and again at the weekend with Doctor and Mrs Maitland—who are off to Malaya at the end of the month. So I shall know this show by heart if I keep going like this. They say they have extended it for another fortnight. I am very pleased they are pleased.' He maintained that this exhibition was yet another major turning point in his career; he ranked it with 1921 and 1939 as a significant first. And, as he commented to Maitland: 'Reid's shows got a lot better after that— they put their prices up.'[28]

Two years later the pattern was to be repeated in an almost identical fashion. Ronald and Phyllis Marshall (known as Micky and Tilly to all but Lowry, who invariably referred to them as Mr and Mrs Marshall) of the Stone Gallery in Newcastle-upon-Tyne had fortuitously found the same entrée into the artist's affections. They had met briefly at the Harrogate Festival of the Visual Arts in August, 1960, at which Lowry was not only exhibiting but was also present by arrangement 'to discuss with Festival visitors his work and matters of artistic interest'.[29] They did not pursue the acquaintance. Then, one day in 1964, Mrs Marshall was in the Gallery, which is housed in a fine, late Georgian terrace near the university, when

her assistant came through from the art shop behind to announce: 'There's a Mr Lowry to see you.' 'I told you,' said Mrs Marshall tetchily, 'I can't see any travellers today.' There was a moment's silence while realization dawned. The artist was quickly ushered in.[30]

'At that time,' Tilly recalls, 'we had had numerous shows of modern artists and had been extensively reviewed. Anne Redpath had got virtually a page in the *Guardian* which, I should think, was more than Lowry could resist; he always seemed to feel a bit competitive about her—she was with Reid and Lefevre, too.'[31]

Lowry said he was just passing; in the '60s he was much in the north-east having discovered in Sunderland a hotel called the Seaburn. He had called there by chance during a tour with Pat Cooke and her husband, and finding the staff happy to serve a full cooked lunch at three o'clock in the afternoon, he was to make the hotel practically a home from home—a bolt-hole from fame.

That day at the Marshalls, Tilly relates, Lowry 'sat and talked ... he went all through the gallery, upstairs and down, and found a little Rowlandson he liked. Then he sat down again. We had tea. Still he sat on. We had sherry and he had orange squash. Still he sat on. We suggested dinner. He agreed. It must have been past midnight when we dropped him back at the Seaburn. Three weeks later he turned up again. And so it went on for years. I always say he came to tea and stayed for fourteen years.'[32]

During his initial marathon visit they did, of course, discuss his work. Tilly, who was not over-fond of the industrials, remarked that she greatly admired the single figures. She could hardly have said anything to please him more; and when Mrs Marshall enthuses, she enthuses; she is an ex-actress who projects her personality to the gods and beyond, a woman with the power to make a man feel the object of her delighted interest. Lowry visibly glowed with pleasure. 'Do you?' he said. 'Nobody else does. They won't show them, you know.'[33] 'We would,' she replied.[34] And they did.

Much as Constantine had done, the Marshalls drove to Southport to see the Bloom collection, hoping to select four or five paintings to include in their own exhibition. After about half an hour, as Monty recalls, the couple 'went into a little huddle and then said: "We would like to base the whole show on these pictures. May we take forty-eight?"'[35] They showed them all in October, 1964, and no others.

One of the major attributes of the Marshalls of the Stone Gallery is their ability to attract the right people and the right publicity for the right exhibitions; Tilly's extroverted charm is matched only by her husband's expertise in public relations and their mutual ability

to put on a good show. Even *The Times* was to lament their passing when they closed the next summer, following financial problems; when they re-opened three months later, as a limited company, Lowry was among the shareholders.

'Mr Marshall,' he remarked in a letter to Monty,[36] 'is very imaginative and seems to be a very good dealer.' The success of the show, he decided, was due 'to the cleverness and the personality of the promoters. They are marvellous people, you know. Remarkable.' And, pondering later on the interest the event had attracted: '... that shook the great Gerald, didn't it?'—taking a gentle dig at the elder Corcoran of Reid and Lefevre.

Edwin Mullins travelled from London for the week and was given two *private* private views, one in the presence of the artist and one, the first, without; Lowry looked, Mullins observed, 'at seventy-seven ... disconcertingly like Jacques Tati impersonating General de Gaulle.' The critic was enthralled; and in the *Sunday Telegraph* the following weekend he admitted with some surprise that he too had been infected by the artist's ability to perceive the unusual in the mundane: 'For several days now all railway porters, newspaper vendors, men seated on park benches, not to mention my friends, have been pure Lowry. I once heard him described as an entomologist stalking human insects with his butterfly net. Lowry has become a collector of people....'

The entomologist himself, temporarily abandoning his dislike of social occasions, attended each day that week; he mingled charmingly with the critics, chatted with the reporters, posed for the television cameras. A girl from one of the papers confronted him: 'Tell me, Mr Lowry,' she said, 'why has this man Bloom got all these pictures? And why have we never seen them in London?' 'That's simple,' replied Lowry. 'Mr Bloom said: "How much?" And he went on saying: "How much?" And now there are none left.'

To Mullins, as they walked together beneath his gallery of grotesques, he had said: 'At last I feel I'm getting what I've wanted.' Then, suddenly: 'I think I'll die, sir. There's nothing left. I'm old.' He paused. 'Well, perhaps not till after the private view.'[37]

PART FIVE

Masterly inactivity

Far away,
For the last time,
I heard the scream,
The scream of terror
The voice of loneliness
Screaming for love.

Dag Hammarskjold

1 '*This art is a* terrible *business*'

LOWRY ANNOUNCED his retirement from painting soon after his eightieth birthday. He was not so much laying down his brushes as retreating from the world in which he now found himself, a world he neither understood nor sought to understand. He was, he said, pleased to have found the contemporary idiom, 'a sit-in, a one-man strike'.[1]

For some years past he had been threatening to '*give it all up*', at first to friends and later to the steady stream of writers and critics who came knocking at his door. No one believed him; they could not understand how, having found fame so late, he could now turn his back upon their recognition of him. It was, as the *Daily Mirror* observed in May 1968, 'the final paradox in a lifetime of contradiction. For at a time when his work is at last fetching high prices, Lowry is giving up for financial reasons.'[2] (The fact that the mass-circulation *Daily Mirror* commented at all upon this event in the life of an artist was an indication of his popularity.) In an attempt to explain his apparent folly in terms the world could understand and accept, he had blamed his retirement on the Inland Revenue. 'Painting', he had said, 'does not pay.' The reporter was sceptical: 'This cannot be the only reason,'[3] he commented.

The real reason was that Lowry was tired: tired of work in which he no longer found release; tired of the unceasing demands of the greedy art world; tired of seeking the purpose of the compulsion that had held him enthralled. For half a century he had hoped to find self-esteem in the recognition of others; now that it had come he found it to be as meaningless as the uncritical acclaim they now lavished upon him. Worth was no corollary of fame; but he had had to achieve it to believe it. Now he wanted only peace in which to pass his remaining years, enjoying the friendships in which he found comfort, and painting for his own pleasure almost as a reflex action. He could shut down the assembly line, but he could not deny the habits of a lifetime and close his eyes to the instinctive observation of line and shape and form. His attitudes to his art were now those of an addict who tries to avoid temptation.

'I have done no work at all,' he wrote to Monty Bloom in 1965, 'tho' whilst I was in Middlesbrough yesterday I saw a queer sort of tower on the dock I felt would be worth doing—but I fought against it! But I expect to go there often so I may fall yet, but I hope not—that would be too dreadful.' Later the same month he wrote: 'I aren't doing anything much—I am afraid the lust for work appears to have left me.' And after a visit to Carol Ann in Swansea in 1967 he confessed to her: 'I can't get that dam out of mind and it is possible I might find I have to do something about it which is a horrible thought and I shall certainly banish it—if I can.' And returning from a subsequent trip to Wales, he reported to Monty Bloom: 'We went over the Black Mountains and I had an awful experience—we came across an ancient coal pit or the remains of it and for a dreadful moment I felt I wanted to do it but I fought hard against it and then Carol took a photo of it, but I will be firm.'

To Maitland he wrote: 'I aren't as young as I used to be and am doodling a little when I have nothing else to do but nothing more—I feel a lot better for it.' And, later: 'I am drifting along: odd doodle now and then, but I don't feel like painting serious pictures now, I am quite past that, in spite of lots of people saying: "Go on, you're all right, keep on turning them out, never mind your eyesight, we like looking at them." And so it goes on....' To that letter, written in November 1970 soon after his eighty-third birthday, he added a scrawled postscript: 'This art,' he wrote, 'is a *terrible* business.'

From the early '60s, the disturbing physical effects of the strain of exhibiting, of demands for more work and still more work, began to tell on him. He hid the signs of tension and worry, just as he had hidden their causes from all but his most perceptive friends, shutting

himself into the bleak stone house at Mottram or retiring to the modest comfort of Pat Cooke's Cheshire home. There, as had Edith in another time and another place, she cooked for him and cosseted him, watching the stress lines fade from his face and the trembling of his limbs abate. To her knowledge he had three attacks of shingles, a physical manifestation of the nervous tension that consumed him and which he endured without complaint. He came to her moody, strangely inarticulate, withdrawn, difficult to please; he wanted no company save hers and her husband Brian's; no talk of art; no visits to galleries; no expeditions that might lure him to lift a pencil. But with care and home-cooking—the inevitable meat and potato pie, treacle tart and lashings of cream, and innumerable cups of tea— he recovered well and was fit and spry in time for their next Irish holiday—fit enough, at least, to sketch freely and to enjoy the strange and the new with his old enthusiasm.

'But,' Pat recalls, 'he was very sick for a time. Really poorly. He would hide himself away during these attacks, but after a while they became worse and more frequent. The strain of hiding them from the outside world became almost as much as the strain of the exhibition that had caused them. I first began to notice the effect upon him after the Graves [Graves Art Gallery, Sheffield] exhibition; then again after the Newcastle show; the worst was after the Tate—that really knocked him out. He had put everything into that, just as he had put everything into the work that made it.'[4]

Ironically it was the great Arts Council Lowry Retrospective, a touring exhibition culminating, in a rare tribute to a living artist, in six weeks at the Tate Gallery, that had finally and irrevocably put him on the artistic map. It had also 'nearly finished me off'.

The exhibition opened in Sunderland in August 1966 and closed in London in January of the following year; more than one hundred pictures were shown on tour, in Northumberland, Manchester and Bristol; and nearly two hundred were gathered together for the grand finale at the Tate. From that time there was no denying Lowry's place in the history of British art.

Throughout the two years of the planning, he had, of course, been closely involved with Edwin Mullins, who was to write a masterly foreword to the catalogue, and with Colin Anson of the Arts Council who actually hung the pictures. The work spanned the whole spectrum of Lowry's art, from a 1906 still-life done in the studios of his first master, to a 1965 Northumberland seascape drawn from the window of his bedroom at the Seaburn Hotel. Arrangements were changed and changed again, and the date and positioning of the show altered and altered again; one minute it was on, the

next it was off. Lowry alternately wanted one thing, refused another, demanded this and denied that; he was raging, cajoling, advising, planning, writing, telephoning, calling, hoping and worrying, always worrying.

'That Tate Gallery show has been pushed back to Nov.–Jan.,' he wrote in March 1966 to Maitland who, although still in Malaya, had agreed to lend for the exhibition. 'They had been intending to have had a show at Reid's Gallery before it—but, oh dear me, it is terrible, is it not—there won't be enough stuff, so that's that. I have to explain to people that I aren't like Tennyson's Brook—the brook may have done so but I certainly am not going on for ever.' In May he was complaining to Bloom: 'Letters come in from the Arts Council and Edwin Mullins etc., I feel as if I would like to put them all in the fire. How thankful I shall be when the show is over. I really am tired of it all. More than ever, I think.'

By the time of the opening in Sunderland he had regained his good humour. The following day he wrote from the Seaburn to Bloom: 'Mr Anson himself hung the show here and it certainly looks very well and an excellent choice of pictures is here. The catalogues haven't arrived yet (trust the Arts Council for that)—I went in on the Saturday afternoon and a good many people were there and a gentleman who wore his hat all the time and who I thought was the man who comes in to see about the electricity lights but who proved to be the Lord Mayor—was very interesting and did say they never had had a show like this one before and my expressive face flushed with pleasure at that and we parted great friends. There are 50 to 60 pictures not here that will be in the London show. . . . The show at Whitworth Art Gallery [Manchester] opens on the 23rd and it looks as if I shall be putting in an appearance there at 8 o'clock in the evening on that day so I shall come back to Mottram on the 22nd. . . .' (Carol was with him in Sunderland, he added, and, with pride: 'She got through her exams as I think I told you . . . she has been very good.')

The show arrived in London as scheduled; Lowry, despite pro-phecies to the contrary (mainly his own), attended the opening where he was composed with the critics, respectful of the eminent, and so attentive to the ladies that the three spinster sisters who had travelled from Wales for the great occasion observed that he 'seemed to be in his element. He made such a great fuss of us that we felt almost as if we were the most important people there.'

This was a very different man from the shy recluse they had come to know in the privacy of their own home; this was L. S. Lowry, actor, playing the celebrity. For a brief moment, or so it had

appeared to them, he almost seemed at home in the role. The critics, for the most part, were complimentary; their newspapers gave him ample space in their columns, as befitted the honour done to him. The *Guardian*, however, declared he had become a national '*maître populaire de la réalité*'[5] and deplored the cult of personality that had become associated with his art.

This was the first hint of establishment pique that all too often greets success, a peculiarly British attitude that equates popularity with trash. It was to be the old story: great art can only emanate from obscurity, can only be produced in penury; all too soon they were to forget that Lowry had served his time in both. He was given hardly a year or two in which to enjoy his new status before the more self-consciously serious art commentators began to refer to his work as hackneyed, over-exposed, too familiar—an artistic cliché.

Three days before the close of the show Lowry wrote to Maitland in Burton-on-Trent: 'This show has put years on me—Oh, the people who have wanted one of my things all their lives—good gracious, there must be thousands and thousands of them and to think that none of them will get any—why, the thought is terrible. It is not painting so much as the thousand and one things attached to the job that is the awful thing, it is too harrowing for words. . . . The show has gone off extremely well to my thinking and others. I didn't get to London again after seeing you there at the beginning. I aren't as active as I used to be by any manner of means—and I didn't really see much point in going: when all is said and done there was nothing to do there—and in fact I couldn't go now if I really wanted to do so.'

He was writing from Cheshire, where he was making a slow recovery; again he had shingles, his hands trembled and, in moments of repose, his limbs twitched in sudden convulsions of nervous tension. Soon he fled from 'the dreadful house with its never ending letters' to the Seaburn to 'restore my shattered nerves'. From there he wrote to Bloom: 'A gentleman upset me this afternoon saying, Of course you have brought your sketch book—I won't sleep tonight at the bare thought.'

Two weeks later, his health apparently restored, he was able to report objectively upon the show. 'I, as you might say, fled for my life from all this art, over a fortnight ago, to here,' he wrote to Maitland. 'I don't have any letters sent on—all this was after the end of the Tate Gallery show which seems to have gone off very well indeed and everybody concerned in London appeared to be delighted. The attendance was very good indeed and, taking into account the exhibition was held at the very worst part of the year, 41,000 odd

paid to go in and they sold practically 8,000 catalogues which they certainly couldn't grumble at.'

He intended staying in his Northumberland sanctuary for as long as he could; he visited the Marshalls regularly, invited Carol Ann over to stay with him for four days, and made frequent journeys to Carlisle to see the Bennetts. 'I don't have any desire to be in Mottram now I have to all intents and purposes finished painting,' he told Maitland. By the middle of the month the full impact of the results of so much attention had dawned upon him; there were, it seemed to him, Lowry shows everywhere. Where Reid's had failed to acquire enough work for a pre-Tate exhibition, Kalman had succeeded in collecting a total of fifty-four paintings for a complementary 'tribute' which ran concurrently in the Brompton Road. (The catalogue for this show was notable for the charming simplicity of its notes, written by Robert Wraight, and contained many delightfully Lowry-esque anecdotes, the very sort that he would have most enjoyed telling himself. One day the two men had been returning from lunch near Lowry's home. 'When we had walked a little way from the pub he suddenly stopped and said, "Oh dear, I've just remembered I've forgotten something." I examined him and reported that he still had his coat, his battered trilby and his walking stick. "Oh dear no, it's nothing like that. Oh no, this is terrible. I've just remembered I promised to spend Boxing Day with some friends." "Well, that's all right," I said, "it's nearly six months to Christmas." "But I don't mean *next* Boxing Day, I promised to go last Boxing Day and I completely forgot until now." ')

Lowry had had a letter from Robert Wraight in Cambridge telling him that he was arranging a show at his gallery there for some time in April. 'He wants me to be present at the opening,' the artist told Bloom. 'He hopes to get works for the show that haven't been shown in either the Tate Gallery or the Crane Gallery. It strikes me there are too many shows by L. S. Lowry knocking about just now. Mr Marshall's gallery is holding one which I believe opens on the 9th March, of drawings of the N. East and some paintings. Reid's are having theirs on the 10th May. I am going to London for the whole day one day next week. It all seems very ridiculous to me— but there it is.'

And that was only part of the story. In the same year there was another exhibition in Nottingham, the Bloom Collection was shown in Southport, followed in 1968 by an exhibition in Mottram and another in York. 'A bitter blow about the York show,' he wrote to Bloom, 'the young lady turned up when I was gleefully thinking it was off. They are collecting on the 18th May and want me,

no us, to be there on the 25th at 8 o'clock in the evening! It is terrible.'

In the same year Kalman put on 'The Loneliness of L. S. Lowry' and Lefevre managed to get sixty more pictures for their February show which, contrary to usual practice, was not announced as 'the recent works of. . . .' A subsequent Lefevre show of new drawings was also to take its toll of him. 'Even just doing those drawings knocked him out,' said Pat Cooke. 'He was almost as ill again; it was not the strain of actually doing the things that took so much out of him. It was the worry. "Are they good enough? Can I still do it? My perspective is not right. Will they like them as drawings, not investments?" '6

In 1970 he was shown at the Tib Lane Gallery in Manchester and at the Norwich Castle Museum; in 1971 in Belfast and at the Haworth Art Gallery in Accrington; and so it went on—in Liverpool, in Nottingham again, at the Whitworth in Manchester, at Lefevre's; and always at Salford, where the permanent collection continued to grow.

In 1972 part of the Bloom Collection was again on show, only this time it was for sale. The event, at the Hamet Gallery in Cork Street, London, attracted great interest; a total of seventy pictures was sold, realizing the grand sum of £100,000. Bloom had, two years previously, moved south where, to his dismay, he had found the elaborate precautions against theft demanded by his insurers to be quite prohibitive. Tentatively he had told Lowry that he was going to have to sell, and try to elicit some guidance on the wisest selection; he received only the muttered judgement 'One of me best' of almost every painting. Predictably, Lowry had displayed no resentment at his friend's decision, but there is no doubt that the relationship was never the same. Monty believes that the cooling of their friendship was prompted by his removal. 'He never liked people moving away,' he says.

The effect of it all was to confirm the artist's intention to retire; the remaining problem lay in his public's refusal to accept that he could do this. He aired his views emphatically to a Granada Television film crew, headed by documentary film-maker Leslie Woodhead, in the autumn of 1965. They produced a film about an artist, and also about money. 'Well, I'm not a young man,' Lowry began while the titles were still rolling, 'I'm not a chicken. I can't go on forever as the saying is; and I can't say I'd like to go on forever.'7 In London, the commentator pointed out, forty-two Lowrys were selling for £40,000. 'People won't believe . . .' Lowry continued, '. . . they see in the press that they sell a picture for £350. And they say:

"Oh, that's very, very good, it's splendid." It isn't £350. Call it £360. There'll be £120 off—£240. And the frame for that'll cost £25 at least. That's £215. Half of that—£107. Won't be that, quite. It isn't worth it. And it takes a lot—I'm a slow worker and it takes me a long time to paint a picture I get £360 for. And I get £107. Like the Beatles, you know. What will the Beatles get, net? What the Beatles get net, each one, won't be very fabulous when everyone's had their shots at it.[8]

'Now I'm all right,' he continued. 'I can sell the stuff. And the blighters won't stop buying them, that's the annoying thing. By writing a letter I could sell everything I've got. I could write one letter ... but that wouldn't be profitable. What with London and selling everything here—well, I ask you, what would happen? I'd have the Official Receiver: "To what do you attribute your failure, Mr Lowry?" "The fact I've sold too many pictures, Your Honour." And he'd say: "Give him twenty years for foolishness." '[9]

After the filming was done, Lowry offered Woodhead the gift of a picture and asked him to choose between a small mill scene and a robin sitting on a bough staring at nothing in particular; he had, he told the director with a fierce twinkle in his eyes, copied the bird from a Christmas card.[10] Woodhead chose the industrial. Bloom later bought the robin, now entitled *Bird Looking at Something*, and was not told that it had been copied.

Eventually, in the summer of 1968 when he was in his eighty-first year, stories of his retirement as an accomplished fact began appearing in many newspapers. They were to continue to appear at approximately six-month intervals almost until the time of his death, always with the same note of incredulity as if such a strange action were yet another manifestation of his eccentricity.

Michael Bateman went to see him for the *Sunday Times* on April 14th, 1968, and found the artist's decision 'pretty strange'; on financial grounds, he remarked, it did not seem to make sense. There had never been such a boom in Lowry paintings. At his last exhibition everything was bought, and some price tags were around the £2,000 mark. At auctions his earlier works had gone for £7,000, and the previous month two Lowrys had been sold at Christie's for 5,000 guineas and 3,500 guineas respectively. 'Aye,' the artist was reported as saying, 'but when I sold the original of the 3,500 guinea picture, I got £31 10s. I'm pleased that they fetch a lot of money, but I don't get any of it. I expect any day to hear from a chappie who's bought one claiming it isn't good value, that he's lost money and would I send him the difference. When I hold an exhibition, I don't make any money, you know. If the pictures in my last exhibition sold for

about £21,000, the gallery took a third, leaving £14,000. After tax I would be getting about £3,000. That isn't much reward these days for a few years' work.'

The fact remained, of course, that despite the tax man and dealers' commission and the cost of framing and all the incidentals of the trade, he was now earning and receiving large sums of money. They made his long years of working to ensure a £200-a-year pension, with which to safeguard his old age, an unnecessary precaution. In 1965, exactly twenty years after he had proclaimed his first year of profit from his art (a profit of £23 12s), his net income for the year was returned at £6,330 7s 2d. By his painting alone he had earned the sum of £9,484. Seven years later, in 1972, his paintings earned him £65,335 bringing him a net total for the previous twelve months of just over £50,000.

Nevertheless his life-style remained ascetic: his profit and loss account for that year revealed that his sundry expenses totalled a mere £47. The £15,000 difference between his net and gross earnings had gone mainly in agents' and accountancy fees. The allowable half portion of his rates at Mottram was £28 and of his heating and light bills just £69. He still did not drink nor smoke; he had, at the most, two or three suits, one so spattered with paint that it had become regulation wear when the photographers came to call. He had no television, had never been on an aeroplane or owned a motor car, had not travelled outside the British Isles. Indeed he had never had a telephone until, after an insignificant burglary at 'The Elms' in June 1968, he was persuaded to have one installed as a link to an alarm system. It was not used for calls, and anyone who wanted to contact him urgently still had to send a telegram or find a willing neighbour with a phone who would deliver a message. He had no housekeeper living in, only the faithful Bessie Swindles who came daily but did not cook for him; he ate most of his meals in the modest restaurants he had always frequented. Once when taken by Andras Kalman to the Ritz Hotel in London for dinner he confided that he was sorely tempted to order egg and chips 'just to see the expression on the face of the marvellously superior waiter—what do you think he would *do*, sir?'

He kept the house and the workroom at what some callers alleged to be sub-zero temperatures because, in fact, he did not greatly feel the cold. Heat was too akin to indulgence, and that his Victorian ethic could never countenance. In later years he turned this discomfort into a game. He would, or so he told Bloom, invite dealers from the soft south into his icy sitting-room and, apparently forgetting to put on the electric fire, watch with interest to see how long it took

before their noses turned blue or their teeth began to chatter. The length of time they allowed to elapse before they asked for some heat he used as a yardstick for their degree of greed. Bloom, hearing the tale while wrapped snugly in his sheepskin jacket, could well believe in the efficacy of the test.

Both out of disinterest in comfort and in perpetuation of the image, he refused to have 'The Elms' renovated although it was badly in need of it. The proud red paint had long turned murky brown and damp had ravaged the walls. Plaster crumbled, and in the once fine flowering garden, weeds grew easel-high; he had not walked in it, nor opened the rickety french windows, for twenty years. He seemed almost to enjoy the dilapidation of it all. He would sprawl, his feet hoisted high on the mantelshelf above the fire, his bottom perched precariously on the edge of his deep green chair, and would let his gaze wander, as if by chance, to the ceiling; after a moment or two of intensive concentration he would remark: 'That's curious. There's eighteen now. How do you account for that, sir?' And the visitor would depart enchanted by the glimpse of a great artist who kept the paper fixed to his ceiling by means of drawing-pins.

Lowry had only two major extravagances. He frequently took taxis rather than trains, although he once said that this was inspired less by laziness than by the desire for congenial company: he spent many hours in conversation with the drivers who took him from Mottram to Sunderland, or to Aspatria to see Sheila Fell, to Rochdale for Sunday lunch with Mattie Lowry, and, once, back from Wales after visiting Carol. His custom became greatly sought by the drivers of the district, more, they said, for the amusement of his chatter and endless questions than for the size of the tip, although it was invariably generous.

His other extravagance was that he bought paintings. At last he could indulge his fascination for the work of the Pre-Raphaelites and, encouraged by the Marshalls whom he had infected with his enthusiasm, he soon acquired a small but choice collection of the works of Rossetti and Ford Madox Brown. His prize possession was *Proserpine*, a sultry, brooding portrait of Jane Morris as the 'Empress of Hades' by Dante Gabriel Rossetti, which he bought through Lefevre—who refused to charge him their five per cent commission—for 5,000 guineas from Christie's in November 1964. Two years later an elite 'Pre-Raphaelite Society' was formed in Newcastle. With Lowry as President, Micky Marshall as Chaplain, Tilly Marshall as Librarian, and a dozen or so assorted friends, it had only one condition of membership: to own a Pre-Raphaelite work, bought preferably from

the Stone Gallery. Their meetings, held over dinners at which there was much talk and laughter, became a regular event in Lowry's life; the Society has not met since he died.

In 1968 he bought in exchange for one of his own pictures the visionary *Pandora* by Rossetti, which he promptly gave to Carol—'So that she could attend the dinners,' says Tilly. He bought Ford Madox Brown's *The Parting of Herwig and Gudren* for £100 (it was later valued at £2,600)[11] and *Moses and the Brazen Serpent* by the same artist, which so attracted and yet repelled him that he would sit and stare at it on the wall of his living-room for hours on end. He bought, too, Daumier and Epstein and Lucien Freud, and the Rowlandson that he had found on his first visit to the Stone Gallery. He took them home and hung them, but pretended, when anyone enquired, that they were in the security of bank vaults; now that he had something worth taking he did not want to be burgled again—last time they had taken mostly his own work, an indication, he said, that the robbers had 'no sense and less taste'.

In his frequent trips to the north-east, the newspapers found some comfort in relating Lowry's retirement less to an abandonment of his art than to a geographical move. Maitland was astonished to read this and wrote immediately to his friend, wanting to know what he meant by it; to have left Lancashire for Cheshire was bad enough, but to have fled now to Northumberland was inconceivable; what about his ethos?

'Journalists are queer creatures,' Lowry replied. 'At no time have I ever said that I was going to give up my house in Mottram and migrate to the north-east and I have no intention of doing so and never had. Mottram is getting uglier and uglier if that is possible, but from my point of view it is as convenient a place to live in as any other and is only a few minutes away from the wonderful moorland country in Derbyshire. I have got quite used to this area—there is a very good gallery here in Newcastle and they have some good shows. The Tyne is a very alive river with a lot of shipping on it and to watch the ships come in and go out keeps me out of mischief and I often wonder now why I was such a d...d fool as to paint all those pictures through the years for the benefit of the Treasury for that is what it amounted to, my accountant tells me.'[12]

The London papers were still not convinced of the sincerity of his repeated claims to be enjoying a happy period of 'masterly inactivity'; and they were not alone. 'I've told my friends, and they won't believe me,' he related to the *Sunday Times*.[13] 'I might do the odd seascape, or a little sketch or autograph a children's book for a friend, but I'll never hold another exhibition.' The reporter was

sceptical: 'He says he's not going to paint, but in his back room there were some little painted sketches which looked suspiciously like South Shields harbour and the stone piers. There's also a dramatic study all in white, pure Lowry, a white ship on a white sea with a white sky, a tanker waiting to come into harbour. Perhaps in his retirement Lowry will do for South Shields what Gauguin did for Tahiti.'[14]

The artist did indeed paint while in retreat in Sunderland; but that was for his pleasure alone and, therefore, did not count. It was not work; it was not *serious* painting, but it was enough to keep the dealers begging for more. He painted monstrous tankers, manœuvring into unbelieveably tiny harbours; he drew silly people stranded on rocks and plain men on promenades gazing at the ocean; and he painted seascapes of such power that to look at them is to risk drowning in the depth of their mystery. He did only that which came easily, instinctively, to him; when it became more than that, he stopped: 'I started to paint a 20″ × 16″ a while ago,' he wrote in 1970, 'a quick sketch but I found that it was developing into the usual grind and would have taken ages to finish. So I soon settled that and with the assistance of a bottle of turpentine I wiped it off the canvas and mopped my brow with relief. I was free again.'[15]

In the last decade of his life he did give the impression of a man suddenly freed of a great burden. He was more confident, less of a recluse, less frequently withdrawn. He still did not like smart people crowded into smart places, nor the feeling of being produced as a social attraction; when expected to perform he could put on what Tilly called his 'public po face' and play the cloth-cap yokel. But at last he did introduce new friends to old; he took Carol Ann to the Stone Gallery to meet the Marshalls, and the Robertsons, and the Bennetts, and Pat Cooke and Sheila Fell for whom they arranged a one-man show. They never met Ann, though he spoke of her often, projecting her as a woman of some culture and certain means, a woman with whom the Marshalls would undoubtedly relate.

To his friends he presented yet another facet of himself; with them he could be worldly or even earthy, as if seeking an acceptance in their world by adopting their attitudes as his own. He who had found it necessary to insert asterisks in the word 'damned' when writing to Maitland, now swore freely, though never coarsely. He was heard to comment upon the physical attributes of females of their acqaintance, to ponder the nature of their friends' sex lives, and once to speak of his own: 'Never had intercourse, Mr Marshall, never.'[16] They were inclined to believe it, although they had no illusions about his perversity. 'I could usually be sure that if he said one thing, he

meant another. Sometimes he would come into the gallery and say: "I woke up this morning and I thought to myself, there is nowhere I want to go today, nothing I want to do." And one knew immediately that there was indeed something he wanted to do that day, or somewhere he wanted to go. And sure enough, in an hour or two, it would emerge.'[17]

Tilly Marshall found herself wondering about the artist's relationship with women, observing minutely his behaviour towards Pat, or Sheila, or Carol Ann. 'I remember once,' she relates, 'Lowry and Carol returning from a trip up the river in a boat and sitting at the tea table—I can see it all now—and telling me, with a sort of bashful grin on his face, that he had introduced Carol to the press as his wife—"What do you think of that, Mrs Marshall?" I was completely taken aback for a moment and looked quickly at Carol to see how she was reacting. She said nothing, did nothing. She sat there eating her tea without a flicker of emotion on her face. It was, to me, incredible. He had a strange protective attitude towards her and used to irritate me enormously by calling her "the poor little wretch". I would say, "Why do you call her that, Mr Lowry?" and he would reply, "Because she is a poor little wretch." And I would smoulder silently to think of all the holidays she was having, going here and going there, and I hadn't had a holiday for twenty-five years.'[18]

With Micky Marshall, or with their son, Simon, Lowry travelled to many parts of the north-east and Scotland, sometimes to visit a specific exhibition, sometimes for a change of air. In June, 1968, Simon, Carol and Lowry went to Port Patrick to see the town in which the artist's ancestors had landed from Ireland in 1827; 'I have always wanted to see the place where my worthy great-grandfather landed,' he had written to Carol, 'I have a vague suspicion that the gentleman was a queer fish.'[19] It was to this Irish heritage that Maitland, and some others, attributed the contrariness in Lowry's character. 'A clue to the understanding of Lowry's personality, his cast of mind and many of his eccentricities is his Irishness,' the Professor wrote. 'He himself is akin to an original Irish character with strong individuality. On only one occasion had I known him to refer to himself in this sense. Someone from abroad who evidently had some difficulty in making him out asked him whether he was English or Welsh and he replied that he was neither, he was Irish.'[20] That reply could, of course, have been prompted by the very perversity which intrigued Maitland; it was the unexpected reply.

One trait which had not changed with the years was certainly Lowry's perversity. He was still projecting his loneliness, enjoying the way his words were interpreted by the media. 'I think people read

a lot of silly nonsense into your pictures when they talk about "this represents the loneliness of Mr Lowry",' Maitland once said to him. 'I think that it is all bosh myself.' The artist replied: 'I do myself. You read a lot of bosh,'—he savoured the word—'in the journals. My word, yes.'[21] And yet this was the man who had told Collis: 'Had I not been lonely, I would not have seen what I did.'

He was, however, no nearer an understanding of himself; he was still asking questions and receiving no answers. Again and again he would retreat to a favoured axiom: 'All I know is that I know nothing.' He would walk day after day along the Sunderland shore, pausing every few moments to gaze at the sea as if in the inexorable ebb and flow of the water he would find the knowledge that evaded him. He would walk and talk, with Carol or with another, and he would stare into the ocean and say: 'It's all there. It's all in the sea. The Battle of Life is there. And fate. And the inevitability of it all. And the purpose.' And he would watch the tide come in, saying: 'What if it doesn't stop? What if it doesn't turn? What if it goes on coming in and coming in and coming in?' And he would sit on a bench and stir the gravel with his walking stick and say: 'We are like these pebbles. Each as important as the other. We all have a place in the pattern of things.' And so he would go on: 'What is it for? Why are we here? What is the purpose of it all?'

As he got older and nearer to death, one last question came to obsess him. 'Will I live?' he would ask. 'Will my pictures live after I am gone?' And the laymen shook their heads and said they could not tell; and the flatterers gushed and said 'assuredly you will live for ever'; and the artists answered 'certainly', and told him why.

But, was it possible? Could it happen? Might it just be true? There was no solace still in mortal fame, but was there comfort yet in immortality? Would this at last make a sort of sense out of it all? Was this the purpose of his life? Or was it all for nothing as he feared?

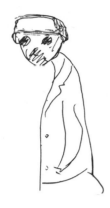

2 'Can they not wait
till I'm dead, Sir?'

'Was it Ben Jonson who said that a man who writes other than for money is a fool?' Lowry pondered reflectively, putting his thoughts into another's words as he so often did. 'He did that. And I did that. I've been a fool. A d...d fool.'[1]

Indeed he had never seemed to be interested in money for its own sake; he had valued it merely as a measure of the public's desire for his work, relating the size of his income to the extent of his recognition as an artist. Now in his old age, however, he was becoming almost acquisitive—but not for what he could do with money; he still did not *use* it; it sat in the bank, attracting interest and tax, as his clocks and china attracted dust. Neither was to be disturbed. Each had its place in the pattern of his existence; one was his past, the other his future.

By this time he was well into his eighties and, seeing in his life-style no reason for such concern for the acquisition of wealth, his friends continually questioned his purpose and design. It was, they felt, almost as if he were preparing to pay his passage across the Styx. Predictably he did not explain himself.

It was not that he had resumed painting for the public, much as they pleaded that he should; he had found a quicker and easier way. Lowry had gone into print. A lucrative source of income had appeared and the fact that he so readily accepted the offers made to him shocked and dismayed his higher-minded associates. That he should be reproduced in any quantity was bad enough; but that he should now, for a fee, add his signature to those reproductions, thus increasing their re-sale value out of all proportion to their worth, was, to them, totally incomprehensible. They feared for his reputation and worried what over-exposure in a popular market might do

to his status as a serious artist. Such considerations seemed to concern Lowry not at all.

They argued with him, pleaded with him, reasoned with him. 'You must be,' one told him sternly, 'the only artist of such repute who has allowed himself to be used in his way.' 'I'm not being used,' he retorted with unaccustomed ferocity, 'I know what I am doing.'[2] Lowry, as ever, did what he wanted to do and kept his motives to himself; he was not about to begin to justify himself to anyone.

The first to persuade him to add his name to a reproduction of his work was a highly personable businesswoman named Wendy Bridgman, then proprietor of a print company called the Adam Collection. They had already reproduced Sir William Russell Flint and his son, both with signatures, and the quality of their products was admittedly high—not that Lowry was, initially, aware of this fact. Even Mrs Bridgman, with her evident ability to attract artists to co-operate in her enterprises, was surprised at the speed with which Lowry had agreed to her proposals. She had called, unannounced, one day in the late '60s at 'The Elms' and had put her suggestions to him. She had brought with her samples of their products; 'but he did not want to see them,' she recalls. 'He was more interested in knowing where I had found the picture I wanted to reproduce and in examining it to see how time had treated it.'[3] Over the years she was to reproduce many Lowrys, signed and unsigned; they, and others like them, can be seen today in virtually every furniture shop in the north of England.

'He was so sensitive of others' feelings,' says Mrs Bridgman, 'and so kind, that I felt that once he had said "Yes" to me he did not feel he could refuse others, particularly if they had a sad tale to tell; I remember him doing one simply because the people's son was desperately ill and they quite genuinely needed the money. Thus were the floodgates opened.'[4]

The boom in the print market in the early '70s attracted much criticism. Lowry was not by any means the only artist of repute to add his name to reproductions, though for a while he did it more than most. Even the Royal Academy joined in the game, though their participation was excused on the grounds that they needed the money. In the early '70s they advertised an edition of 850 signed 'artist's proofs' of a Lowry oil which, without his signature, might have been worth about £5; with it, the public were persuaded that £45 was a reasonable price. The crux of the controversy lay in the euphemistic use of the term 'artist's proof' and in the inflated price for ordinary prints with the addition of an autograph, which by itself

would have realized no more than a few pounds in the auction rooms. Sotheby's, in fact, refused to deal in signed prints.

The situation was examined in an article by Pat Gilmour which appeared in the *Arts Review* on March 24th, 1973. 'Observer Art recently offered a signed Lowry reproduction—a colour lithograph copied from his original by a chromiste, published in 1947 in an edition of 6,000, printed on inferior war-time paper, and selling until recently for around £3,' the author wrote. 'When the *Observer* took over the remainder of the edition they captioned the print as a lithograph drawn on stone, conveniently forgot to mention that Lowry had not drawn it, and sold the remaining unsigned prints for £20 each and a special edition of 75 which they persuaded Lowry to sign 25 years after publication, for £100 apiece. Anyone of intelligence cogitating the implications of the argument that a signature gives a "seal of approval" will be able to consider whether this means that (a) the other 5,925 in the edition were *disapproved* by the artist, or (b) Lowry's autograph is worth £97.'

By the end of 1973 such products were being ranked with property, vintage wines and veteran cars as good investments. The profits to be made by a dealer in this market were, indeed, enormous and, as Robert Wraight pointed out in his book *The Art Game Again!*, that was only the beginning. 'Every time these reproductions change hands in the idiot-fringe market the price goes up by fifty per cent,' he observed. 'Good short-term investments they have certainly been, but when sanity returns to the art market they are surely going to be virtually valueless, the junk of the not-so-distant future.'[5]

The artist, of course, had no part in the dealing once he had been paid for his initial co-operation; Lowry received, on average, between £3 and £5 per signature and approximately fifteen per cent of the trade price of the first sale of a print. From Medici, for example, in 1972 he received for the sale of *Industrial Panorama* (unsigned) the sum of £650·45, plus an identical sum for *Going to the Match*.[6]

Robert Wraight was not alone in his opinions; in many galleries, dealers of standing had reached much the same conclusions. And finding Lowry browsing one day in their Tib Lane Gallery, Geoffrey and Jan Green put the point to him. 'Don't worry about it,' he said, smiling to see their concern for him. 'I know what I am doing. In a few years these things will be worthless. But my pictures will survive.'[7]

It was rare for Lowry to express confidence in the immortality of his work and, in the face of such apparent conviction, the Greens decided they had perceived Lowry's motives in the game. 'It was all,' they say, 'his sweet revenge for the years of neglect. It was his

way of getting back at all the people who attempted to exploit him in the years of renown and yet had ignored him in the years of need. He knew that genuine admirers would buy either his original pictures or, if they could not afford them, an unsigned print of his work. He hoped, in his heart, that after his death a lot of greedy dealers would get their fingers badly burnt.'[8]

Lowry never at any time confirmed in so many words such opinions. And, knowing his basically non-vindictive nature, both Carol Ann and the Marshalls continued to try to convince him of the error of his ways. 'It is no more than selling your signature,' they would say; and he would reply: 'Well, why shouldn't I?' which was an open invitation for anyone and everyone to tell him why he should not. But nothing anyone could say was to change his determination to continue, out of perversity if nothing else, in his own way. 'I remember him becoming really angry about it all,' recalls Carol; 'possibly the only time I have ever seen him quite so angry. We were in a restaurant off St James's and we were having a real humdinger over the prints. Micky Marshall was there too, arguing with me against them. Uncle Laurie was banging the table and saying: "We will finish it, we will finish this discussion, sir," and Micky Marshall was banging too and saying: "We will not finish it, sir." And, seeing how cross Uncle Laurie was, how he refused to be questioned, how distressed he became to find we did not trust his judgement, I thought to myself: "Well, he feels so strongly about it for some reason of his own, so leave it, Carol." It took him a long time to get anywhere, perhaps at last he had decided to get something out of it.'[9]

But there were others among his circle who, in retrospect, decided that his motivation for the uncharacteristic urge to amass money in the bank was for a very different reason—and one which he could hardly have confided in Carol. In 1970 he had made his last will, leaving his estate to this girl whom he had tutored so well, the girl whom he had taught to think as he thought, to value what he valued. It was at about the same time that he became noticeably pre-occupied with the taxation level in the country, particularly in relation to death duties. He had seen so many of his contemporaries die, their meticulously collected worldly estates sold or otherwise dispersed in the frantic efforts of their heirs to meet the demands of crippling duties. Thus it seemed to those who explored beneath the façade of his parsimony, that he was attempting to leave Carol not only the memorabilia of his long life, but also the means by which to protect it from disposal. It was what he wanted and, Monty Bloom believes, he knew Carol well enough to know that it would be what

she wanted; she would be concerned more for his pictures, for the memories of him, than for the cash; this did, indeed, prove to be the case.

But, with the enigma no nearer to being explained, his habits were observed even more meticulously. There was to be no change in his way of life; he still gave his money away when moved to do so; he still offered it when he felt it to be needed, as he had to Joan Ellis when her husband Tony, Lowry's young companion from Salford Art Gallery, had been tragically killed in a car crash leaving a widow and young child. He still took taxis, but equally he still took the bus to Manchester, standing in the queue in Stalybridge Road, or cadged a lift with acquaintances who seemed happy to be thus used. He still paid his share when eating out with friends, such as Leggat or Robertson, although he was as insistent as ever that those on company expense accounts paid the bill when they entertained him for their purpose rather than for his. He still pleaded poverty, much as a joke, a ritual acting out of the part he had chosen to play. In a hotel once, during an interview with the *Observer* writer John Heilpern, he became fascinated by a new-fangled contraption in the gentlemen's lavatory. 'It's a mechanical shoe polisher,' Heilpern informed him. '*Is* it? You going to have your shoes polished?' 'No, are you?' 'No. Can't afford it. I'm too poor. I'm old and poor. And I'm clapped out.'[10] This was in 1975. He was then worth a quarter of a million.

His old friend Alick Leggat once asked him why he bothered with the signing of prints. 'For the money,' Lowry replied, explaining himself, as he thought, satisfactorily to the businessman. But he should be careful, Leggat warned; he could be taken in by these smooth-talking entrepreneurs. He let too many people into his house, he was too trusting. Rubbish, retorted Lowry, he knew when he was being conned. And, to illustrate the point, he told a story. A printmaker, he said, had made an arrangement with him to pay the sum of £5 per signature on a special issue of one of his pictures. When the dealer arrived a cheque was handed over which, the artist quickly noticed, worked out at only £3 a print. Without a word Lowry began to sign each one. After a while the dealer glanced over his shoulder and saw, with horror, that he had signed his name L. S. Low. 'What are you doing?' the dealer demanded. 'That,' said Lowry, 'is a small signature for a small fee. When I get the other £2, you will get the other two letters.' The cheque was immediately adjusted.[11]

The tale is quite possibly apocryphal since the dealer whom Lowry named denies any such occurrence as, indeed, do others. But it does show that Lowry, despite his age and his pretended gullibility,

was as sharp and as shrewd as ever. He had, in the phrase that Bessie Swindles liked to use of him, 'all his chairs at home—and then some'.[12]

But still, to the despair of those who concerned themselves for him, he opened the door to whoever chose to call. He had learned that to accept intrusion as inevitable was less trouble than trying to evade it. And he had yet another tale to illustrate that point: 'One day a friend came in and I said: "I'm awfully sorry, but I've got to go to London." I wasn't really, but I wanted to be alone. And I made a dreadful mistake. I said: "I'm going now, on the twelve o'clock train." "Oh," he said, "I'll run you to the station." "Oh no," I said, "don't bother." "I will bother," he said. "I'll run you to the station." So I collected a bag and stuffed some heavy books into it and dragged it into his car. We got to the station approach and he stopped the car. "Well," I said, "thank you very much. It really was most kind." "Oh, I'll see you off," he said. I thought, what am I going to do here? Oh, my God. So I went into the station with him and I said: "Look here, would you go and get me a *Times* and a *Manchester Guardian*?" He did—and I darted to the booking office and bought a third-class ticket to Stockport [the first stop on the Manchester–London train]. When he came back I said: "Well, thank you." "Oh," he said, "I'll see you off." "But someone might pinch your car," I said. "Well, what of it?" he said. "It's well insured." What can you do with a man like that? So I got in the carriage and he did too and I was perspiring in case he should want to come to London. But then they blew the whistle and he said: "Well, I'd better get out now," and he got out and I heaved a sigh of relief, my word I did, and I waved to him joyously as he went. Oh, I was thankful. I dragged that ridiculous bag down to the taxi rank and for the first time ever there wasn't a taxi there and I had to drag it down to a bus about half a mile away. That taught me. I'll never do it again. Never go into detail.'[13]

In future he kept his excuses simple: 'No, Mr Lowry is out. I'm Fred, his brother.' But once his face had become familiar, that subterfuge was no longer possible. They knew him too well, and his reputation for being an easy prey to a sob-story. The cadgers were still coming in even greater numbers—in Sunderland even at breakfast time 'as they wanted to be sure they could catch me in'. In Mottram they would sit 'talking platitudes and all the time you're wondering "What are you after? Why don't you get it off your chest and save time?"'[14] To the students, calling in search of material for their theses, he expounded happily, listening intently to theories on him earnestly presented, and nodding politely when they had done, so

that they departed content in the rightness of their views. It was the dealers in sheep's clothing whom he abhorred.

At his own gallery, Lefevre, after the retirement of McNeill Reid, he had learned to accept flamboyant showmanship as part of the new Bond Street technique; he even appreciated that, although it could never be his way, it had its merits: 'Gerald [Corcoran] said they had sold about £21,000 worth of the stuff, so I shall be revived if this sort of thing goes on,'[15] he once reported. Accepting that such methods were part of the business, he reacted with pleased surprise when this sort of approach was respectfully turned on him: 'I saw them both [Corcoran father and son] and they were very polite— no gush, you know.'[16]

The itinerant runners of the trade he viewed with deep suspicion; they were to give him no peace, pursuing him relentlessly from Mottram to Sunderland and back, knocking at the door, lurking, it seemed, everywhere in masks of friendship or need. These pursuers began to appear in his private pictures, in drawings he made in the rare privacy of his last years; they came to him in animal form, surrealistic, fantastic, with the bodies of snakes and the faces of rats, or sharks, or weasels. In some the figure of a tall man, wearing a hat such as he wore, stands dwarfed by the enormity of their forms and numbers. In others the same figure, in the same hat, is sinking in a sea that writhes with them, evil teeth exposed in evil grins, greed in their beady eyes. They peer round corners, leer from behind pillars, rise from the ground in fearsome form, sneering, smiling, slavering.... 'Why do I do them?' he once asked Frank Mullineux and Gerald Cotton. 'Well, you tell us,' they replied, at a loss to know what was expected of them. 'I don't know,' the artist insisted. 'They just come on the paper.' 'Well,' said Mullineux, 'what are they?' 'I don't know,' said Lowry, shaking his head as if bewildered. 'Do you think I'm going potty?'[17] And yet to the end he rarely denied a request; he would rather have been wrong in his judgement of character than have refused a genuine appeal: he was still working on the old maxim: 'It is more shameful to distrust one's friends than to be deceived by them.'

The genuine admirer he welcomed, and often gave generously or sold cheaply. He once signed an imitation, knowing he had not painted it, simply because the caller—an elderly woman—had bought it for a large sum in the belief that it was his; he could not bring himself to disillusion her, feeling that she could ill afford the money. 'What else could I do?'[18] he asked, wanting no answer. He was not always so accommodating; Bob Wraight recalls being at the artist's home when an acquaintance called with a fake Lowry he

had bought for £100. 'As gently as possible he was told that he had been cheated but, like most people in such circumstances, he was very reluctant to believe it and to Lowry's astonishment he asked: "Are you sure it isn't yours? Isn't there some expert I could take it to for an opinion?"'[19]

He was not, in fact, greatly forged; the majority of doubtful Lowrys in current circulation are questioned less as outright fakes than as partial Lowrys. He made no secret of his habit of enthusiastic participation in the working of friends with whom he would sometimes collaborate, adding a figure here or a finishing touch there, so that the final product is a bastard version of two talents. Both Harold Riley and Geoffrey Bennett own such works, signed with both names—giving rise to the fear that if he could play such games with them, he might well have done so with others less scrupulous who neglected to add their own name to his. When the work of his imitators did finally begin to filter on to the market, Lowry took it more as a compliment than a source of irritation; it was yet another sign that he had arrived. 'They didn't forge me ten years ago, you know,' he remarked to Maitland in 1970. 'They would be barmy if they tried to, with my experience. They'd be wanting in the head to do it. There's no money in it ... but now I get forgeries every week.'

There were times when his innate faith in human nature was rewarded. In the late '60s a woman arrived on his doorstep. He felt her face to be familiar but he could not recall where or when they had met. 'Well,' she said, 'do you remember me? You haven't changed much.' It was the girl he once called 'Pet', the girl who had bought his earliest works way back in 1919: his very first client. She was now a widow who had lost her husband and two sons in the war; she had come in search of the artist because, as he recounted, 'she was very worried, she was very worried indeed. She had got about twenty of my drawings, ones she had bought in London for a lot of money and she now felt she ought to give me something for the ones she got so cheap. Well, that stunned me. That absolutely stunned me. That had never happened before. I couldn't believe it. So I told her I wouldn't take anything, of course. The pleasure of selling those drawings to her then was worth more than getting a thousand pounds now.'[20]

Incidents such as this encouraged his habit of 'testing the wicket'; the older he got the more he enjoyed exploring the nature of avarice. There was one critic whom he teased persistently, arranging his room with items of tantalizing finished and half-finished work and then professing that he had nothing to offer. The man was one who had

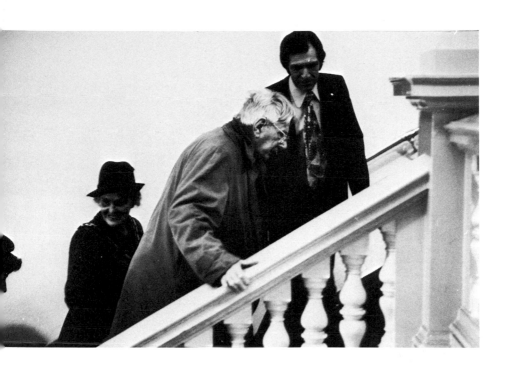

Lowry being helped
up the stairs of
Salford City Art
Gallery by the
curator Stanley
Shaw only a short
time before his
death. *Photograph:
Denis Thorpe.*

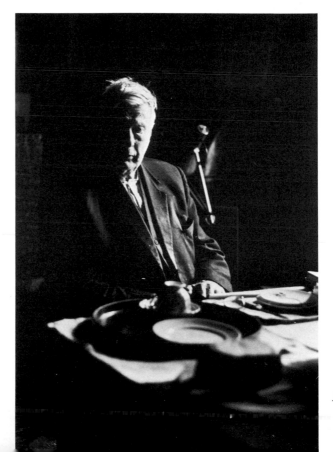

Lowry in sombre
mood, without
collar and tie, alone
at his home in
Mottram-in-
Longdendale.
*Photograph:
Barry Greenwood,
Daily Mail.*

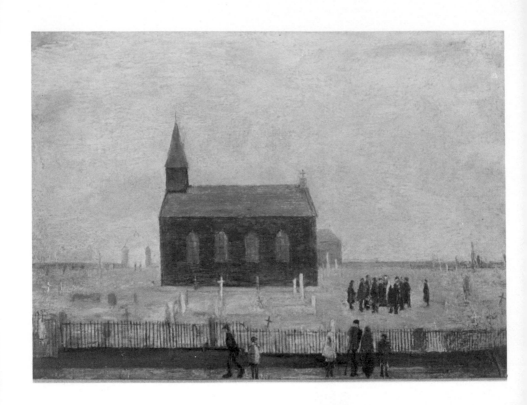

The Funeral (1928). *Collection: Monty Bloom.*

'There'll only be two at my funeral, the undertaker and the lawyer – and he'll be looking at his watch to see if he can get to the match on time.'

February 28th, 1976: the reality of Lowry's funeral at Southern Cemetery was very different. *Photograph: Denis Thorpe.*

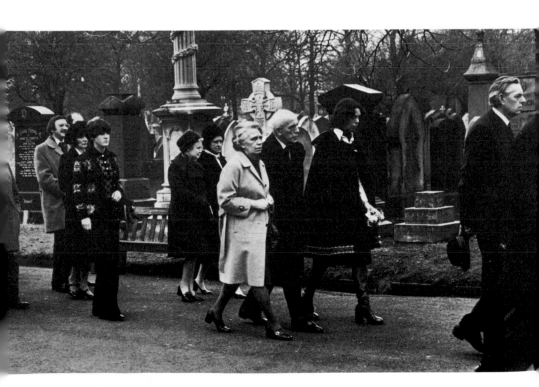

The Elms at Mottram-in-Longdendale where Lowry moved 'temporarily' in the late forties and stayed until he died. He drew the picture especially for a *House and Garden* series in 1958. House and Garden.

The dressing-gown behind the door, and the Rossetti women: Lowry's bedroom after he died. *Photograph: Denis Thorpe,* Guardian.

already had much and had allowed it to appear too quickly in the auction rooms. All Lowry required was for people to want his work for its own sake; he did not enjoy seeing it offered for sale a short time after they had got a bargain. Too many were to make that mistake. But it is an indication of the artist's nature that he never refused to see this particular man, or others of his ilk, and always treated him with unfailing courtesy despite the teasing.

He developed endless variations in the exploration of the 'testing the wicket' theme; and, when such situations did not arise, he provoked them. One time, returning to Newcastle from an exhibition in Middlesbrough with Micky Marshall, he stopped for lunch at a public house called the Wilson Arms ('Do you think it matters?' he enquired. 'No,' said Marshall, quick as ever to catch the artist's train of thought, 'I don't expect he will ever find out.') After their meal they were shown to the lounge for coffee, a room 'rather like a railway carriage with a long bench down the middle'. On a wall facing them there hung, recalls Marshall, 'the most appalling watercolour of the hotel, done by an itinerant schoolteacher in 1923'. The room was now full. They sat a moment in silent contemplation of the awful picture. Then, 'Do you think they know what they've got?' asked Lowry in a stage whisper. 'Shouldn't think so,' replied Marshall, dead-pan, 'they wouldn't have it up there like that if they did.' 'It's an early one, isn't it, sir?' Lowry pressed. By now the entire company was staring at the painting. 'Oh, very early, I'd say. Must be worth a bob or two.' And so they went on. Suddenly a man sitting nearby got up and rushed out of the room; he was later seen by the now nearly hysterical pair leaving the hotel with a picture-sized parcel tucked under his arm.[21]

It was Sir John Betjeman who, all unwittingly, brought into the open the covetous scrabbling for a piece of the Lowry estate that had begun while the old man was far from dead and buried. The poet's letter to the *Guardian* appeared in its columns on November 10th, 1975. He wrote: 'I would like to mention a Manchester subject ... and he is Mr L. S. Lowry. He is now well over eighty, unmarried, with no heirs, a Manchester artist of international reputation. I have never met him but have followed his work. . . . At his latest exhibition in a London gallery of 36 of his paintings I could see the wide range of this artist. He is associated in the public mind down here only with simplified Gothic against a wide sky under which hurry crowds of factory workers, children and parents. But, gathered into one room, his paintings range much further out—into a grey North Sea with nothing on it at all, down into Cornwall and a remote stone

circle, up on to the Brontë-haunted moors and out into prosperous Manchester suburbs which are his birthplace. His work is best appreciated, its colour, its variety, humour, affection and loneliness when assembled in a single gallery. This could be in Manchester rather as the Van Gogh Museum is in Amsterdam or the Rodin Museum is in Paris, the Peter de Wint is in Lincoln and many others. Could it be in addition to the Whitworth Gallery or the City Art Gallery? Manchester, I know, is proud of this great artist. Can it assemble a permanent Lowry exhibition?'

The following morning the *Guardian* declared, in a muted leader, its support for the basic conception of such a scheme, but with reservations not solely related to cost. Somewhat reprovingly the writer began: 'Most British artists have to wait until they die before being honoured. L. S. Lowry has been luckier than most.' Lowry's laughter upon reading those words must indeed have had a hollow ring.

Kalman, an ardent supporter of the Betjeman proposal, particularly when linked with the Whitworth, was quick to join the fray. 'Can the City afford it?' he asked next day. 'Can the City afford the roads that lead right into Manchester? Fifty yards of it would pay for a Lowry museum.'

It was now open season on the subject. Views were aired on television, stances taken, loyalties adopted and recriminations bandied freely; the newspapers, both local and national, were full of it. In the *Guardian* the letters continued. Professor Horlock, Vice-Chancellor of Salford University, adopted the mantle of spokesman for the City, pointing out that, if in nothing else, the early support of the artist and the comprehensive works already displayed in the Lowry Room more than qualified them as contenders for the privilege. Manchester, in the shape of Professor Reginald Dodwell, Director of the Whitworth, spoke out, pleading his gallery's cause. The artist Alan Lowndes wrote from Gloucestershire reproving the *Guardian* for its regional emphasis, implicit in the headline 'Housing the Hogarth of the North'. 'I suppose,' he commented dryly, 'any one of the Brontë sisters would have been "The North's answer to George Sand"?' A Mr Capindale of Leeds reminded the world that, not so very long ago, 'a well-known national newspaper' had taken the City Fathers to task for spending £60 of the ratepayers' money on a Lowry painting. And a Mr Preston from Bristol commented, tongue in cheek, on the unjustness of siting a Lowry memorial in an area that already had the Railway Museum: 'How much longer must the south suffer this lack of the basic necessities of life?' he asked. Suggestions poured in for the possible location for such a monument to the

artist: a terrace of Salford cottages, an old factory, a derelict mill, the artist's own house. It was not until the correspondence had been running nearly a week that Fred Marple wrote from Rawtenstall to point out that the subject of their debate was still very much alive. 'Do we need to enshrine the old man just yet?' he queried.

In fact the machinations had begun long before; claims had been made, rights mooted, needs proclaimed; the subsequent petty rivalries, small jealousies and irrelevant feuds had simmered for years. Manchester and Salford squabbled endlessly over their prerogatives to him, claiming both the man and his estate as if he were some sort of public monument which could be hoisted and heaved from one location to another according to the whims of contemporary opinion. They talked of wanting him to live on enshrined in their belated esteem and, preoccupied with their own interests, saw no irony in their endeavours to involve him in their fine plans. Each new approach Lowry had greeted with initial courtesy and subsequent suspicion. 'What do they really *want* of me?' he had asked one intermediary, after he had been told what they had said they wanted. And 'Why do they come to me *now*?' It was, he felt, neither his place nor his privilege to organize the means of his own honouring; it was as if he had been asked to propose his own canonization. It all embarrassed him deeply.

Salford City Art Gallery, of course, had entered the arena with a distinct advantage—with more than one hundred distinct advantages. They had been the first and only public gallery to collect him in any quantity; and they had already received his promise to remember them in his will: 'I've left them four,' Lowry announced, and he did. They tried to stand aloof from the unseemly squabbling, worrying him for reassurances only when they felt their position threatened by the persuasive arguments of their rivals, which was often enough.

The Greater Manchester Council, who wanted his house (though he still lived in it) for a museum dedicated to his memory, felt themselves to be suffering certain handicaps; they had no mandate by which to honour him. One councillor, Bernard Langton, the Chairman of the Recreation and Art Committee, made strenuous efforts to find a way to make the artist a Freeman of the County, or some such, only to discover his authority had no power to do so. Langton knew Lowry, having met him occasionally lunching at the Manchester Club, formerly the Reform Club, a Liberal stronghold in the days when Manchester was a Liberal stronghold. The councillor had researched his subject and approached Lowry with what he believed to be the appropriate words of sincerity and admiration;

but he met, he felt, only suspicion behind the bland smile, and after many meetings received a brusque referral to the artist's solicitor, Alfred Hulme. In the event all G.M.C. proposals came to nothing.

The Whitworth had started to plead their cause, through a selected intermediary known to have the ear of the artist, soon after the attendance figures for their 1974 exhibition of works from the collection of Lawrence Ives of Mottram had brought Lowry's ascendant popularity to their notice. They entered the fray with little in their favour save Lowry's admiration for the academic. To their embarrassment, though they do not like to admit it, they could not claim to have bought one single Lowry. Their entire collection numbered three drawings and two oils, all presented to the Gallery, and one oil bequeathed in memory of the late Mary Cowan (Mrs Maitland). The young Dodwell embarked hopefully on protracted negotiations, with only his enthusiasm for the artist to recommend him, and backed by Kalman's promise to obtain as many major works as required from his wide clientele of Lowry collectors. He would undertake to raise the money by subscription and appeal, he said; all that was needed from Lowry was his approval and, possibly, an item or two from his house left to Whitworth in his will, so that an authentic replica of his home could be reproduced in the museum. Lowry had heard such pleas before; he knew the script by heart. And what exactly did they want? he would ask. Oh, just a few things; his walking sticks; the letters left overflowing in the fruit bowl; the trivia of life, that's all. Nothing else? Oh no, except perhaps a picture or two? Just one or two? Well, perhaps three or four—oh, and perhaps a Rossetti or two—and maybe, if he felt like it, of course, one of those old clocks, and a bit of china and maybe the Madox Brown, and what about the Freud, and did he have many drawings, and what was going to happen to it all, anyway, if they didn't have it. . . .

Lowry intimated his consent, the shutters fast over his eyes so that none could guess the reality of his intent. Dodwell, content in the sincerity of Lowry's interest, determined to raise the necessary funds. The money was not forthcoming. Lowry, being Lowry, took the failure of the City to find the finance to be his shame, not theirs; Manchester, he felt, had once again humiliated him by their disinterest.

He had, anyway, long ago decided where his estate was going when he died; he saw no cause to change his will. 'I'm making sure they won't go to a public gallery,' he had said of his pictures back in 1967. 'I wouldn't like any of my work to be at the whim of the existing director and go into the cellars and remain unseen for years.' Manchester City, he had always felt, was just such a gallery; Manchester had once claimed to have twenty Lowrys, he related to Mait-

land, but 'where are they—no one has ever seen them on a wall there, I've never seen them on a wall there'.[22]

'What shall I do with all this when I'm gone?' he would ask Carol Ann each time she arrived to visit him. 'Oh,' she would say, 'give it to the Salvation Army and be done with it.' And he smiled a secret smile which she thought to be because she had divined the truth of his intent.

It would, no doubt, be unfair and untrue to say that the concerted pressures put upon Lowry hastened his end; but they certainly did nothing to ease his declining years. That the intentions were of the highest cannot be denied; what was in doubt was the understanding of the nature of the man, a modest man who could never have countenanced connivance in their honour of him. Had they honoured him without demanding his co-operation, had they presented it to him as an accomplished fact, he would no doubt have been moved and delighted. What he could not stomach, and wanted no part of, was the inter-city rivalry that soured each approach no matter how gracefully they couched their words in phrases of respect and admiration. No one person or single organization could be blamed for the distress to which he was exposed; but together they brought him much pain.

It was no more than unfortunate mischance that took him one day at the height of the debate to Salford, to the gallery he regarded as the one constant factor in a fickle world. He arrived, unnoticed, in the Lowry Room, just as workmen were removing the last of his works from the wall. It was indeed a cruel stroke of fate that had brought him there on the very day they were re-organizing the rooms for redecoration; his absence from the walls was no more than temporary, a matter of expediency. But for him it was a disturbing experience; the wounds were by now too deep to be assuaged by rational explanations or by the sight, only a few days later, of his pictures restored to former prominence. His faith had been badly shattered and, quite illogically, was never to recover.

His impatience came to a head one day in December, 1975, just three months before his death. In the morning the dignitaries of Liverpool University had travelled to Mottram to present a now reluctant Lowry with their Doctorate; his reception of them was less than gracious. 'Why do they bother,' he whispered in an aside; and 'What do *they* want?' After a formal lunch at the Midland Hotel, they whisked him by car to Salford Art Gallery for the launching of a new book about him. The public controversy, Manchester versus Salford, was still fresh in the public mind. The press were there in force, loaded with questions to which they received no answers.

There were equally loaded speeches and barbed remarks, and a hundred and one people pestering to know which way he would jump. He had no intention of jumping at all, particularly not through their hoops. The Curator Stanley Shaw's public references to the 'lack of sensitivity and good taste' on the part of those urging the establishment of a memorial gallery in Manchester or anywhere but Salford did nothing to soften the impact of their concerted pre-occupation with the distribution of his estate.

He left the assembled dignitaries just as soon as he was able and went to sit awhile in the body of the hall beside his friend Frank Mullineux. 'Can they not leave me alone?' he asked with a long sigh. He looked old and ill that day; he looked every bit of his eighty-eight years. Then there was tea, and he was moved again, to another chair, round which more people crowded, peering and probing, questioning and querying, flattering and fawning. His hand shook as he lifted his cup to his mouth and tea spilt, staining his shirt and marking his trousers. Someone fussed with a handkerchief, trying to mop him dry as if he were a small child who had committed a social gaffe; another pushed an autograph book at him; and yet another said loudly that he should ignore all regional claims and leave it all to found a scholarship at the Royal Academy. They spoke as if he were not there, or too old and stupid to understand their words.

He turned his head away and, in a voice of aching weariness, remarked to one he knew quite well: 'Can they not wait until I'm dead, sir?'

3 'Can't do it'

DEATH HELD no fears for Lowry; it had held no fears for him for many years. He had never avoided consideration of it and now, with the burden of years weighing more heavily upon him, he regarded it as a state consummately to be desired. Only the manner of his passing concerned him. 'A married man,' he would say, 'lives like a dog and dies like a king; a bachelor lives like a king and dies like a dog.'[1] He did not want to die like a dog.

He had seen so many friends go; and all his family save May, still with her dog but no longer her chickens. Maitland, heartbroken at the long illness of his brilliant wife, had died in 1972; and David Carr, slowly but inevitably, after eight years living with the knowledge of the cancer that was to defeat him; and James Brooke, the restorer in Huddersfield whom Lowry called 'The Great Man'; and Percy Warburton, who collapsed and expired at his feet while they were out walking in Manchester one day in 1968; and Laing, so newly married; and the Fletchers, first Frank, then George in senility at the age of ninety-one; and, as he reported, Ann Hilder's father; and Harold Timperley; and Daisy Jewell; and McNeill Reid in retirement; and Ted Frape, who went quickly and suddenly in the night.

'I think in the end you get tired of it,' he said, wandering obligingly for the television cameras among the graves of Southern Cemetery where soon he was to lie. 'My mother was quite tired of it. My mother was house-fast for fourteen years and bedfast for eight before she died. Never got out of bed for eight years.'[2] He realized suddenly

that without thinking he was leaning disrespectfully upon a head-stone: 'I mustn't lean against this gentleman's grave.' He straight-ened himself hurriedly, resuming his contemplation of the manner of death. 'I wouldn't like to do that. But you can't be sorry for a man like Frape, can you? He went off nicely. He went off a bit soon, but he went off very well. When you see people go, inch by inch, that's the time when you worry about it. Then you wonder who'll look after you. You don't want to be a burden to anybody.' He looked at the gravestones again, the tended and the forgotten. 'They're not worrying a bit, are they? There's not a murmur from them. They're all right now, aren't they? They've nothing more to worry about as far as I know. No, I feel as if the people in them are all right.' He looked directly into the camera, a sudden light of mischief in his eyes. 'It's when they get married I feel sad.'[3]

Ten years later he was displaying an increasing impatience for the advent of such a state of peace; he was still seeking contentment; and answers. 'What are you hoping for?' John Heilpern[4] had asked him in November, three months before his death. 'What would you imagine?' he replied and, seeing the truth in his desolate look, the writer did not want to answer him.

'I want the truth from you,' the artist snapped. 'Point blank. Come on. Come on.' 'You're hoping for death.' 'Correct,' said Lowry. 'Death, comfortably. What is there left? I feel as if I don't belong to this life. Feel as if I'm not here. I'm not *complaining*. Ups and downs in anyone's life. I've got through it quite pleasantly, really. Drifting about. Mustn't complain. Strange thing, life. Why are we *doing* it? What's the point of the whole thing? Why? What of it? I can't get used to it. Why, why? Can you answer me? What's the purpose of it all? Everywhere you turn is suffering. *Why?* God only knows. I don't. Why all the fuss and flurry? Can you *tell* me?' 'To make a better life?' ventured Heilpern. 'For *what*?' Lowry resumed. 'It gets worse. *Worse*! Do you think the world is really a better place than it used to be? What can it all have been *for*? It can't all have been waste. There must be something after. I don't understand a thing. What's the idea? Tell me what the *point* of all this is and I'll be happy.'

'I can't help you,' said the writer, 'I know you've created fine art.' 'What's the *good* of art? What's the *good* of it!' 'You've given people enormous pleasure.' 'Fleeting. It's only been fleeting.' 'It's gone deeper,' Heilpern insisted. 'Perhaps,' Lowry agreed, 'it might have done. I don't know. I wish I knew.' And he lapsed into silence.[5]

Thursday, February 12th, 1976, in Mottram-in-Longdendale was a dank, cold day; the mist gathered low in the valleys so that the

Derbyshire peaks hung as if suspended from angry skies. Lowry
awoke early. He had suffered a restless night, his sleep plagued by
dreams that left him with a feeling of unease that lingered into con-
sciousness. It was not the familiar morning sense of isolation that
disturbed him. He had, over the years since his mother's death,
become accustomed to that. This was somehow more than the deep
sense of loss that engulfed him each morning on waking. This was
a new sensation; almost a foreboding. He lay in his bed awhile, trying
to define the dread that suffused him, to put a name, a reason, to
something that defied reason.

The room was cold; so cold that white tendrils of frost etched
the grime on the tall windows that looked on to bleak hills. The
battered electric fire, relegated to the bedroom when the new gas
fitting had been installed downstairs, was on the other side of the
room, too far away to be switched on from where he lay, yet he longed
for its comfort.

He glanced around him, at the photograph on the mantelshelf
of a young Carol Ann, her long dark hair drawn softly back from
her face and tied with a ribbon; at the dream women of Rossetti, and
Proserpine still unhung after its return from exhibition at the Royal
Academy three years before, propped on the floor against the ward-
robe that held his three suits.

Abruptly, as if making a sudden decision, he sat up and thrust
his feet out of bed. He did this every morning, almost as a ritual,
a discipline designed to force him to face another day. 'I'll wake up
and nobody is there and it is very quiet and very still and—I don't
know—sometimes my mother is there with me. I don't see her, but
I feel her presence and I hear her telling me, as she always did: "Get
up, Laurie, get up." And I know, from experience, that if I stick my
feet out of bed, shove my legs right out, it'll be all right. And that's
what I do. And it *is* all right. I'll get dressed and as soon as I've got
my collar and tie on, I'm ready to face the world—as long as they
leave me in peace to have my egg for breakfast.'[6] And in telling it to
friends as he often did, he would demonstrate the method from where
he sat, sticking out his long legs before him in swift, jerky movements.

That morning, following the well-tested procedure—lathering the
granite-like face which was more hewn than moulded by age—he
noticed with surprise more than concern that it all took slightly
longer than usual, the buttons on his thick union shirt resisting his
fumbling fingers with unaccustomed obstinacy. The journey down
the steep, carpeted stairs of the old house seemed more perilous, de-
spite the extra care he took since he had slipped and nearly fallen
the full flight some weeks before. He had blamed his old slippers

so vehemently that, one Monday morning after his Sunday visit, Mattie Lowry had rushed into Rochdale to buy him a new pair. He had delighted in the gift like a small child, more taken with the ceremony of opening the parcel than with the contents. He liked the slippers well enough but he did not wear them. They were not the same somehow as the old pair that moulded to his feet like socks the moment he put them on.

Safely into the front room, he ate his frugal breakfast; no egg that day, just brown bread and butter and tea he brewed on the antique stove in the kitchen. He listened to the morning service on the wireless: he had never learned to call the thing a radio and, besides, it was far too venerable for any such new-fangled name. But today there was no solace in the music, no warmth in the fire, no comfort in routine.

The tray was still before him on the table, the meal barely finished, when he heard the whirring of the front door bell which, once again, he had neglected to rewind. He had remembered that Stanley Shaw, successor at Salford City Art Gallery to his old friend Ted Frape, was due to take him out to lunch, but he had not realized, in his preoccupation, that it was now past eleven o'clock. He knew, without looking at the watch which sat precariously unattached to chain or thong in his waistcoat pocket, that this was indeed the hour. Mr Shaw would not have presumed to arrive at his door any earlier; not since the day when, as a newcomer to 'The Elms', he had presented himself at 10 a.m. on ill-informed advice and brought the wrath of Lowry around his ears. 'What d'ye want to come so soon for?' he had thundered. 'Nearly blew my head off,' Shaw recalls.[7]

Outside, stomping his feet against the cold on the stone steps, the curator was uneasy. The last time they had met was on the embarrassing occasion of his rather ill-considered reminder to Lowry to remember Salford in his will. He preferred not to think about that day. As far as he was concerned the subject was now closed. He saw, dimly through the frosted glass, the smudgy white triangle of Lowry's breast pocket handkerchief topped by the pale form of his face, and hoped fervently that the topic would not be raised again. As soon as the old man opened the door, the keys to the double-action lock still jangling in his hands, Shaw could see that there were other things on the artist's mind that day. 'I've had a terrible night, an awful nightmare,' Lowry began, before they were half into the front room. 'I can't get it out of my mind. It was all about dealers. Oh, it was nasty, I can't tell you. It bothers me still. Dealers coming and worrying me about things. I can't think what brought it on.'[8]

Shaw looked sympathetic. He was thankful he had no particular

request that day. 'Has anyone been?' he asked. 'No. No, they haven't. That's it. That's what's so puzzling. That's why I can't think what brought it on.' His words were clipped, staccato with concern, his hands moving ceaselessly as he sat, his fingers caressing the arm of his chair, his upper lip, his spikey white hair. 'Nasty, nasty,' he kept on, re-living in his mind the images of the night. 'It's quite put me out. Can't get it out of my mind. Oh, it was nasty.' He looked up quickly as Bessie Swindles, with a discreet tap on the door, materialized beside the breakfast tray.

'Hey, don't take that away,' he said. 'I'm not finished yet.' The tea was cold in the pot and had been for some hours. But Lowry emptied the last drop into his cup and drank it while Mrs Swindles stood, watching and waiting without comment.

It was a performance she knew well. Lowry seemed actually to *prefer* his tea cold—and his tomato soup for that matter. He would keep a cup beside him, sometimes for three hours or more, and refuse to abandon it until the last dregs had been drained. 'Never could get the breakfast pots to wash before dinner time,' his housekeeper would grumble in pretended irritation. They were well matched, the housekeeper and the master; kindred spirits in their speech, their black humour and their banter. They understood each other so well that when Mrs Swindles said of a Lowry mill scene: 'I don't think much to that,' he would chuckle and agree: 'Don't like it much myself.' He knew her distaste was not for his art but, like so many of her generation who saw in his industrial paintings the reality rather than the vision, an aversion to the memories they inspired. Perhaps he enjoyed faint echoes of maternal disdain. In contrariness he gave her a thundering industrial composite and called it *Mrs Swindles' Picture*; she gave it to her son and hung, above her own fireplace, a reproduction of *Man Looking Out to Sea*.

Again a faint rasp came from the front door bell. This time the visitor was Donald Rayner, Secretary of the Manchester Academy and an acquaintance of long standing. His thin face was yet paler and more drawn than usual; he was quite obviously upset.

Slowly, after a formal exchange of greetings, Rayner unburdened himself. He had been told only the previous day that he had a disease which, although the doctors had not specified the nature of it, Rayner himself believed to be cancer. He had come to see his fellow artist, more to say farewell than to seek sympathy. Now, finding Stan Shaw there too, he made the curator promise that, should he, Rayner, die before the scheduled exhibition of his work at the Salford Gallery in November that year, the show would go on. Shaw gave his word and, in the event, the artist lived to attend his private view,

ill though he was. 'The curious thing about that morning,' Shaw
recalls, 'was that Lowry seemed to take in everything poor old
Donald Rayner was saying. But after an anxious "dear, dear", he
would lapse into a sort of reverie and revive himself after a pause
with a jolly "Well, how are you keeping then?" He was obsessed
with his bad night, his dream. It wasn't like him to be insensitive
to others. And yet he asked several times: "Well, how are you keep-
ing then?" until I got quite embarrassed. But Mr Rayner seemed
to accept it and in the end he replied: "Oh, all right, thank you."
He could see Mr Lowry wasn't terribly well and so, soon after noon,
he left.'[9] The two artists were not to meet again. Rayner had eleven
months to live; Lowry had ten days.

A certain malaise lingered in the chill room after Rayner had
gone. Lowry was silent, his chin slumped into his chest, his eyes
closed. 'Look,' said Shaw, 'you've had a rough night. Would you
rather not go out?'

Lowry stared. 'Oh no, we're going out. We've got to eat, haven't
we? But it's early yet. We'll leave it a bit.'

And so they sat, the fraying cobwebs on the high dadoes swaying
gently in the currents of warm air from the gas fire, the stillness orches-
trated by the rapid tick-tock of the Tompion clock on the mantle-
piece. It was nearly 1.30 p.m. when they left, Lowry finding a curious
difficulty in getting into Shaw's car which was parked outside the
house. He seemed stiff, awkward, unco-ordinated.

'I'm going to die,' Lowry announced casually as they drove to-
wards Stockport.

Shaw blinked. 'Give me notice, won't you,' he said, as lightly
as he could.

For the first time that day Lowry grinned. 'Oh, not this moment,
I'm not. But very shortly.' So involved were they with talk of the
artist's imminent demise that they drove past the Alma Lodge Hotel
where they were to lunch. 'Oh, my goodness,' said Lowry, when he
realized. 'What's the matter with me? Why did I miss it? Well I
never—never done that before. What's the matter? That nightmare
has quite upset me.'

The hotel drive where they stopped was wet, a thin film of thaw-
ing frost underfoot. That was the first time Lowry fell that day, and
it was the moment when Stanley Shaw began to worry. 'He just
couldn't get on his feet. I tried to hold him, but he was a big man.
He said: "You know what it is—I've got my wrong slippers on."
It wasn't that, of course. When we were inside he sank, or fell rather,
into a chair in the foyer. But on the way to it he stumbled to his
knees by the door. I asked: "Are you all right?" After a few minutes

he said: "I'm all right," and we went in to dinner. We had roast beef because the head waiter recommended it, but Lowry didn't eat much, which was unusual. We spent a lot of time speculating as to whether the people at a nearby table were both men or both women or one of each. That sort of thing fascinated the man—the observation of people. I kept having to look round because they were behind me.

'Lowry couldn't seem to handle his knife and fork very well and I became anxious to get him home. But he insisted on having the sweet. We had trifle and he whooped that. Then we went out again and sat in the lounge and I said: "I don't think you should stay here. You're not too good," because what he usually did was to go off to sleep for half an hour. He replied: "Perhaps you're right." So I got him out, but again I had great difficulty getting him into the car and enormous trouble extracting him at the other end. He fell to his knees a couple of times. I was getting rather upset about it. One moment I turned to shut the car door and when I looked round he had fallen right over. Any rate, I got him sat down in his chair and he had a little snooze, and a chat, and a snooze, and a chat.

'It got darker and darker and the curtains weren't drawn and he'd just come to and say: "You'll want to be going, won't you?" and then doze off again. I did have to go really, but I was waiting for him to let me out.

'"Ah, I expect you'll want to go now."

'"Well, I must get back. It's tea time."

'"Aye, you've got a family to get back to. . . ."

'"Yes. Yes, I have."

'"How many children?"

'"Four."

'"That's nice. Do you know, I never had any family. All I had round me was the garden fence."

'"I suppose you are used to it. That sort of life."

'"Yes, but it's not the same."[10] And, with that, Lowry got up and shambled to the door. He fell against the table as he passed. Lying on it was a reproduction, just a small one, of an industrial scene. He picked it up with a long sigh. "How did I ever do that? Lot of hard work in that. How did I do it? Couldn't do it now, you know. Can't do it now."' He had written those words, 'Can't do it', in the slim pocket diary he carried, two days earlier, on February 10th, the forty-fourth anniversary of his father's death.

And so they parted, the curator and the artist, Lowry still muttering 'Hard work . . . can't do it' as he shut himself into the

old house with his isolation and his fears and his inexplicable fore-
boding.

It seemed as if he had been sitting in the deep greeen chair only
a few minutes when the door bell moaned again. He dragged himself
up and started towards the door. As he passed the table, his knees
seemed to give beneath his weight and he fell yet again, halfway
between the room and the passage. This time he did not get up. He
was fully conscious, conscious of the insistent knocking and the hoarse
whirring of the bell. 'I'm coming, I'm coming,' he called, but his
body refused to obey the commands of his mind. Through the glass
he could see the shape of a man. 'Wait,' he cried, 'wait,' as he
struggled once more to rise. But there was no strength in his voice
and his words did not carry clearly to the other side, where stood
one Johnny Morris, ex-tap-dancer turned art dealer, the man Lowry
called a lovable rogue; he had come on his usual quest for doodles,
with his sketch pad, his pen and his patter. He thought he heard
the artist shout 'I'm coming', but, when he did not appear, gave
up, leaving as a calling card his accustomed child-like offering of
biscuits which he fed carefully through the letter box.[11]

A few feet away, on the floor, Lowry watched as a slow stream
of chocolate digestives tumbled through the door to lie, as he lay,
immobile on the mat.

'Wait,' he tried again; but the figure moved and faded as, in
despair, he heard the sound of footsteps going away into the night.
Then silence which, as he listened, became no silence at all but the
distant cacophony of busy people intent on busy lives. They passed
by his door not ten yards from where he lay and, in his imagination
and his need, he heard them approach not once but many times,
only to wait in vain for the knock he thought must quickly follow.
He threw his slippers at the door. He threw his diary. He threw his
wallet. He knocked a pile of framed pictures to the floor with a clatter
he felt must surely have been heard at the bus stop where many must
be gathered. He hurled everything within reach, large or small, even
his watch. No one came.

The artist and the biscuits still lay where they had fallen when
Philip Robertson arrived well after nine that evening. The Glossop
hatter, a man whose musical tastes and nocturnal habits had turned
acquaintance into friendship, came each Thursday by long-standing
arrangement to spend a night of conversation and company with
his comrade. When he received no answer to his knock he called
anxiously through the letter box: 'Are you there?' 'I'm on the floor,'
came the reply, loud and clear, and, peering through the slit in the
door, Robertson saw Lowry lying on the floor. 'Right,' he shouted,

'hang on—I'll be back.' He drove the half mile to Mrs Swindles' cottage, brought her to the door in her dressing-gown, told her what had happened, and obtained her keys to 'The Elms'.[12]

Within minutes of Robertson's return the artist was back in the old green chair, firmly claiming to be fine, just fine. Lowry had no doctor they could call; he had not bothered to register himself in the village in which he had lived for nearly thirty years. He had consulted none since old Mills Popple died. They tried the ambulance service, who could not respond to such a call, the police, and many others; eventually they received a visit from an emergency duty doctor for whom Lowry performed, with dogged determination, a series of simple tests designed to demonstrate his fitness. He had a touch of 'flu, said the doctor; nonsense, said Lowry, he had fallen. He would not go to hospital; he would have no fuss; he would go to his own bed in his own home; thank you kindly, sir, and good night.

In the face of such resolute insistence they—Robertson, Mrs Swindles, and the doctor—had no choice but to leave him. When the housekeeper arrived next morning she found him once more in a state of collapse, on the floor beside his bed. Bessie Swindles did not wait for his permission; she called her own doctor.

'Hospital,' he suggested when he arrived. 'No,' said Lowry, and once more performed the acts of walking, talking and touching his nose with his forefinger, all calculated to convince them of his abundant good health. They were not deceived. Quietly the doctor arranged that Robertson and a mutual friend from Tintwhistle called Frank Whalley should stay the night in the house to watch over him. Whalley was already aware of the situation, having called that morning expecting to collect Lowry for a visit to Manchester; both he and Robertson were constant in their visits to 'The Elms' to place both their companionship and their cars at the artist's disposal. Lowry was indignant when he first realized what was planned; finally with ill grace he consented and, gradually warming to their presence, sat up in bed to eat boiled eggs with toast soldiers lavishly buttered, which they served to him beneath the gaze of his Rossetti women.

The night passed, and the next day, Saturday, Lowry was taken, protesting, to the Woods Hospital at Glossop, where he was put into a private room with a sign marked 'Strictly No Visitors' on the door. Curiously, both Robertson and Whalley now became fiercely protective of the artist they regarded as friend first, celebrity second. Fearing a circus of vested interest around the dying man, they guarded the secret of his illness from all except those whom they knew

to be his true friends. Carol Ann came from the Isle of Man, travelling on the morning boat with Alick Leggat who, by coincidence, had also made his home on the island and who was now regretting that he had left his friend at such a time. Mattie Lowry came from Rochdale, blaming herself that she had not *made* him let her care for him; and Mrs Swindles came reluctantly, feeling that he would not want to be bothered with visitors, although he had asked for her. Tilly Marshall arrived with Micky, barely recovered from a serious operation; and the Rev. Geoffrey Bennett with Alice, herself suffering a terminal disease; and Margery, from the past. They had tried to tell Ann Hilder, but could find no trace of her.

Such was the humour of the invalid that though they came in tears, they left in smiles; it was he who cheered them. He needed rest and quiet, they told him, but he laughed at their fears and asked them to turn the gaudy flower picture that faced him on the wall sideways or upside-down, so that it might look more interesting. They did as they were told and he watched closely to see how long it took each caller to notice the fact; few did. As always, he wanted no sentiment, though for the first time ever he asked Carol for a kiss, which she gave him, holding his hand as if to hold him in this world. One night, as he lay with his eyes half closed, a young man who had blossomed under the influence of the artist and who had never witnessed death, tried to tell him what knowing him had meant. He struggled to find the words, wanting him to understand the depth of the gratitude he felt for the simple gift of friendship. He was choked with emotion, and his voice faltered. Lowry opened one eye and observed him wryly. 'What, sir,' he said, the crooked smile flickering the corners of his mouth, 'are you going to kiss me?'

In the early hours of the morning on Monday, February 23rd, 1976, nine days after his admittance to hospital, Laurence Stephen Lowry died in his sleep of pneumonia following a stroke. He had achieved his last ambition: he had become a burden to no one. He had died, as he had lived, alone, with humour, with dignity and with courage.

The day of the funeral, Friday the 27th, was as dark and as dank as he had said it would be; but there were not two people but two hundred present: press-men and press-women by the score, artists and friends, gate-crashers and unknown admirers, the curious and the concerned, dealers and collectors. There was Kalman from the Brompton Road, and the Kunzels from Clithero in great distress; and tiny Mattie Lowry and all the Marshalls; and the Earnshaws from Sunderland, and Leggat and Robertson and Whalley; and Jim Fitton, representing the Royal Academy, who went home to

paint a picture of the scene that day. Bessie Swindles would not go: 'He said he wanted no cups of tea and no buns,' she reproved later, 'they should have respected his wishes.'[13] The Rev. Geoffrey Bennett read the 23rd Psalm and thanked God for 'his life and his work'. 'His friends,' he said, 'are better for having known him and the world better for having their eyes opened by his penetrating insight into what lies around them.'

Thus, on a grey day in Manchester, Lowry was buried in Southern Cemetery, in the plot where both Robert and Elizabeth lay at rest.

The public speculation and private intrigue that Lowry had known would inevitably follow his death had begun even before he was cold in his grave. Few, it seemed, imagined that he would have allowed his 1970 will to stand; he surely could not have intended his estate to go to that girl who was, in truth, no niece at all—in all probability she was not even a relation. He would, they said, have wanted it to go to the Royal Academy, or the Whitworth or Manchester or Salford. Lowry, of course, wanted no such thing. There was no new will, only shock, surprise and consternation when the truth of his intent was finally revealed. He had left a small Rossetti to his faithful friend and solicitor, Alfred Hulme; the sum of £1,000 to Bessie Swindles; the four paintings he had promised to Salford; and an inlaid Tompion grandfather clock, which ironically turned out to be a partial fake, to Geoffrey Bennett. To Carol Ann he left specifically his prize possession, *Proserpine*, plus all the rest, residue and remainder of his estate, which was valued at £298,459. Of his godchild, Ann, whom he had said would receive her portraits, there was no mention.

Nine months after his death the Royal Academy paid their ultimate tribute to the artist whom they had intended uniquely to honour with a full exhibition in his lifetime. 'Like most things in Lowry's life,' observed *The Guardian*, 'it came too late.'

The catalogue, notable for the fine sentiments and real praise contributed by the artist's eminent friends, revealed the truth of Lowry's early life: of his job at Pall Mall. The great man was a mere rent collector. The reaction of certain members of the art establishment was, as James Fitton commented so aptly, 'highly suspect'. There were some who, in the complacency of their own esteem, saw him diminished by the revelation. 'We always knew he was an amateur,' they sneered.

To the ordinary public, such trivia were irrelevant. They queued through the courtyard of Burlington House and beyond to marvel

at the range and mastery of this ordinary yet extraordinary man. When the exhibition closed ten weeks later, the attendance had set new records, rivalled only by the great Turner exhibition two years previously.

The prices of his pictures had, initially, soared as is common when an artist dies; the public knew there were to be no more. His output was not prodigious; he painted perhaps 800, possibly 900 oils; and did maybe 3,000 drawings. By the first anniversary of his death his prices had stabilized; by the second they still held. Only time will bring the answer to his constant question: 'Will I live?' He guessed it would take about a hundred years. But today those who believe he will survive outnumber those who still deny him recognition.

The final irony of Lowry's life is that his genius outlives the transient fame of so many of his detractors. The tragedy is that he never *knew* it. He would have so enjoyed the joke.

APPENDIX ONE
Galleries holding Lowry's work

ABERDEEN	Art Gallery
BEDFORD	Cecil Higgins Art Gallery
BOLTON	Art Gallery
BRADFORD	Art Gallery & Museum, Cartwright Hall
BRISTOL	Museum and Art Gallery
BURY	Art Gallery
CARDIFF	Museum and Art Gallery
COVENTRY	Herbert Art Gallery
ECCLES	Monks Hall Museum
EDINBURGH	Royal Scottish Academy
	Scottish National Gallery of Modern Art
GLASGOW	Museums and Art Gallery
HUDDERSFIELD	Art Gallery
LEEDS	City Art Gallery
LEICESTERSHIRE	Museum and Art Gallery
LINCOLN	Usher Gallery
LIVERPOOL	Walker Art Gallery
LONDON	Arts Council of Great Britain
	Imperial War Museum
	Royal Academy
	Tate Gallery
	Victoria and Albert Museum
MANCHESTER	Whitworth Art Gallery, Univ. of Manchester
	City Art Gallery
NEWCASTLE	Laing Art Gallery
NEWPORT	Museum and Art Gallery
NORWICH	Castle Museum
NOTTINGHAM	City Art Gallery
OLDHAM	Central Library
ROCHDALE	Art Gallery
SALFORD	City Art Gallery
SHEFFIELD	City Art Gallery
SOUTHAMPTON	Art Gallery
STOKE ON TRENT	Museum
WAKEFIELD	City Art Gallery
YORK	City Art Gallery
NEW YORK	Robert Osborne Art Gallery

APPENDIX TWO
Notes and Sources

PART ONE *Chapter 1*

1. Diaries of Annie Hall, later Mrs W. H. Shephard, first cousin to Eliza-beth Lowry, in the possession of her grandson, Professor Geoffrey Shep-hard; 1889.
2. An Edward Hobson, clothier, is listed in the first Manchester Direc-tory of 1772.
3. 'Famous men who made Manchester' by J. Cuming Walters in *The Soul of Manchester*, ed. W. H. Brindley (E. P. Publishing Ltd, London, 1974).
4. Detail from family history compiled by the late William James Shep-hard, son of William Henry Shephard and Annie (née Hall), in the possession of Professor Geoffrey Shephard.
5. The late May Eddowes (née Shephard), first cousin to L. S. Lowry, to author.
6. Founded in 1801 by David Stott, the school was built by public sub-scription in 1818 and until that time its meetings were held in the 'turrets' of members' houses. The building, on the corner of Turner Street and Bennett Street, was demolished in 1968.
7. Robert Lowry's accounts.
8. *Portrait of Manchester* by Michael Kennedy (Robert Hale, London, 1970).
9. May Eddowes to author.
10. Rowley Fletcher, nephew of Charles Rowley, Chairman of the Trustees of Bennett Street Sunday School, to author.
11. Obituary for George Milner by Thomas Derby, in the records of Ben-nett Street Sunday School and St Paul's Literary and Educational Society; Manchester City Library Archives Department.
12. 'Memories of George Milner' by J. E. Chatfield, BSSS records.
13. 'The Ancoats Brother', a tribute to Charles Rowley, BSSS records.
14. Kennedy, *Portrait of Manchester*.
15. 'Men with Missions', *Manchester City News*, April 13th, 1907.
16. *Ford Madox Brown: A Record of His Life* by Ford Madox Ford (Long-mans, Green and Co., London, New York and Bombay, 1896).

17. 'Manchester and Art' by F. W. Halliday in Brindley (ed.), *The Soul of Manchester*.
18. Rowley Fletcher to author.
19. 'The Ancoats Brother', BSSS records.
20. 'Music in Manchester' by Neville Cardus in Brindley (ed.), *The Soul of Manchester*.
21. The canary's habit of ruffling up its feathers and falling in apparent agony on the floor of its cage, legs in the air—only to recover miraculously if ignored—is still used by northerners to describe the antics of a woman prone to convenient bouts of illness.
22. Letter to Elizabeth Lowry from Annie at 9 Crisp Street, Poplar; December 1883.
23. Family records of W. J. Shephard.
24. The Brand Lane concerts were 'always a part of the musical soul of Manchester; they were founded by a man of rich Northern humour and shrewdness who knew a Kreisler when he heard one, never mind the expense.' Cardus, 'Music in Manchester' in Brindley (ed.), *The Soul of Manchester*.
25. Edward and Selina were married on October 10th, 1875, at St Mark's Church, Manchester, and had three children, Alfred, Gwen and yet another William.
26. In the 1920s when Robert and Laurence Lowry travelled from Salford to work in Manchester together, Robert would repeatedly make specific detours past a particular house. He told his son it had a special significance for him. 'He never told me what it was and I never asked him. But I've wondered, oh I've wondered.' Carol Ann Spiers (née Lowry), heir to L. S. Lowry, to author.
27. Manchester Poor Rate Books, 1857; Manchester City Library Archives Department.
28. Carol Ann Spiers (née Lowry) to author. In June 1968 Lowry went with Carol Ann on a romantic pilgrimage to Port Patrick 'to see where my ancestors landed'. They stayed three days. In 1967 he went with Pat Cooke and her husband, Brian, to Belfast 'but hated it so much that he fled back to Dublin' to continue their holiday.
29. Pat Cooke to author.
30. Monty Bloom to author.
31. Ronald Marshall of the Stone Gallery, Newcastle-upon-Tyne, to author.
32. Phyllis Marshall of the Stone Gallery, Newcastle-upon-Tyne, to author.
33. Carol Ann Spiers to author.
34. 'L. S. Lowry: a man of his people' by Barrie Sturt-Penrose, *Nova*, August 1966.
35. W. J. Shephard records Helen, Mary, Robert and Martin (who died at sea); L. S. Lowry's own notes mention a Martha, born two years after Robert.
36. Minute Books of Henshaw's Blue Coat School, 1867.

37. *The History of Henshaw's Blue Coat School, Oldham, 1829–1942* by T. T. Richards (Geo. Whittaker & Sons, Stalybridge, 1945).
38. In 1870, according to the Minutes of Oldham School Board, there were in Oldham 6,000 children between the ages of three and thirteen not attending school.
39. May Eddowes to author.
40. Robert Topham died six months later; he was buried at Harpurhey Cemetery on January 30th, 1886, where the service was conducted by the Rev. Edward Parke, the man who married Robert and Elizabeth Lowry. 'Robert Topham' by George Milner in St Paul's Literary and Educational Society supplementary volume of the manuscript magazine *Odds and Ends* in commemoration of the Society's Jubilee, 1893; Manchester City Library Archives Department.
41. 'Old Trafford', *The Free Lance*, February 12th, 1875.
42. May Eddowes to author.
43. Letter to Annie Hall from W. H. Shephard; December 21st, 1888.
44. 'In memoriam: W. H. Shephard', in the Parish Magazine of St Paul's Church, New Cross, Manchester, February 1925.
45. Letter to W. H. Shephard from Annie Hall; undated.
46. Letter to Annie Hall from W. H. Shephard; November 12th, 1887.
47. 'A seven days' cycling tour' by W. H. Shephard in the manuscript magazine *Odds and Ends*, vol. 42 (1896); BSSS records.
48. Comment in the satirical magazine *The Parrott*, November 11th, 1887.
49. May Eddowes to author.
50. ibid.

Chapter 2

1. The late May Eddowes (née Shephard), first cousin to L. S. Lowry, to author.
2. ibid.
3. Baptismal Records of St Bride's Church, Old Trafford, Manchester; 1887.
4. L. S. Lowry to Professor Hugh Maitland at Burton-on-Trent, on tape, during a period of several weeks in the winter of 1970, when Maitland was preparing a biography of Lowry.
5. May Eddowes to author.
6. ibid.
7. Annual Reports of the Home and Day Nursery for the Children of Widows, 112/114 Bloomsbury, Rusholme Road, Manchester; 1890–1904.
8. L. S. Lowry to Monty Bloom; on tape (undated).
9. Confirmation Certificate in the estate of L. S. Lowry.
10. ibid.
11. Lucy Holmes (née Snarr), general maid in the Lowry home at 14 Pine Grove, Victoria Park, Manchester, to author.

12. Diaries of Annie Hall, later Mrs W. H. Shephard, first cousin to Elizabeth Lowry, in the possession of her grandson, Professor Geoffrey Shephard; September 15th, 1889.
13. ibid; May 20th, 1889.
14. ibid; November 24th, 1889.
15. ibid.; June 1st, 1889.
16. Rowley Fletcher, nephew of Charles Rowley, chairman o£ the Trustees of Bennett Street Sunday School, to author.
17. The Rev. Albert Willcock, grandson of Mr Handforth, churchwarden at St Clement's Church, Longsight, Manchester, to the author.
18. Lucy Holmes to author.
19. ibid.
20. The Rev. Willcock in a letter to the author.
21. May Eddowes to author.
22. It was his mother who first introduced Lowry to poetry. Typically, she gave Annie Hall a collection of Kingsley's poems for her birthday in 1889; Annie gave Elizabeth 'a pair of small compots for her table'.
23. Family history compiled by the late W. J. Shephard, son of William Henry Shephard and Annie, in the possession of Professor Geoffrey Shephard.
24. 'A cycle ride in the land of Burns' by Ruth Mary Shephard in *Odds and Ends*, the manuscript magazine of St Paul's Literary Society, vol. 44 (1898). Manchester City Library Archives Department.
25. Maitland tapes.
26. Letter from Annie Shephard to her husband; September 10th, 1900.
27. Professor Ronald Shephard, son of the late W. J. (Billie) Shephard, to author.
28. Clifford Openshaw to author.
29. Tyne Tees Television documentary film 'Mister Lowry', produced by Robert Tyrrell. This film, made in August 1968, but not shown until March 1971, was awarded a Silver Medal at the 1970 Venice Festival of Art Films.
30. L. S. Lowry to the late Gerald B. Cotton, Chief Librarian of Swinton and Pendlebury and later Salford, and Frank Mullineux, Keeper of Monks Hall Museum, Eccles; on tape (undated).
31. 'Mister Lowry', Tyne Tees Television.
32. 'Manchester' by A. J. P. Taylor, *Encounter*, March 1957.
33. *A Short Account of Victoria Park, Manchester*, published by the Park Trust Committee in commemoration of the opening of the park on July 31st, 1837.
34. Monty Bloom to author.
35. *Portrait of Manchester* by Michael Kennedy (Robert Hale, London, 1970).
36. In 1972, when Ford Madox Brown's house was being demolished, Frank Whalley, a young friend of Lowry's, foraging in the debris, found the doorknob of No. 33, had it mounted and presented to the artist.

37. Lucy Holmes to author.
38. Manchester Poor Rate Books, 1898. Manchester City Library Archives Department.
39. Harold Riley to author.
40. Margery Clarke to author.
41. Many years later Lowry was to paint *Boy in a Yellow Jacket* (page *IX*), one of his most powerful portrait heads, in which the bright colour of the boy's coat only serves to accentuate the anguish in his eyes.
42. Edith Timperley to author.
43. Monty Bloom to author.
44. School Diligence Certificate in the estate of L. S. Lowry.
45. Interview given by Lowry to students at Salford College of Art; on tape, 1965.
46. Lucy Holmes to author.
47. 'Mister Lowry', Tyne Tees Television.
48. Cotton/Mullineux tapes.
49. Letter from L. S. Lowry to David Carr; April 28th, 1952. In the Lowry/Carr correspondence, Victoria and Albert Museum, London.
50. Pat Cooke to author.
51. Bloom tapes.
52. Maitland tapes.
53. ibid.
54. Letters to Robert Lowry from the Topham and Davis families, in the estate of L. S. Lowry.
55. Lucy Holmes to author.

Chapter 3

1. Monty Bloom to author.
2. Lucy Holmes (née Snarr), general maid in the Lowry home at 14 Pine Grove, Victoria Park, Manchester, to author.
3. The late May Eddowes (née Shephard), first cousin to L. S. Lowry, to author.
4. 'Gentlemen Impressionists' by Andrew Forge, *Encounter*, December 1960.
5. L. S. Lowry to Professor Hugh B. Maitland; on tape, 1970.
6. *Conversations with L. S. Lowry* by Hugh Maitland (unpublished).
7. Letter from L. S. Lowry to the Pall Mall Property Company; March 21st, 1910.
8. *Dictionnaire de Peintres* by E. Benezit (Librairie Gründ, 1966).
9. *Manchester at the Close of the Nineteenth Century and Contemporary Biography* by William Burnett Tracy and William Pike (W. T Pike and Co., Brighton, 1899).
10. Maitland tapes.
11. May Eddowes to author.

12. There is, in fact, some doubt about this date. Sotheby's, who sold the picture in 1971, believe it to have been done much later.
13. Maitland tapes.
14. Interview given by L. S. Lowry to students at Salford College of Art; on tape, 1965.
15. 'Lancashire made them' by Frank and Vincent Tilsley, *News Chronicle and Daily Despatch*, December 1st, 1955.
16. Maitland, *Conversations with L. S. Lowry*.
17. Tyne Tees Television documentary film 'Mister Lowry', produced by Robert Tyrrell, 1968.
18. Maitland tapes.
19. Sam Rabin, artist, to author.
20. Notes by Frank Mullineux in the Salford City Art Gallery catalogue to the Lowry Collection, 1977.
21. ibid.
22. L. S. Lowry to the late Gerald B. Cotton, Chief Librarian of Swinton and Pendlebury and later Salford, and Frank Mullineux, Keeper of Monks Hall Museum, Eccles; on tape (undated).
23. L. S. Lowry to Monty Bloom; on tape (undated).
24. Clifford Openshaw to author.
25. James Fitton, RA, writing in the Royal Academy catalogue to the Lowry Exhibition, 1976.
26. 'Mr Monsieur: Adolphe Valette in Manchester' by Sandra A. Martin, *Lancashire Life*, November 1976.
27. Obituary notice in French newspapers, May 23rd, 1942.
28. *Manchester Evening News*, May 21st, 1928.
29. James Fitton, RA, to author.
30. Martin, 'Mr Monsieur', *Lancashire Life*.
31. ibid.
32. 'L. S. Lowry: a man of his people' by Barrie Sturt-Penrose, *Nova*, August 1966.
33. Bloom tapes.
34. Catalogue notes by Sandra A. Martin for the Manchester City Art Gallery Valette Exhibition, October/November 1976.
35. Sam Rabin to author.
36. *Manchester Evening News*, August 18th, 1970.
37. Maitland tapes.
38. Bloom tapes.
39. Letter from George Lyons to A. J. M. Maltby, Director of Salford City Art Gallery; June 3rd, 1929.
40. ibid.
41. Salford City Art Gallery catalogue to the Lowry Collection, 1977.
42. ibid.
43. Maitland tapes.
44. James Fitton, RA, to author.
45. Martin, 'Mr Monsieur', *Lancashire Life*.
46. James Fitton, RA, to author.

47. Martin, 'Mr Monsieur', *Lancashire Life*.
48. *Modern English Painters:* vol. 2, *Lewis to Moore* by John Rothenstein (Macdonald and Jane's, London, 1976).
49. Maitland tapes.
50. Cotton/Mullineux tapes.
51. *L. S. Lowry* by Margo Ingham, Fine Art Editions No. 2 (Aquarius Publications, 1977).

Chapter 4

1. A penny-a-week insurance policy which Robert took out on the life of his son when Laurie was two, was allowed to lapse when the boy was seven.
2. Memorial to Jacob Earnshaw, *Manchester Guardian*, October 13th, 1908.
3. Carol Ann Spiers (née Lowry), heir to L. S. Lowry, to author.
4. Contemporary photographs of John Earnshaw show a marked
4. similarity to Lowry's *Portrait Head* reproduced in the *Manchester Guardian*, May 1st, 1964.
 L. S. Lowry to Professor Hugh B. Maitland; on tape, 1970.
6. Stanley Shaw, Director of Salford City Art Gallery, to author.
7. Mervyn Levy in the Royal Academy catalogue to the Lowry Exhibition, 1976.
8. Manchester Poor Rate Books, 1908–9. Manchester City Library Archives Department.
9. Robert Lowry's accounts.
10. Lucy Holmes (née Snarr), general maid in the Lowry home at 14 Pine Grove, Victoria Park, Manchester, to author.
11. ibid.
12. Papers in the estate of L. S. Lowry.
13. The late May Eddowes (née Shephard), first cousin to L. S. Lowry, to author.
14. N. M. Baines, Executive Assistant, General Accident Fire and Life Assurance Corporation Ltd, in a letter to the author.
15. ibid.
16. Sam Rabin, artist, to author.
17. Letter to L. S. Lowry from Mary Fletcher Shelmerdine; February 18th, 1932.
18. May Eddowes to author.
19. Poor and District Rate Books for Swinton and Pendlebury, 1909–10. These same Rate Books list a Mrs Mary Charlton at a No. 117A Station Road, a number that no longer exists, which could mean that the house was at that time divided and the rent therefore shared.
20. Councillor Jack Gallagher, son of the late Mrs Jemima Dickman, to author.
21. Maitland tapes.
22. *The Discovery of L. S. Lowry* by Maurice Collis (Alex Reid and Lefevre Ltd, London, 1951).

23. 'L. S. Lowry sees beauty through the smoke' by Harry Hopkins, *John Bull*, November 16th, 1957. It is interesting, in view of the date (1916) that Lowry puts on this event, to note that on the back of a small washed pastel mill scene he sent to David Carr Lowry wrote: 'This is my first mill drawing done about 1916 or 1917.' The picture was in the Arts Council Retrospective Exhibition.

24. *Modern English Painters:* vol. 2, *Lewis to Moore* by John Rothenstein (Macdonald and Jane's, London, 1976).

25. BBC Television documentary film 'L. S. Lowry', produced by John Read; 1957.

26. L. S. Lowry to the late Gerald B. Cotton, Chief Librarian of Swinton and Pendlebury and later Salford, and Frank Mullineux, Keeper of Monks Hall Museum, Eccles; on tape (undated).

27. 'Old man of the sea' by Robert Tyrrell, *The Observer*, April 4th, 1971.

28. Robert Wraight in catalogue notes to the Crane Kalman Gallery Lowry Exhibition, November 1966/January 1967.

29. Tyne Tees Television documentary film 'Mister Lowry', produced by Robert Tyrrell; 1968.

30. *Mill Worker*, which is in a private collection, was shown at the Royal Academy Lowry Exhibition of 1976, and is reproduced in *The Selected Paintings of L. S. Lowry* by Mervyn Levy (Jupiter Books, London, 1976).

31. *Clifton Junction, Morning* and *Clifton Junction, Evening* are in the Swinton Collection on show at Salford City Art Gallery. The artist gave them to Swinton in 1974, saying that they were virtually the last pictures he painted out of doors.

32. Cotton/Mullineux tapes.

33. Collis, *The Discovery of L. S. Lowry*.

34. Cotton/Mullineux tapes.

35. Frank Mullineux to author.

36. Clifford Openshaw to author.

37. Letter from Norman Goodfellow, Chairman of the Pall Mall Property Company, to author.

38. Clifford Openshaw to author.

39. ibid.

40. ibid.

41. ibid.

42. BBC Television documentary film 'I'm just a simple man', produced by John Read; 1977.

43. Clifford Openshaw to author.

44. ibid.

45. Frank Mullineux to author.

46. Clifford Openshaw to author.

47. Monty Bloom to author.

48. Letter from L. S. Lowry to Harold Timperley; May 22nd, 1932.

49. L. S. Lowry in Granada Television documentary film 'Mr Lowry', produced by Leslie Woodhead; 1956.

50. L. S. Lowry to Monty Bloom; on tape (undated).
51. Clifford Openshaw to author.
52. 'Mr Lowry', Granada Television.
53. Clifford Openshaw to author.
54. ibid.
55. Tyrrell, 'Old man of the sea', *The Observer*.
56. ibid.
57. Cotton/Mullineux tapes.
58. Sir John Rothenstein in 'Mister Lowry', Tyne Tees Television.
59. Cotton/Mullineux tapes.
60. Maitland tapes.
61. ibid.
62. ibid.
63. Cotton/Mullineux tapes.
64. Maitland tapes.
65. Cotton/Mullineux tapes.
66. Bloom tapes.
67. Frank Mullineux to author.
68. Hal Yates, author of *A Short History of the Manchester Academy of Fine Arts*, to author.
69. Rothenstein, *Modern English Painters*, vol. 2, page 88.
70. ibid.
71. Collis, *The Discovery of L. S. Lowry*.
72. 'Mister Lowry', Tyne Tees Television.

Chapter 5

1. Robert Lowry's accounts.
2. L. S. Lowry to Professor Hugh B. Maitland; on tape, 1970.
3. Alick Leggat to author.
4. Lowry's personal papers.
5. The late May Eddowes (née Shephard), first cousin to L. S. Lowry, to author.
6. Letter from Oswald P. Lancashire, JP, to the Officer in Charge, Bury Barracks; August 23rd, 1918.
7. ibid.
8. Carol Ann Spiers (née Lowry), heir to L. S. Lowry, to author.
9. Louis Duffy in Tyne Tees Television documentary film 'Mister Lowry', produced by Robert Tyrrell; 1968.
10. Maitland tapes.
11. May Eddowes to author.
12. ibid.
13. ibid.
14. Philip Robertson to author.
15. L. S. Lowry to the late Gerald B. Cotton, Chief Librarian of Swinton and Pendlebury and later Salford, and Frank Mullineux, Keeper of Monks Hall Museum, Eccles; on tape (undated).

16. *Manchester Evening News*, June 26th, 1968.
17. Letter to Elizabeth Lowry from Lizzie Anderson; undated.
18. Letter from Denys Dyer Ball, son of Arthur and Ruth Dyer Ball, to author.
19. ibid.
20. Letter from Miss J. M. R. Campbell, Archivist of the National Westminster Bank, to author.
21. Letter from Bert Shephard to W. J. Shephard; March 22nd, 1939.
22. Professor Geoffrey Shephard to author.
23. Maitland tapes.
24. *Guardian: Biography of a Newspaper* by David Ayerst (Collins, London, 1971).
25. 'Music in Manchester' by Neville Cardus in *The Soul of Manchester*, ed. W. H. Brindley (E.P. Publishing Ltd, London, 1974).
26. ibid.
27. Phillip Fletcher to author.
28. Cotton/Mullineux tapes.
29. Phillip Fletcher to author.
30. ibid.
31. ibid.
32. Maitland tapes. This portrait is at Salford City Art Gallery and is illustrated in the catalogue to their Lowry Collection (1977).
33. ibid.
34. Phillip Fletcher to author.
35. Maitland tapes.
36. Clifford Openshaw to author.
37. *Modern English Painters* vol. 2, *Lewis to Moore* by John Rothenstein (Macdonald and Jane's, London, 1976).
38. Phillip Fletcher to author.
39. Author's own source.
40. 'Mister Lowry', Tyne Tees Television.
41. Alfred Hulme to author.

PART TWO *Chapter 1*

1. *The Soul of Manchester* ed. W. H. Brindley (E.P. Publishing Ltd, London, 1974).
 'Manchester and Art' by F. W. Halliday in Brindley (ed.), *The Soul of Manchester*.
3. ibid.
4. *Portrait of Manchester* by Michael Kennedy (Robert Hale, London, 1970).
5. *A Short History of the Manchester Academy of Fine Arts* by Hal Yates, published in support of the exhibition on the history of the Academy held as part of the 1973 Manchester Festival.
6. L. S. Lowry to the late Gerald B. Cotton, Chief Librarian of Swinton

and Pendlebury and later Salford, and Frank Mullineux, Keeper of
Monks Hall Museum, Eccles; on tape (undated).

7. Yates, *A Short History of the Manchester Academy of Fine Arts.*
8. ibid.
9. ibid.
10. Catalogue notes by Sandra A. Martin for the Valette Exhibition at Manchester City Art Gallery, October/November, 1976.
11. ibid.
12. Interview given by L. S. Lowry to students of Salford College of Art; on tape, 1965.
13. Clifford Openshaw to author.
14. *Manchester Guardian*, February 18th, 1919.
15. *Manchester City News*, February 22nd, 1919.
16. Hal Yates to author.
17. ibid.
18. L. S. Lowry to Professor Hugh B. Maitland; on tape, 1970.
19. ibid.
20. Tyne Tees Television documentary film 'Mister Lowry', produced by Robert Tyrrell; 1968.
21. *Shabby Tiger* by Howard Spring (Collins, London, 1934).
22. 'The world of L. S. Lowry' by Howard Spring in *The Saturday Book*, No. 17, ed. John Hadfield (Hutchinson, London, 1957).
23. ibid.
24. Maitland tapes.
25. The Rev. Geoffrey Bennett to author.
26. Letter from L. S. Lowry to Monty Bloom; August 26th, 1970.
27. L. S. Lowry to Monty Bloom; on tape (undated).
28. The Rev. Geoffrey Bennett to author.
29. Maitland tapes.
30. Salford tapes.
31. ibid.
32. Cotton/Mullineux tapes.
33. 'L. S. Lowry: the artist' by Frank Mullineux, in the catalogue of the Salford City Art Gallery Lowry Collection, 1977.
34. Cotton/Mullineux tapes.
35. Bloom tapes.
36. Salford tapes.
37. Clifford Openshaw to author.
38. Frank Whalley.
39. Clifford Openshaw to author.
40. Stanley Shaw, Director of Salford City Art Gallery, to author.
41. George Parker Fletcher, Secretary of the Pall Mall Property Company, died in 1967, at the age of ninety-one.
42. Maitland tapes.
43. *Conversations with L. S. Lowry* by Hugh Maitland (unpublished).
44. *The Discovery of L. S. Lowry* by Maurice Collis (Alex Reid and Lefevre Ltd, London, 1951).

308 Notes and Sources

45. *The Discovery of L. S. Lowry* by Maurice Collis (Alex Reid and Lefevre Ltd, London, 1951).
46. ibid.
47. The Rev. Geoffrey Bennett to author.
48. Joan Ellis, widow of the late Tony Ellis, to author.
49. Phyllis Marshall of the Stone Gallery, Newcastle-upon-Tyne, to author.
50. 'Mister Lowry', Tyne Tees Television.
51. 'My lonely life' by L. S. Lowry as told to Edwin Mullins, *Sunday Telegraph*, November 20th, 1966.
52. 'L. S. Lowry: a man of his people' by Barrie Sturt-Penrose, *Nova*, August 1966.
53. 'Sad, solitary and abubble with humour' by Michael Hardcastle, *Life*, October 30th, 1967.
54. Frank Bradley to author.
55. Bloom tapes.
56. James Fitton, RA, to author.
57. BBC Television documentary film 'I'm just a simple man', produced by John Read; 1977.

Chapter 2

1. L. S. Lowry to Monty Bloom; on tape (undated).
2. L. S. Lowry to the late Gerald B. Cotton, Chief Librarian of Swinton and Pendlebury and later Salford, and Frank Mullineux, Keeper of Monks Hall Museum, Eccles; on tape (undated).
3. Tyne Tees Television documentary film 'Mister Lowry', produced by Robert Tyrrell; 1968.
4. ibid.
5. Cotton/Mullineux tapes.
6. 'Mister Lowry', Tyne Tees Television.
7. Cotton/Mullineux tapes.
8. Muriel Orton to author.
9. ibid.
10. Ethelwyn Taylor, daughter of the late Percy Warburton, to author.
11. Muriel Orton to author.
12. ibid.
13. *Guardian: Biography of a Newspaper* by David Ayerst (Collins, London, 1971).
14. L. S. Lowry to Professor Hugh B. Maitland; on tape, 1970.
15. ibid.
16. 'L. S. Lowry: the artist' by Frank Mullineux in the catalogue of the Salford City Art Gallery Lowry Collection, 1977.
17. Bloom tapes.
18. 'My lonely life' by L. S. Lowry as told to Edwin Mullins, *Sunday Telegraph*, November 20th, 1966.
19. Cotton/Mullineux tapes.
20. Maitland tapes.

21. ibid.
22. ibid.
23. ibid.
24. Monty Bloom to author. Bloom's action was not unique in the history of art. In 1893 the critic Walter Crane asked Arthur Key, owner of the controversial Degas painting *l'Absinthe*, how he could live with it; Key promptly replied that he could not live without it for, having sold it, within forty-eight hours he bought it back at an enhanced price. The picture is now in the Louvre. *Fifty Years of the New English Art Club 1886–1935* by Alfred Thornton (Curwen Press, London, 1935).
25. Letter to L. S. Lowry from Howard Spring; May 21st, 1942.
26. ibid.; June 24th, 1942.
27. *Manchester Guardian*, October 31st, 1921.
28. The late Eric Newton in 'For your leisure', BBC Radio, November 14th, 1948.
29. Bloom tapes.
30. ibid.
31. Letter from L. S. Lowry to A. S. Wallace, Literary Editor of the *Manchester Guardian*; November 9th, 1926.
32. 'Mister Lowry', Tyne Tees Television.
33. Doris Jewell, sister of the late Daisy Jewell, to author.
34. Letter to L. S. Lowry from Major Armand Blackley, Director of James Bourlet & Sons Ltd, Nassau Street, London; April 26th, 1955. (Founded in 1828, Bourlet's was acquired by Sotheby's in 1973, but still trades under its original name in Fulham Road, London.)
35. Letter from L. S. Lowry to Major Blackley, published in the Bourlet brochure.
36. Bert Jones of James Bourlet & Sons Ltd, to author.
37. ibid.
38. Fred Ball of James Bourlet & Sons Ltd, to author.
39. ibid.
40. Bert Jones to author.
41. Doris Jewell to author.
42. Thornton, *Fifty Years of the New English Art Club: 1886–1935.*
43. ibid.
44. *Mediterranea*, June 1928.
45. ibid.
46. *Dictionnaire Biographique des Artistes Contemporains, 1910–1930* (Art & Edition, Paris, 1931).
47. Draft letter from L. S. Lowry to Edouard-Joseph et Cie, Paris, 18eme; November 5th, 1931.
48. 'My Lonely Life' as told to Edwin Mullins, *Sunday Telegraph.*
49. Letter to L. S. Lowry from May Aimée Smith; Armistice Day, 1930.
50. 'Adolphe Valette, his life and work' by Sandra A. Martin in the Manchester City Art Gallery catalogue to the Valette Exhibition, 1976.

51. Letter from L. S. Lowry to the late Harold Timperley; December 15th, 1929. From the Lowry/Timperley correspondence in the Archives Department of Salford City Art Gallery and Museum.

52. 'Catalogue of Drawings and Paintings by M. S. Nicholls, L. S. Lowry and H. Ritchie at the Salon Gallery, 2a Hall Street, Oxford Street, Manchester, January 27th/February 7th, 1931.' Lowry's drawing *An Arrest, 1922* is in the Monty Bloom collection and was used as the basis for a painting done five years later, *An Arrest, 1927*, now in the collection of the Castle Museum and Art Gallery, Nottingham.

53. Letter from L. S. Lowry to Harold Timperley; October 8th, 1929.

Chapter 3

1. *The Journal*, Eccles, July 15th, 1927.
2. *The Times*, March 18th, 1927.
3. Letter from Ronald Alley, Keeper of the Modern Collection at the Tate Gallery, to the author.
4. Letter to L. S. Lowry from the late Harold Timperley; June 10th, 1927.
5. Edith Timperley to author.
6. ibid.
7. ibid.
8. Letter from L. S. Lowry to Harold Timperley; March 9th, 1930.
9. Letter from Edith Timperley to the author.
10. *The Mink Coat* by Edith Brill (Humphrey Toulmin at the Cayme Press Ltd, London, 1930).
11. Edith Timperley to author.
12. Letter from L. S. Lowry to Harold Timperley; June 14th, 1929.
13. Edith Timperley to author.
14. Letter from L. S. Lowry to Harold Timperley; October 8th, 1929.
15. ibid.; December 5th, 1931.
16. Letter from Harold Timperley to L. S. Lowry; June 10th, 1927.
17. 'My Lonely Life' by Robert Robinson, *Sunday Times*, September 11th, 1962.
18. Letter from L. S. Lowry to Harold Timperley; September 10th, 1931.
19. ibid.; April 10th, 1944.
20. ibid.; November 24th, 1944.
21. Edith Timperley to author.
22. ibid.
23. Letter from Edith Timperley to the Editor, *The Observer*, November 16th, 1975.
24. Edith Timperley to author.
25. James Fitton, RA, to author.
26. Edith Timperley to author.
27. *The Cotswold Book* was published in 1931 at 7s. 6d. In the '70s it was being sold in secondhand bookshops for £7.
28. L. S. Lowry to Professor Hugh B. Maitland; on tape, 1970.

29. Letter from L. S. Lowry to Harold Timperley; September 10th, 1931.
30. ibid.; November 30th, 1930.
31. Letter to L. S. Lowry from Harold Timperley; March 7th, 1943.
32. ibid.; September 21st, 1942.
33. ibid.; November 29th, 1942.
34. Edith Timperley to author.
35. ibid.
36. Sir John Betjeman in 'Tributes to L. S. Lowry' in the Royal Academy of Arts catalogue, 1976.
37. The Rev. Geoffrey Bennett to author.
38. ibid.
39. ibid.
40. ibid.
41. Maitland tapes.
42. *Drawings of L. S. Lowry* by Mervyn Levy (Cory Adams & Mackay, London, 1963).
43. Article by Jessica W. Stevens in *The Studio*, vol. 95, no. 48, January 1928.
44. L. S. Lowry to Monty Bloom; on tape (undated).
45. Maitland tapes.
46. ibid.
47. Draft letter from Robert Lowry to Mrs Bolton; May 9th, 1926.
48. Maitland tapes.
49. The late May Eddowes (née Shephard), first cousin to L. S. Lowry, to author.
50. Letter to Robert Lowry from May Bell; August 18th, 1927.
51. May Eddowes to author.
52. *Manchester Guardian*, March 29th, 1930.
53. Letter from L. S. Lowry to Lawrence Haward, Curator of Manchester City Art Gallery; September 18th, 1930.
54. ibid.; April 3rd, 1930.
55. ibid.; July, 1930.
56. Letter to L. S. Lowry from Lawrence Haward; July 23rd, 1930.
57. Letter from L. S. Lowry to Lawrence Haward; July 28th, 1930.
58. ibid.
59. Draft note in pencil from L. S. Lowry to Lawrence Haward; undated.
60. Maitland tapes.
61. *Conversations with L. S. Lowry* by Hugh Maitland (unpublished).
62. 'Lowry revisits his landscape' by Arthur Hopcraft, *Illustrated London News*, July 9th, 1966.
63. Letter to Robert Lowry from Fred Davis; 1919.
64. Bloom tapes.
65. Councillor Jack Gallagher to author.
66. Maitland tapes. The artist always refused to part with that picture; it now hangs in Salford City Art Gallery, on loan from the Lowry estate.
67. Letter from Gordon Phillips 'for the editor' of the *Manchester Guardian*, to L. S. Lowry; March 5th, 1939.

68. Cotton/Mullineux tapes.
69. ibid.

Chapter 4

1. Carol Ann Spiers (née Lowry), heir to L. S. Lowry, to author.
2. Lowry's personal papers.
3. Letter to L. S. Lowry from Mary Fletcher Shelmerdine; February 13th, 1932.
4. ibid.; February 14th, 1932.
5. L. S. Lowry to Professor Hugh B. Maitland; on tape, 1970.
6. ibid.
7. Letter to L. S. Lowry from Mary Fletcher Shelmerdine; February 13th, 1932.
8. Letter to Elizabeth Lowry from Mary Davis; February 12th, 1932.
9. Letter to Elizabeth Lowry from May Eddowes; February 13th, 1932.
10. Clifford Openshaw to author.
11. 'Masterpieces in his spare time' by Frank Whalley, *Manchester Evening News*, August 18th, 1976.
12. Lowry's personal papers.
13. ibid.
14. Draft letter from L. S. Lowry to Messrs Brook, Hulme and Ruddin, Manchester; April 16th, 1932.
15. Letter to Robert Lowry from Willie Hobson; February 16th, 1923.
16. ibid.; February 16th, 1925.
17. ibid.; February 20th, 1925.
18. Letter to Elizabeth Lowry from Willie Hobson; February 12th, 1932.
19. Letter to Robert Lowry from F. W. Ward; April 5th, 1931.
20. Letter to Robert Lowry from John Earnshaw; February 6th, 1932.
21. Letter to L. S. Lowry from Mary Fletcher Shelmerdine; February 18th, 1932.
22. Lowry's personal papers.
23. Draft letter from L. S. Lowry to Messrs Brook, Hulme and Ruddin; April 16th, 1932.
24. Letter to L. S. Lowry from Gertrude Topham; April 11th, 1932.
25. Letter to L. S. Lowry from Mary Fletcher Shelmerdine; May 9th, 1932.
26. Letter to L. S. Lowry from James Chettle, President of the Manchester Academy of Fine Arts; April 17th, 1935.
27. The late Walter Greenwood to author.
28. Councillor Jack Gallagher to author.
29. Enoch Leatherbarrow to author.
30. L. S. Lowry to the late Gerald B. Cotton, Chief Librarian of Swinton and Pendlebury and later Salford, and Frank Mullineux, Keeper of Monks Hall Museum, Eccles; on tape (undated).
31. *Salford City Reporter*, December 31st, 1931.

32. Notes by Stanley Shaw, Director of Salford City Art Gallery, in the Salford catalogue for the permanent Lowry Exhibition.
33. L. S. Lowry to Monty Bloom; on tape (undated).
34. Maitland tapes.
35. Bloom tapes.

Chapter 5

1. Letter from L. S. Lowry to Harold Timperley; April 25th, 1937.
2. Clifford Openshaw to author.
3. Letter to L. S. Lowry from Daisy Jewell of James Bourlet and Sons Ltd, London; March 23rd, 1937.
4. Bert Jones of James Bourlet and Sons Ltd, to author.
5. The late A. J. McNeill Reid in Tyne Tees Television documentary film 'Mister Lowry', produced by Robert Tyrrell; 1968.
6. 'L. S. Lowry sees beauty through the smoke' by Harry Hopkins, *John Bull*, November 16th, 1957.
7. 'The Lefevre Gallery' by G. S. Whittet, *The Studio*, June 1951.
8. ibid.
9. Letter to L. S. Lowry from A. J. McNeill Reid of Alex Reid and Lefevre Ltd, London; May 6th, 1938.
10. Draft letter from L. S. Lowry to Alex Reid and Lefevre Ltd; May 8th, 1938.
11. *The Discovery of L. S. Lowry* by Maurice Collis (Alex Reid and Lefevre Ltd, London, 1951).
12. ibid.
13. ibid.
14. Monty Bloom to author.
15. Letter to L. S. Lowry from Daisy Jewell; February 25th, 1939.
16. ibid.; undated.
17. *Brave Day, Hideous Night* by John Rothenstein (Hamish Hamilton, London, 1965).
18. ibid.
19. Sir John Rothenstein in 'Mister Lowry', Tyne Tees Television.
20. ibid.
21. Letter to L. S. Lowry from Sir John Rothenstein; November 2nd, 1951.
22. Letter to L. S. Lowry from Daisy Jewell; November 16th, 1939.
23. ibid.
24. Letter to L. S. Lowry from A. J. McNeill Reid; June 22nd, 1940.
25. ibid.
26. 'Mister Lowry', Tyne Tees Television.
27. L. S. Lowry to Professor Hugh B. Maitland; on tape, 1970.
28. Clifford Openshaw to author.
29. Edith Timperley to author.
30. ibid.
31. Clifford Openshaw to author.

32. L. S. Lowry to Monty Bloom; on tape (undated).
33. Maitland tapes.
34. Kathleen Robinson to author.
35. Edith Timperley to author.
36. Letter from L. S. Lowry to Harold Timperley; September 10th, 1940.
37. ibid.
38. 'Mister Lowry', Tyne Tees Television.
39. ibid.
40. Maitland tapes.
41. ibid.
42. ibid.

PART THREE *Chapter 1*

1. BBC Television documentary film 'I'm just a simple man', produced by John Read; 1977.
2. L. S. Lowry to the late Gerald B. Cotton, Chief Librarian at Swinton and Pendlebury and later Salford, and Frank Mullineux, Keeper of Monks Hall Museum, Eccles; on tape (undated).
3. ibid.
4. ibid.
5. ibid.
6. 'My lonely life' by L. S. Lowry as told to Edwin Mullins, *Sunday Telegraph*, November 20th, 1966.
7. Frank Mullineux to author.
8. Tyne Tees Television documentary film 'Mister Lowry', produced by Robert Tyrrell; 1968.
9. Cotton/Mullineux tapes.
10. James Fitton, RA, to author.
11. Article by Dora Holmes in *Art Quarterly Publication*, vol. 2, no. 1, September 30th, 1958.
12. Muriel Orton to author.
13. ibid.
14. 'Mister Lowry', Tyne Tees Television.
15. ibid.
16. Notes made by the late Tony Ellis during interviews with L. S. Lowry, in preparation for a biography of the artist.
17. Pat Cooke to author.
18. Edith Timperley to author.
19. ibid.

Chapter 7

1. *News Chronicle*, April 28th, 1958.
2. ibid.
3. G. S. Whittet writing in *The Studio*, August 1958.
4. A. J. Allport writing in *600 Magazine*.

5. Nesta Ellis writing in *Sphinx*, March 1963.
6. L. S. Lowry to Professor Hugh B. Maitland; on tape, 1970.
7. Pat Cooke to author.
8. Frank Bradley to author.
9. Edith Timperley to author.
10. Maitland tapes.
11. Letter from Dame Ninette de Valois to author.
12. Margery Clarke to author.
13. ibid.
14. Pat Cooke to author.
15. ibid.
16. Carol Ann Spiers (née Lowry), heir to L. S. Lowry, to author.
17. Monty Bloom to author.
18. Frank Bradley to author.
19. Carol Ann Spiers to author.
20. Gladys Brooke to author.
21. Letter from Alfred Hulme of Wm. Hulme and Son, Manchester, to author.
22. Doreen Crouch to author.
23. ibid.
24. Mervyn Levy in catalogue notes to the Royal Academy of Arts Lowry Exhibition, 1976.
25. ibid.
26. 'A Pre-Raphaelite passion' by Sandra A. Martin, catalogue notes to the Manchester City Art Gallery exhibition of the private Lowry collection, 1977.
27. L. S. Lowry to Monty Bloom; on tape (undated).

PART FOUR *Chapter 1*

1. L. S. Lowry to Professor Hugh B. Maitland; on tape, 1970.
2. Granada Television documentary film 'Mr Lowry', produced by Leslie Woodhead; 1956.
3. Letter from L. S. Lowry to Percy Warburton; undated.
4. Letter from L. S. Lowry to Harold Timperley; August 9th, 1942.
5. ibid.; July 20th, 1941.
6. Inexplicably, although both Maitland and Lowry gave the date as 1940, Doctor Laing's nephew, Doctor Gordon Laing, remembers Lowry paintings hung in the Droylesden house before the war.
7. Maitland tapes.
8. L. S. Lowry to Monty Bloom; on tape (undated).
9. Notes found in the estate of the late Margo Ingham.
10. *Conversations with L. S. Lowry* by Hugh Maitland (unpublished).
11. ibid.
12. Philip Robertson of Glossop, who travelled to Berwick-upon-Tweed with Lowry on many occasions during their holidays together in Sunderland.

13. Maitland, *Conversations with L. S. Lowry*.
14. Louis Duffy in Tyne Tees Television documentary film 'Mister Lowry', produced by Robert Tyrrell; 1968.
15. 'Mister Lowry', Tyne Tees Television.
16. *Manchester Evening News*, February 21st, 1962.
17. Letter from L. S. Lowry to David Carr; June 7th, 1947.
18. ibid.; July 5th, 1947.
19. ibid.; August 5th, 1947.
20. ibid.; January 10th, 1948.
21. Frank Bradley to author.
22. Letter from L. S. Lowry to David Carr; August 16th, 1948.
23. Barbara Carr to author.
24. Letter to L. S. Lowry from David Carr; December 5th, 1943.
25. Letter from L. S. Lowry to David Carr; December 9th, 1943.
26. ibid.; December 16th, 1943.
27. ibid.; November 25th, 1944.
28. Bloom tapes.
29. Letter from L. S. Lowry to David Carr; June 24th, 1945.
30. ibid.; September 1st, 1945.
31. ibid.; September 20th, 1945.
32. ibid.; October 31st, 1947.
33. ibid.; August 14th, 1947.
34. L. S. Lowry to the late Gerald B. Cotton, Chief Librarian of Swinton and Pendlebury and later Salford, and Frank Mullineux, Keeper of Monks Hall Museum, Eccles; on tape (undated).
35. ibid.
36. Clifford Openshaw to author. The picture *Old Church and Steps* was reproduced as a print by Ganymed Press.
37. *Journal of Mental Science*, vol. 99, pp. 136–143.
38. Letter to L. S. Lowry from Harold Palmer, MD, Medical Superintendent, Hill End Hospital, St Alban's; July 5th, 1951.
39. 'Notes on the work of L. S. Lowry' by Norman C. Colquhoun and Harold Palmer, MD; papers in the Lowry estate.
40. Harold Palmer, MD, to author.
41. ibid.
42. Letter from L. S. Lowry to David Carr; November 1st, 1949.
43. ibid.; May 9th, 1950.
44. ibid.; November 1st, 1950.
45. ibid.; November 1st, 1954.
46. Notes by Frank Whalley in the catalogue for the Mottram Memorial Exhibition, June 1977.
47. Maitland tapes.
48. 'Mister Lowry', Tyne Tees Television.
49. ibid.
50. Charles Roscoe to author.
51. 'Mister Lowry', Tyne Tees Television.

52. *The Discovery of L. S. Lowry* by Maurice Collis (Alex Reid and Lefevre Ltd, London, 1951).
53. Harold Riley to author.

Chapter 2

1. Letter to L. S. Lowry from Daisy Jewell of James Bourlet and Sons Ltd, London; February 21st, 1943.
2. It was from the 1943 exhibition that Collis's interest sprang, although it was to be another nine years before the book he planned to write on Lowry materialized. Initially he was hampered by the lack of paper for printing, later by lack of interest; eventually Alex Reid and Lefevre published it themselves, prepared to make a financial loss.
3. L. S. Lowry's accounts.
4. Letter to L. S. Lowry from A. J. McNeill Reid of Alex Reid and Lefevre Ltd, London; March 8th, 1944.
5. ibid.; October 6th, 1944.
6. ibid.; October 18th, 1944.
7. L. S. Lowry to Professor Hugh B. Maitland; on tape, 1970.
8. Letter to L. S. Lowry from Duncan MacDonald of Alex Reid and Lefevre Ltd; March 5th, 1945.
9. ibid.
10. ibid.; March 8th, 1945.
11. ibid.; March 20th, 1945.
12. ibid.
13. 'Sad, solitary and abubble with humour' by Michael Hardcastle, *Life*, October 30th, 1967.
14. Notes in the estate of the late Margo Ingham.
15. Margo Ingham to author.
16. ibid.
17. The late Eric Newton in 'For your leisure', BBC Radio, November 14th, 1948.
18. Andras Kalman of the Crane Kalman Gallery, London, to author.
19. 'A civilized man with an eye for primitives' by Geoffrey Nicholson, *Sunday Times*, January 23rd, 1962.
20. Andras Kalman to author.
21. ibid.
22. Nicholson, 'A civilized man', *Sunday Times*.
23. Andras Kalman to author.
24. ibid.
25. 'Artist into film' by John Read, *The Studio*, March 1958.
26. Maitland tapes.
27. Lady Beaverbrook was the widow of Sir James Dunn, whose collection was being exhibited at the Tate Gallery.
28. Maitland tapes.

29. 'When you quit Art School, forget about it' by Margaret Roberts, *News Chronicle*, May 3rd, 1955.
30. *Manchester Guardian*, December 2nd, 1954.
31. ibid.
32. Frank Mullineux to author.
33. Letter from A. Frape to S. D. Cleveland, Director of the Manchester City Art Gallery; April 10th, 1959.
34. Letter from Ian Dalrymple to Manchester City Art Gallery; April 10th, 1959.
35. Catalogue notes by S. D. Cleveland for Manchester City Art Gallery's L. S. Lowry Retrospective Exhibition, 3rd June/12th July, 1959.
36. BBC Television documentary film 'I'm just a simple man', produced by John Read; 1977.
37. Letter from L. S. Lowry to S. D. Cleveland; April 23rd, 1959.
38. Professor and Mrs Ronald Shephard to author.
39. Letter from L. S. Lowry to David Carr; June 8th, 1953.
40. Pat Cooke to author.
41. Presentation address by Professor R. A. C. Oliver at the Manchester University degree ceremony, May 1961.
42. Tyne Tees Television documentary film 'Mister Lowry', produced by Robert Tyrrell; 1968.
43. L. S. Lowry to the Prime Minister; May 1955. From a copy of his letter in the Lowry estate.
44. ibid.; December 1st, 1967.
45. ibid.; undated.
46. Maitland tapes.
47. 'Why Lowry politely refused knighthood' by John Dunsford, *Daily Telegraph*, October 31st, 1974.
48. ibid.
49. Letter from L. S. Lowry to the late Percy Warburton; June 2nd, 1962.
50. James Fitton, RA, to author.
51. *Hip, Hip, R.A.* by Robert Wraight (Leslie Frewin, London, 1968).
52. Mervyn Levy on BBC Television.
53. James Fitton, RA, to author.
54. Letter from L. S. Lowry to Sally Vickers, Invitations Secretary, 10 Downing Street; undated copy in the Lowry estate.
55. Hardcastle, 'Sad, solitary and abubble with humour', *Life*.
56. Pat Cooke to author.
57. Letter from L. S. Lowry to the Prime Minister; December 28th, 1975.
58. Dunsford, 'Why Lowry politely refused knighthood', *Daily Telegraph*.
59. 'Mister Lowry', Tyne Tees Television.

Chapter 3

1. L. S. Lowry to the late Gerald B. Cotton, Chief Librarian of Swinton and Pendlebury and later Salford, and Frank Mullineux, Keeper of Monks Hall Museum, Eccles; on tape (undated).
2. Tyne Tees Television documentary film 'Mister Lowry', produced by Robert Tyrrell; 1968.
3. L. S. Lowry to Professor Hugh B. Maitland; on tape, 1970.
4. ibid.
5. Cotton/Mullineux tapes.
6. 'Mister Lowry', Tyne Tees Television.
7. ibid.
8. *Painters of Today: L. S. Lowry, A.R.A.* by Mervyn Levy (Studio Books, London, 1961).
9. Harold Riley to author.
10. Cotton/Mullineux tapes.
11. Letter from L. S. Lowry to David Carr; September 7th, 1949.
12. ibid.; November 13th, 1948.
13. Letter to L. S. Lowry from the late A. J. McNeill Reid of Alex Reid and Lefevre Ltd, London; June 26th, 1946.
14. Letter to L. S. Lowry from David Carr; undated.
15. Christmas card to L. S. Lowry from David Carr; undated.
16. Maitland tapes.
17. 'My lonely life' by L. S. Lowry as told to Edwin Mullins, *Sunday Telegraph*, November 20th, 1966.
18. Cotton/Mullineux tapes.
19. Monty Bloom to author.
20. 'A Souvenir of Mr Lowry' by Mervyn Levy, *Art News and Review*, June 20th, 1957.
21. Monty Bloom to author.
22. L. S. Lowry to Monty Bloom; on tape (undated).
23. Letter from L. S. Lowry to Monty Bloom; undated.
24. Carol Ann Spiers (née Lowry), heir to L. S. Lowry, to author.
25. Bloom tapes.
26. Monty Bloom to author.
27. Maurice Collis in catalogue notes to the exhibition of the Bloom Collection of the works of L. S. Lowry at the Hammett Gallery, London, September 21st/October 21st, 1972.
28. Maitland tapes.
29. Brochure for the Harrogate Festival of the Visual Arts.
30. Phyllis Marshall of the Stone Gallery, Newcastle-upon-Tyne, to author.
31. ibid.
32. ibid.
33. ibid.
34. ibid.
35. Monty Bloom to author.

36. Letter from L. S. Lowry to Monty Bloom; June 1st, 1967.
37. Edwin Mullins, *Sunday Telegraph*, October 1964.

PART FIVE *Chapter 1*

1. L. S. Lowry to author.
2. 'Scene: a man alone' by Michael Molloy, *Daily Mirror*, May 8th, 1968.
3. ibid.
4. Pat Cooke to author.
5. Review by Norbert Lynton in the *Guardian*, November 26th, 1966.
6. Pat Cooke to author.
7. Granada Television documentary film 'Mr Lowry', produced by Leslie Woodhead; 1956.
8. ibid.
9. ibid.
10. Leslie Woodhead to author.
11. Phyllis Marshall of the Stone Gallery, Newcastle-upon-Tyne, to author.
12. Letter from L. S. Lowry to Professor Hugh B. Maitland; July 10th, 1968.
13. Michael Bateman writing in 'Atticus', *Sunday Times*, April 14th, 1968.
14. ibid.
15. Letter from L. S. Lowry to Monty Bloom; April 26th, 1970.
16. Ronald Marshall of the Stone Gallery, Newcastle-upon-Tyne, to author.
17. Phyllis Marshall to author.
18. ibid.
19. Two letters from L. S. Lowry to Carol Ann Spiers; May 15th and June 4th, 1968.
20. *Conversations with L. S. Lowry* by Hugh Maitland (unpublished).
21. L. S. Lowry to Professor Hugh B. Maitland; on tape, 1970.

Chapter 2

1. L. S. Lowry to Professor Hugh B. Maitland; on tape, 1970.
2. Geoffrey and Jan Green, of the Tib Lane Gallery, Manchester, to author.
3. Wendy Bridgman to author.
4. ibid.
5. *The Art Game Again!* by Robert Wraight (Leslie Frewin, London, 1974).
6. L. S. Lowry's accounts.
7. Geoffrey and Jan Green to author.
8. ibid.
9. Carol Ann Spiers (née Lowry), heir to L. S. Lowry, to author.

10. 'Portrait of the artist, Mr Lowry' by John Heilpern, *The Observer*, November 9th, 1975.
11. Alick Leggat to author.
12. The late Bessie Swindles to author.
13. L. S. Lowry to Monty Bloom; on tape (undated).
14. L. S. Lowry on Granada Television documentary film 'Mr Lowry', produced by Leslie Woodhead; 1956.
15. Letter from L. S. Lowry to Monty Bloom; June 1st, 1967.
16. ibid.; September 6th, 1964.
17. L. S. Lowry to the late Gerald B. Cotton, Chief Librarian of Swinton and Pendlebury and later Salford, and Frank Mullineux, Keeper of Monks Hall Museum, Eccles; on tape (undated).
18. Maitland tapes.
19. Wraight, *The Art Game Again!*
20. Maitland tapes.
21. Ronald Marshall of the Stone Gallery, Newcastle-upon-Tyne, to author.
22. Maitland tapes.

Chapter 3

1. Granada Television documentary film 'Mr Lowry', produced by Leslie Woodhead; 1956.
2. ibid.
3. ibid.
4. 'Portrait of the artist, Mr Lowry' by John Heilpern, *The Observer*, November 9th, 1975.
5. ibid.
6. Frank Whalley to author.
7. Stanely Shaw, Director of Salford City Art Gallery, to author.
8. ibid.
9. ibid.
10. ibid.
11. John Morris to author.
12. Philip Robertson to author.
13. The late Bessie Swindles to author.

APPENDIX THREE
Select Bibliography

Collis, Maurice, *The Discovery of L. S. Lowry* (Alex Reid and Lefevre, London, 1951).

Levy, Mervyn, *Painters of Today: L. S. Lowry, A.R.A.* (Studio Books, London, 1961).

The Drawings of L. S. Lowry (Cory, Adams & McKay, London, 1963).

Rothenstein, John, *Modern English Painters:* vol. 2, *Lewis to Moore* (Macdonald and Jane's, London, 1976).

Spring, Howard, 'The World of L. S. Lowry' in *The Saturday Book*, No. 17, ed. John Hadfield (Hutchinson, London, 1957).

Wraight, Robert, *The Art Game Again!* (Leslie Frewin, London, 1974).

'Laurence Steven Lowry, 1887–1976', a catalogue of the Salford Collection, with notes by Frank Mullineux and Stanley Shaw (City of Salford Cultural Services Department, 1977).

Notes to the Arts Council Catalogue for the L. S. Lowry Retrospective Exhibition at the Tate Gallery, 1966.

'Tributes to L. S. Lowry', a catalogue to the Royal Academy exhibition of Lowry's work, 1976.

INDEX